For Cathy

Acknowledgments

Once again thanks to executive editor Kevin Harreld, who granted me the freedom to whisk you, the reader, along whereever my photographic explorations took me, and enough time to do the job right. I also couldn't have completed this book without my veteran editorial team, headed by project editor Jenny Davidson, assisted by photography guru Mike Sullivan, book/cover designer Mike Tanamachi, interior designer Bill Hartman, proofreader Sara Gullion, and indexer Katherine Stimson.

Also special thanks to my agent, Carole McClendon, and my wife, Cathy, who, in addition to their continued support and advice, are quick to jump in and supply the common sense that I often lack.

Digital SLR Pro Secrets

David D. Busch

THOMSON

COURSE TECHNOLOGY

Professional ■ Technical ■ Reference

ISBN: 1-59863-019-9

Library of Congress Catalog Card Number: 2005931886

Printed in the United States of America

06 07 08 09 10 BU 10 9 8 7 6 5 4 3 2 1

Publisher and General Manager, Thomson Course Technology PTR:
Stacy L. Hiquet

Associate Director of Marketing:
Sarah O'Donnell

Manager of Editorial Services:
Heather Talbot

Marketing Manager:
Jordan Casey

Executive Editor:
Kevin Harreld

Project Editor:
Jenny Davidson

Technical Reviewer:
Michael D. Sullivan

PTR Editorial Services Coordinator:
Elizabeth Furbish

Interior Layout Tech:
Bill Hartman

Cover Designer:
Mike Tanamachi

Indexer:
Katherine Stimson

Proofreader:
Sara Gullion

THOMSON
━━━━━━━★━━━━━━━ ™
COURSE TECHNOLOGY
Professional ■ Technical ■ Reference

Thomson Course Technology PTR, a division of Thomson Course Technology
25 Thomson Place ■ Boston, MA 02210 ■ http://www.courseptr.com

About the Author

As a roving photojournalist for more than 20 years, **David D. Busch** illustrated his books, magazine articles, and newspaper reports with award-winning images. He has operated his own commercial studio, suffocated in formal dress while shooting weddings-for-hire, and shot sports for a daily newspaper and upstate New York college. His photos have been published in magazines as diverse as *Scientific American* and *Petersen's PhotoGraphic*, and his articles have appeared in *Popular Photography & Imaging, The Rangefinder, The Professional Photographer*, and hundreds of other publications. He's currently reviewing digital cameras for CNet and *Computer Shopper*, and recently returned from a week-long photo safari in Toledo, Spain, where he collected many of the photographs used in this book.

When **About.com** named its top five books on beginning digital photography, occupying the #1 and #2 slots were Busch's *Digital Photography All-In-One Desk Reference for Dummies* and *Mastering Digital Photography*. His 80-plus other books published since 1983 include bestsellers like *Mastering Digital SLR Photography, The Official Hewlett-Packard Scanner Handbook*, and *Photoshop CS2: Photographers' Guide*.

Busch earned top category honors in the Computer Press Awards the first two years they were given (for *Sorry About The Explosion* and *Secrets of MacWrite, MacPaint and MacDraw*), and later served as Master of Ceremonies for the awards.

Contributor Bio

Technical editor **Michael D. Sullivan** added a great deal to this book in addition to checking all the text for technical accuracy. A veteran photographer (in the military sense of the word!), he has always generously contributed some of the best images you'll find in my books, which I usually select because his photos of a particular subject are far superior to my own. Mike also volunteers his expertise in Mac OS X for important behind-the-scenes testing of software and hardware.

Mike began his photo career in high school where he first learned the craft and amazed his classmates by having Monday morning coverage of Saturday's big game pictured on the school bulletin board. Sullivan pursued his interest in photography into the U.S. Navy, graduating in the top ten of his photo school class. Following Navy photo assignments in Bermuda and Arizona, he earned a bachelor's degree from West Virginia Wesleyan College.

He became publicity coordinator for Eastman Kodak Company's largest division, where he directed the press introduction of the company's major consumer products and guided their continuing promotion. Following a 25-year stint with Kodak, Sullivan pursued a second career with a PR agency as a writer-photographer covering technical imaging subjects and producing articles that appeared in leading trade publications. In recent years, Sullivan has used his imaging expertise as a technical editor specializing in digital imaging and photographic subjects for top-selling books.

Contents

1
Pro Secrets for Raising the Bar on Quality 1

2
Using Telephoto Lenses Like a Pro — 55

3
Pro Wide-Angle Lens Tips — 91

4
Advanced Infrared Photography 131

5
Close-Up, Macro, and Product Photography 157

6
Pro Lighting and Studio Techniques 201

7
More Build-It-Yourself Gadgets and Tricks 235

Preface

Are you ready to take your digital SLR photography to the next level? Would you like to raise the bar on quality, and get all the sharpness, broad tonal range, and accurate color rendition built into your camera? Do you want to *really* understand how telephoto and wide-angle lenses work, and learn how to use their capabilities creatively? Have you been frustrated by the sketchy information you've been able to find on interesting topics like infrared photography, macro photography, or using studio lighting with a digital single lens reflex? Does the gadget freak in you crave ideas for gadgets that can help you shoot compelling images or produce special effects that simply aren't possible in Photoshop?

If so, this book is for you. It's a book about *digital photography* with SLR cameras, and doesn't waste half its chapters telling you how to overcome your camera's shortcomings in Photoshop. There are lots of great Photoshop books that can do that. The best part about the latest digital SLRs is that they have exciting new capabilities that will let you take great pictures *in the camera*, if you know how to use the tools at your fingertips.

Introduction

I've been amazed at the features and capabilities that have been packed into affordable digital SLRs in the last 12 months. The uprising kicked off by the Canon Digital Rebel in 2003 has become an all-out revolution, with cameras and lenses that we couldn't have dreamed of even two years ago available at bargain-basement prices that any serious photographer can afford. Consider that pre-Rebel, low-end 6-megapixel digital SLRs cost $2,000 or more, and those with the features you really need couldn't be purchased for less than $5,000.

Today, 6- and 8-megapixel dSLRs cost $699–$899, and you can buy a 12-megapixel full-frame (24mm × 36mm sensor) Canon 5D for around $3,200. Nikon finally replaced its aging D100 with a spanking new 10.4-megapixel D200 model, and brought extended-zoom-range optics to the masses with an incredible 18mm to 200mm lens that has built-in image stabilization. Exciting new dSLRs from Minolta, Olympus, and Pentax establish even lower price points coupled with ever more sophisticated features. This is a very good time to be exploring photography with a digital SLR camera.

That's why I was eager to put together this book, my fifth dedicated to the special capabilities and quirks of the dSLR. Three of them are offered by Thomson Course Technology PTR, each approaching the topic from a different perspective. They include:

Quick Snap Guide to Digital SLR Photography. This guide (releasing in early 2006) belongs in your camera bag as a reference, so you can always have the basic knowledge you need with you, even if it doesn't yet reside in your head. It serves as a refresher that summarizes the basic features of digital SLR cameras, and what settings to use and when, such as continuous autofocus/single autofocus, aperture/shutter priority, EV settings, and so forth. The guide also includes recipes for shooting the most common kinds of pictures, with step-by-step instructions for capturing effective sports photos, portraits, landscapes, and other types of images.

Mastering Digital SLR Photography. This book is an introduction to digital SLR photography, with nuts-and-bolts explanations of the technology, more in-depth

coverage of settings, and whole chapters on the most common types of photography. Use this book to learn how to operate your dSLR and get the most from its capabilities.

Digital SLR Pro Secrets. This is the book you're holding in your hands. It's a much more advanced guide to dSLR photography with greater depth and detail about the topics you're most interested in. If you've already mastered the basics in *Mastering Digital SLR Photography*, this book will take you to the next level.

Why dSLRs Need Coverage

In one sense, both conventional and digital photography have always been about the eye and vision, and translating compositions that the photographer sees internally into tangible form on film, paper, or, most recently, on a computer display. Serious photographers have never lost sight of the fact that picture-taking depends most on the imagination and the skills that make it possible to convert what the mind dreams into an image that can be shared. Good photographers can do this with a box camera, a single-use "disposable" camera, or a deluxe digital device costing thousands of dollars.

At the same time, both conventional and digital photography have also had a focus on the capabilities of the tools and equipment. Color films let you capture images that aren't black and white; larger films and larger sensors offer images with more resolution and the potential for larger prints. Longer lenses let you photograph things from a greater distance; wide-angle lenses let you get close and still take in a broad perspective; close-up lenses facilitate exploring tiny universes from millimeters away. Electronic flash units can fill murky scenes with light and freeze action in its tracks, while sequence shooting capabilities allow capturing a series of progressive images within a few seconds. Gadgets and technology allow the photographer's vision to encompass more of what the mind imagines.

Digital SLRs are perhaps the ultimate melding of tools and capabilities that allow the photographer to conveniently apply artistic skills to photography, while making it possible to capture images that simply weren't possible in the recent past. You can do more with a dSLR, do it more quickly, and do it in more creative ways. Photography with digital SLRs isn't precisely like conventional film SLR photography, nor is it exactly like digital photography with non-SLR cameras. The dSLR has special advantages, special features, and special problems that need to be addressed and embraced. There's enough of a difference that the quest for affordable dSLR cameras spawned a whole new category of SLR-wannabe digital cameras, the "SLR-like" models with internal electronic viewfinders and long-range, super-zoom lenses. Fortunately, true dSLRs have now become so affordable that there's little need to settle for anything less. And, when it comes to books about

digital photography, you needn't settle for anything other than one devoted exclusively to the very different capabilities and features of the digital SLR.

Why This Book?

I've learned a lot of what I know by going out and taking hundreds of thousands of photos, but I also have picked up some tricks and techniques from reading about what other photographers are doing. So, like you, I always pick up and skim through each new photography book to see what's being offered. Unfortunately, photo enthusiasts end up being disappointed with what they find.

Some of the books concentrate solely on equipment. One "digital SLR" book I've seen actually deals largely with comparisons of the different cameras that are available and offers little that you can't glean (in more timely form) from Web sites like Digital Photography Review (**www.dpreview.com**). I'm amazed at the number of books that spend most of their chapters telling you how to get the photos you really want by processing images in Photoshop. Do you really want to spend hours fiddling with your images in an editor to get the same look you could achieve *in your camera* if you knew what to do? Do you want a "digital photography" book that devotes a chapter or two to discussing storage options, or techniques for sharing your images over the Internet?

Or would you rather learn about photography? I've always been a photographer first, and a darkroom denizen or image-editing troll only as a last resort, and this book was written for people like me, who'd rather have their eye glued to a camera than fixed on a CRT. In this book, you'll find only scant coverage of image editing, and then, only where absolutely necessary. For example, most of us can't afford perspective control lenses, so I'll show you how to correct some kinds of distortion using Photoshop plug-ins. Infrared photos are an exciting kind of imaging, but one that digital SLRs specifically make more difficult, so a few tips on whipping your IR pictures into shape in an image editor are in order. But, most of the time, I'm going to show you photo techniques you can use with your camera.

Each chapter will also include "pro secrets," which may be tricks for testing how your equipment really performs, or ways to cobble together gadgets that help you do something interesting. I'm also especially proud of the hefty illustrated glossary I put together for this book. It's not just a word list, but, instead, a compendium of definitions of the key concepts of photography. You'll find all the most important terms from this book, plus many others you'll encounter while creating images. I've liberally sprinkled the glossary with illustrations that help clarify the definitions. If you're reading this book and find something confusing, check the glossary first before you head to the index. Between the two of them, everything you need to know should be at your fingertips.

I've aimed this book squarely at advanced digital SLR users who want to go beyond simply using their dSLR at its most basic level and explore the world of photography with the special capabilities these cameras have. For anyone who has learned most of a digital SLR camera's basic features and now wonder what to do with them, this is a dream guide to pixel proficiency. If you fall into one of the following categories, you need this book or one of my earlier dSLR efforts:

- Individuals who want to get better pictures, or perhaps transform their growing interest in photography into a full-fledged hobby or artistic outlet with a digital SLR and advanced techniques.

- Those who want to produce more professional-looking images for their personal or business website, and feel that digital SLRs will give them more control and capabilities.

- Small business owners with more advanced graphics capabilities who want to use digital SLR photography to document or promote their business.

- Corporate workers who may or may not have photographic skills in their job descriptions, but who work regularly with graphics and need to learn how to use digital images taken with a digital SLR for reports, presentations, or other applications.

- Professional Webmasters with strong skills in programming (including Java, JavaScript, HTML, Perl, etc.) but little background in photography, and who realize that digital SLRs can be used for sophisticated photography.

- Graphic artists and others who already may be adept in image editing with Photoshop or another program, and who may already be using a film SLR, but who need to learn more about digital photography and the special capabilities of the dSLR.

- Trainers who need a non-threatening, but more advanced textbook for digital photography classes.

Who Am I?

You may have seen my photography articles in *Popular Photography & Imaging* magazine. I've also written about 2,000 articles for *Petersen's PhotoGraphic, The Rangefinder, Professional Photographer,* and dozens of other photographic publications. First, and foremost, I'm a photojournalist and made my living in the field until I began devoting most of my time to writing books. Although I love writing, I'm happiest when I'm out taking pictures, which is why I took 10 days off late in 2005 on a solo visit to Toledo, Spain—not as a tourist, because I've been to Toledo no less than a dozen times in the past—but solely to take photographs of the people, landscapes, and monuments that I've grown to love.

Most digital photography books (I call them digital *camera* books), even those dealing with SLRs, are not always written by photographers. Certainly, the authors have some experience in taking pictures, if only for family vacations, but they have insufficient knowledge of lighting, composition, techie things like the difference between depth-of-field and depth-of-focus, and other aspects of photography that can make or break a picture. The majority of these books are written by well-meaning folks who know more about Photoshop than they do about photons.

Digital SLR Pro Secrets, on the other hand, was written by someone with an incurable photography bug. I've worked as a sports photographer for an Ohio newspaper and for an upstate New York college. I've operated my own commercial studio and photo lab, cranking out product shots on demand and then printing a few hundred glossy 8 × 10s on a tight deadline for a press kit. I've served as photo-posing instructor for a modeling agency. People have actually paid me to shoot their weddings and immortalize them with portraits. I even prepared press kits and articles on photography as a PR consultant for a large Rochester, N.Y., company which shall remain nameless. My trials and travails with imaging and computer technology have made their way into print in book form an alarming number of times, including a few dozen on scanners and photography.

So, what does that mean? In practice, it means that, like you, I love photography for its own merits, and view technology as just another tool to help me get the images I see in my mind's eye. It also means that, like you, when I peer through the viewfinder, I sometimes forget everything I know and take a real clunker of a picture. Unlike most, however, once I see the result, I can offer detailed technical reasons that explain exactly what I did wrong, although I usually keep this information to myself. (The flip side is that when a potential disaster actually looks good, I can say "I meant to do that!" and come up with some convincing, but bogus, explanation of how I accomplished the "miracle.")

But, like you, I still am able to learn from goofs and temporary lapses in photographic judgment and go back and do better the next time around. For example, each Spring I trot down to the ballpark and take lots of photos of a local professional baseball team. With the rapid evolution of digital SLRs these days, it's likely that I am using a different camera than the one I worked with last season. Invariably, I'm not satisfied with my initial efforts, even though I've photographed baseball games hundreds of times. Like the players, I work my way through Spring training each year, re-honing my skills and refining the ways I take these pictures. It's this combination of experience—both good and bad—and expertise that lets me help you avoid making the same mistakes I sometimes do, so that your picture taking can get better with a minimum of trial-and-error pain.

Chapter Outline

Chapter 1: Pro Secrets for Raising the Bar on Quality

Digital SLRs can give you great results right out of the box. But, as an avid photographer, you know that you can get better sharpness, improved tonal scale, reduced noise, and more accurate colors with some hard work and attention to detail. This chapter details all the factors that affect image quality, and shows you how to optimize your results with your digital SLR.

Chapter 2: Using Telephoto Lenses Like a Pro

This chapter provides an inside look at how telephoto lenses work, with advice on choosing the best lens for various kinds of photography, ways of using both desirable and undesirable effects of long lenses, and choosing the right accessories to augment your telephoto optics.

Chapter 3: Pro Wide-Angle Lens Tips

Wide-angle lenses provide a unique perspective on the world, and this chapter shows you how to apply a wide view to your images. You'll also learn about various types of distortion and how to accentuate or eliminate them, as well as tips for working with ultra-wide and fish-eye lenses. Learn to use wide-angle lenses to emphasize the foreground, or to explore "forbidden" territory such as portraiture.

Chapter 4: Advanced Infrared Photography

Information on shooting infrared with digital SLRs can be scarce, so you'll want to study this full chapter on the topic. Included is a description of a way to make your own infrared filter using inexpensive adapter rings and an old piece of transparency film.

Chapter 5: Close-Up, Macro, and Product Photography

Just about any digital camera can take close-up photos, but digital SLRs have some special properties that make macro imaging especially effective. You'll learn ways to use non-macro lenses for close-ups, work with diopter attachments, improve sharpness with reversing rings, and use specialized tools like bellows and extension tubes. A quick-and-dirty way to create your own diffusion tent for reflection-free photos will save you time and money.

Chapter 6: Pro Lighting and Studio Techniques

Learn how to use electronic flash and continuous lighting, including ways of connecting external flash to your dSLR, building your own soft box, and using multiple lights to create broad lighting, short lighting, butterfly lighting, and other pro lighting setups the easy way.

Chapter 7: More Build-It-Yourself Gadgets and Tricks

You'll find even more gadgets and projects to build yourself in this chapter, including techniques for creating your own special effects filters, a do-it-yourself Harris shutter for multicolor effects, and instructions on building your own sensor cleaning tools that can save you $100 or more over buying one of the commercial kits.

Appendix: Glossary

1

Pro Secrets for Raising the Bar on Quality

Be honest. One of the main reasons you purchased your digital SLR was to *dramatically* improve the quality of the pictures you take, both from a creative and technical standpoint. Whether you were using a film camera, a point-and-shoot digital camera, a "high-end" non-SLR digital shooter, or even another digital SLR, the reason you purchased the camera you now own was because you wanted to raise the bar on quality to the next level. Specifically:

You're *not* interested in just pointing your camera at a subject and snapping away. You want to work quickly, but you also are willing to take the time to do the job right.

You're *not* convinced that buying your digital SLR will magically convert you into a better photographer. You know that your skills are what count and are willing to acquire those skills by reading and practice.

You're *not* parading around with your dSLR, assuming that display of such a magnificent piece of machinery will automatically garner the respect and awe of your friends, relatives, and other photographers. You understand that a camera and a lens are just tools that, in the right hands, can achieve the kind of results you're looking for.

You're *not* completely satisfied with your current level of competence and are not fooling yourself that you just need to fine-tune your abilities the tiniest bit with a few tricks and techniques. Instead, while you're happy with lots of the photos you get, you tend to pick apart the results of each shoot, and are constantly looking for ways to do better.

If you agree with those four principles I've just outlined, then you're the kind of photographer I'm looking for. You want to work like I do. I tote around a tripod or monopod more often than not because I know they'll help me shoot sharper photos. I use a $1,000 dSLR and a $5,000 dSLR interchangeably when each will let me do a better job or work more efficiently, and I don't suffer from the delusion that one or the other enhances or detracts from my abilities or reputation. And, although I've been taking photos for decades, I always learn something new from examining my best shots and outtakes. I'm getting better all the time—and you can, too.

So, let's dispense with the usual first chapter chatty explorations of the history of digital SLR photography and how a digital camera's sensor works. (You can find all the background and nuts-and-bolts you could want in my companion book, *Mastering Digital SLR Photography*, also from Thomson Course Technology.) Let's get busy raising the bar on quality.

Technical Quality Busters

For the purposes of this chapter, when I talk about quality, I'll be referring to *technical* quality. How well is your photograph exposed? Is it sharp where it's supposed to be sharp? Are the colors right? Is there unwanted distortion? Does the photograph have icky artifacts, such as those multicolored speckles we call noise? These are all technical defects that can be tamed or eliminated when you're interested in raising the bar on quality.

Of course, the other aspect of image quality is *content*. A technically perfect image can still suck if its content is poorly composed, uninteresting, or repellent. Figure 1.1 is an example of an imperfect photo that, with one exception, is technically okay, even though the composition is less than compelling. The goose is nice and sharp, the background is as blurry as intended, the colors are accurate, and there is no visible noise. Even the exposure of the goose itself is pretty good, with detail in the darkest feathers as well as the lightest areas, except for the very brightest areas of the bird's underfeathers. The most glaring technical flaw is a lack of separation between the goose and the background, even with the blurred background. A slightly lighter background would have helped this image technically.

However, from a content standpoint, this image has some serious problems. The goose is smack-dab in the middle of

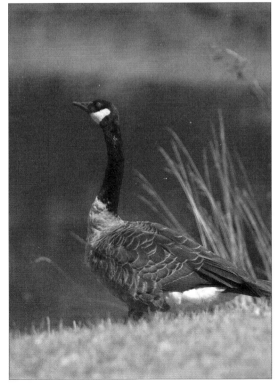

Figure 1.1 Although this photo has only a few technical flaws, it still fails photographically because of poor composition.

the frame, yet its beak is pointed *out* of the frame at who knows what. The blurred foliage in the background intrude at odd angles, and the blurry grass in the foreground, as the brightest object in the frame, tends to attract the eye to… nothing in particular. The bird's tail is clipped off at the right side of the picture, and its feet aren't visible at all.

Figure 1.2 shows a different goose, and it's technically not as good from an overall exposure standpoint (check out those blown highlights in the white feathers!), but it's a much more interesting goose picture, if you're into goose pictures. You'll need to work on content by perfecting your compositional skills. You'll find some tips in the chapters that follow. For this chapter, I'm going to concentrate on elevating that quality bar.

As this chapter unfolds, you'll learn that the main technical quality busters are:

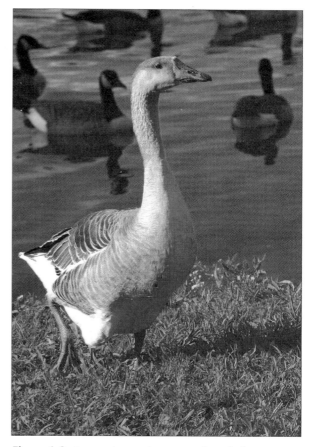

Figure 1.2 A more interesting goose, though the technique is loose.

- ◆ **Sharpness**—affected most dramatically by overall lens quality, shutter speed/motion stopping, and lens aperture selected.

- ◆ **Focus**—which is an additional, but separate creative and technical consideration that affects sharpness.

- ◆ **Tonal rendition**—controlled by exposure and the dynamic range of your camera and the workflow you apply to your images.

- ◆ **Quality**—involving other factors, such as ISO settings and noise.

The next sections look at each of these in turn.

Understanding Image Sharpness

The sharpness of your images is one of the two most important technical aspects of a good photograph, running neck-and-neck with tonal qualities in terms of importance. A superior photograph looks sharp to the eye in the areas the photographer wants it to appear sharp, and contains the desired number and distribution of tones to display all the detail that's in the highlights, shadows, and midtones. I'll delve into achieving tonal perfection later in this chapter. This section looks at sharpness.

Point-and-click snapshooters want their pictures to look "sharp and clear." For serious dSLR photographers, image sharpness is a little more complicated, and there are many factors involved. For example, it's very likely that you don't want a particular photo to be *uniformly* sharp. Applying sharpness selectively through creative application of depth-of-field can improve many compositions dramatically. Having the main subject sharp against a blurry background concentrates the viewer's attention on the photo's center of interest.

A lack of sharpness can add some blurry excitement to action photos, or create a specific retro "look" like the weird effects you can see in Figure 1.3, made possible by the popular optic-on-a-Slinky, the Lensbabies Flexible Lens Mounting System (**www.lensbabies.com**). For the dSLR photographer, sharpness is not only an important factor, it's one that needs to remain under the shooter's constant control. Ideally, you'll want to have the maximum sharpness available to you when you want it, with the ability to apply that sharpness to your photo as required.

Figure 1.3 Sharpness is not the main goal of a creative tool like the Lensbabies Flexible Lens Mounting System.

What's Sharpness, Anyway?

Most of us define sharpness in a rather circular way: it's what *looks* sharp. Actually, that's not far from the truth, because the apparent sharpness of an image can, in fact, depend on the amount of enlargement of the image and the viewing distance. An image that *looks* sharp when printed as an 8 × 10 and viewed from three feet away might appear to be very *unsharp* when enlarged to 16 × 20 and examined

from the same distance. Move back a dozen feet, and the image probably looks sharp again.

What appears to be sharp to our eyes and what is considered blurry is determined by the point at which the individual points of light in an image change visually from points to out-of-focus discs called *circles of confusion*. Detail seen as distinct points is perceived as sharp. Detail in discernable fuzzy discs is seen as unsharp. The degree of enlargement, how close we are to the image, the amount of contrast between the points/fuzzy discs, and how fussy an individual is all contribute to the phenomenon of sharpness. You'll learn more about circles of confusion and other aspects of sharpness later in this chapter.

Sharpness is usually measured using components called resolution and acutance, and a sharp image must have both qualities, carefully balanced. A given photograph can be high in resolution, but low in acutance, or have high acutance but low resolution. Ideally, you'll combine both in a single image, so there's no harm in learning how these elements affect your picture taking.

Resolution

In the digital photography world, resolution is misleadingly easy to measure. The amount of detail that a digital SLR can capture is fixed by the number of pixels in the sensor. If your camera has a sensor measuring 3456×2304 pixels, then your dSLR's resolution is 7,962,624 pixels, or, 8 megapixels, right? Eh… not quite. It's very likely that your camera actually captures 4 megapixels worth of green information (distributed over the entire area of the sensor), and 2 megapixels each of red and blue data (somewhat more widely distributed). The camera then uses some mathematical mumbo jumbo to interpolate the missing information, usually with a high degree of precision. Your sensor captures information in this way because the eye is more sensitive to green light than to red or blue, so the color-sensitive pixels are laid out in what is called a *Bayer array*, with rows of green- and blue-sensitive pixels alternated with rows of green- and red-sensitive pixels. Figure 1.4

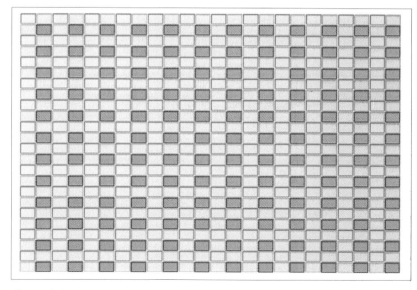

Figure 1.4 A typical sensor array uses alternating rows of green-blue and green-red pixels.

shows a tiny segment of such an array, representing about 1/10,000th of the area of a 6-megapixel sensor. In Figure 1.5 you can see the true relationship between the green, red, and blue pixels.

Other factors also affect resolution, such as the accuracy of the light delivered to the sensor after passing through the lens, and things like "pixel overflow," when too many photons strike a particular photosite and spill over into an adjacent pixel, causing a "blooming" effect.

The resolution of an image is fixed once you've taken the photo. There's no way to go back and change it without reshooting the picture, although you can use post-processing in an image editor such as Adobe Photoshop to reinterpolate or resample the image to change the *apparent* resolution. But there is no way to add detail that wasn't captured in the first place.

Absolute resolution in the digital realm can be measured as it is in the film world, using benchmarks like line pairs imaged per millimeter. Of course, film sharpness can be affected by things that don't worry the digital photographer, such as flatness of the film plane and the qualities of the film's grain and developer chemicals used. (Some developers produce "sharp" grain, while others create "mushy" grain, and neither are exactly analogous to the digital effect we call *noise*.) But many of the factors are shared and conspire to reduce the maximum resolution your camera can produce. These include lens quality, aperture, and shutter speed. I'll address all these individually in this chapter.

Acutance

New digital photographers often don't understand the term *acutance*, even though they've worked with this property every time they've sharpened an image in Photoshop. Acutance is a way of describing the transitions between edge details in an image. If the transition is abrupt, going from one tone to the next with no intermediate tones, the edge is sharp. If the change is gradual, transitioning from one tone to the next with a gradient from one to the other, the edge is blurry.

Like resolution, acutance can be affected by the quality of your lens, how the lens is focused, the f/stop selected, and the shutter speed you used, which can all conspire to blur edge details in an image and thus reduce acutance. However, unlike

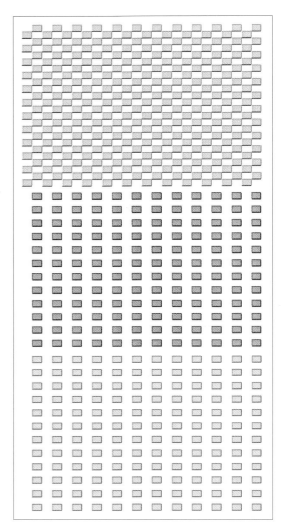

Figure 1.5 The true resolution of the sensor is divided among 50 percent green pixels, 25 percent red pixels, and 25 percent blue pixels.

resolution, you can adjust acutance to some extent after the photo is taken. In fact, if you've used unsharp masking or a similar tool in Photoshop or another image editor, that's exactly what you've done: adjusted the contrast in the transitions between edge details in your photograph, as you can see in Figure 1.6.

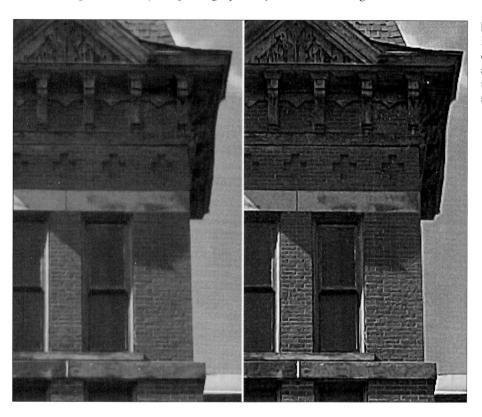

Figure 1.6 We perceive the increased contrast between edges in an image as sharpness, as you can see in this unprocessed image (left) and a sharpened version (right).

Because artificially boosting acutance after a photo is taken actually improves sharpness while sacrificing some resolution as detail in the transitional areas is removed, your goal should be to achieve a balance between the two.

Optimizing Sharpness

Raising the bar on sharpness means optimizing the detail available for capture by your dSLR's sensor. Most digital cameras do a good job of preserving image information with sharp lenses and settings that minimize sharpness loss through camera or subject movement, digital noise, and other factors. But, it's usually possible to do better. This section will look at each component separately, and show you how to get the absolute best results.

Lens Sharpness

Sharpness starts with your lens choice, quite literally. The photons that will eventually form your image first wend their way through your dSLR's optical system before arriving at the sensor. The quality of those optics can have a significant impact on your image sharpness. Here are some things to keep in mind.

◆ **Zoom vs. Prime.** There are some amazing zoom lenses available today, and many of them rival fixed focal length, or *prime* lenses for sharpness. However, *in general,* you'll want to consider using a prime lens when you want the absolute ultimate in sharpness. The strength of zoom lenses is their convenience; you can take photos using the equivalent of many different focal lengths without changing lenses or changing position. However, zooms require additional elements that must shift in complex ways to provide these different magnifications, and some of those elements do nothing but correct for errors introduced by other pieces of glass in the lens. A prime lens, in contrast, can be built to do one thing: provide a sharp image at its intended focal length, with much less compromise. It's true that a fixed focal length lens design must also accommodate the desired maximum aperture (that is, an f/1.4 lens is often more complicated to design than an f/2.0 lens of the same focal length), and (with extreme wide angles in particular) require special elements to minimize various kinds of distortion. However, if you're maximizing sharpness, a top-quality prime lens will beat most zooms at its focal length.

◆ **Expensive vs. Inexpensive.** You needn't spend a bundle to get the sharpest lens. Most dSLR vendors have an f/2 or f/1.8 50mm prime lens designed for their film camera line that is priced at around $100. If you need a relatively fast lens and can work with the 50mm focal length, such an optic is likely to be one of the most useful and sharpest lenses you own. Lenses are priced based on their complexity to design and manufacture, how many the vendor expects to sell, and marketing factors such as the competition for the lens and what the market will bear. You might pay more and get a sharper lens, but then, again, you might not.

◆ **Special Features.** A more accurate predictor of lens price is the special features a lens has. A very fast maximum aperture is a special feature, so you can expect to pay a lot more for, say, a 70–300mm zoom lens with a constant f/2.8 maximum aperture than for one with a variable f/4.5/f/5.6 maximum aperture that changes as you zoom. You *might* get a sharper lens for the extra money, but that's not guaranteed. Vibration reduction/image stabilization is another extra-cost feature that boosts the price of the lens without necessarily giving you sharper optics. Certainly, VR will *steady* your lens to produce sharper images at a particular shutter speed, but won't necessarily offer better sharpness than another lens at the same focal length and aperture when the

non-VR lens is mounted on a tripod or used with a high shutter speed. I've seen dSLR owners who invested big bucks in a VR lens expecting sharper pictures, when all they really gained was less image shake at a particular shutter speed.

◆ **Design Quality.** Some lenses are designed better than others. One lens might have extra low dispersion (ED) glass that allows it to focus all colors on the same point, reducing a defect called *chromatic aberration*. Another might use more non-spherical (*aspherical*) lens elements to improve sharpness, or improved multicoating on the lens elements to reduce contrast- and sharpness-robbing flare. Lenses with high-quality designs focus quickly and accurately. The tiniest details in a well-designed lens, such as the shape of the aperture, can have a significant impact on sharpness. Even when comparing prime lenses with prime lenses, or zooms with zooms, and equivalent focal lengths, you'll find that some are just better than others. Forums like DP Review (**www.dpreview.com**) have discussions among actual users of every lens on the market, making it easier to separate the superb from the subpar.

COATINGS

Complex lens coatings were originally applied to the front elements of lenses to reduce flare caused by light striking the lens from outside the image area. For digital SLRs, flare-reduction coatings on the *back* elements of the lens can be especially important, because the surface of the sensor is so much shinier than that of film that it's easy for light reaching the sensor to bounce back, strike the rear of the lens, and then reflect back onto the sensor (which is a bad thing; trust me).

◆ **Build Quality.** Some lenses are simply better built than others. It's always nice to own a lens that's solid as a rock and won't wear out prematurely, but if your quest is for sharpness, good build quality takes on extra importance. A well-built lens won't bind when zooming or wobble when focusing, even after years of use; is well sealed so it won't become infested with dust or become a host for fungus; has a tough, wear-resistant lens mount that maintains perfect alignment with the sensor; and is accurate in all its particulars, especially lens openings.

◆ **Other factors.** There are some other factors that can affect the sharpness of your lens. The most important of these is the use of filters over the front of the lens, either to provide some special effect, such as filtration (say, to polarize the light or to remove visible light and leave only infrared), or for protection (it's easier to clean a filter or replace a cracked filter than to clean or replace a cracked lens). Poor quality filters can degrade the image, an effect

that's compounded when you stack several filters on top of one another. Filters can also add to lens flare. The very best filters have virtually no effect on sharpness. In my own work, I use filters only when I want to filter something, and never for protection unless the conditions are ridiculous (lots of dust or moisture flying around). In decades of shooting, I've never had one of my naked lenses damaged because I didn't use a filter; although, I've heard hundreds of war stories from photographers who managed to swing their cameras, lens first, into the most appalling obstacles. Perhaps they are clumsy, or perhaps I am paranoid. But if you want the absolute best sharpness, bear in mind that a filter *can* have an effect.

Choosing the Right Aperture for Sharpness

It's easy to think of your lens opening only in terms of exposure, at least, until you decide to use depth-of-field creatively and remember that larger apertures (the smaller numbers) provide *less* DOF, while the smaller apertures (the larger numbers) provide *more*. Digital SLR owners tend to use either programmed exposure (in which the camera uses its smarts to select an f/stop and shutter speed) or shutter priority (with the camera selecting an available aperture to suit the shutter speed you dial in), with full manual or aperture priority (letting the camera decide on the shutter speed) often being reserved for special conditions.

However, there are many shooting situations where maintaining control over the aperture used is a good idea when your main concern is sharpness.

◆ **Using your lens' best aperture.** All lenses have an aperture at which they produce their sharpest overall image, as you can see in Figure 1.7. Generally, that's usually about two f/stops smaller than the maximum aperture of the lens, but it can vary from lens to lens. For a zoom or prime lens with an f/2.8 to f/3.5 maximum aperture, the best results will often be found at f/5.6 to f/6.3. If you've run some rudimentary tests and discovered the best f/stop for your particular lens, you can achieve your best sharpness by using aperture priority, and fixing the f/stop used to that optimum aperture.

◆ **Understanding your lens' design goals.** Some lenses are designed to produce good sharpness at certain apertures. The results might not be *optimum* for that lens, but certainly can be better than you'd get at that aperture with another lens that is designed differently. A good example of this phenomenon can be found in so-called "fast" lenses that are intended to be used wide open under relatively low light conditions. A 55mm f/1.2 lens, a 400mm f/2.8 optic, or an 80–200mm f/2.8 zoom are all likely to provide good results at their maximum apertures. That's what they were designed to do. You wouldn't pay $1,500 for a 28mm f/1.4 lens to use it at f/2.8 or f/4 all the time. While such a lens would indeed offer a bit of extra sharpness when stopped down,

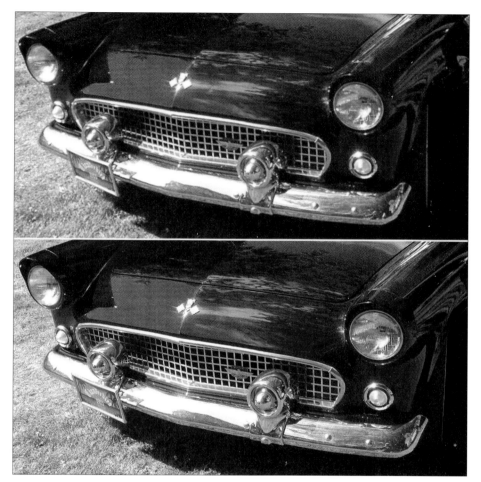

Figure 1.7 The image at the top, exposed with the zoom lens' maximum f/4.5 aperture is less sharp than the version taken a second later at f/8 (bottom).

it's very likely that the improvement wouldn't be all that much. A fast lens is *designed* to be useful at its maximum aperture.

◆ **Using depth-of-field tradeoffs.** Don't be locked into your lens' "optimum" aperture when you need a specific depth-of-field range for close-up photography or creative purposes. Know when to trade a little overall sharpness at the exact plane of focus for a larger degree of apparent sharpness elsewhere in the image through use of smaller apertures. Or, if you want to isolate your subject with very shallow depth-of-field, realize that a wider lens opening while possibly less sharp in an absolute sense, might *look* sharper because of the contrast between the object in focus and the out-of-focus foreground and background. At its most fundamental level, sharpness is the contrast between objects, and your use of depth-of-field can increase or decrease this contrast.

♦ **Don't fear diffraction.** Here we have another twist on the depth-of-field tradeoff puzzle. *Diffraction* is the phenomenon that reduces sharpness at smaller and smaller f/stops. The sharpness lost to diffraction is partially offset by increased depth-of-field. When taking macro photographs, in particular, you might find that your flower photograph at f/32 *looks* sharper than the same image exposed at f/11, even though the portion of the image in the plane of focus is sharpest at the latter aperture.

WHAT'S DIFFRACTION?

The photons used to create photographic images travel in parallel lines until they are bent into new directions by the elements in your lenses. When these photons are forced to squeeze through a small hole (your lens' aperture), some of the photons strike the edges of the hole and disperse and diverge, interfering with one another in a sharpness-robbing process called diffraction. As the hole becomes smaller, this tendency increases, because the proportion of photons affected by the edges of the diaphragm are greater compared to those which pass through the decreasingly small center portion unimpeded.

Diffraction is dependent only on the actual f/stop used, and the wavelength of the light being used. If you want to get really techie about it, that means that diffraction actually affects each of the colors of light in slightly different ways. Green pixels in an image are impacted first (remember, there are twice as many green pixels as red or blue pixels in a dSLR sensor's Bayer array), while blue pixels are affected the least. As a practical matter, this may make little difference under most circumstances. All you need to know is that using smaller f/stops can decrease sharpness.

Testing Your Lenses for Sharpness

Lens testing is one of the most misunderstood and misused aspects of maintaining photographic quality. Despite the difficulty in testing lenses in any objective way (due to the huge number of variables involved), lens tests have been popular for longer than I care to remember.

The reason why we have lens testing is that lenses can range from expensive to *very* expensive, and nobody wants to get stuck with a bad lens. That's especially true because you might not be immediately aware that you have a bad lens; it's easy to blame lack of sharpness on camera shake or your sensor's resolution. Tests are supposedly an easy way of separating the subpar from the superb, so we can all have the luxury of buying only the very best lenses in our price ranges, while the true dogs deservedly languish on dealer shelves.

The theory behind lens testing is that by photographing certain standard subjects in standard ways, it should be possible to measure their performance, either in terms of the number of line pairs per millimeter a lens can resolve at a particular aperture, focal length, and distance, to more exotic benchmarks such as modulation transfer functions. Unfortunately, even standardized testing procedures can be flawed, and, worse, the results might not apply to the lenses we buy and the pictures we take. The true best approach was probably taken by Life Magazine photographer Alfred Eisenstaedt: He bought a lens, and if he liked the pictures he took with it, he kept it. Otherwise, he returned or sold it.

Third-Party Tests often Flawed

The problem with relying on the lens tests that you see in the magazines is that the information is probably not very helpful. The tests weren't conducted in the kind of conditions under which you actually take pictures. The tests might be biased in some unknown way. Most importantly, *you can't buy the exact lens they tested*. Some vendors produce lenses that are very consistent; the one you buy might perform like the one tested in the magazine. Other vendors have spotty quality control, and the lens you get might be *nothing* like the one used for the test. The online photography forums are filled with lamentations from lens buyers who purchased a Signacon Super 14–300mm f/2.8 zoom based on a recommendation they read, and found it to be a terrible lens. These complaints are usually answered with protests from other owners of the same lens who are delighted, either because they, in fact, own a better example of that lens or, perhaps don't know how to tell a good lens from a bad one.

You're better off testing lenses yourself, although even then your mileage may vary enough to render your results useless. You can perform the traditional "brick wall" test, which involves photographing a brick wall (natch) to see if the bricks and their texture are sharp, as well as to evaluate how straight the straight lines appear. Some lenses will cause straight lines to bow inwards towards the center of the frame, or outwards, in what is known as pincushion and barrel distortion. Taking pictures of a brick wall, as shown in Figure 1.8 can give you an idea of the sharpness of your lens, or use a test chart. (Run a Google search for "lens testing" to find many different test charts you can download or purchase. I provide one you can download, too, later in this chapter.)

Test 'Em Yourself

Or, you can simply take photos and examine your results. Figure 1.9 shows an informal test that used two cameras and two different lenses for photographs of the remains of a playground that was shattered by a falling tree. I mounted the cameras on a tripod, shot all the pictures within minutes of each other, at the same f/stop and shutter speed, and under roughly the same lighting conditions. At the upper-right corner of the figure you can see most of the original frame, with the area that's been enlarged outlined in red. One of the other three photos was taken with a $1,300 17–55mm f/2.8 zoom lens set to 55mm mounted on an $800 6-megapixel digital SLR. Another was taken with a $200 18–55mm f/3.5 lens also set to 55mm on the same $800 digital SLR. The third shot was taken with the $1,300 lens on a 12.4 megapixel, $5,000 dSLR, also at 55mm, and the image slightly reduced in size to match the other two.

Given that all the images have been subjected to the halftone screening process for printing in this book, can you tell which is which? If not, did this lens "test" really accomplish anything? Could you have gotten

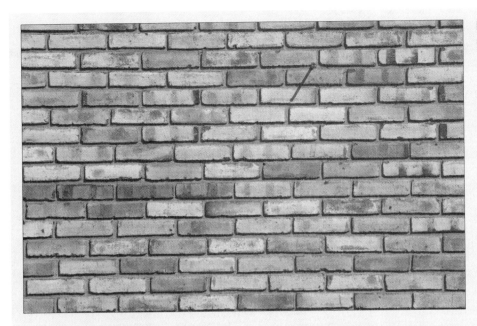

Figure 1.8 A brick wall is an easy test for your lens.

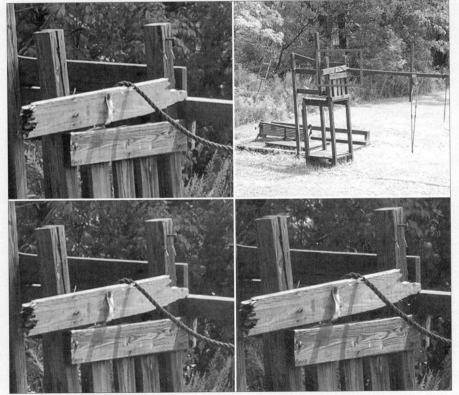

Figure 1.9 Pit one lens against another. This test shows the results obtained when testing a $1,300 lens on a 6-megapixel dSLR (upper left), a $200 lens on the same camera (lower left), and the expensive lens on a pro-quality 12.4-megapixel digital SLR (lower right).

a better evaluation relying on tests posted on a Web site or printed in a magazine? My recommendation is to go ahead and get some lens test charts and make tests of lenses you're contemplating purchasing under the kinds of conditions you actually shoot under—but then temper your results with an honest examination of how well you like the pictures you take with a particular lens. While a $1,300 zoom will usually outperform a $200 zoom, what really counts is the Eisenstaedt Test. Do you like your photos, especially when blown up? If so, buy the lens and forget about what others say.

A Simple Lens Test

Here is a simple lens test you can do. It uses the United States Air Force 1951 lens testing chart shown in Figure 1.10, which has the advantage of being in the public domain and available to anyone. You'll find a copy to download at the Web site that accompanies this book (**www.courseptr.com**).

The testing procedure I outline here is simple, because it doesn't give you confusing lines/millimeter readouts that correlate with other tests you may have seen. Instead, it's intended to be used to compare *your* lenses (or lenses you're thinking of buying) with each other. You can use the results to judge how your lenses stack up against each other, where the "sweet spots" are for each lens, and how sharp they are at the edges compared to the center. Just follow these steps:

1. Download chart.jpg from the Web site. Although it's a JPEG file, it has minimal compression to preserve the resolution of the original chart.

2. Make multiple copies of the chart at about 3 × 3 inches. Use the highest resolution printer you have available, and resize carefully to avoid losing resolution. You might find that printing a larger version and then having it duplicated in a smaller size at a reproduction shop is the best way.

3. Glue copies of the chart to a 2 × 3-foot foamcore board, with charts at the corners, edges, and centers.

4. Fix the board to a sturdy support, such as a wall, so that it is perpendicular to the floor. Tape a label to the bottom of the board listing the name of the lens, focal length, aperture being tested, and date. Replace this label when you change lenses, focal lengths, or apertures. (D'oh!)

5. Mount your camera on a tripod, and position it at a distance roughly equivalent to one inch per mm of lens focal length that will be tested. For example, if you're testing an 80mm–200mm zoom lens, you'd want to place the tripod 80 inches (about 6.6 feet) from the chart to test the lens' shortest focal length, then move the tripod out to about 16 feet (200 inches) to test it at the telephoto end of the scale.

6. Adjust the tripod so the camera back is parallel to the plane of the test chart.

7. Set your camera for its highest resolution.

8. Focus *very* carefully on the test chart. Refocus as you change f/stops for different test shots.

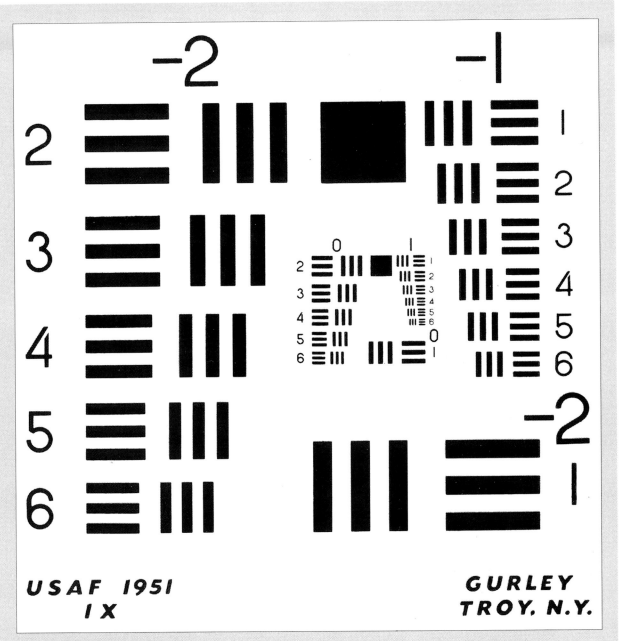

Figure 1.10 Use this classic lens test chart to evaluate your own lens.

9. Take several test pictures at various lens openings. Make sure that you minimize the effects of camera and subject movement on the image:

 ◆ Use a fast shutter speed to minimize any movement if you're illuminating the charts with daylight or indoor illumination (a pair of desk lamps on either side of the chart is good). Because your shutter speed will be largely governed by the aperture you're testing, you may have to increase the amount of light to allow for a higher speed. Or, better yet, use a pair of electronic flash units placed to the side of the chart at 45-degree angles. The high speed of the flash will eliminate the shutter speed variables.

 ◆ If your camera has pre-shot mirror lockup, use it to eliminate any loss of sharpness from mirror slap.

 ◆ Use your camera's self-timer, infrared remote, or wireless shutter release to trigger the shot.

10. Examine your test shots in your image editor. The smaller the sets of lines that can be distinguished, the better your lens. Compare the center results with the edges, and with other lenses for the best "picture" of how good your lenses are.

Shutter Speed

Shutter speed is another key part of the sharpness equation. The duration of the exposure, as determined by the shutter speed, is what freezes movement in your image. If movement is *not* cancelled, a detail in your image will be rendered in something other than its true shape. A perfectly round point of light will be imaged as an oval skewed in one direction or another. Other shapes will be stretched and blurred, too, so what were originally sharp elements will be captured as some other, inaccurate shape.

Worse, the *amount* of this blurring will be different for different elements in your image, depending on the cause of the blurring, the direction of the movement, and how close the element is to your camera. It's entirely possible to have a single image with dozens of objects, all with slightly different types of blur caused by movement. You'll see how this is possible if you examine the causes of motion blur and apply them to a typical situation, such as a photo of a sports activity like soccer.

◆ **Across the frame.** Motion that's parallel to the plane of the sensor (that is, across the width or height of an image in a horizontal, vertical, or diagonal direction) appears to move the fastest and will cause the most blur. In sports, any players running across your frame will have the highest relative speed, and will blur the most if the shutter speed isn't high enough. Your subject doesn't even have to be running. Figure 1.11 shows how a pitcher's arm and upper torso will appear blurred as he uncorks a pitch.

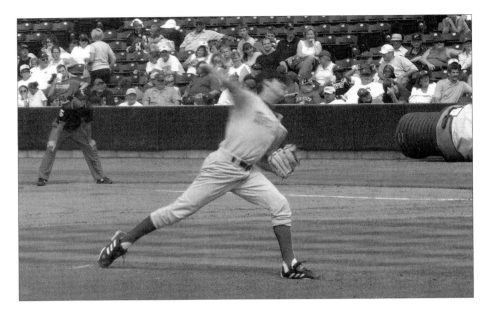

Figure 1.11 Action moving parallel to the frame is more easily blurred.

◆ **Towards the camera.** Motion coming toward the camera appears to move much slower, and will cause a much lesser amount of blur. If you have one player racing across the frame while another is headed toward the camera to intercept him, the second player will be less blurred, in comparison, at the same shutter speed. In Figure 1.12, a relatively slow 1/125th second shutter speed was able to stop the motion of the runner headed towards the camera.

◆ **Movement on a slant.** Motion coming toward the camera on a slant (perhaps a player dashing from the upper-left background of your frame to the lower-right foreground) will display blur somewhere between the two extremes.

◆ **Distance from camera.** Subjects that are closer to the camera blur more easily than subjects that are farther away, even though they're moving at the same absolute speed. Motion across the camera frame is more rapid with a subject that is closer to the camera.

◆ **Camera movement.** Blur is relative to the camera's motion, too. If you happened to pan the camera in the direction several soccer players are running (even slightly), while others are running to meet them, the second set will be more blurry, even if they are racing at the same speed and at the same distance from the camera. Or, if you just hold the camera in an unsteady way, *everything* in the image will have some blur added by the camera movement.

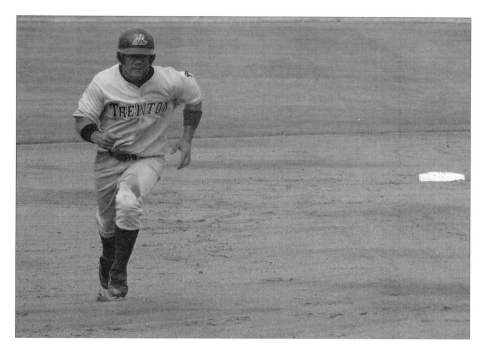

Figure 1.12 Action headed towards the camera can be frozen at a lower shutter speed.

Although I don't have a single photograph that illustrates all these types of blur, you can imagine how all of them could easily occur in one photograph. But don't be misled by my sports action example. Blur caused by a shutter speed that's too slow can affect *any* photograph, regardless of type, from landscapes to portraits to close-up photography (and *especially* close-up photography).

Of course, motion blur can be used as a creative effect, in which case, understanding the causes of blur I've just outlined can be helpful when you want to implement it. But, most of the time, you'll want to keep this sharpness-robbing factor under tight control and either eliminate or minimize it.

Taming motion blur is actually one of the easiest ways to improve the sharpness of your images, and also the one that's easiest to neglect. Photographers upgrade to higher-resolution cameras to get better photos, buy the best-quality lenses to converge the sharpest possible images onto the sensor, and focus with utmost precision, only to lose detail to camera or subject motion. Some even brag that they are able to capture images handheld at remarkably low shutter speeds, not realizing that those shots at 1/15th second, while acceptable, aren't as good as they *might* have been. Taking and partially releasing deep breaths, special bracing techniques, and a gentle finger on the shutter release can help, but they can't replace other methods for reducing camera motion, and do nothing at all when your subject is moving faster than your shutter speed can freeze.

Subject motion is one sharpness-robber that has an easy set of cures. Either reduce the apparent speed of your subject relative to your frame (e.g. pan, or have the subject moving toward you) or increase the shutter speed sufficiently to freeze the action. Most digital SLRs have shutter speeds of at least 1/4000th second; some top out at 1/8000th second. Either speed should be enough to stop virtually any action this side of a speeding bullet. Your only challenge is making sure you have enough light to allow using one of these tiny time slices at a reasonable ISO setting. (Use 1/8000th second at ISO 3200 and subject blur won't be the limiting quality factor—excess noise will be.) When the available light is insufficient, electronic flash units have even more action-stopping power; the duration of some of them can be 1/50,000th second.

Most people find to their astonishment that, in a formal test (like the one outlined next), their handheld photos with wide-angle or normal lenses at 1/500th second are sharper than those taken at 1/125th second, and those they snap off at 1/30th second aren't nearly as tack sharp as they'd been boasting. What *looks* pretty good at normal enlargement and viewing distances turns out to be not so good when you isolate your subject matter so the blur can be seen more easily, and examine the results up close. If you're truly committed to raising the bar on your image quality, you might be making some changes in how you shoot after you try my sure-fire blur tester to see for yourself.

Testing for Camera Motion Blur

Feel free to conduct this test in private and not reveal the results to your friends and colleagues if you find, as I suspect you will, that you can't hand-hold a camera quite as steadily as you thought you could. Nobody needs to know your photographic failings—the only thing they should be aware of is the dramatic improvements in quality that you can make.

The first step is to build yourself a blur tester. I like to use a large piece of aluminum. You can use a scrap panel of aluminum, sacrifice a cookie sheet, or use a serving tray like I did. Take the sheet and poke a series of tiny pinholes in it, as perfectly round as you can make them. Although the size of the holes isn't crucial, smaller is better; anything one-eighth inch or smaller should work. The most important thing is to have clean, perfectly round holes so you'll be able to detect any deformation caused by camera shake.

Array the holes in a pattern resembling a plus sign, with intersecting vertical and horizontal arms, as shown in Figure 1.13. In a pinch you can use aluminum foil, although it's more difficult to create perfectly round holes in foil because it tends to tear. If necessary, file away any burrs that result when you poke through the sheet. Remember, you want nice circular holes.

If you want to get fancy, you can spray paint the sheet with flat black paint to increase the contrast between the sheet itself and the light coming through the holes. After the paint dries, clean out any paint that goes

into the holes. Painting is not really necessary if you conduct the test in a darkened room. Now you're ready for your test.

1. Mount the sheet vertically, perpendicular to the ground.

2. Point a strong light at the back of the sheet, illuminating the pinholes. Make sure no light spills over beyond the sheet itself, as excess light could cause flare in the test shots.

3. Position yourself far enough from the sheet that you can fill the frame with the sheet.

4. Focus *very* carefully on the sheet, using manual focus. Your autofocus system might not work well in this situation. Use the pinpoints of light as your focus point, and turn the focus ring until the points are as sharp as possible.

5. Take a few shots using manual exposure until you find out which f/stop will give you a good exposure. Try to use f/8 to f/11 so your lens will be at a relatively sharp aperture. Although exposure isn't super critical, you don't want to overexpose and cause the pinholes to enlarge too much from blooming. You want tight, round dots of light.

6. Take several pictures at each shutter speed you want to test.

7. When you're done, examine your shots. As you reduce the shutter speed, you'll probably notice that the pin circles become elongated in the vertical, horizontal, or diagonal directions, depending on the bias of your shakiness. At worst, you may notice little wavering trails of light that show you're not merely shaking a bit, but positively quivering, as you can see in Figure 1.14.

The next section will show you how to put your findings to work.

Figure 1.13 Your sharpness tester can be a serving tray with an array of holes drilled through.

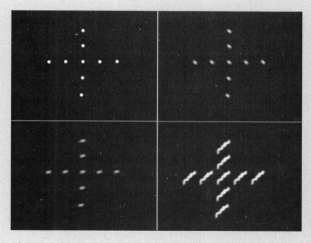

Figure 1.14 The shape of the holes that you photograph will reveal the amount of camera shake at any tested shutter speed.

Fixing Camera Motion Blur

Once you understand how much of an impact camera motion has on your images, you can take the easy steps to correct it. I'll explain all the solutions in detail: they range from simply changing some of your shooting habits to using higher shutter speeds, relying on a camera-steadying device such as a tripod or monopod, or using a dSLR or lens with built-in image stabilization technology. These address most of the leading causes of camera motion blur, which can include an unsteady photographer, poorly balanced camera/lens combinations that exacerbate normal camera wobble, and dSLR crop/magnification factors that make 300mm lenses act, in some ways, like 450mm telephoto monsters.

The latter effect is especially insidious. Photographers often follow the rule of thumb that calls for using a shutter speed that's the reciprocal of the lens's focal length, e.g. 1/400th second with a 400mm lens. With digital cameras that have a sensor that's smaller than the 24mm × 36mm frame size we associate with lens focal lengths, the guideline no longer holds true. The smaller section cropped out of the center of the "full" frame is enlarged and corresponds to the field of view of, say, a 600mm lens. A shutter speed of 1/600th second might be more appropriate. Figure 1.15 shows two images of seagulls taken with a 170mm–500mm zoom lens set to 500mm on a dSLR with a 1.5X crop factor. The image at top was taken hand-held at 1/500th second; the bottom version was shot a few minutes later at 1/2000th second. Assuming that both images were well-focused, the camera shake present in the top version can be blamed for most of the unsharpness in that image. Either 1/500th second or 1/2000th second was enough to freeze these birds in flight, even if the slower speed couldn't overcome a shaky, front-heavy camera/lens combination.

Changing Shooting Habits

Sometimes, just making a few adjustments in how you take pictures can help reduce camera shake. The biggest and most common offense is punching the shutter release. Beginners do this all the time as a matter of course; I've taken a photo with a simple point-and-shoot camera, handed the camera to a friend who then fired off a shot using the same settings. My picture turned out relatively sharp, while the friend's was egregiously blurry. I'm no paragon of hand-holding steadiness, but I know enough to wait until the camera has stopped moving when I bring it to my eye, and then squeeze off a shot gently. I've seen amateurs flip their camera up and shoot in a single motion. That's a perfect recipe for camera shake! Yet, even more experienced photographers are prone to bad shooting habits like these when they're in a hurry or a photo opportunity presents itself without warning. Impromptu grab shots are especially dangerous because you may not even have time to notice what shutter speed the camera is using before taking the photo.

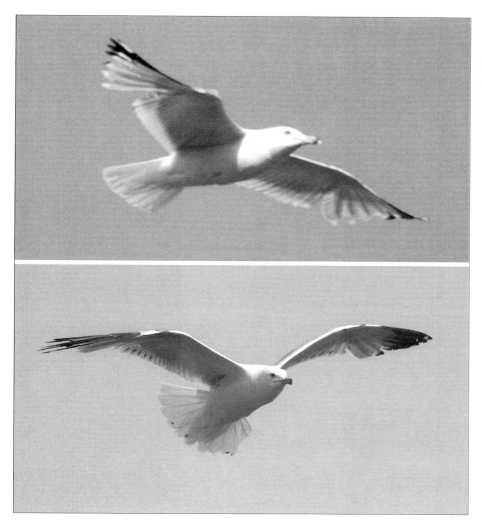

Figure 1.15 The shot at 1/500th second with a 500mm lens is less sharp than the version taken a few seconds later at 1/2000th second.

Even the most careless among us are a bit more careful when we know the shutter speed is set to 1/60th second than when it's 1/500th second. If you take an extra half-second before shooting, you can improve your odds of getting a sharp shot significantly. Modern cameras that lock focus and exposure when the shutter release is depressed halfway have actually helped improve sharpness, because more of us are now gently releasing the shutter after that initial half press.

Countering Mirror Bounce

The mirror in a dSLR directs light to the viewfinder and then, just before exposure, flips up (or sideways, with some specialized models), allowing the light to proceed directly to the shutter curtain and sensor. Then, the mirror moves back

to its original position. Unfortunately, the movement of the mirror prior to exposure can cause a tiny bit of vibration that's transmitted to the sensor, producing a minor, but potentially significant kind of camera shake.

The good news is that, for the most part, mirror bounce affects your image most within only a small window of shutter speeds, about 1/15th to 1 second. With shorter shutter speeds, the effects are not very pronounced, and at longer exposures the period of vibration is such a small part of the overall exposure that it's more or less canceled out. But, within that window, the mirror's movement is more likely to have an effect on critical images.

The bad news has two elements. First, the usual counter for camera shake—putting the camera on a tripod—doesn't have the desired effect for mirror bounce. The mirror's motion causes vibration whether the camera is tripod mounted or not. Second, some digital SLRs have a provision for locking up the mirror prior to exposure, which eliminates the problem, but many (if not most) dSLRs don't have this feature.

That's unfortunate, because preshot mirror lockup is entirely practical for the kinds of photography that would most benefit—long telephoto shots and close-ups. In both cases, it's very likely that the camera will be locked down on a tripod and the image already composed. There's no great problem in flipping up the mirror and then taking the picture—if the digital camera has that feature. Indeed, some pro-level dSLRs have what is called *mirror prerelease*, which causes the mirror to flip up and lock automatically a very short interval before the picture is taken, but allowing enough time to elapse to damp the vibration the mirror's movement caused. In use, mirror prerelease mode feels more like bloated shutter lag than anything else.

Some digital SLRs do have mirror lock-up, but it's provided only to allow for cleaning the sensor safely. True preshot mirror lock-up is one of the most desired features among serious photographers. I'm not certain that all who desire this feature would actually need it or use it, but if you frequent the digital photo forums you'll see many bitter complaints about this camera or that which lacks mirror lock-up facilities.

Higher Shutter Speeds

Switching to a higher shutter speed isn't always as easy as it sounds. When you're not using flash, the shutter speed is often dictated by the amount of available light and the aperture you want to use. So, if you discover that your images are susceptible to a little camera shake even when you're using 1/125th second, you *might* be able to adjust by using 1/250th or 1/500th second speeds—but you might not. It's easy enough to switch from 1/125th second at f/11 to 1/250th second at f/8, especially when using a normal or wide-angle lens that still provides adequate

depth-of-field at the wider aperture. But if you're already shooting at 1/125th at f/1.8, gaining a faster shutter speed might require boosting ISO a notch. While you can double ISO from ISO 100 to 200 or even from ISO 200 to 400 with most dSLRs without infesting an image with noise, if the sensitivity gain you need takes you in to ISO 800 territory and above, you might find that the extra sharpness you get from a faster shutter speed is more than offset by multicolored speckles. Noise reduction options can help, but are no panacea.

Higher shutter speeds are impractical from a technical or creative standpoint (say, you really *need* the extra depth-of-field a smaller f/stop provides). In that case you might need to turn to one of the two options I discuss next.

Image Stabilization

One technology that's growing in popularity is image stabilization (IS), which uses electronics built into the camera or lens to respond to camera movement with adjustments that counter the shake or vibration that occurs when shooting photos hand-held. IS can be built into the camera, which is the case with the Konica Minolta Maxxum 7D and 5D, or into lenses, which is the approach taken by Canon and Nikon. In either case, the IS technology gives you the same hand-held steadiness that you might get with a shutter speed two or three increments faster.

So, if you're shooting at 1/500th second at f/2.8 and need more depth-of-field, you can drop down to 1/125th second at f/5.6 and get almost the exact same steadiness. Should you be stymied by a low-light situation that calls for 1/15th second at f/1.8, you can fire away. You'll get the same camera steadiness you could expect at 1/60th second (in other words, you'll still need to hold the camera as steady as you can).

Of course, IS does nothing for *subject* motion. I recently photographed a stage production of *The Marriage of Figaro* using image stabilization and slow shutter speeds and found that the scenery was tack sharp, the actors and actresses reasonably sharp, but hands fluttering fans, batting eyelashes, and moving lips were hopelessly blurred, as you can see in Figure 1.16. Keep these cardinal rules of IS in mind when using this tool.

- ◆ **Freezing action.** As I noted, image stabilization can reduce camera wobble, but won't stop action. Use IS in low light, with long lenses, or when you need a longer shutter speed for creative purposes. When your subject matter is moving, you'll still need to use a sufficiently high shutter speed to freeze the movement.

- ◆ **Don't pan.** Some IS systems are fooled by panning movements, and should be shut off if you plan on using this technique. As odd as it might seem, mounting a camera on a tripod may also give an image stabilization system

fits. Vendors such as Canon are starting to design systems with two stabilization processes that handle these kinds of situations, and recent Nikon vibration reduction systems, such as that found in the company's 18mm–200mm VR zoom introduced at the same time as the Nikon D200, are able to sense panning and respond appropriately. But you're still better off not using IS when panning or using a tripod.

◆ **Not so good for sports.** One by-product of IS is the hit on your camera's performance caused by the extra time needed to shift things around to compensate for camera motion. Add in the normal delays you get from autofocus and autoexposure and the whole process just might introduce enough of a delay that you'll experience shutter lag. Many photographers report using IS successfully for sports, but you should be aware of the potential slow down before you purchase IS-enabled equipment specifically for action work. It's best to test the gear out first to see if it works for you before taking the plunge.

◆ **Good for wildlife and close-ups.** The best applications for image stabilization are wildlife photography with long lenses, macro photography in the field when your camera is not mounted on a tripod, and things like photography in museums or at concerts, where flash photography is prohibited.

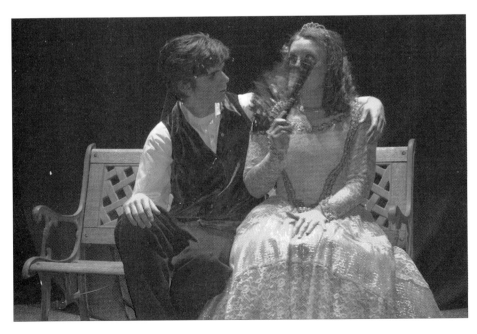

Figure 1.16 With image stabilization activated, 1/15th second was fast enough to freeze the scenery, but not the fluttering fan held by the actress.

QUO VADIS, IMAGE STABILIZATION?

Call it vibration reduction, image stabilization, anti-shake, or whatever you like, even though it's been around in some form for more than a decade, IS is still an emerging technology. The future directions of this kind of camera steadying facility is still up for debate. Originally developed for video cameras, IS was initially implemented in electronic form. IS-enabled videocams captured an image that's slightly larger than the actual frame, then shifted the image in the direction needed to counter camera motion. Repeated once for each frame, many times a second, electronic IS helps ensure that each successive frame is adjusted to show the same field of view as the last.

Digital still cameras don't need this same frame-to-frame consistency. Instead, the goal is to counter movement so that adjacent pixels don't blur into their neighbors in the direction of the camera motion. Motion sensors detect tiny movements of the camera and lens and adjust prisms or floating lens elements to compensate (in the case of IS-enabled lenses). Systems built into cameras, rather than lenses, move the sensor itself in response to camera motion, which means you don't have to purchase a special lens to get image stabilization. Konica Minolta's anti-shake technology, for example, works with virtually all Konica Minolta lenses.

Getting Some Support

As I just noted, even image stabilization won't totally eliminate the need for a tripod, monopod (the one-legged version of a tripod), or other visible means of support. Although one of the very best things about today's compact digital SLR cameras is the freedom they give you to move about freely and take photos quickly from a variety of angles, there are still times when you can improve the sharpness of your finished work simply by steadying the camera. If you're truly committed to raising the bar on quality, you need to know where and when to work with a tripod, and, most importantly, how to *use* a tripod effectively.

First, here are some situations when you almost certainly *don't* need to use a tripod or monopod:

◆ When you're shooting quickly and taking shots from many different angles. Perhaps you're taking pictures of your kids or grandkids at play, and want to get down to their level for many shots, then follow them as they clamber around on the furniture or playground equipment. Or, you're shooting a fast-moving sport like basketball and need to cover both ends of the court and everything in between. In such situations, a tripod or monopod would only get in the way and might actually be a hindrance and/or danger to you or the participants.

◆ When you're shooting in a studio-type setting with electronic flash, or indoors in other environments with flash. Any time electronic flash is your main source of illumination, you can generally count on the flash to freeze movement. A high shutter speed isn't necessary (except to curb ghost images caused by ambient light when the subject moves during the exposure), and a tripod or monopod is superfluous.

◆ When tripods are prohibited. Museums, professional sports events, and other public settings may not allow tripods. You'll need to do without, or work with one of the alternatives I describe later in this chapter.

On the other hand, you should at least consider having a tripod or monopod available in these kinds of situations, some of which are related to convenience rather than image quality alone:

◆ **When you're using a long telephoto lens.** Any lens longer than 200mm (actual focal length or equivalent) can usually benefit from a little extra steadying. Once you reach the 400mm–500mm range, you'll definitely get better results if you can mount the camera or, better yet, the lens, on a tripod or monopod. While some telephotos are fairly compact (I own a 28mm–200mm zoom that's only three inches long!), others are front-heavy monsters that can easily set up a seesawing motion as you try to aim, zoom, and control your camera using just two hands. Longer lenses often have their own tripod socket collars, and bracing them with a monopod will provide the steadying influence you need and enable you to more easily manipulate your camera's controls.

◆ **When shooting wildlife.** A tripod may let you set up your camera, point it where the activity or creature you expect to capture will be, and then trigger the shutter release (with a remote control or wired cable release, if you like) at the proper moment. Perhaps you're set up in a blind that hides you from your prey, or have placed some salt blocks to lure wildlife. Or, your intended subjects are smaller, like hummingbirds you hope will be attracted to a feeder you've set up. Fast-moving creatures can be hard to capture on the fly, but with a tripod you can preframe and prefocus your picture and be ready to shoot at the right moment. Of course, wildlife photography often involves long telephoto lenses, too, like the one used for Figure 1.17, so you have *two* reasons for using a tripod.

◆ **When creating careful compositions.** Landscape and architectural photography often involves painstaking preparation and meticulous framing of just the right composition. A tripod lets you set up, compose your image, shoot multiple versions, and fine-tune your picture without needing to reframe after every shot. You'll be glad you used a tripod the first time you look through

Figure 1.17 Wildlife photography often calls for long telephoto lenses that are best supported by a tripod.

your viewfinder, discover an odd object that's out of place, run to move or fix it, and then return to the camera to shoot.

- **When doing close-up photography.** Macro photography is another kind of contemplative work that benefits from a tripod's ability to lock down your camera in a particular spot. You can frame your image, fiddle with focus, and shoot without worrying that the camera will move and throw your subject out of focus and that your depth-of-field is applied just the way you intended. Of course, some close-up photos require the long shutter speeds because of low light levels or the small f/stops needed, and a tripod can be a valuable steadying tool. You'll find more on macro photography in Chapter 5.

- **When doing low light, no light, and time exposures.** A rock-solid tripod lets you make long exposures without blur caused by camera motion.

- **When shooting photos by remote control or for time-lapse sequences.** Many digital cameras can link to a computer for images taken by remote control. A tripod allows you to set up the camera and trigger it from your desktop or laptop. Or, you can use the built-in time-lapse feature (if your camera has it) or the timed sequence feature of your camera's capture software to take a series of exposures.

- **When you're shooting infrared.** Digital SLRs force you to shoot blind when you've mounted an infrared filter on your camera. In addition, IR photography usually calls for long shutter speeds. A tripod will let you frame the photo

without the filter, then expose the same composition for the requisite second or two after you've locked down the tripod and mounted the IR filter. (More on infrared work in Chapter 4.)

- **When you want to get in the photo yourself.** You can always set your camera down on a nearby wall or shelf, activate the self-timer, and then run and get into the picture. But, you'll find that a tripod is more convenient.

Your Support Options

Although I've been using the term *tripod* for the most part, your actual options for camera support are much broader than just the traditional three-legged camera stand. This next section will provide a quick rundown on the options you have. A complete camera kit might include several or all of these, each suited for a particular type of shooting situation.

Traditional All-in-One Tripod

The all-in-one tripod is what beginner photographers think of when they imagine a tripod. These devices consist of a set of telescoping legs, topped with a pan and tilt head with a tripod screw to mount a camera, usually fastened to a center column that can be raised or lowered to add or reduce height without the need to adjust the legs. Often, they'll have braces between the legs (usually because they are so flimsy they *need* the braces). Some may replace the pan (side to side) and tilt (up and down) head with a ball-and-socket style head that can be moved over a larger range of angles. You can find these in your local discount store for as little as $30, and tripods in that price range are actually little more than camera stands. They don't keep your camera very steady.

You'll also find more expensive all-in-one tripods, priced at $100 and up (way up!). The better designed models actually do an excellent job, but can limit your flexibility. You're pretty much stuck with the configuration of the tripod as purchased, and there is little you can do to customize it. I own a versatile Manfrotto all-in-one (shown in Figure 1.18) with a ball head that works very well for me because it's so light in weight that I can take it anywhere. It slips through a loop in my camera bag, adds only a few pounds to my kit, and will be there for me should I find that I need a tripod in a situation where I never expected to want one. Because it folds down to 22 inches in length, I took this tripod with me on a travel-light trip to Spain that involved only an overnight bag (the tripod slipped inside), a couple changes of clothing, two camera bodies, and two lenses.

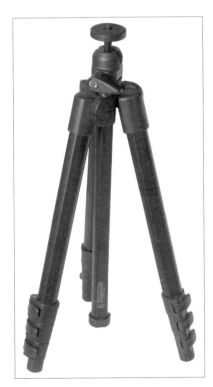

Figure 1.18 An all-in-one tripod can be compact and very portable.

Modular Tripods

Serious photographers are more likely to purchase their tripods as a set of legs, often with a center column, but no head at all, even though the legs-only setups might cost $300–$500. The head is purchased separately, and can easily cost almost as much as the tripod legs. Before you choke, remember that a good tripod might be a once-in-a-lifetime purchase. I bought my studio tripod while in college and have used it for virtually my entire career. It's only very recently that I've augmented my original tripod with several lightweight carbon fiber/magnesium models that are a bit easier to carry around.

Here are the things to consider when choosing a set of tripod legs:

◆ **Composition/material.** Tripods are most often made of aluminum, which is lightweight and reasonably rigid. Wood has been a popular material, too, although you don't see quite as many of these. More recently, tripods are being constructed of carbon fiber materials, magnesium, or even basalt, which all provide enviable rigidity at a weight that's 30 percent less than aluminum. If you're working in studio-type environments or traveling by car to your destination, an aluminum tripod can save you money. Should you be backpacking or traveling on vacation, the carbon fiber lightweights are well worth the investment.

◆ **Height.** Ideally, a tripod should adjust to the height you need using extension of the legs alone. The center column is best suited for fine-tuning the camera position without the need to fiddle with the legs. I like a tripod that positions the camera at eye level, or higher, with the center column fully retracted.

◆ **Number of leg sections.** The more leg sections a particular tripod has, the smaller it will be when collapsed and packed away. A tripod with three leg sections, like the one shown in Figure 1.19, will be less compact than one with four or five sections. Because telescoping sections must be smaller and smaller to fit inside the section above it, you'll find that tripods with more than three leg sections are less sturdy and require more manipulation of controls to lock and unlock the individual pieces. If the size of the tripod when folded up is not critical, you'll find that a three-section tripod will be more convenient and provide better support.

◆ **Leg adjustments.** You'll want legs that adjust easily so you can change the height of the tripod quickly. The ability to adjust the angle of each leg separately is a plus. Some have flip levers that lock and unlock the legs; others twist. Easy action may not sound like a big deal, until you discover just how often you must adjust the length of each leg individually to account for uneven surfaces, such as stairs or sloping hills. Leg locks should be fast to use and fasten securely.

Figure 1.19 Three leg sections are faster to set up because you can unlock and adjust the three legs more quickly.

- **Sure-grip "feet."** Rubberized feet at the end of each leg are good for gripping slippery surfaces. Some tripods have feet that can be adjusted to use spiky tips that can dig into dirt, grass, or other iffy surfaces.

- **Center column.** You'll need one that's long enough to let you move the camera up or down by a foot or two without the need to adjust the legs. Some tripods have center columns that swivel to allow shooting at an angle, or which reverse to allow shooting straight down or from a low angle.

- **Accessories.** Professional-quality tripods can be outfitted with a range of accessories that make your work easier, or to simplify difficult tasks. For example, Gitzo and other vendors offer center columns in a variety of lengths, which include both geared versions for making fine height adjustments, and quick-set columns that can be moved rapidly over their entire range. You'll find dollies that let you roll a tripod around on flat surfaces, platforms that let you mount two cameras side by side on a single tripod, special clamps that let you attach flash units to your tripod, and aprons that fasten to the tripod legs to allow storing gear underneath the tripod as you shoot. (You can also fill the apron with rocks to add some heft to your tripod.)

Tripod Heads

Every modular set of tripod legs needs to be topped with a head that holds the camera. These usually fall into one of two types: the traditional pan-and-tilt head and the ball head. The former consists of a flat plate that fastens to the bottom of the camera, and a mechanism that allows it to rotate side to side (pan) or up and down (tilt). A separate handle controls each directional movement and, usually, is twisted to lock the head in position for that direction. For example, you can lock the tilt of the camera and rotate it freely from side to side, or fix the sideways movement and tilt up and down. Pan-and-tilt heads usually have a lever you can flip to change from a horizontal to vertical orientation, too.

Figure 1.20 Ball heads allow a greater degree of freedom when making adjustments.

Ball heads, like the one shown in Figure 1.20, use a ball-and-socket mechanism that lets the camera platform move in any direction within the limits of the ball. Usually there are one or more "slots" in the head to allow moving the camera into a vertical position.

Pan-and-tilt heads are actually better suited for video cameras than still cameras, especially in their *fluid head* incarnations, which provide smoother movements while the camera is operating. As photographers become more experienced, they usually find that the freedom the ball head provides is better suited to digital SLR photography.

You'll find ball heads in a variety of configurations. Some have a single lever that locks the ball in place. Others have mechanisms that allow smooth panning of the whole head independently of the ball movement, and are marked with degrees to allow precise positioning. Built-in spirit levels, double ball heads, and other niceties spice up the more advanced ball heads.

Regardless of the type of head you get, you'll want a quick release plate mechanism, like the one shown in Figure 1.21, to make it easier to mount and dismount your camera from the tripod. These gadgets consist of two parts: a plate that attaches to the underside of your camera, and a mount that mates with the plate. Attaching and removing the camera from the tripod takes only a second or two. Quick release plates include a security lever that must be flipped before the camera can be detached, eliminating the possibility of accidentally releasing the camera from the tripod. (Note that it's important to make sure the security lever is locked into place before letting go of your camera. Some quick release plates/mounts snap together, but aren't locked until the lever clicks *all the way* into its final position, as I discovered by near accident.)

Figure 1.21 The top adapter attaches to the bottom of your camera or lens, and then snaps into the plate underneath, which is fastened to your tripod or monopod.

Monopods

You'll find a monopod, like the one shown in Figure 1.22, a handy alternative to a tripod when all you need is to steady the camera and don't need a free-standing support. My Manfrotto carbon fiber is my take-everywhere accessory that goes right in my shoulder bag for use whenever I mount a lens longer than 200mm, or in light levels less than full daylight when I am not using flash. I've also found it useful when shooting outdoors in full daylight at low sensitivity settings (such as ISO 100) when using a light-robbing polarizing filter. I have a quick-release adapter on my monopod and a matching plate on every camera, so I can just whip out the monopod, snap on the camera, and shoot with just a few seconds' preparation.

You don't necessarily need a ball head on your monopod (although you'll find one useful), because it's usually possible to just press the monopod down firmly and

Figure 1.22 A monopod is a lightweight substitute for a tripod.

tilt the whole rig to shoot at any particular angle. Like tripods, monopods are available in both aluminum and lightweight materials such as carbon fiber, and can be purchased in three-, four-, and five-section configurations. Some tripods have a detachable leg that can be used as a monopod. If you throw your knee out (as I did last year), you'll find that a monopod can double as a handy cane, too. I found I could easily take my monopod/cane into venues that didn't allow tripods, and use it discreetly without triggering any protests.

Tripod Alternatives

There are lots of alternatives to tripods and monopods, many of them a lot more portable and convenient. For example, many photographers like to carry around a beanbag or two. Throw the beanbag down on just about any surface, then set your camera's lens on top. The beanbag molds to the shape of the lens, provides solid support, and is pliable enough to allow aiming the camera at various subjects without moving the beanbag. Some photographers swear by gunstocks they can put to their shoulders and steady their cameras and long lenses. Others use chestpods and other gadgets.

Figure 1.23 A C-clamp with camera mount attached can turn any stationary object into a camera stand.

I favor the clamp device shown in Figure 1.23. It's always in the front pocket of my shoulder bag, ready for use. I've fastened it to fence railings at an amusement park to create a "tripod" for photographing a carousel, and clamped it to the back of an empty seat in front of me at a baseball game to support a long lens in waning daylight. Back when I had a gimpy knee and hadn't learned that a monopod can serve double duty, I'd clamp my gadget to the real cane I was using to create an instant monopod.

Some other tripod alternatives are described next.

Do-It-Yourself Support

Here are some easy gadgets you can make yourself. None of them cost more than a dollar or two to make, weigh more than an ounce or so, and, if you play your cards right, you get some soda to drink and oranges to eat out of the deal.

The Amazing Two-Ounce Tripod

Here's a "tripod" you can throw in a pocket of your camera bag and use anywhere you can find a bottle. Or, you can take your own bottle along. Either way, it's a convenient tabletop tripod substitute you can use anywhere. Here's how to create your own.

1. Find a knurled tripod screw like the one shown in Figure 1.24. The screw should have a 1/4–20 thread to fit most cameras, or a 3/8-inch thread if you have a component which uses that particular size. These screws should cost no more than a dollar or two, and you'll find them in the junk bin at most camera stores. They can usually be liberated from old camera "never-ready" cases.

2. Locate a twist-off bottle cap and bottle you can use as your "tripod." For maximum portability, use a 2-liter beverage bottle, then discard the bottle when you're done with it, saving the cap. When you need to use your bottle-cap tripod again, just find another bottle.

3. Poke a hole in the center of the cap and force the tripod screw through the opening. That's it; you're done!

Figure 1.24 A knurled screw and a bottle cap makes a portable "tripod."

To use your bottle-cap tripod, take the cap and screw it into the tripod socket of your camera. Then, fill the bottle with water, sand, pebbles, or whatever you have, and attach the cap to the bottle. The weighted bottle will hold your camera steady. "Pan" by turning the bottle itself. Tilting is a little more problematic; this setup pretty much holds the camera level. But what do you expect from a two-ounce tripod that cost you just a few bucks?

The Amazing Two-Ounce Monopod

This one's so easy to use, they should sell them everywhere. Actually, you can buy one of these, but it's just as easy to make your own. Just follow these steps.

1. Get another one of those knurled tripod screws. Then find a strap of some sort that's about an inch wide and four or five feet long. Your ideal strap should have a small amount of stretchiness, but not too much.

2. Make a loop in one end big enough to put your foot through. Insert foot and stretch the strap out until it comes up to your eye level. Cut it off at that length.

3. At the other end of the strap, cut a hole for the tripod screw. That's all you need to do.

To use your monopod, fasten the tripod screw into your camera or lens' tripod socket. Put your foot through the other end of the strap. Pull up on your camera until the strap is taut and the camera is up to your eye. You'll find that you can keep the camera quite steady by applying continuous upwards tension on the strap. It's not quite as good as a real monopod, but it's a lot better than nothing.

The Amazing Two-Ounce Tripod Weight

This one requires use of an actual tripod, but makes your existing tripod even steadier. All you do is buy a bag of oranges that comes in a mesh bag. Eat the oranges and save the bag. In a pinch, you can use mesh bags that potatoes or onions sometimes come in. Fold up the bag and tuck it in your camera kit.

Then, when you're out shooting with a tripod that's not quite as heavy as you'd like, take the bag out, fill it with rocks, and suspend it from the center column. The extra weight will help steady your tripod. When you're done shooting, take out the rocks, shake out the bag, and return it to your camera bag or backpack. Use a plastic zipper bag to store the mesh container to keep rock dust out of your camera kit.

Focus on Focus

The third component of a high quality image is correct focus. For an image to look its best, and to take advantage of the sharpness built into your lens and detail frozen by the proper shutter speed, those areas that are supposed to be sharp should look *sharp*. Of course, not all of an image will be or should be sharp; controlling exactly what is sharp and what is not is part of your creative palette. Use of depth-of-field characteristics to throw part of an image out of focus while other parts are sharply focused is one of the most valuable tools available to a photographer. But selective focus works only when the desired areas of an image are in focus properly. For the digital SLR photographer, correct focus can be one of the trickiest parts of the technical and creative process. Before we can tackle using focus correctly and efficiently, it's a good idea to look at why correct focus can be problematic.

Focus Challenges for dSLR Users

There are several reasons why correct focus can be so difficult to obtain. Prior to the early 1980s, it was fairly easy to place the blame for badly focused pictures on the photographer. That's because 25 years ago autofocus wasn't widely used as it is now. Focusing was done by the photographer, manually. Certainly, it was more difficult to focus particular cameras and lenses at particular f/stops using the various viewing mechanisms that were available. Gadgets abounded to help improve manual focus, including eyepiece magnifiers, special focusing screens, and other aids. But when an image was poorly focused, it was the photographer who was responsible. Today, autofocus is an important part of the process—something that *should work* just fine, but often doesn't.

Our eyes and focus-screen-based automatic focus systems operate on similar principles. When part of an image is in sharp focus, the contrast of the image at the boundaries between tones is the highest. As an image goes out of focus, the contrast between edges decreases, creating a blur. As we focus manually, our brains try to judge whether the image we are looking at now is more or less contrasty than the image we saw most recently. Unfortunately, humans have a very poor memory for contrast. That's why manual focusing involves jogging the focus ring back and forth as you go from almost in focus, to sharp focus, to almost focused again. The little clockwise and counterclockwise arcs decrease in size until you've zeroed in on the point of correct focus.

Your dSLR's autofocus mechanism also evaluates increases and decreases in sharpness, but is able to remember perfectly the progression, so that autofocus can lock in much more quickly and, with an image that has sufficient contrast, more precisely. Unfortunately, there are some factors that can throw a monkey wrench into the works and thwart the most sophisticated autofocus systems. They can also

affect our ability to manually focus accurately. Here are some of the reasons why accurate focus can be problematic:

◆ **Focus on what?** Your camera doesn't know what object in the frame you want to be in sharpest focus. Is it the closest object? The subject in the center? Something lurking *behind* the closest subject? A person standing over at the side of the picture? Many of the techniques for using autofocus effectively involve telling your camera exactly what it should be focusing on.

◆ **Too much depth-of-field.** A lot of DOF can be a good thing when you want a great range of objects in your image to be reasonably sharp. But when it comes time to focus, you want the least amount of depth-of-field possible, so that the contrast between the object being focused on and those in the foreground and background is easily discerned. As you know, DOF is increased by using a smaller aperture or a shorter focal length. Consequently, it's easier to achieve sharp focus at f/1.8 than it is at f/8, which is one of the reasons why dSLRs are focused with the lens wide open (the other reason to keep the lens at its maximum aperture until the moment of exposure is that the view will remain bright right up until the picture is taken). It's easier to focus at 70mm than it is at 18mm, too. Digital SLRs with a sensor that's smaller than the 35mm frame take a hit here, because they use a lens with a wider angle to achieve the same field of view. A 30mm "normal" lens mounted on a dSLR with a 1.5X crop factor will be more difficult to focus than a 50mm "normal" lens on a full-frame film or digital camera.

◆ **Non-memory effect.** As I mentioned earlier, your brain's inability to remember whether an image was sharper a second ago, compared to now, makes manual focus more difficult.

◆ **Subjects move.** With subject matter that's moving, the point of sharpest focus may shift rapidly. Perhaps someone is coming towards the camera, and your autofocus mechanism needs to compensate dynamically. Worse, something may move across your frame, blocking your subject for an instant before moving on. Your camera has to decide whether to lock focus on this new object, or to keep the focus on the original subject until a short interval has passed.

◆ **Confusing subjects.** Some kinds of subject matter can be difficult to focus on because of a lack of sufficient contrast to let our eyes or the camera's autofocus mechanism "lock on." A classic example is a clear blue sky, which can drive an autofocus system nuts (humans are smart enough to set the lens on infinity when focusing manually). Blank walls or other subjects with a multitude of tiny details that can't be resolved easily by the autofocus system can also cause problems, as can shiny subjects and windows. You may end up with your lens focusing back and forth in vain, unable to find something to focus on.

ALTERNATE FOCUS SYSTEMS

While digital SLRs generally measure the contrast of images on the focus screen to achieve sharp focus, you should be aware of some alternative aids and systems. The most common is the *focus assist lamp*, which is usually a white, red, or green LED on the front of the camera that illuminates under dim or low-contrast lighting conditions and may help boost the relative contrast of the image the camera sees enough to improve focus. Some vendors, such as Nikon, also include a focus assist lamp on their add-on external electronic flash units, which makes sense because speedlights are often used under the sort of reduced lighting that can stymie auto-focus systems. Some vendors have supplemented their camera's focus mechanisms with other external aids, which have ranged from a grid pattern projected on the subject to infrared or ultrasonic "rangefinding." Don't be surprised if some of these older or experimental technologies pop up on digital SLRs in the future.

What's in Focus, and What's Not

One of the trickiest parts of achieving focus is the notion that, in one sense, correct focus is partially subjective. Whether a subject is sharply focused varies, depending on how large the image is rendered, the viewing distance, and, to a certain extent, how "fussy" the viewer is. If that statement encircles you with confusion, you're on the right track. Focus is, in fact, measured using something called a *circle of confusion*.

An ideal image consists of zillions of tiny little points, which, like all points, theoretically have no height or width. There is perfect contrast between the point and its surroundings. You can think of each point as a pinpoint of light in a darkened room. When a given point is out of focus, its edges decrease in contrast and it changes from a perfect point to a tiny disc with blurry edges (remember, blur is the lack of contrast between boundaries in an image).

If this blurry disc, which is called the *circle of confusion*, is small enough, our eye still perceives it as a point. It's only when the disc grows large enough that we can see it as a blur rather than a sharp point that a given point is viewed as out of focus. You can see, then, that enlarging an image, either by displaying it larger on your computer monitor or by making a large print, also enlarges the size of each circle of confusion. Moving closer to the image does the same thing. So, parts of an image that may look perfectly sharp in a 5 × 7-inch print viewed at arm's length might appear blurry when blown up to 11 × 14 and examined at the same distance. Take a few steps back, however, and it may look sharp again.

To a lesser extent, the viewer also affects the apparent size of these circles of confusion. Some people see details better at a given distance, and may perceive smaller

NOT BOKEH

Blurry discs have another characteristic that is not, strictly speaking, exclusively related to sharp focus. This attribute is called *bokeh* (from the Japanese word *boke* or blur) and has aesthetic effects. I'll cover bokeh in Chapter 2, but for now you need to know only that some blurry discs (such as those with darker centers and lighter edges) are more distracting than those with other characteristics (such as those with edges that blend into the edges of blurry discs around them, so that the discs are almost invisible, as shown in Figure 1.25). Bokeh varies from lens to lens, and its quality may be an important factor when you choose a particular optic.

Figure 1.25 Visible circles of confusion can be distracting; those that blend together are better.

circles of confusion than someone standing next to them. For the most part, however, such differences are small. Truly blurry images will look blurry to just about everyone under the same conditions.

Technically, there is just one plane within your picture area, parallel to the back of the camera (or sensor, in the case of a digital camera), that is in sharp focus. That's the plane in which the points of the image are rendered as precise points. At every other plane in front of or behind the focus plane, the points show up as discs that range from slightly blurry to extremely blurry. In practice, the discs in many of these planes will still be so small that we see them as points, and that's where we get *depth-of-field*. DOF is just the range of planes that include discs that we perceive as points rather than blurred splotches. The size of this range increases as the aperture is reduced in size, and is allocated roughly one-third in front of the plane of sharpest focus, and two-thirds behind it.

Understanding how focus works will let you improve the focus quality of your images when you choose to. You can decide whether it makes more sense to focus the image yourself, manually, let the camera focus for you, or step in and fine-tune focus after the camera has done its best. There are advantages and disadvantages to each approach.

Autofocus Basics

Because of the challenges I've already listed, you'll find that your camera doesn't have just a single autofocus system, it has what can be considered several different systems, all of them based on the same internal components. The chief difference between these systems is how the information is collected and interpreted. One of the things you'll need to learn as you become more familiar with your dSLR's operation is how each autofocus option works, and when to use it.

The first thing to understand is what factors and components go into defining a particular type of autofocus system. Although dSLRs use measurements of the contrast on your viewfinder's focus screen to determine the proper point of focus, how these measurements are made and implemented can differ dramatically from camera to camera.

Autofocus Sensors

If you've used your dSLR for any amount of time, you already know that the autofocus system determines focus by measuring distinct areas or zones in the image area, marked in the viewing screen in some way, and usually individually illuminated with a red or green light when active. The number of focus zones varies by camera. The Nikon D70s and D50 have five zones, shown in Figure 1.26; the upscale Nikon D2X has eleven. The Canon Digital Rebel XT comes with seven

Figure 1.26 Just five focus zones is a bit on the skimpy side; some dSLRs have 9 to 11 zones, or even more.

focus points, the Canon EOS 5D has nine arranged in a diamond shape, while the top of the line Canon EOS-1Ds Mark II has a whopping 45 focus points. Models from other vendors, like Pentax and Konica Minolta, offer from 3 to 11 zones. While more focus points seems better, remember that the camera must be able to choose and interpret the autofocus information quickly and effectively to operate efficiently.

These focus sensors can consist of vertical or horizontal lines of pixels, cross-shapes, and often a mixture of these types within a single camera. Different sensors may be used in bright light than in dim light. Plus, you may be able to *move* the sensor's viewpoint from place to place in the frame, using your camera's cursor keys. Your camera may work with a single sensor at a time, or zero in on one sensor but take into account the other adjacent zones. How the camera selects which sensor to use (or how you choose the zone manually) has a significant impact on how successfully the image is focused.

Autofocus Evaluation

The camera collects contrast information from the sensor and then evaluates it to determine whether the desired sharp focus has been achieved. The calculations may include whether the subject is moving, and whether it appears to be the closest object to the camera. The speed that your camera acts on its evaluation to fix

focus affects how quickly an image snaps into focus. Some autofocus systems, particularly those found on more expensive, "pro" dSLRs operate much more quickly than those installed in consumer digital SLRs. If your camera happens to be one of the slowpokes, you need to know how to deal with that, usually by selecting a more forgiving autofocus option (described below) or even, in extreme circumstances, by switching to manual focus. Although a dSLR will almost always focus more quickly than a human, there are types of shooting situations where that's not fast enough. For example, if you're having problems shooting sports because your dSLR's autofocus system manically follows each moving subject, a better choice might be to shift into manual and prefocus on a spot where you anticipate the action will be, such as a goal line or soccer net.

Lens Autofocus Speed

There's a speed factor entirely separate from the performance of your camera's internal autofocus system. The actual focus for a photograph is, of course, set by the lens itself, and the speed with which the lens can implement the focus instructions conveyed by the camera can be critical. This speed is highly dependent on the design of the lens. Some models focus more slowly than others, either because focusing involves lens elements that can't be shifted rapidly or because the motors and actuators in the system move too darn slow. Some lenses use *internal focus*, which involves shifting the elements inside the lens such that the lens itself never gets physically longer. Internal focus can be very fast. Other lenses change in size, with elements telescoping in and out as focus is adjusted. This greater amount of movement can take quite a bit longer, slowing the autofocus mechanism.

Choosing Autofocus Modes and Parameters

Choosing the right autofocus mode and the parameters that refine how the mode is applied is your key to success. Using the wrong mode for a particular type of photography can lead to a series of pictures that are all sharply focused—on the wrong subject. When I first started shooting sports with an autofocus SLR, I managed to shoot an entire series of pictures of a promising young pitcher from a position next to the third base dugout—with focus tightly zeroed in on the fans in the stands behind him. A simple change in mode would have worked—in this case, any of several choices, including setting the focus zone manually, locking focus, or using "closest subject" zone selection.

To save battery power, your dSLR doesn't start to focus the lens until you partially depress the shutter release. But, autofocus isn't some mindless beast out there snapping your pictures in and out of focus with no feedback from you after you press that button. There are several settings you can modify that return at least a modicum of control to you. Your first decision should be whether the camera uses *continuous autofocus, single autofocus,* or both.

Continuous Autofocus

Continuous autofocus is the mode to use for sports and other fast-moving subjects. In this mode, once the shutter release is partially depressed, the camera sets the focus, but continues to monitor the subject, so that if it moves or you move, the lens will be refocused to suit. You'll often see continuous autofocus referred to as *release priority*. If you press the shutter release down all the way while the system is refining focus, the camera will go ahead and take a picture, even if the image is slightly out of focus. You'll find that continuous autofocus produces the least amount of shutter lag of any autofocus mode: press the button, and the camera fires. It also uses the most battery power, because the autofocus system operates as long as the shutter release button is partially depressed.

Single Autofocus

In this mode, once you begin to press the shutter release, focus is set once and remains at that setting until the button is fully depressed, taking the picture, or until you release the shutter button without taking a shot. For non-action photography, this setting is usually your best choice, as it minimizes out-of-focus pictures (at the expense of spontaneity). The drawback here is that you might not be able to take a picture at all while the camera is seeking focus; you're locked out until the autofocus mechanism is happy with the current setting. Single autofocus is sometimes referred to as *focus priority* for that reason. Because of the small delay while the camera zeroes in on correct focus, you might experience slightly more shutter lag. This mode uses less battery power.

Automatic Autofocus

This setting, found in cameras like the Nikon D50, is actually a combination of the first two. When selected, the camera will examine a scene and then switch to either continuous autofocus or single autofocus as appropriate. It's a good choice when you're shooting a mixture of action pictures and less dynamic shots and want the camera to make the focus mode choice for you.

The next parameter to choose is how the camera selects a focus zone. This is a crucial setting, because if the focus zone is set incorrectly, your chances of getting sharply focused images are reduced. You can allow the camera to choose a focus area for you, based on criteria that you specify, or select the focus zone manually. When you're shooting action pictures or subjects that change rapidly, it's almost always a good idea to let the camera choose the zone. It takes a lot of practice to move the zone around quickly in manual mode, and I find this technique to be distracting as well as prone to error. When you're shooting landscape, architecture, portraits, and similar subjects, manual zone selection is likely to be easy and more accurate. Here are some of the settings from which you can choose.

Single Focus Area

When using this option, only one focus sensor will be used, and it cannot be changed dynamically by the photographer. The focus zone may be the sensor in the center of the frame. This is a super-simple mode you can use when you want to be sure that the subject in the middle of the picture is sharply focused.

Dynamic Focus Area

When this option is selected, your dSLR will use more than one focus sensor while checking your frame, moving among them as focus is calculated. With dynamic area autofocus, the camera may automatically switch from using one sensor to a different sensor if it detects subject motion. This is an especially good match for continuous autofocus when shooting sports, but it can work well with subjects that remain in place, too. As you reframe the image, a dynamic focus system will automatically refocus on the main subject in its new position.

Focus Pattern

Some dSLRs let you choose the way sensors are grouped to measure focus. You may be able to tell the camera to use just a single sensor, or to use one sensor but take into account readings from adjacent sensors. This option is most common on digital SLRs that have 9 to 11 or more focus zones, and thus lend themselves to pattern groupings. This option comes in handy when your subject may be moving around in a limited area in one portion of the frame, and you want the autofocus system to be able to follow it quickly.

User Selected Focus Area

This is an autofocus option that allows you to switch from one focus area to another using the same cursor pad used to navigate up, down, left, and right, through menus. Once you've moved the active zone to a particular sensor, it will stay there and not budge until you manually change to a different zone. The focus area in use will often be indicated in the viewfinder by a glowing light.

Nearest Subject

Nearest subject focus is an option that tells the autofocus system to lock onto a subject that's closest to the camera, no matter where it is located in the frame. This is an excellent option to use when you know that your main subject, like the baseball pitcher described earlier in this chapter, or, frequently, children, will always be closer to the camera than other possible subjects.

Electronic Rangefinder

Most dSLRs have an "in focus" indicator in the viewfinder that blinks when the subject in the currently highlighted focus zone is sharply focused. You can use this as feedback to assure yourself that your image is, in fact, focused properly. The

electronic rangefinder is also useful when using manual focus lenses to confirm that your visual focus jockeying is accurate.

Finally, there are a few other controls and settings you can make to fine-tune your autofocus.

Focus Lock

All digital SLRs have a focus-locking button that lets you fix the focus at the current point until you take a picture. Once you've set focus, you can reframe the shot slightly and the focus point will be retained.

Focus Override

Cameras and lenses generally have an AF/M button you can use to switch between autofocus and manual. Some let you use a mode that focuses automatically, but which can be fine-tuned manually with no danger of grinding gears or gnashing teeth.

Macro Lock/Lockout

Some cameras and lenses have a provision for locking the lens into macro position so focus can be achieved only within the narrower close-up range. Or, you might find a macro lockout feature that keeps the autofocus mechanism from trying to focus closer than a given distance. That can come in handy when you're shooting distant subjects, because the lens won't bother seeking close focus, which can be time-consuming.

Autofocus Assist Lamp

This is an optional feature that can improve autofocus operation in low light situations. The light, which is most often either white or red, is rarely strong enough to be of much help beyond a few feet, tends to be annoying to your human or animal subjects, and uses enough power to drain your battery a bit.

Testing for Back Focus and Front Focus

Back focus and front focus are defects in an autofocus system that cause a lens to focus behind or in front of the actual point of sharp focus. The camera determines the focus point accurately, but somehow the focus instructions become lost in translation, and your result is a photo that is not sharply focused. If you have a lens with this problem, you'll want to return it to the vendor for recalibration. Here's how to test for back focus and front focus yourself.

You'll need a chart like the one shown in Figure 1.27. You can prepare your own, use the chart in the figure, or download the file from the Web site for this book. The chart can be printed on a single 8.5 × 11-inch

Figure 1.27 Use this chart to test for focus, or make your own.

sheet of paper. Many focus charts include measurements showing the distance between the lines, so you can see just how errant your lens' focus is, but I've simplified things so you can print the chart I provide at any size you like.

To use the chart, lay it down on a flat surface and place an object on the line at the middle, which will represent the point of focus (we hope). Then, shoot the chart at an angle using your lens' widest aperture and the autofocus mode you want to test. Mount the camera on a tripod so you can get accurate, repeatable results.

If your camera/lens combination doesn't suffer from front or back focus, the point of sharpest focus will be the center line of the chart, as you can see in Figure 1.28. If you do have a problem, one of the other lines will be sharply focused instead. Should you discover that your lens consistently front or back focuses, it should be sent in for calibration.

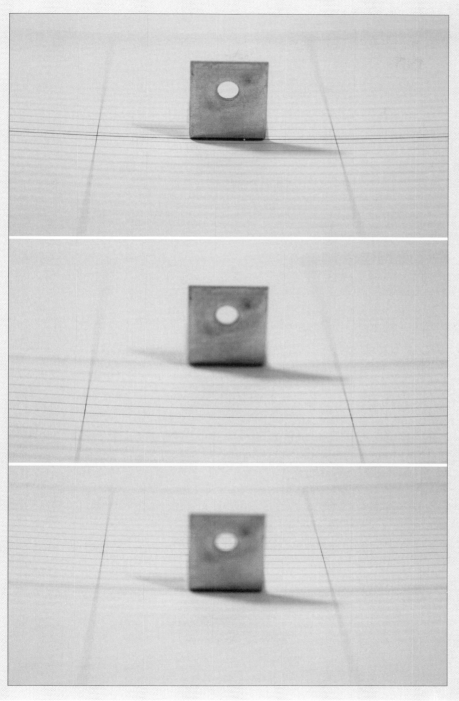

Figure 1.28 Correct focus (top), front focus (middle), and back focus (bottom).

Tonal Rendition

Proper tonal rendition is another key criterion for image quality. Unlike poor sharpness and improper focus, bad tonality is something that can sometimes be fixed in an image editor. However, you're always better off getting your tones right the first time.

The tonal range is defined as the continuum of dark to light tones, from a complete absence of brightness (black) to the brightest possible tone (white), and all the middle tones in between. Because all values for tones fall into a continuous spectrum between black and white, it's easiest to think of a photo's tonality in terms of a black and white or grayscale image, even though you're capturing tones in three separate color layers of red, green, and blue. A full-color photo is nothing more than the representative gray scales for each of the primary colors of light, combined into a single image.

Of course, grayscale images never represent the true range of tones from black to white, because the blackest black in any photo isn't a true black, because *some* light is always reflected from the surface of the print, emitted by the phosphors of a CRT, or by the pixels of an LCD monitor. The whitest white isn't a true white, either, because even the lightest areas of a print absorb some light, and your CRT or LCD display's full white tones may be bright, but they're not *perfectly* reflective or transmissive.

Moreover, in the digital world no scale can be truly continuous, because it's always divided into increments. A grayscale is, by convention, usually divided into 256 different tones ranging from black to white. A color image is *three* "grayscales" (one for each color), producing $256 \times 256 \times 256$ colors, or 16.8 million in all in an 8-bit color image. Your digital camera actually captures more tones than that, perhaps 1024 per color channel. The number of colors captured is called the *dynamic range*, and those extra colors captured by the camera may exist for a time in a *high dynamic range*, or 16-bit color file, which can be manipulated by some image editors, including the latest version of Photoshop. Eventually they're reduced to 16.8 million hues by the time your image editor is finished processing the file. This isn't intended to be a Photoshop book, so I'm going to skip over most of the technical details about dynamic range and bit depth and cut to the chase.

Your job, as a digital photographer, is to do your best to capture as many of the actual tones available in an image as you can, producing the best dynamic range and most faithful rendition of the original scene. You have two tools at your disposal. One of them is applying the correct exposure for a scene, and that's the area over which you have the most control. The second tool is to manipulate the tones captured by your camera using *tonal curves*, which distribute the captured tones in ways that will do your image the most good.

Many digital cameras have the ability to upload customized tonal curves and apply them to images as they are taken. Custom curves are actually an in-camera application of sophisticated image editing tools available in Photoshop, and, as I said, this isn't intended to be a Photoshop book. If you want to use custom curves with your dSLR, your best bet is to either become proficient in applying curves in an image editor (so you can create your own custom curves) or, on a more practical level, upload curves developed by others. You'll find a particularly rich set of custom curves available on the Internet for cameras like the Nikon D70s, with names like "White Wedding." Just use Google to find sites offering custom curves for your particular model camera. Given the highly technical nature of preparing curves, you're probably better off experimenting with these canned curves until you find one that provides the results you like.

The other tool—applying the correct exposure—is something that is more easily handled by the average dSLR owner. You can use your camera's matrix, center-weighted, or spot metering to achieve *close* to the ideal exposure in most cases. After that, zeroing in on the *best* exposure may be simply a matter of doing some fine-tuning. One way to fine-tune is to use your camera's automatic bracketing feature to shoot several pictures at different exposures: the ideal exposure, plus one or more photos a fraction of an exposure value (EV) more or less than the calculated exposure. These exposure compensation adjustments can be made by spinning a dial on your camera to add or subtract exposure. The problem is determining precisely how much more or less exposure to use. That's where your dSLR's histogram feature comes in.

Enter the Histogram

A histogram is a chart displayed on your camera's LCD that shows the number of tones being captured at each brightness level. With a dSLR, this display is available only after you've taken the photo, but you can use the information to provide correction for the next shot you take. The histogram chart includes up to 256 vertical lines that show the number of pixels in the image at each brightness level, from 0 (black) on the left side to 255 (white) on the right. The more pixels at a given level, the taller the bar at that position. If no bar appears at a particular position on the scale from left to right, there are no pixels at that particular brightness level.

A typical histogram produces a mountain-like shape, with most of the pixels bunched in the middle gray tones, with fewer pixels at the dark and light ends of the scale, as you can see in Figure 1.29. Ideally, though, there will be at least some pixels at either extreme, so that your image has both a true black and a true white representing some details.

Figure 1.29 The histogram of an image with normal exposure and contrast looks like this.

As you gain experience with histograms, you can actually perceive both the contrast and exposure of an image just by examining the shape of the curve and distribution of the tones. An image of normal contrast and good exposure will look like Figure 1.29. With a lower contrast image, like the one shown in Figure 1.30, the basic shape of the histogram will remain recognizable, but will be gradually compressed to cover a smaller area of the gray spectrum. The squished shape of the histogram is caused by all the grays in the original image being represented by a limited number of gray tones in a smaller range of the scale.

Instead of the darkest tones reaching into the black end of the spectrum and the whitest tones extending to the lightest end, the blackest areas are now represented by a light gray, and the whites by a somewhat lighter gray. The overall contrast of the image is reduced. Because all the darker tones are actually a middle gray or lighter, this version of the photo appears lighter as well.

Going in the other direction, increasing the contrast of an image produces a histogram like the one shown in Figure 1.31. In this case, the tonal range is now spread over a much larger area, and there are many tones missing, causing gaps between bars in the histogram. When you stretch the grayscale in both directions like this, the darkest tones become darker (that may not be possible) and the lightest tones become lighter (ditto). In fact, shades that might have been gray before can change to black or white as they are moved toward either end of the scale.

Figure 1.30 Histogram of a lower contrast image.

Figure 1.31 Histogram of a higher contrast image.

The effect of increasing contrast may be to move some tones off either end of the scale altogether, while spreading the remaining grays over a smaller number of locations on the spectrum. That's exactly the case in the example shown above. The number of possible tones is smaller and the image appears harsher.

Unfortunately, short of using custom curves, there is little you can do in your camera to compensate for low contrast or high contrast in an image. Instead, your emphasis should be on reading the histogram so you can adjust exposure with an EV change. Learn to spot histograms that represent over and underexposure, and add or subtract exposure to compensate.

For example, Figure 1.32 shows the histogram for an image that is badly underexposed. You can guess from the shape of the histogram that many of the dark tones to the left of the graph have been clipped off. There's plenty of room on the right side for additional pixels to reside without having them become overexposed. Or, a histogram might look like Figure 1.33, which is overexposed. In either case, you can increase or decrease the exposure (either by changing the f/stop or shutter speed in manual mode or by adding or subtracting an EV value in autoexposure mode) to produce the corrected histogram shown in Figure 1.34.

Figure 1.32 Histogram of an underexposed image.

Figure 1.33 Histogram of an overexposed image.

Figure 1.34 Histogram of a properly exposed image.

Noise and ISO Settings

The final set of controls you have over image quality are the tools that control random visual noise in your image, often a symptom of using higher ISO settings or taking photos with longer exposures. Once you know how noise can affect your image, you can take steps to reduce it.

Although noise can be used as a special effect, much as photographic grain was, most of the time it's objectionable. It most commonly appears when you raise your camera's sensitivity setting above ISO 400. With most dSLRs, noise starts to appear at ISO 800, and is usually quite noticeable at ISO 1600 (although a few digital SLRs do a good job at this speed). This kind of noise appears as a result of the amplification needed to increase the sensitivity of the sensor. While higher

ISOs do pull details out of dark areas, they also amplify non-signal information randomly, creating noise.

A similar phenomenon occurs during long time exposures, which allow more photons to reach the sensor, increasing your ability to capture a picture under low light conditions. However, the longer exposures also increase the likelihood that some pixels will register random phantom photons, often because the longer an imager is "hot" the warmer it gets, and that heat can be mistaken for photons. Figure 1.35 shows the noise that can crop up in a 30 second exposure with no noise reduction used. Figure 1.36 shows a similar photo, with in-camera noise reduction turned on.

There's also a special kind of noise that CMOS sensors are susceptible to. With a CCD, the entire signal is conveyed off the chip and funneled through a single amplifier and analog to digital conversion circuit. Any noise introduced there is, at least, consistent. CMOS imagers, on the other hand, contain millions of individual amplifiers and A/D converters, all working in unison. Because all these circuits don't necessarily all process in precisely the same way all the time, they can introduce something called fixed-pattern noise into the image data.

When shooting at higher ISO settings, use your camera's built-in noise reduction feature to cut down on that noxious, multicolored hash that results from boosted ISOs. Noise reduction involves the camera taking a second, blank exposure, and comparing the random pixels in that image with the photograph you just took. Pixels that coincide in the two represent noise and can safely be suppressed. Most noise reduction systems effectively double the amount of time required to take a picture, and are applied only for longer exposures (typically those that are one second or more). The extra time comes from the follow up, dark frame that's exposed for the same length of time as your original shot. A warning will probably appear in your dSLR's viewfinder telling you the cause of the delay. This form of noise reduction, also called *dark frame subtraction*, can be turned on and off, so you can apply it only when you need to. You can also apply noise reduction to a lesser extent using Photoshop, and when converting RAW files to some other format, using your favorite RAW converter, or an industrial-strength product like Noise Ninja (**www.picturecode.com**) to wipe out noise after you've already taken the picture.

Next Up

Now that you've learned some key ways to raise the bar on image quality, we can move on and study the best ways to improve image content. The next chapter shows you how to use telephoto lenses like a professional.

Figure 1.35 A 30-second exposure without noise reduction.

Figure 1.36 A 30-second exposure with in-camera noise reduction activated.

2

Using Telephoto Lenses Like a Pro

One of the key strengths of the single lens reflex camera is the ability to swap lenses whenever you need characteristics that aren't available in the optics currently mounted on the camera, but which are offered by a replacement lens. If you need a lens that's faster, longer, wider, or focuses closer, you can probably find one. Non-SLR digital cameras face some significant limitations simply because their lenses are permanently mounted. What you get is what you see.

Of course, there are a growing number of "mega-zoom" non-SLR digital models with 10X or 12X zoom lenses, extending from around 28–36mm (at the widest end of the scale) to as much as 432mm (at the long end), using the ever-popular "35mm camera equivalent" figures (that is, what focal length would be required on a full-frame camera, film or digital, to produce the same field of view). Such an extensive range ought to be enough zoom for anyone, you say, until you start thinking about how you might actually use such a camera. There's more to a zoom lens than the minimum and maximum focal lengths, because performance at particular positions, maximum aperture, closest focusing position, and other factors can be just as important. If you plan to use your camera creatively, you don't want to get locked into any particular set of characteristics. That's why the lens flexibility of dSLRs is so cool.

It's true that the equivalent of 432mm will be long enough for all but the most extreme sports and wildlife photo situations. But those who enjoy shooting with wide-angle lenses note that 36mm really isn't very wide. For them, 12X zoom lenses with 28mm to 336mm or even 24mm to 288mm ranges would be more suitable, if just barely. You're probably sensing a trend here: Cameras with fixed

lenses end up offering a compromise of available focal lengths, probably with maximum apertures and minimum focusing distances that are compromises as well. No one lens, no matter how sophisticated, really suits all the possible needs of a serious photographer. That's why the ability to remove a lens that's unsuitable for the picture at hand and replace it with one that's better designed for a particular use provides the dSLR with such a powerful advantage.

Although wide-angle and telephoto adapters can be fastened to fixed lenses on non-SLRs to increase their range, and close-up gadgets can modify their minimum focus distance, nothing be done to increase the size of an aperture that's not large enough, nor to add special features like image stabilization to a lens that doesn't have it. The dSLR owner isn't locked into a single set of optics. You can put the right lens for the job to work at any time, assuming you have the funds to buy the lens you really need.

This chapter and the next look at the advantages of those specialized lenses we call wide angles and telephotos. You'll learn a bit about how they work with digital SLRs, and how to use their special attributes to improve your photography. I'm going to start first with telephoto lenses. If you have a particular fondness for the wide-angle perspective, you can temporarily skip this chapter and work your way through Chapter 3 first.

Lenses and Focal Lengths

As you may know, lenses are usually named for the actual focal lengths they provide, measured from the optical center of the lens to the plane of the sensor (or film, if you can remember back that far). A "normal" lens for a digital SLR will have a focal length of something between about 28mm to 50mm. What we call telephoto lenses are generally those with longer focal lengths than normal; wide angles are lenses with focal lengths that are shorter.

Why is there such a wide variation in the baseline "normal" designation? Isn't a normal lens just a normal lens? Actually, a given camera's normal lens is by convention described as a lens with a focal length roughly equal to the diagonal of the film or sensor. With a "full-frame" dSLR, such as the Canon EOS 5D, which uses a sensor sized at 24mm × 36mm, that diagonal is about 43mm. But, over the years, the slightly longer value of 50mm has been informally adopted as the normal focal length for full-frame cameras.

In a camera with a sensor measuring 14.8mm × 22.2mm, such as the Canon Digital Rebels, the diagonal measures about 27mm, with the odd effect that a normal lens for one Canon dSLR isn't the same as the normal lens for other digital SLRs sold by the same vendor. Canon has three different sensor sizes and three different normal lens specifications within its digital camera line.

Actually, the situation is even more of a mess, because digital SLR cameras can have sensors ranging from 13.5mm × 18mm (Olympus), to 15.5 × 23.7 (Nikon), to 19 × 28.7 (Canon again) *in addition to* the "standard" 24mm × 36mm full-frame sensor size.

Of course, dSLR camera vendors don't build lenses with focal lengths proportional to the sensor size; they tend to design lenses with the familiar focal lengths we were already comfortable with prior to the digital age. You'll find lots of 24mm, 28mm, 35mm, 50mm, 85mm, 200mm, 400mm (and so forth) prime lenses, as well as zoom lenses that often encompass these time-honored focal lengths. (There are exceptions, of course; Sigma, for example, offers a 30mm f/1.4 lens specifically as a "normal" lens for digital cameras.)

The vendors' strategy is probably correct: There is no universal common sensor size, so producing lenses in multiples of a particular sensor's "normal" focal length would be just as confusing as the present state of affairs, which is to provide a *lens multiplier factor*. The term itself is a misnomer, as nothing physical is being multiplied; indeed, your field of view is being *reduced*. This "multiplier" allows you to calculate the effective focal length of a particular lens with a particular sensor size, compared with the same lens used on a full-frame camera. So, if you happen to own a 100mm lens and use it with Canon cameras offering 1.6X, 1.3X, or 1X multipliers, respectively, your lens when used with the varied sensors of that camera array will offer the same field of view as a 160mm, 130mm, and 100mm lens on a full-frame SLR. Figure 2.1 shows a hot air balloon ascension as if photographed (at top) with a 50mm normal lens on a full-frame digital SLR. At bottom, you can see the field of view provided by the smaller Four Thirds sensor of an Olympus dSLR with the same focal length lens, corresponding to a 100mm telephoto.

LENS DIVISOR FACTOR?

The unfortunate "multiplier factor" term arose because we innumerate photo-types (as well as almost everyone else) find multiplication a lot easier to do mentally than division. A "divisor factor" would, in one sense, more accurately reflect what's going on (your field of view is being cropped by a given amount), but would you prefer to calculate the result by dividing, say, 100mm by 0.67X instead of just multiplying the number by 1.5X? The most common divisors would be 0.5X, 0.625X, 0.667X, and 0.77X (instead of 2X, 1.6X, 1.5X, and 1.3X), so you can quickly see the wisdom of using the more intuitive multiplication paradigm, but calling it a crop factor, instead.

Figure 2.1 A 50mm lens produces two very different fields of view when mounted on a full-frame dSLR (top) and one with a smaller Four Thirds sensor.

The multiplier is more properly called a *crop factor*, because what is actually happening is that the sensor is capturing only a portion of the image that would be grabbed with a full-frame camera, and cropping out the rest. For the rest of this book I'll use the term crop factor exclusively.

Figure 2.2 shows the relative fields of view of the most common crop factors used in digital SLRs today, a 1X factor (full-frame), 1.3X, 1.5X, and 2X (which is pro-

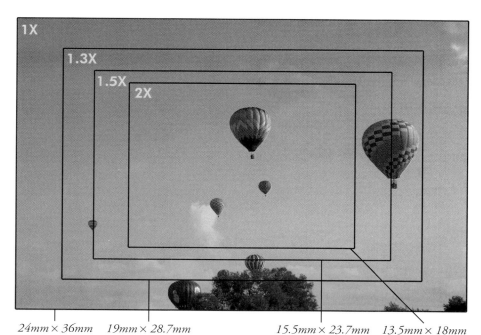

24mm × 36mm 19mm × 28.7mm 15.5mm × 23.7mm 13.5mm × 18mm

Figure 2.2 This shot shows the field of view of a 50mm lens using common crop factors, ranging from 2X (center), to (outwards from the center) 1.5X, 1.3X, and 1X (full-frame).

vided both by Olympus Four Thirds cameras and Nikon cameras using High Speed Crop mode). I haven't shown a 1.6X crop factor because it's virtually identical to the 1.5X factor illustrated.

As we continue with this book, what I will *not* do is refer to the crop factor at every possible opportunity to remind you of this particular fact of life. When it's important, I'll mention that, say, a 200mm lens actually has the same field of view as a 300mm lens when used with a camera with a 1.5X crop factor. But the rest of the time I will refer only to the actual physical focal lengths of lenses, and leave it to you to translate that focal length mentally to whatever is appropriate for your dSLR and your particular crop factor. Keep that in mind, and appreciate the reduced amount of verbiage.

Telephotos and Long Lenses

You'll understand how to use teles more effectively if you know what they are and how they work. For starters, not every lens that magnifies an image and brings it closer can be called a telephoto lens. The term *telephoto* actually applies to a particular type of lens design. For convenience, all long lenses are usually called telephotos, but that's not necessarily accurate.

As I mentioned earlier, the focal length of a particular lens is measured from the optical center of the lens to the sensor/film plane. In a simple long lens (and such lenses can be very simple indeed, with only a few separate optical elements), the

glass may be located at the very front of the lens. I own an old 400mm f/6.3 lens with optics that consist entirely of two elements (called a *doublet*) up front, and a long, empty tube behind. The lens itself measures 355mm in length, which, when added to the roughly 45mm distance from the lens mount to the sensor plane, provides a focal length of 400mm. Strictly speaking, this lens is a *long focus* lens, and not a telephoto at all.

All lenses are designed using elements of various shapes. I'm not going to hit you with a lot of super-technical optical science, but you might find it easier to visualize how lenses work if you know the basic terminology. Figure 2.3 shows the basic shapes used to create lens designs. The examples shown are all *spherical* elements, that is, at least one surface is a section of a sphere. Lenses can also take these basic shapes using nonspherical or *aspherical* elements, which can be custom shaped to provide the optimum amount and type of light bending (or *refraction)* needed for a particular optic.

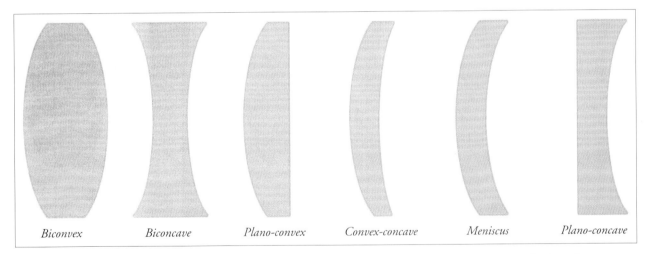

| Biconvex | Biconcave | Plano-convex | Convex-concave | Meniscus | Plano-concave |

Figure 2.3 The basic lens element shapes. The oddball meniscus shape is one that has the same curve on both surfaces.

The concepts behind the true telephoto lens were initially discovered by a British mathematician named Peter Barlow in the early part of the 19th century—well before the invention of photography itself. Barlow found that placing a negative (concave) rear lens behind the main (convex) element in a telescope caused the device to focus at a greater distance than its unmodified focal length would indicate. In a camera, this has the effect of producing, say, a lens with a 400mm focal length that need be only 200mm in length. Photo lenses using a telephoto design can be shorter and more compact. Optical devices called Barlow lenses are used to this day with telescopes to multiply their effective focal length.

There's no quality advantage to using a lens with a telephoto design rather than a simpler long focus optical layout. The only real benefit is the reduction in physical length. Trust me: You wouldn't want to lug around a 400mm, 500mm, or 600mm lens that *wasn't* a telephoto, and such extreme focal lengths aren't all that rare among digital photographers who shoot sports, wildlife, or their unsuspecting neighbors. The chief disadvantage is that telephoto lenses are slightly more complex to design and more expensive to build. My bargain basement 400mm long-focus lens was about one-quarter the price of equivalent telephoto lenses sold at that time.

To better understand telephoto lens design (especially because I'll explain in Chapter 3 how the concept must be turned on its head to produce wide-angle lenses), check out Figure 2.4. It shows an excessively simplified lens with one positive (biconvex) element. This is known as a *symmetrical* lens design because both halves of the lens system are mirror images. The optical center of this lens is in the center of the single element, and the distance from the center to the sensor is the same as the focal length of the lens. Assuming it's a 400mm lens, that distance would be 400mm, or almost 16 inches.

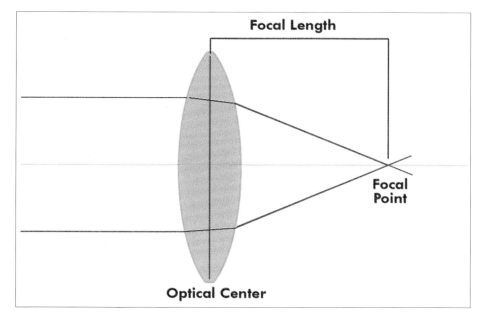

Figure 2.4 In a simple lens, the optical center is in the center of the element or group.

You won't really see any lenses with only a single element. The chief problem with this basic long-focus lens design is that there is a tendency for the different wavelengths of light to focus at different positions, rather than converge at a single point at the focal plane. This property is known as dispersion, and varies depending on the composition of the glass. Indeed, most vendors advertise the fact that

particular lenses feature *low dispersion* (LD) or *extra-low dispersion* (ED) glass. Excessive dispersion creates a phenomenon known as *chromatic aberration.* There are several types of chromatic aberration. Figure 2.5 shows the cause of *longitudinal (axial) chromatic aberration,* which we see as a blurring of colors. The other sort, called *lateral (transverse) chromatic aberration,* can cause fringes of color that are especially visible around backlit subject matter. Depending on how much differently each of the primary colors of light are refracted, chromatic aberration may show as color haloes, cyan fringing (when both the long focal length red and short focal length blue rays are misaligned), purple fringing, or some other defect. You can see some aberrant chroma in the form of purple fringing in Figure 2.6. I'll show you an even better example later in this chapter.

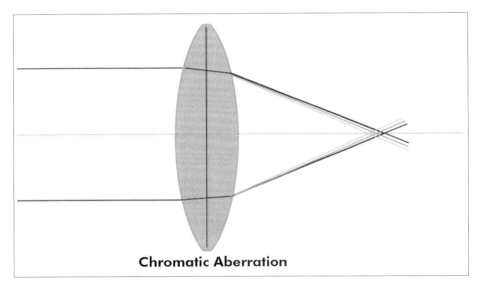

Chromatic Aberration

Figure 2.5 When each color of light has a different focal point, longitudinal chromatic aberration results.

To counter chromatic aberration of either type, even the most simple lenses will add lens elements with different dispersion characteristics to cancel out the misdirection of the different colors. Figure 2.7 shows a doublet in which the second element is concave on one side (so it fits snugly against the convex surface of the first lens), and flat on the other side, designed to reduce longitudinal chromatic aberration. If this second element (bonded to the first element to form a single lens) is made of a different material that disperses the light in a different way, its own longitudinal chromatic aberration can cancel out the effects of the first lens. For example, a strong positive lens made of low dispersion crown glass (made of a soda-lime-silica composite) may be mated with a weaker negative lens made of high dispersion flint glass, which contains lead.

Thus far, the lens we've "designed" has no telephoto properties; the distance from the optical center to the sensor is the same as the focal length. What if we don't

Figure 2.6 Lateral chromatic aberration produces fringes of color around backlit subjects.

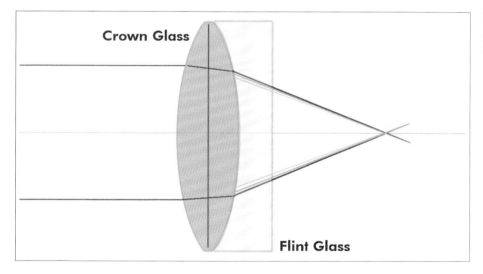

Figure 2.7 A second lens can correct for some kinds of chromatic aberration.

want a 400mm lens that's 16 inches long? One way to shorten the length of the lens is to use what is called a *catadioptric* system, or mirror lens, in which the optical path is folded, as shown in Figure 2.8. The light bounces off a mirror at the camera end of the lens onto another lens in the center of the front, and then out through the back to the film or sensor. Because of the arrangement of the mirrors, such lenses produce a distinctive "hole" in out-of-focus elements that looks like rings or donuts in the final image.

Figure 2.8 Catadioptric lenses fold the light path to provide a shorter lens.

There's a better way, through the use of an *asymmetrical* lens design. In this configuration, a negative (double concave) lens element is placed *behind* the convex positive element, spreading the incoming light farther apart again, causing the photons to converge a little farther from the optical center than they would otherwise, as you can see in Figure 2.9. The negative element has the effect of moving the optical center ahead of the front element of the lens, so that, even though the focal length from that center to the sensor/film plane is exactly the same, the distance from the front of the lens itself to the sensor can be less. The result: a "shorter" telephoto lens.

The most obvious result is the infamous *lens crop factor*. Because only part of the image is captured by the sensor, your cropped version appears to be 1.3, 1.5, 1.6,

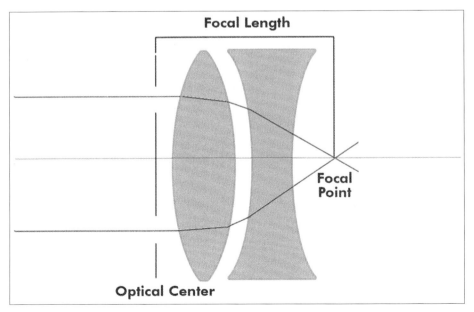

Figure 2.9 A telephoto lens uses a negative element to move the optical center out in front of the lens.

or even 2.0 times larger. (Nikon's D2x has a high-speed burst mode that crops the already cropped image even further to produce a 2X lens multiplier. With Olympus cameras based on the Four Thirds sensor, this 2X multiplier is the natural state of affairs.) While this crop factor can be, seemingly, a boon to those needing longer lenses, it's a hindrance in the wide-angle realm. A decently wide 28mm full-frame lens becomes the equivalent of a 45mm normal lens when mounted on a camera with a 1.6X crop factor.

There are other ramifications. Because a smaller portion of the lens coverage area is used, the smaller sensor effectively crops out the edges and corners of the image, where aberrations and other defects traditionally hide. If you use a full-frame lens on a dSLR with a smaller sensor, you may be using the best part of the lens. This is nothing new; users of pro film cameras have a much more intimate knowledge of coverage circles. They know that, say, a 200mm telephoto lens for a 2 1/4 × 2 1/4 SLR like a Hasselblad may cover a square no larger than 3 × 3 inches, whereas a 200mm lens for a view camera may have an image circle that's 11 to 20 inches in diameter.

Still, you'd probably be surprised to realize that an inexpensive 200mm lens developed for a 35mm film camera is a great deal sharper within its 24mm × 36mm image area than a mondo-expensive 200mm "normal" lens for a 4 × 5 view camera cropped to the same size. Because 4 × 5 film is rarely enlarged as much as a 35mm film image—or digital camera image—lenses produced for that format don't need to be as sharp, overall. Instead they need to be built to cover *larger areas with even illumination.*

Conversely, when creating a lens that's designed to cover *only* the smaller sensor, the vendor must make the lens sharper to concentrate its resolution on the area to be covered. Olympus claims that its Four Thirds lenses have double the resolution of similar lenses it builds for its 35mm cameras.

Of course, if the coverage area is made smaller, that can reintroduce distortion problems at the periphery of the coverage circle. This is particularly true of ultra-wide-angle lenses, which are difficult to produce in short focal lengths anyway, including the zooms in the 10 to 24mm range. In this chapter, we're going to concentrate on long lenses and telephotos. You'll find more information about wide-angle problems in Chapter 3.

Choosing a Telephoto Lens

For the rest of this book I'm going to use the term telephoto to refer to both long focus and telephoto lenses, as well as to the telephoto positions found in what we've come to call tele-zoom lenses, in focal lengths longer than about 70mm. I'm going to ignore the crop factor for the most part, too, except where it's especially important. So, when I discuss, say, a 70mm lens, you can think "short telephoto"

whether you're using a prime lens or zoom, and whether your camera has a 1.5X, 2X, or no crop factor at all. A "long telephoto" will be any prime or zoom lens more than about 200mm, regardless of crop factor. You can mentally translate the focal lengths into those that apply to your particular dSLR. Trust me; these generalizations will simplify our discussions.

Most of us can't afford to buy all the lenses we'd like to own. And, among those who can, few are foolish enough to purchase lenses with overlapping characteristics, unless there is a special need to do so. You may love your 70mm–300mm zoom, and find the new 18mm–200mm or 28mm–300mm alternatives intriguing, but it's unlikely you'd need two in this range. However, you could easily make a case for a 24mm–120mm lens with shake-canceling image stabilization built in, or a 300mm f/2.8 lens with enough speed for nighttime football games.

The next sections will help you choose the tele lenses that will work best for you, based on the most important attributes you should use as criteria.

Image Quality

I explained sharpness, acuity, and other factors related to image quality in Chapter 1. It's arguable that image quality should be the overriding concern for anyone choosing a telephoto lens. You might be willing to give up a little sharpness for a lens with a faster maximum aperture, because without that speed you might not be able to get any shot at all. An imperfect picture is still better than nothing. Or, you might opt for a long lens with image stabilization over one that's a little sharper in the same range, because that extra sharpness is likely to be lost to camera shake at slow shutter speeds.

But, most of the time, you'll want the sharpest lens you can get. In Chapter 1, I emphasized the raw resolution and acutance properties of a lens, but mentioned some of the other things that can affect image quality, such as diffraction. There are a few more things to consider. Chromatic aberration (commonly called CA), introduced earlier in this chapter, is among the most important for telephoto lens users.

As I noted, there are two types of chromatic aberration: longitudinal or axial (because the distortion occurs along the axis of the center of the lens) and lateral. With longitudinal aberrations, the colors of light are focused at different points, so the out-of-focus hues form a color-tinged blur that's visible in the photos. You can reduce this effect somewhat in an insufficiently corrected lens simply by stopping the lens down. The increased depth-of-field at the smaller f/stop reduces the color blurring by effectively bringing the misfocused colors back into relative focus.

In lateral (or transverse) chromatic aberration, the distortion causes a change in the relative size or magnification of the images produced by each color. The different wavelengths of light are shifted to the side across the image plane, especially

at peripheral areas of the lens (the edges), producing color fringing. Reducing the lens aperture has no effect on this kind of CA. Figure 2.10 shows a classic example of lateral chromatic aberration, with magenta fringes located at the left side of subject details, and cyan fringes on the right. This degree of CA is even more objectionable than the mild purple fringing shown earlier in Figure 2.6.

Figure 2.10 Both magenta and cyan fringing afflict this telephoto image.

These aberrations are especially noticeable with long telephoto lenses. You can reduce color fringing after the photo is taken using the tools built into Photoshop or the software furnished with your digital SLR. Be sure to make these changes *before* you apply any sharpening in post-processing. Otherwise, you'll just end up with sharper bands of color. But, your best bet is to avoid buying lenses that do a poor job of correcting for this defect.

CA is the most pernicious optical problem found in telephoto lenses. There are others, including spherical aberration, astigmatism, coma, curvature of field, and similarly scary-sounding phenomena. I'm not going to explain these in any detail, because most of them are difficult for the average photographer to measure with any accuracy, not always easily correctable (although some can be partially fixed simply by using a smaller f/stop), and best left to the experts. Read your favorite technical reviews online or in print magazines, find lenses with the least amount of these aberrations, and include that information on your checklist.

Lens Aperture Range

If image quality is a "must have" feature, a lens with a versatile aperture range falls into the "nice to have" category. I use the term aperture range rather than, say, "maximum f/stop" because there's a lot more involved here than just how wide a lens can open. Whether that maximum aperture is constant (or varies with a zoom's focal length), and, under some circumstances, the size of the *minimum* aperture can also be important.

Maximum Aperture

Let's start with speed. The maximum aperture of a telephoto lens is especially important when you're shooting hand-held, because it can determine the top shutter speed you can use at a particular ISO rating, and, as you know, fast shutter speeds are needed to counter blur that is magnified by the narrow field of view of the tele lens.

Suppose you're using a 300mm lens with the camera set to ISO 800 under lighting conditions that call for an exposure of 1/500th second at f/2.8. With careful focus and a steady hand, you can probably get good images at those settings, if your subjects don't require extensive depth-of-field (say, a quarterback dropping back for a pass at midfield or a pitcher winding up to throw). Figure 2.11 shows such a picture, taken wide open at ISO 800 with a long lens.

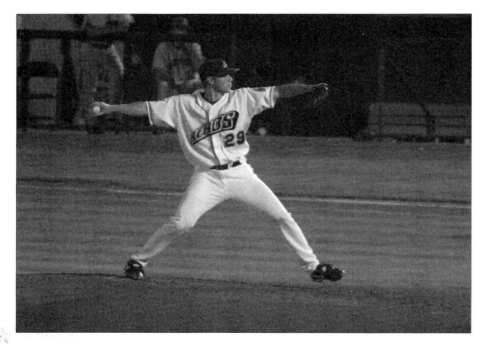

Figure 2.11 Even under ballpark lights at night, it's possible to get decent pictures with a fast telephoto lens at f/2.8.

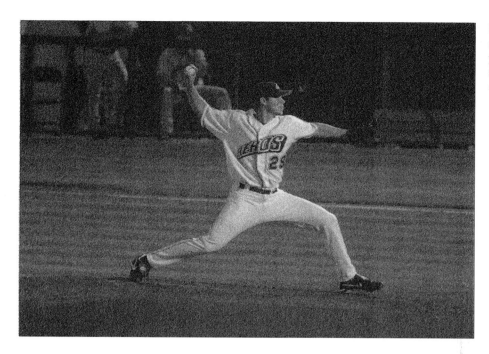

Figure 2.12 Bumping up the sensitivity to ISO 1600 allows you to shoot at 1/320th second at f/4.5, but with much more noise in the picture.

Unfortunately, you're using a lens with an f/4.5 maximum aperture. You have a few options. You can bump up the ISO sensitivity to ISO 1600, but that still leaves you a half/stop underexposed and an image that will have a little more noise (with some dSLRs) or a *lot* more noise (with many others), as you can see in Figure 2.12. So, you reduce the shutter speed to 1/320th second to provide the correct exposure, at the same time exposing your picture to the possibility of blur from camera/photographer shake.

Alternatively, you can keep the ISO set at 800 and reduce the shutter speed to, perhaps 1/180th second, which will just about guarantee blur from both camera shake and subject motion. Not a pretty picture, as you can see in Figure 2.13. Richard the Third was willing to trade his kingdom for a horse; in conditions like this, you'd be tempted to give and arm or a leg for an extra 1.5 f/stops of lens speed.

Unfortunately, fast lenses, particularly those of the telephoto variety, can be expensive. Canon's 300mm f/2.8 sports lens costs $4,000; Nikon's lists for $4,500 (both have image stabilization), while the bargain basement Sigma 300mm f/2.8 will set you back $2,600. Unless you need such a lens frequently, or have more money than you know what to do with, the fastest super-telephotos may be beyond your reach. Fortunately, there are quite a few telephoto prime lenses and zooms with relatively fast apertures in the 100mm to 200mm focal length range for under $1,000.

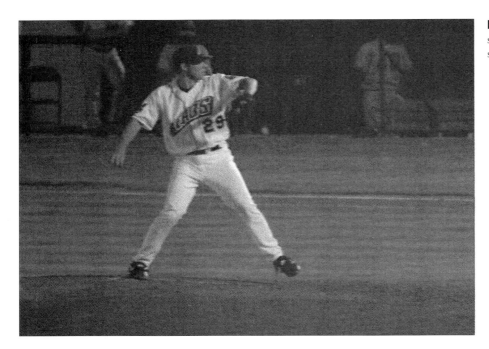

Figure 2.13 A slow shutter speed isn't really practical for some sports shots in low light.

Constant Aperture

When you're using zoom lenses, that coveted maximum aperture may change as the lens's focal length is adjusted, and not in a good way. There are many reasons why this happens. At longer focal lengths, the design of the lens may be such that the wide-open aperture causes vignetting, or, perhaps, optical aberrations are egregious. Designing the lens so the aperture is stopped down a little at the long end of the zoom scale can solve both problems. Rack your 170mm–500mm f/5.0–f/6.3 lens out to its maximum zoom setting and you'll discover that the difference between f/5 and f/6.3 is more than just a stop or so less light for exposure. The smaller effective f/stop makes for a dimmer image that's harder to focus. Indeed, some dSLR autofocus systems won't work at all at f/stops smaller than f/5.6.

There are some zoom lenses, usually of the more expensive variety, that are carefully designed so that the effective aperture size doesn't need to change as the lens is zoomed. These are sometimes called "fixed aperture" lenses, which, of course is nonsense. The correct term is *constant aperture*, meaning that at any particular zoom setting, the f/stop remains at the same, constant value. A 70mm–200mm f/2.8 zoom has a maximum aperture of f/2.8 whether you're shooting at 70mm or 200mm. A 70mm–200mm f/4.5–f/5.6 zoom loses a total of one-half f/stop as you zoom out, which is really not too bad, unless you need to shoot wide open all the time.

Minimum Aperture

The minimum, or smallest aperture a telephoto lens offers tends to be of less importance for most applications. Telephoto lenses are probably used at their wide-open to middle apertures most of the time; the maximum stops provide needed speed, while the smaller f/stops offer the required depth-of-field.

The very smallest f/stops, of course, provide even more depth-of-field, but may lose a little sharpness to diffraction (see Chapter 1 for more on that). Most teles offer minimum stops of f/22; some go down to f/32 or f/45. You'd need those extra-small stops under two conditions:

◆ You really do require deep focus with the maximum amount of depth-of-field. Perhaps you're photographing a family of deer with a very long lens and want to have as many of the animals in focus as possible (this ignores the possibility that having one of the creatures in focus and the others blurry might very well be the better image artistically). With your camera/lens mounted on a tripod, you can shoot at f/32 at 1/200th second in bright daylight with the ISO set to 800. That could very well produce a technically good image, and certainly one with appreciably more depth-of-field than one shot at f/16.

◆ You're hoping to use slower shutter speeds for an artistic effect, say to allow moving deer or water to blur. That same f/32 aperture will let you shoot at 1/25th second at ISO 100 in bright sunlight, or even longer if the day is overcast, or you're in the woods cloaked by a canopy of trees.

Zoom or Prime?

I covered this in Chapter 1, but it belongs on your telephoto shopping list. Zoom lenses are more versatile and convenient, prime lenses tend to be faster, sharper, and more compact. Enough said.

Autofocus Accuracy, Speed, and Distance

The qualities of the autofocus system in a telephoto lens are likely to be more crucial than in a wide angle because depth-of-field is more limited at ordinary shooting distances. With a wide-angle lens, you're likely to have a great deal of depth-of-field at just about any f/stop, unless you're shooting close-ups. So, any slowness or errors in the autofocus system are likely to be less evident. With a telephoto lens, correct focus is more critical, but more complicated from a technical standpoint. (You'll find more of a focus on autofocus in Chapter 1.)

With any lens, focus is achieved by moving parts of the lens closer or farther away from the focal plane until sharp focus is achieved. The required distance is related to the focal length of the lens. For example, when changing from focus at infinity to the distance required to produce a life size (1:1) enlargement of the image

(more on this in Chapter 5 when I explain macro photography), the distance is equal to the focal length. A 50mm lens must be moved out 50mm (about two inches), while a 100mm lens must be given a 100mm extension (about four inches).

In short, telephoto lenses require a greater degree of movement than shorter optics to focus. That's why teles often don't focus as close as shorter lenses (those that do are readily given the *macro* or *micro* honorific); when they do achieve focus, they may take longer to generate the required movement. One popular 80mm–200mm zoom lens for one of the leading dSLR product lines focuses no closer than 6 feet, which is barely acceptable for a 200mm lens and something of a handicap for a 70mm optic. My own Sigma 170mm–500mm lens can't get any closer than about 10 feet, which sometimes puts a crimp in my shooting.

If you plan to use a telephoto lens for subject matter that isn't positioned at least a dozen or so feet from the camera, check out that lens' close-focusing capabilities. A long lens can be useful for photographing skittish wildlife (frogs, small mammals, birds, and so forth) at relatively short distances—but not if your telephoto won't focus close enough.

Also examine your lens' autofocus accuracy and speed. How quickly does it achieve sharp focus? A lot may be determined by the physical design of the lens. In conventional lens design, a double helicoid focusing system (think of a cylinder with spiral grooves, like a DNA helix) moves all lens groups towards the front or rear of the lens as the lens is twisted during focus. These systems are bulky and complicated, especially in telephoto lenses.

Much better is an internal focusing system, which shifts only small internal lens groups as required to focus, producing no change in the physical length of the lens, resulting in a more compact, lightweight lens, as well as one that focuses closer, faster. For fastest autofocus, you want a lens that focuses as quickly as possible. The best places to glean information about how well and quickly a particular telephoto lens focus are the online news groups and forums frequented by fans of the dSLR camera system you use.

Build Quality

Such forums are also a good place to learn about the quality of construction of a particular lens, popularly known as *build quality*. Build is important for two reasons. First, a well-built lens will last longer and stand up to heavy use and mistreatment. Professional photographers aren't really callous about their gear, and try to treat it with respect and care. However, when working hard, getting the shot comes first. I've taken photos in the rain, tossed a lens in a shoulder bag without

front or rear lens caps, and performed other atrocities on my beloved lenses. Many of my older lenses show brassing on worn surfaces and lots of nicks and scratches everywhere except the lens elements, although these, too, are rarely pristine after years of use—I'm one of those who uses a filter only when I want to filter something. Because I didn't scrimp and purchased top-quality lenses, they all work today as well as when they were new, despite all the battle scars.

In addition, good build quality can mean better image quality from Day One. Photographers frequently exchange stories about such and such a lens being a "good copy" while another example of the exact same lens model being a "dog." When lenses are not constructed as well, it's easy for some samples from the same vendor to be better than others, even though both have "passed" the manufacturer's quality control screening.

The problem derives from relaxed "tolerances." No mechanical part can be built exactly to specifications. There's a precise or ideal spec, and then a little tolerance on either side of that mark that's still acceptable. The differences may be small, but they can add up. A particular lens is built from a large collection of these parts, some parts at one or the other edge of tolerances, and some smack in the middle. If you happen to get a lens that has a lot of parts that barely made the grade, you can end up with a "sloppy" lens that may not function smoothly and may even fall a little short in optical quality. Vendors who keep tolerances tight and produce lenses that are well-designed in the first place offer better build quality and superior lenses.

Check out quality of materials. See if the key lens components are made of metal or plastic. Believe it or not, some lower-cost lenses have mounts that are made of non-metallic components. They're less sturdy, and more likely to wear if you attach and detach them from your camera often. Also check for play in the focusing and zooming mechanisms. You don't want any looseness, stickiness, odd noises, or other qualities that signify cheap or poor construction. Your investment in lenses will probably exceed your cost for your digital camera body after a few months, so you want your lenses to hold up under the kind of use and abuse you'll subject them to.

I've almost always stuck with lenses built by the manufacturer of my camera, because quality control and build quality is likely to be better (although it's possible to purchase a "dog" from any vendor; if that happens, send it back and get another example). I've purchased third-party lenses only when I'm able to examine them closely before I buy, give the lens a real workout, and confirm to my satisfaction that I'm getting one of the good ones. Used lenses and third-party lenses are almost always best purchased locally, rather than from mail order or online sources.

Dealing with Bokeh

If you're new to the world of the SLR, the term *bokeh* may be unfamiliar to you. Bokeh isn't an attribute discernable only by the cognoscenti, in the way that audiophiles can tell aurally whether a sound system has tube or transistor amplifiers or uses those extra-special "thick" wires to connect up the speakers. Bokeh is very real, is most readily apparent in photos taken with telephoto lenses (because of the shallow depth-of-field these lenses provide), and should be a part of your lens buying decision.

Bokeh describes the aesthetic qualities of the out-of-focus parts of an image, with some lenses producing "good" bokeh and others offering "bad" bokeh. *Boke* is a Japanese word for "blur," and the h was added to keep English speakers from rhyming it with *broke*.

In Chapter 1, I described how out-of-focus points of light become disks, which are called *circles of confusion*. These fuzzy discs are produced when a point of light is outside the range of an image's depth-of-field. Most often, circles of confusion appear in close-up or telephoto images, particularly those with bright backgrounds. As you've learned, the circle of confusion is not a fixed size, nor is it necessarily always a perfect circle. The viewing distance and amount of enlargement of the image determine whether we see a particular spot on the image as a point or as a disc.

Bokeh enters the equation when a given lens doesn't produce circles of confusion that are evenly illuminated. A defect called spherical aberration may produce out-of-focus discs that are brighter on the edges and darker in the center, because the lens doesn't focus light passing through the edges of the lens exactly as it does light going through the center. (Aspheric, or nonspherical, lens elements can partially correct for this characteristic.)

So, some of these blurry disks are brighter on the edges and darker in the center. Others are brighter in the middle and darker at the edges. With no spherical aberration at all, the circles of confusion would all be discs of a uniform color. (Actually, the shape of the lens' diaphragm can determine whether the "disc" is round, nonagonal, or some other configuration, and that's another aspect of "good" or non-obtrusive bokeh.)

The interesting thing is that good bokeh and bad bokeh derive from the fact that some of these circles are more distracting than others. That uniformly illuminated disc created by a lens with no spherical aberration actually isn't the ideal from a bokeh standpoint. Such disks have more sharply defined edges and are actually more noticeable, and, thus, "bad."

Others, most notably *mirror* or *catadioptric* lenses, produce a disk that has a bright edge and a dark center, producing a "doughnut" effect, which is even worse from a bokeh standpoint, as you can see in Figure 2.14. Ironically, lenses that *do* have spherical aberration, but which have the sort that creates a blurry disc that has a bright center that fades to a darker edge, is favored most of all. Their bokeh allows the circle of confusion to blend more smoothly with the surroundings, because those darker edges "fade out" in the finished picture, with the blurry discs barely visible, as in Figure 2.15.

If you think you're beginning to understand bokeh, don't lose your focus yet. Bokeh can *change* within a given lens, depending on the location of the blurry subject matter. The trap we fall into is to think only of the out-of-focus *backgrounds* in our images, and ignore that fact that selective focus also can produce out-of-focus *foregrounds* if objects are located in the part of the image closest to the lens. (You'll see an

Figure 2.14 Discs with dark centers and light edges produce the worst bokeh.

Figure 2.15 Discs that are lighter in the center but fade out at the edges blend together and become virtually invisible.

example of this in Figure 2.21 later in this chapter.) The circles of confusion vary in quality based on the spherical aberrations that affect them, and an aberration that might concentrate brightness in the center of the disc for objects that are out of focus in the background may very well concentrate brightness more towards the edges for foreground objects. One lens might have good background bokeh, but poor foreground bokeh, or vice versa.

The bokeh characteristics of a lens are most important when you are using selective focus (say, when shooting a portrait) to deemphasize the background, or when shallow depth-of-field is a given because you're working with a macro lens, long telephoto, or with a wide-open aperture. Figure 2.16 shows what the three general varieties of bokeh look like when captured and isolated from their native habitats so you can see them more clearly. At left, spherical aberration has caused a disc that's dark in the center and light along its edges, the "worst" kind of bokeh. The center disc might be produced by a lens that has had its spherical aberration largely corrected, producing an evenly illuminated circle of confusion. At right you can see the "best" bokeh, created by spherical aberration that generates discs that fade out at the edges.

Figure 2.16 Bad bokeh (left), neutral bokeh (middle), and good bokeh (right).

Add-ons for Your Telephoto Lens

Once you've purchased your telephoto lens, you'll want to think about some appropriate accessories for it. There are some handy add-ons available that can be valuable. Here are a couple of them to think about.

Lens Hoods

I think that good lens hoods are an important accessory for all lenses, but they're especially valuable with telephotos, for several reasons. First, they do a good job of keeping bright light sources outside the field of view from striking the lens and, potentially, bouncing around inside that long tube to generate contrast-robbing flare. Telephoto lenses used to photograph subjects that are far away must already counter reductions in contrast caused by atmospheric haze. Add in a little lens flare, and you've got a low-contrast image that lacks detail in the shadows. Not a good scenario.

In addition, lens hoods serve as valuable protection for that large, vulnerable, front lens element. It's easy to forget that you've got that long tube sticking out in front of your camera, and accidentally whack the front of your lens into something. It's cheaper to replace a lens hood than it is to have a lens repaired, so you might find that a good hood is valuable protection for your prized optics.

When choosing a lens hood, it's important to have the right hood for the lens, usually the one offered for that lens by the vendor. After all, the goal is to shield the lens from extraneous light outside the field of view, so you want a hood that does exactly that, and neither blocks too much light nor too little. A hood with a front diameter that is too small can show up in your pictures as vignetting. A hood that has a front diameter that's too large isn't stopping all the light it should. Generic lens hoods may not do the job.

When your telephoto is a zoom lens, it's even more important to get the right hood, because you need one that does what it is supposed to at both the wide-angle and telephoto ends of the zoom range. Lens hoods may be cylindrical, rectangular (shaped like the image frame), or petal shaped (that is, cylindrical, but with cut out areas at the corners which correspond to the actual image area). Figure 2.17 shows two types of lens hoods. Lens hoods should be mounted in the correct orientation (a bayonet mount for the hood usually takes care of this), and should be sized so they don't cast a shadow into the subject area in flash pictures. (This is actually more of a problem with wide-angle lenses.)

Figure 2.17 Both cylindrical (left) and petal-type lens hoods (right) are used with telephoto lenses.

Extending Your Telephoto's Range

Avid photographers love to get something for nothing, which is one of the reasons for the popularity of the lens "multiplier" factor that's applied to cameras with sensors smaller than full-frame. Hey, who doesn't enjoy having a 200mm f/4 lens magically transformed into a 300mm f/4 optic at absolutely no cost or obligation to you, the lucky shooter?

Teleconverters are a variation on this theme, although in this case you *do* actually get something and the price is considerably more than nothing. What a teleconverter does is extend the reach of your telephoto lens for considerably less than the price of a much longer lens. These converters fit between the lens and your camera, and contain optical elements that magnify the image produced by the lens, effectively increasing the focal length, while retaining the closest focusing characteristics of the original lens. They're compact and easy to carry around, and can give you a longer lens in a pinch when you have no alternative. They are available with multiplier factors ranging from 1.4X to 1.7X up to 2.0X or even 3X, and, in this case, really perform some multiplication.

However, this particular brand of magic does come at a cost. The optical magnification can cost you some sharpness, particularly if you're using a low-cost third-party converter that lacks the sophistication of design found in the units offered by your camera's vendor. Let me put it this way: one leading camera manufacturer's 1.4X teleconverter costs $400. A third-party vendor offers a 1.5X converter for $89. Of course, the original equipment converter is a better fit with the seller's own autofocus and exposure features, but are you willing to take bets as to which one would have the better optical quality?

The second price you pay comes from the light lost when the converter moves the lens (and its aperture) farther away from the focal plane, and further reduction in illumination caused by the optical system. A 1.4X teleconverter costs you about 1 f/stop, transforming a 300mm f/4 lens into a 420mm f/5.6 optic. A 1.7X teleconverter robs you of 1.5 f/stops, while 2X and 3X converters reduce the available light by 2 and 3 f/stops, respectively. You'll find 3X teleconverters generally available only from third parties. There aren't too many of them, because the "cost" is so great. Is that 300mm really usable as a 900mm lens with a *maximum* aperture of f/11, and significantly reduced sharpness?

In fact, the light loss converters cause seriously restricts their usefulness. That lens with an f/4 maximum aperture (before converter) must actually be stopped down two stops from f/11 to the equivalent of f/22, or even three stops to f/32 to provide even barely acceptable depth-of-field. In *bright* sunlight that means an exposure of 1/400th second at f/32 and a noisy ISO 1600. Forget about hand-holding your camera with such a setup. Now you know why the 1.4X teleconverters are more popular than the 2X and 3X variety.

I use a 2X teleconverter from time to time, especially when I can mount my lens on a tripod to make rock-steady exposures with my "1000mm" (originally 500mm) lens, as you can see in Figure 2.18.

Figure 2.18 If you can mount your lens/camera on a tripod and use a small aperture to maximize sharpness, a 2X teleconverter and long lens can produce decent results.

Here are some other things to consider when thinking about purchasing a tele-converter:

♦ Some dSLR autofocus systems won't work with maximum apertures smaller than f/5.6. Your teleconverter offers autofocus capabilities only with relatively fast lenses. Otherwise, you'll have to resort to manual focus.

♦ Teleconverters may introduce or accentuate lens defects, including astigma-tism and chromatic aberration. You may double your focal length, but end up with an image that's not much better than one you could have gotten by just cropping in Photoshop.

♦ Some teleconverters work only with specific lenses, or work best with lenses they were designed for. If you're considering a teleconverter offered by your camera vendor, you can usually find a chart on the vendor's Web site listing which teleconverters are compatible with each of that manufacturer's lenses. The physical configuration of the teleconverter may be the limiting factor: Lenses with protruding rear lens elements might not be mountable on tele-converters that have optical elements that interfere. For example, it's well-known that Sigma teleconverters work best with Sigma lenses and may have problems with those from other manufacturers.

◆ Make sure your teleconverter supports all the functions of the lenses you'll be using it with. You want a converter that's compatible with the metering system and autofocus mechanism of your camera, of course, but you might also want to check to see if features like image stabilization or distance communication between lens and camera are maintained.

Using Telephoto Lenses Creatively

Telephoto lenses are a lot more than just a gadget you put on your camera to make things look bigger. As you've seen so far, long lenses have some special characteristics that differentiate them from normal and wide-angle lenses. You can apply these differences creatively to craft more interesting images. This section looks at some of the things you can do with your longer lenses.

Compressing Distances

Most action movies make use of the telephoto lens' tendency to compress the apparent distance between objects. The hero is shown facing down a speeding train heading directly towards the camera. It looks like he's going to be run down. We're terrified. He's terrified (or is pretending to be). In truth, that locomotive may be 100 feet away and only *seem* to be right on top of the actor because of the telephoto effect. Or, the heroine bravely runs into the street to dodge oncoming speeding cars that narrowly miss her, even though they never really come closer than five or ten feet from the actress. It's that telephoto effect again.

You can use this effect to make a row of fenceposts appear to be virtually on top of one another, or flatten the perspective of a city scene to produce a tighter, more crowded urban environment. Once you appreciate telephoto compression, you can put it to work.

Or, you can avoid it in other situations. That same compression operates in an undesired way on subjects like people. A telephoto that is too long for portraiture can flatten a person's features, making faces appear wider than they really are. This is the opposite of the wide-angle effect that narrows faces and enlarges noses while reducing the apparent size of features such as ears. Clearly, when shooting portraits, there is an ideal focal length, neither too wide, nor too short (I'll explain this in more detail in Chapter 4). Even so, it's important to remember that for people, the truly long focal lengths (in the 300mm range and up) are probably not going to provide the flattering rendition you really want.

Figure 2.19 A rag-tag line of Civil Warriors appear to be huddled together when a long lens compresses the distance between them.

When you want to use compression as a special effect, mount the longest lens you have and stand as far away from your subject as possible. A 400mm to 500mm lens will work best, although you can get good results from lenses as short as 200mm. For Figure 2.19, I was about 100 yards away from a row of Civil War reenactors, but my long lens compressed the line of men into a single group.

Compression can often be used for humorous effects. The camels shown in Figure 2.20 were actually about six feet apart. My long lens and a perspective from the side makes it appear as if they are having an intimate chat.

Figure 2.20 These camels weren't actually standing this close together—telephoto compression brought them together.

Producing Images of Isolation

Although selective focus can be used with any focal length, the reduced depth-of-field of telephoto lenses minimizes depth-of-field enough to let you use selective focus easily when you want to isolate your subjects from the foreground or background. Just choose a long enough lens, focus carefully, and use an appropriate aperture. You need not shoot wide open, because telephotos provide suitably limited depth-of-field even when closed down a few f/stops.

Selective focus can be applied in many different ways. You can focus on your main subject and allow the foreground and background to blur. You focus somewhere between the main subject and foreground, so that both will be reasonably sharp, while the background becomes even blurrier. I've even seen effective images where some object in the foreground was in sharp focus and the main subject was blurred, but recognizable, behind it. Figure 2.21 turns that concept on its head: The two crystal chess pieces in the back are sharply focused, but the king in front is not, rendering the main subject of the picture blurry.

A telephoto lens as short as 70mm can be used effectively for isolating a subject, particularly if you use a large aperture. Longer lenses, up to about 200mm, work even better. Super-telephotos also are suitable, but the increased working distances required may make them impractical, particularly if you are shooting a human subject and want to provide some helpful posing directions during the shoot. I

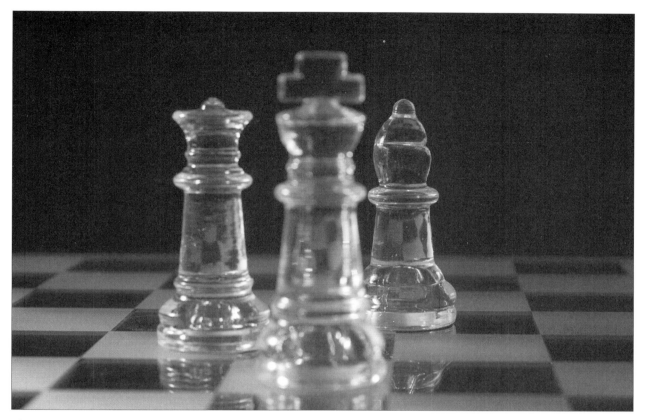

Figure 2.21 Yes, the main subject of a photo can be blurry while subordinate subjects are in sharp focus.

have, however, seen interesting photos of a model posing on the beach while the photographer shot from a great distance using a 500mm lens. They communicated with walkie-talkies!

Getting Close to Sports Action

A telephoto lens brings you from the sidelines into the middle of the huddle, from the stands into the action on the field, from just behind the dugout to the dust action of a runner sliding into second base. While some sports, like basketball, benefit from wide-angle lens coverage, most sports are best photographed with a telephoto lens that brings everything much closer.

Remember that the other attributes of a telephoto lens can be applied to sports photography, too. The offensive line in a football game is never more fearsome than when compressed into a single moving juggernaut at the moment of a snap. Selective focus can concentrate attention on a tennis player reaching back to serve an ace, or a soccer goalie blocking the ball in front of a net.

Many sports can be shot with 200mm to 300mm lenses. Even longer lenses usually require a monopod or a very high shutter speed to avoid blur from camera shake. For Figure 2.22, I was seated far away in the stands, but used a 500mm lens on a monopod to take a picture that looks as if I were less than a dozen feet from the player.

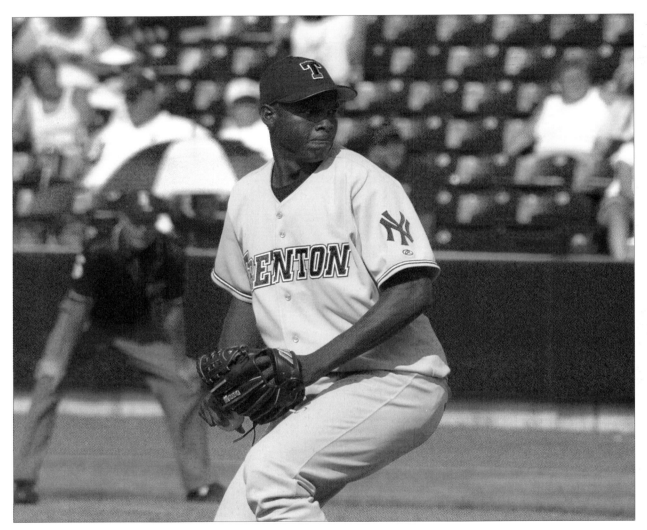

Figure 2.22 A telephoto lens can take you right up to the action.

Getting Close to Nature

Whether your photographic subject is a distant volcano that you'd rather not approach too closely, or a nervous doe who'd prefer you not get too close to her, a telephoto lens can take you up close, with no risk to you or your prey.

Telephoto lenses are sometimes used for landscape photography, especially when the vistas are especially distant. Selective focus generally isn't a tool you can use when photographing things that are, for practical purposes, located at infinity. However, the flattening effects of telephoto lenses can help you in several ways. You can compress a distant mountain range to make it seem as flat as a cardboard cutout on the horizon. The haze of the intervening atmosphere between you and your subject can add an interesting tone and texture to your photo. You can also capture details of distant objects that you might otherwise not be able to see. Figure 2.23 shows the summit of a craggy mountain peak that was impossible to approach on foot, so I grabbed this shot with a very long telephoto lens.

Telephotos are also perfect for shooting wildlife, and often the only practical way of grabbing a picture of creatures that aren't prone to waiting around while you set up and squeeze off a shot. A state park in my area has built a two-story "blind" with high walls and windows to view or shoot through. I go there frequently to take pictures of passing woodland animals. The lower level is covered and protected on three sides from the weather, while the upper level is open to the sky. A little patience and a long lens can yield wonderful results.

Figure 2.23 This mountain peak was captured from miles away with a very long telephoto lens. Or was it?

Trompe L'oeil

Telephoto lenses can be used to present a different perspective of familiar objects, providing an entirely unexpected view. I must now admit that I have lied to you, even though my intentions were good. While the image shown in Figure 2.23 was, in fact, taken with a telephoto lens, the optic in question was actually a 105mm macro lens, and the distance from the subject was more like 12 inches or so than several miles. The purpose of the deception was to show how easy it is to fool the eye, which expects to see one thing, and doesn't realize it is looking at something else entirely.

My subject matter for this practical joke? It wasn't a craggy mountain peak. Instead, the object pictured happens to be a weathered post on the deck outside my office, cracked from exposure and badly in need of painting. If you're looking for a challenging and rewarding photographic activity, you can't do better than the quest for subjects that look like one thing, and are actually something else.

Figure 2.24 provides another example of this kind of visual stunt. Now that I've tipped you off in advance about what I'm up to, you're probably already screaming "Fake!" and sneering with indignation. For this image does appear to portray, in dramatic fashion, a fighter pilot soaring through the sky at dusk. That was some powerful telephoto lens I must have used to capture this image, right?

Figure 2.24 Up, up, and away! Telephoto lenses let you capture dramatic moments like this one.

In truth, I used an ordinary 28mm–200mm telephoto zoom and was actually standing on the ground about 30 feet from the jet pictured, which is mounted on concrete pylons in front of a high school in my area (nickname: The Aviators). The plane was a donated memento of a war long past, and isn't especially dramatic in its current setting in a residential area, surrounded by power lines and homes. You can see another perspective in Figure 2.25.

Figure 2.25 You can better see the jet's actual mundane surroundings from this perspective.

I photographed the plane from the right side, then darkened the sky and added a ruddy sunset hue in Photoshop (it actually was late evening but a few hours before dusk when I took the picture). This is one of the few pictures in this book that has been extensively processed in Photoshop, because I like to emphasize what you can do with your camera rather than what you can do with your computer. Even so, I wanted to use this image to show the kinds of things you can do when telephoto lenses are used for visual fakery.

A third example is shown in Figure 2.26. This time there are no Photoshop shenanigans, other than some judicious cropping to make the composition tighter. This is simply a shot taken one-half mile in the air of an ultralight aircraft, using a telephoto lens as I soared past as a passenger in another ultralight flyer. I love the clouds and the feeling of complete freedom from being Earth-bound portrayed in this photo.

Well, that isn't 100 percent accurate. In truth, the ultralight aircraft shown was coming in for a landing, and I took this picture while crouching at the edge of the landing field with my camera pointed skyward. All I really did to arrive at the final photo was to crop out the ground at the bottom of the frame, making it appear that the photo was taken thousands of feet in the air. Sometimes, your photo fakes require nothing more than the ability to see a new picture within an existing one.

Figure 2.26 Sometimes a photographer must be willing to do daring things to capture a compelling image.

Taking the Stage

One avenue for exercising your telephoto creativity is the stage performance. Much of the fun involves the technical challenges of taking good pictures under high contrast lighting that changes constantly throughout the evening, from distances that are restricted by the security measures of the venue (and the quality of your seats, unless you're an "official" photographer), from angles that are often much lower than you'd like from a compositional standpoint. To make things more interesting, use of electronic flash at these performances may be annoying, prohibited, or, if not forbidden, fairly silly anyway. Who wants a flash photo when you've got subjects with overexposed highlights and inky black shadows there for your high-ISO shooting enjoyment?

Such situations are where my monopod and fast 85mm f/1.8 lens come in handy. Figure 2.27 was taken at a recent concert (cowboy music fans will recognize Riders

Figure 2.27 Unless you have a backstage pass or are part of the band, good concert photos call for a good telephoto lens.

in the Sky's Joey Misculin, the CowPolka King). As a world-famous photographer (I insisted, and they bought it), I merited a front row seat, even though I was relegated to the far end of the row so I wouldn't mingle with the VIPs seated directly in front of the performers.

Despite my decent, if not less-than-ideal vantage point, I was able to get some great pictures under these circumstances. I shot at ISO 800 at 1/125th and 1/250th second at f/1.8, with the camera steadied by the monopod well enough that most of the blurring was caused by the players' flying fingers.

Macro Photography

I'll get into close-up photography in more detail in Chapter 5, but when thinking about uses for telephoto lenses, you should definitely consider macro photography. As I mentioned earlier, many telephoto lenses don't really focus close enough for macro pictures. However, others do have an acceptably close minimum focus distance and work quite well for macro photography. You can also attach an automatic extension tube to the rear of many telephoto lenses and focus closer that way. Teles make good macro lenses of insects and small cold-blooded animals, because you can remain far enough away to avoid chasing the creature away while still getting an acceptably large image.

Next Up

If you thought learning how to get the most from your telephoto lens was fun, wait until you see what you can do with wide-angle optics. That's the topic of the next chapter.

3

Pro Wide-Angle Lens Tips

In some ways, wide-angle lenses are a lot more exciting to work with than tele-photo lenses, because the changes they make in your perspective are much more obvious, even to the untrained observer. The quirks and qualities of wide-angle lenses can be used creatively in many different ways, and the technical challenges of using them, while significant, are the sort that will exercise your mind rather than tax your patience.

This chapter explores all the different things you can do with wide angles, and shows why so many photographers tend to favor them, not simply because their more expansive field of view is necessary to cram a lot of different stuff into a tight frame, but because they provide a new and interesting way of looking at subjects.

Telephotos versus Wide Angles

To understand the power and popularity of wide-angle lenses, you just need to compare them, and their capabilities, to those of telephoto optics. As you learned in the last chapter, teles do a bit more than just bring subjects closer, but the abil-ity to reach out and pull in distant subjects is a valuable one. When you're 100 feet or 1,000 feet from a tempting subject and have no opportunity or time to get closer, a telephoto lens is a valuable tool. Long lenses are useful when you want to keep your distance because you don't want your victims to be aware that their pic-ture is being taken, or because your subject is skittish and easily scared off.

Of course, telephoto lenses tend to compress and shorten the relative distance between objects (such as the fenceposts or moving cars used as examples in the

last chapter). Long lenses can make some subjects, such as faces, appear to be wider than they might seem when photographed up close, generally because the 3D effect we use to judge depth is lost, so the faces look "flatter" than normal.

Finally, telephoto lenses tend to have less depth-of-field, which can be useful when you want to use selective focus to isolate or emphasize a particular subject, but that characteristic can also be a technical challenge when you really need to have more of your subject in sharp focus than is provided by your long lens' current focal length and f/stop.

The other major technical challenge of the telephoto lens is the need to use a high enough shutter speed to counter camera/photographer movement during exposure. Long lenses magnify small amounts of shakiness, and can even aggravate the problem, as these often bulky optics are sometimes more difficult to hold steadily.

In contrast, wide-angle lenses have a more dramatic impact on the perspective of your photographs. An image like the one shown in Figure 3.1 (nothing more than one of those endless queue railings in an amusement park) couldn't have been taken easily with anything other than the 12mm super-wide-angle lens used (equivalent to an 18mm lens on a full-frame camera). The photo actually looks a little like the view you get while viewing one mirror in the reflection of another. The vertical and horizontal lines, extending off into infinity (exaggerated by the wide-angle perspective) all work together to create a pattern that expresses the feelings of eternity we all experience while waiting for a 24-second thrill ride.

Figure 3.1 The extreme wide-angle view in this photograph emphasizes the foreground, while turning the background into an infinity view like that provided by dueling mirrors.

Wide-angle lenses have technical roadblocks of their own, but they tend to be related to the extreme broad perspective a wide lens provides, or with some optical aberrations that these complex lenses often display. Here are some of the key characteristics of wide angles:

◆ **Objects *not* closer than they appear.** Where telephoto lenses take you closer to your subjects, wide angles move you back, seemingly at a greater distance

from what you're shooting. Perhaps you're 15 feet from a storefront and want to photograph an interesting display window, but you can't back up further without stepping into a busy street. A wide-angle lens can give you a field of view that is similar to what you'd get if you were 25 or 30 feet away (with some caveats I'll note later). Or, maybe you're shooting indoors and find yourself backed up against a wall. A wide-angle lens can let you take in the whole room without going outside and shooting through an open window.

♦ **More subject matter in your photo.** While telephotos make it easier to zero in on a specific subject, and then isolate that subject with reduced depth-of-field, wide angles tend to be more inclusive, pulling in so much of the surrounding environment that it's easy to end up with an untidy photo. Creative composition can counter this clutter, as you strive to include all the components of your image in your photo creation. The expansive view of the wide angle can work for you, or against you.

♦ **Added emphasis to foreground.** Background objects are made to appear farther away, and additional foreground subjects are brought into view by wide-angle lenses, as you saw in Figure 3.1 earlier. That means you'll find a greater emphasis on the foreground in your wide-view pictures. Those mountains in the background will shrink, while that lake and its beach in the foreground will become the dominant elements of your photograph. You can use this extra emphasis on the foreground when you want to call attention to or highlight that part of your image.

♦ **Additional depth-of-field.** Wide-angle lenses provide more depth-of-field at a particular distance and f/stop. That's good news when you want to use deep focus to stretch the zone of sharpness over a broad area, but can be a challenge when you need to isolate one subject in your image.

♦ **Size distortion.** The wide angle's tendency to "enlarge" the foreground compared to a "reduced" background can work against you when shooting subjects that don't lend themselves to this kind of rendition. For example, if you're shooting a close-up of a human face, that nose in the foreground will look much larger, in comparison, to the tiny ears in what becomes the background, producing either a comical or unflattering effect. Of course, this "distortion," which, like perspective distortion isn't really a defect of the lens, can also be used creatively, as I'll show you later in this chapter. You can see this effect in Figure 3.2, although whether its use was creative in this case might be up for debate.

Figure 3.2 Both the vast depth-of-field provided by wide-angle lenses and size distortion can be seen in this shot of an old steam tractor.

- **Perspective distortion.** This comes into play whenever the camera is tilted so that the sensor plane is no longer perpendicular to the ground and, therefore, not parallel to the plane of ordinary subject matter. The result is a subject, such as a building or tall structure, that appears to be tilting or falling backwards. Strictly speaking, it's not a distortion (which implies a defect in the optical system) at all, but simply an accurate rendition that goes counter to what we expect to see. While perspective distortion isn't a property of wide-angle lenses *per se*, it's emphasized by the tendency of these lenses to enlarge the foreground, the part of the subject that's closer to the camera (usually the base), while diminishing the upper part that's farther away. You'll learn more about perspective distortion later in this chapter.

- **Camera shake demagnified.** Small amounts of camera movement seem less apparent when using wide-angle lenses, because a tiny amount of shakiness is demagnified, rather than enlarged. You'll probably find that you can hand-hold wide-angle lenses at much slower shutter speeds, compared to telephotos, within limits. For example, if you need to use 1/125th second with even relatively short telephoto lenses, you'll find that you can often get sharp results at 1/60th or 1/30th second with a wide angle. But don't press your luck—you'll discover that 1/4-second exposures are likely to be plagued by camera shake no matter how wide the lens you're working with.

As you work through this chapter, you'll learn more about how these factors and others can be used to make wide-angle lenses work for you. But first, I'm going to expand on the discussion begun in Chapter 2 on how lenses work.

How Wide Angles Work

In the last chapter, you learned a little about how lenses are used to focus light reflected or transmitted by your subject onto the sensor plane. Variously shaped lens elements perform this magic, with positive (convex) elements converging the light to a sharp point, and negative (concave) elements causing the photons to diverge. A simple, one-element lens, like the one shown in Figure 3.3, can be either a long focal-length lens or a wide angle, depending on whether its curvature brings the light to a point of focus a greater distance or shorter distance from the optical center.

As I noted in Chapter 2, a lens that has a long focus distance tends to create a physically long lens, one that can become unwieldy once its focal length exceeds, say, 100mm (about four inches). Using negative elements to move the optical center out in front of the lens, so that the size of the lens can be shorter than the effective focal length, produces more compact telephoto lenses. Figure 3.4, which

originally appeared in Chapter 2, is reproduced here so you can compare the tele-photo layout with the same concept turned upside down for wide-angle lenses in what is called an *inverted telephoto* or *retro-focus* design. If you can picture how telephoto lenses work, the same optical tricks applied to wide angles makes a lot more sense.

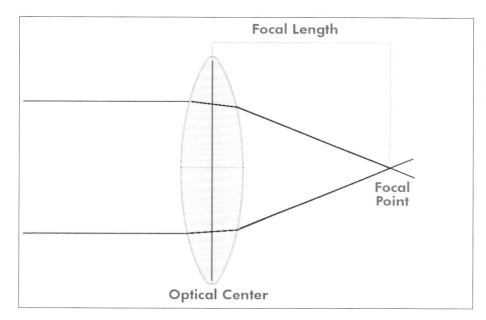

Figure 3.3 With a simple lens, the focal length is determined by the point at which the curvature of the optics brings the light to a point of sharp focus.

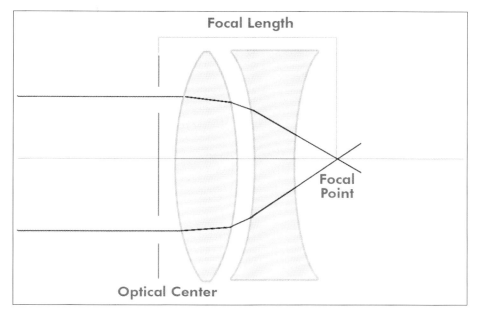

Figure 3.4 A telephoto lens uses a negative lens element to shorten the distance from the front of the lens to the focal point, while keeping the actual focal length the same.

With wide angles, we have the opposite problem from the one we encountered with telephoto lenses. Where teles focus light over a path that's too long, from a convenience standpoint, wide angles have a focal length that's too short. For example, with a 25mm wide-angle lens, the distance from the optical center of the lens to the focal plane is almost exactly one inch. That sounds cool on first consideration (hey, a one-inch long lens would be remarkably compact!) but isn't practical from a technical standpoint.

If you'll look at your dSLR with the lens removed, you'll see that the distance from the lens mount to the sensor (located behind the flip-up mirror) can be *less* than an inch. So, an ordinary 25mm lens would have to extend far back into the body cavity of the camera, leaving no room for the mirror. In most cases, that's not practical. There are non-SLR interchangeable lens cameras, the most common variety of which goes by the name *rangefinder* cameras, such as the venerable Leicas that don't use a mirror. Wide-angle lenses for these cameras can and do extend back into the camera body. In addition, in the past there have been specialized lenses (chiefly so-called "fish-eye" lenses) for SLR cameras that intruded into the mirror chamber and required locking up the mirror before they could be mounted. However, neither of these situations applies to modern SLR models.

Instead, other optical trickery must be used to enable single lens reflexes to gain wide-angle capabilities. As you've probably already guessed, the solution is to create an "inverted" telephoto lens in which one or more negative lens elements are placed *in front* of the positive element, spreading the beam of light so that when the positive lens element focuses it again on the sensor, the focal point is much farther back than it would be otherwise. The optical center has been moved *behind* the center of the lens, as you can see in Figure 3.5.

You can see that an inverted telephoto design helps digital camera lens designers produce wide angles that are physically "longer" than their focal lengths, just as the traditional telephoto configuration produced lenses that were physically "shorter" than their focal lengths. Indeed, the "shorter" a wide-angle lens for an SLR becomes, the longer and larger it often must be to accommodate all the extra lens elements required to work this magic. My 12mm–24mm wide-angle zoom lens (18mm–36mm equivalent) for my favorite digital SLR is almost a full inch longer and half an inch wider than my 28mm–200mm telephoto zoom (you do the crop-factor math). Of course, the tele zoom gains a couple inches in length when it is cranked out to its longest position, but you can see the disparity.

This size increase for wide-angle lenses is even more acute with optics designed for dSLRs with smaller than full-frame sensors, because additional optical legerdemain must be performed to create the very wide-angle lenses needed to achieve the same field of view. For example, while an 18mm focal length serves perfectly

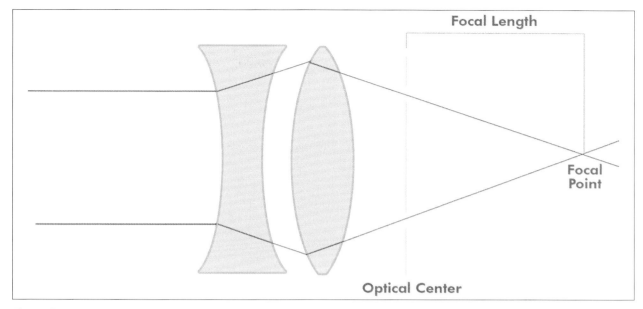

Figure 3.5 A retro-focus design solves the back focus distance problem by moving the optical center behind the lens, increasing the distance between the lens and the focal plane, even though the focal length remains the same.

well as a super-wide-angle lens for a full-frame, 24mm × 36mm sensor, a camera with a smaller sensor and a 1.5X crop factor requires a more complex lens with a 12mm actual focal length to achieve the same field of view.

Optical Problems

Unfortunately, these more complex lens layouts lead to undesired effects in both telephoto and wide-angle lenses. The most challenging problems appear in wide-angle lenses, which are usually more complicated to design. Long lenses, including the telephoto variety, are simpler to create and manufacture, even when the optics involve long zoom ranges and large maximum apertures. (Ignoring telephotos with optical vibration reduction systems, of course.) Wide-angle lenses for dSLRs, especially wide-angle zooms, tend to be more complicated, include more specialized elements, and yet still suffer from more optical problems than their telephoto stablemates. This next section will look at some of these hassles.

Chromatic Aberration Again

A primary symptom are the two varieties of *chromatic aberration*, mentioned in the last chapter, as the inability of a lens to focus all the colors of light at the same point, producing a color fringing effect. As you learned, this color effect is caused by the glass's tendency to refract different colors of light in different ways, much

like a prism. As I noted earlier, there are actually two types of chromatic aberration: *axial* (in which the colors don't focus in the same plane) and *transverse,* in which the colors are shifted to one side. The partial cure is the use of low diffraction index glass (given an ED code by Nikon, and UD by Canon), which minimizes the effect, or software fixes that can minimize some kinds of fringing.

Barrel Distortion

Other ailments include barrel distortion, which is a tendency for straight lines to bow outwards, and various spherical aberrations. Lens designers have countered with *aspherical* lens elements. As you might guess, aspherical optics are lenses with a surface that is not a cross-section of a sphere. These lenses are precisely ground (or, more recently, molded) to the required shape, and do a good job of correcting certain kinds of distortion.

Barrel distortion, which plagues some wide-angle lenses, tends to be more of a problem for photographers than pincushion distortion, which is found in telephoto lenses. The barrel variety seems to be more noticeable than pincushion distortion, and part of the reason for that may be because wide-angle lenses are often used for subjects, such as building exteriors or room interiors, which have lots of straight lines. Lines that run through the center of the image aren't affected by barrel distortion, nor are circular objects that are concentric with the center of the image (although the radius of the object may change slightly). Other lines are bent to a greater or lesser degree, depending on their proximity to the edge of the image. When those lines appear at the edges of a photograph, barrel distortion is especially apparent.

Figure 3.6 shows a rustic cabin, photographed from only a few feet away using an ultrawide-angle lens. You should be able to detect the barrel distortion in the roof and left edge of the photo, even without any other straight lines for comparison. However, when you compare this shot with Figure 3.7, taken from farther away, with a lens less susceptible to this kind of distortion, the amount of curving in the original image is easy to see. Later in this chapter I'll show you a couple tricks for minimizing or eliminating this defect.

Angle on Wide Angles

Another problem that can crop up with wide-angle lenses is caused by the acute angle at which the photons approach the dSLR's sensor. With film, the "sensors" consist of tiny light-sensitive grains embedded in several different layers. These grains respond about the same whether the light strikes them head on or from a slight or extreme angle. The angle makes a difference, but not enough to degrade the image.

Figure 3.6 Barrel distortion provides bowed lines at the edges of a photo.

Figure 3.7 Stepping farther back and using a lens that is not quite as wide can eliminate much of the distortion.

Sensors consist of little pixel-catching wells in a single layer. Light that approaches the wells from too steep an angle can strike the side of the well, missing the photosensitive portion, or stray over to adjacent photosites. This is potentially not good, and can produce light fall-off in areas of the image where the incoming angles are steepest, as well as moiré patterns with wide-angle lenses.

Fortunately, the camera vendors have taken steps to minimize these problems. The phenomenon is more acute with lenses with shorter back-focal distances, such as wide angles. Because the rear element of the lens is so close to the sensor, the light must necessarily converge as a much sharper angle. Lens designs that increase the back-focal distance (more on this later) alleviate the problem. With normal and telephoto lenses that have a much deeper back-focal distance anyway, the problem is further reduced.

Another solution is to add a microlens atop each photosite to straighten out the optical path, reducing these severe angles. Figure 3.8 shows how a microlens operates. Newer cameras employ such a system, so you can use lenses designed for either film or digital use without worry.

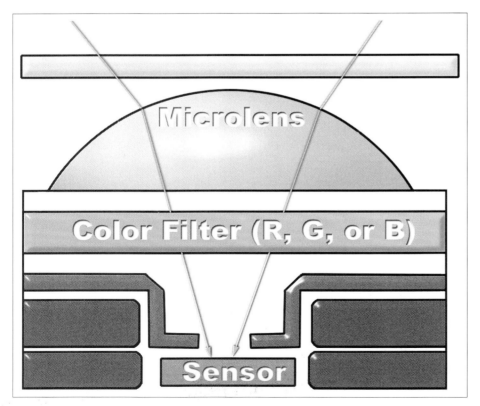

Figure 3.8 A pattern of microlenses above each photosite refocuses the light on the sensor.

Olympus is one vendor that was able to design its dSLRs from scratch because Olympus's dSLRs and their lenses were designed specifically for use with digital sensors that measure 22.5mm diagonally, using the Four Thirds design concept developed in conjunction with Fuji and Kodak. So, the camera was designed with a longer back-focal distance to mate with lenses that had a matching back-focal distance. Even the Olympus wide-angle optics focus the light at an angle that is more friendly to the digital sensor's needs.

Internal Reflections

If you've ever looked at film, you noticed that the emulsion side—the side that is exposed to light—has a relatively matte surface, due to the nature of the top antiabrasion coating and the underlying dyes. Take a glance at your sensor, and you'll see a much shinier surface. It's entirely possible for light to reflect off the sensor, strike the back of the lens, and end up bouncing back to the sensor to produce ghost images, flare, or other distortions. While lens coatings can control this bounce-back to a certain extent, lenses used on digital cameras are more prone to the effect than the same lenses used on film cameras.

Theoretically, lenses designed especially for dSLRs should reflect less light back to the sensor, but how well vendors have handled this potential problem isn't well known.

Rectilinear versus Intentional Distortion

As I noted, wide-angle lenses have a definite tendency towards the outward bowing of straight lines that we call barrel distortion. Most good optical designs correct for this curving, producing what is called a *rectilinear* lens (from the Latin for *straight line*). While some barrel distortion may remain, removing most of it results in a lens that images straight lines correctly over most of the picture area.

Sometimes this distortion is not corrected, or is even exaggerated to produce a lens that deliberately produces curving lines, producing what can be called a *curvilinear* lens (from the Latin for… well, you're probably way ahead of me at this point). This kind of "turning a bug into a feature" produces the so-called *fish-eye* and *semi-fish-eye* lenses, which are so-named because they resemble the bulging eyes of fish and not because, as far as we know, this curvy view is the way fish actually see.

A true fish-eye lens produces a round image (one that doesn't fill the frame) that encompasses a field of view of 180 degrees (or more) horizontally, as shown in Figure 3.9. They were originally designed to image an entire hemisphere, such as the canopy of the sky, and enabled astrophotographers to take one picture that showed the heavens from horizon to horizon, in a 360-degree circle. Fish-eye lenses have also been used to take photos inside very tight quarters, such as boilers, allow-

ing engineers to examine the interiors of components that can't easily be viewed using conventional optical systems. (Of course, today fiber optical gadgets have largely supplanted photographic systems using fish-eye lenses for engineering applications.)

Figure 3.11 shows what one of the earliest fish-eye lenses looked like. This particular model had such a short focal length that it extended far back into the mirror cavity, almost to the film plane, and mandated that the camera's mirror be locked up before the lens could be mounted. Viewing was done with an add-on optical viewfinder that clipped to the film rewind knob.

Semi-fish-eye lenses create distorted, rounded images, but do fill the frame, providing the same kind of intentional distortion but in a less dramatic, but often more practical way, because true fish-eyes can alter a subject so much that it's no longer recognizable. Both kinds of fish-eye lens are most often used today for creative purposes, because of the special perspective they offer. A semi-fish-eye shot is shown in Figure 3.10.

Technically, a fish-eye lens creates its look because the focal length of the lens varies radially outward from the center of the field of view. Objects in the exact center are rendered in somewhat normal fashion at the nominal focal length of the lens

Figure 3.9 A true fish-eye lens produces a circular image.

Figure 3.10 Semi-fish-eye lenses are popular because they produce a less extreme image with reduced distortion.

Figure 3.11 This early fish-eye lens could be used only with film cameras that allowed locking up the mirror.

(that is, 7.5mm, 10mm, 16mm, and so forth), while the focal length decreases as you move outward from the center until, in the case of true fish-eyes, the image detail at the edge becomes so tiny that it actually fades from view. Because of the way a fish-eye lens operates, straight lines that radiate from the center remain straight, while other lines curve outward.

Fish-eye lenses are available in several forms. You'll get the best optical quality from a fish-eye prime lens, but these can be expensive (up to $600 or more). A fish-eye effect can also be gained from special attachments that screw into the filter threads of a conventional lens to produce an extra-wide, fish-eye look. Although the sharpness of such a lens may not equal that of a prime fish-eye, if you just want to play around and don't plan on using a curvilinear lens enough to justify the cost of an expensive model, the attachment type can be a lot of fun. When considering any fish-eye lens, keep in mind your particular camera's crop factor. A full-frame fish-eye might be converted into a semi-fish-eye, and a semi-fish-eye lens transformed into nothing more than a wide-angle lens that curves a lot at the edges.

Some semi-fish-eye lenses can be used effectively as a super-wide-angle ersatz rectilinear lens if you have software that can correct for the curved distortion. Nikon Capture, sold for the Nikon dSLR line, has a "de-fishing" module that does a fairly good job of straightening the curved lines produced by the company's 10.5mm semi-fish-eye lens. Many Nikon fans use this combination to take pictures with a field of view that's even wider than is possible with conventional super-wide lenses for those cameras.

Testing for Distortion

You don't need to wonder whether your wide-angle lens suffers from barrel distortion—you can easily test it. Just photograph a grid pattern, make a print, and evaluate it with a ruler. Or, use the technique described here. Follow these steps:

1. Find yourself a grid pattern to photograph. If you like, you can use the pattern shown in Chapter 1, Figure 1.27, which we initially used to test for back focus. Or, you can use a piece of graph paper.

2. Fasten the pattern to a vertical surface, such as a wall. If necessary, use a level to make sure that the pattern is absolutely perpendicular to the ground.

3. Place your camera on a tripod facing the pattern. Adjust the distance so that the pattern fills up most of your image frame, as shown in Figure 3.12.

4. If necessary, use a level to make sure that the back of your camera, too, is absolutely perpendicular and the plane of the camera back is parallel to the plane of the target.

5. Photograph the target.

6. Load the resulting image into Photoshop or your favorite image editor.

7. Use your image editor's guideline feature to create a horizontal guide. Drag it to the center of the target image. Then, create a vertical guide and drag that to the center.

8. Confirm that the target's center lines are perpendicular to the sides of the frame. Rotate the image if necessary to bring it into alignment.

9. Remove these guidelines and create a new set at the edges of the target, as shown in Figure 3.13.

10. Compare the new guidelines with the target's lines at the edges to see if they bow outward.

Figure 3.12 Fill up your frame with the test pattern.

Figure 3.13 Place guidelines on your image and compare them to the target to see how much barrel distortion your lens has.

Choosing a Wide-Angle Lens

Chapter 2 had an extensive section on choosing the right telephoto lens. Many of the considerations discussed there apply equally to wide-angle lenses, so I'm not going to repeat all that information here. Instead, I'll recap some of the key points as they relate to wide angles, because there are a few differences between long and short lenses when you're shopping for the right optics. To review, the major considerations are:

◆ **Image Quality.** As with telephoto lenses, the quality of the images produced by a wide angle is likely to be your number one selection criterion. You'll want raw resolution, of course, but with a wide-angle lens, freedom from various optical distortions, especially barrel distortion, is particularly important. You'll want a lens that's relatively free from chromatic aberrations, too.

◆ **Aperture range.** The maximum aperture determines how readily you'll be able to shoot under low lighting conditions hand-held. Tripods are used less often with wide lenses than with telephotos because their shorter focal lengths don't magnify camera shake like the longer lenses. (Although a tripod is still a good idea for architectural/interior work to help you compose your image tightly.) So, with all that hand-held work ahead of you, you'll want a fast wide-angle lens. Maximum apertures of f/1.4 or a little slower are available for 28mm and slightly longer wide-angle prime lenses, and f/1.8 and f/2.0 lenses are also common in this range. If your camera's crop factor doesn't convert such an optic into a "normal" lens, you can work effectively in relatively dim light; the extra depth-of-field of the wide angle works for you when you're using those wide f/stops. The *smallest* f/stop available is less important with a wide-angle lens from a depth-of-field standpoint, but you still will need f/22 or smaller to cut down bright light and enable slower shutter speeds when you need to. Wide-angle zooms have the same aperture limitations as their longer cousins: don't be surprised to see f/4–f/5.6 maximum apertures on these complex lenses.

◆ **Constant aperture.** Expect to pay a premium for a wide-angle zoom that doesn't change its maximum aperture when it zooms. One vendor's 18mm–55mm budget wide-to-short-tele zoom (less than $300) varies from f/3.5 to f/5.6 over its zoom range. The same manufacturer also offers a 17mm–55mm f/2.8 lens for about $1,000 more. It happens to be sharper and better built, but part of that grand premium comes from the more sophisticated design that allows a constant aperture.

◆ **Zoom or prime.** As with lenses in the normal and telephoto range, wide-angle optics that can zoom through a range of focal lengths are heavier, slower, and sometimes not as sharp as fixed focal length prime lenses (unless they're very expensive). Yet, zooms can't be beat for convenience. Use a prime lens when

you need the sharpest image and largest maximum aperture. Primes can be extra compact, too, but, in the wide-angle arena, they're not likely to be especially inexpensive. Vendors realize that anyone purchasing a prime lens rather than a zoom is likely to place a premium on image quality and speed, so they lavish a great deal of attention on their wide-angle designs. And that means the lenses aren't cheap.

◆ **Autofocus features.** Because wide-angle lenses boast so much depth-of-field, you might think that autofocus accuracy and speed aren't as important. Not so. Correct focus is correct focus regardless of the focal length used, and you want your image accurately focused when you're using a wide-angle lens. If anything, autofocus is more critical, because the broad focus range provided by wide-angle lenses reduces the contrast factors in an image that an autofocus system uses to zero in on the right setting. (Wide angles can be more difficult to focus manually for the same reason; everything may *appear* to be in focus, even if focus is a little off.)

◆ **Construction quality.** There's really not a lot of difference in the importance of good build quality between telephoto and wide-angle lenses. Both types of optics work best when all the parts are built to fine tolerances and fit together well for smooth operation under moderate to heavy use. If you don't plan on using your wide angle much, you may be able to save money with an inexpensive brand.

When selecting a lens, remember that lenses don't become obsolete as quickly as camera bodies, so you shouldn't hesitate to spend a little more to get a quality product. Five years from now when you're spending $1,000 for a 16-megapixel dSLR, your current lenses may work just as well with the new camera body. I have a 30-year-old 16mm lens that I use with my current digital SLR. I have to focus it manually (not very difficult, considering all that depth-of-field at 16mm), but it couples to my dSLR's metering system if I use aperture priority or manual exposure. It was a high-quality lens 30 years ago, and produces excellent pictures today, too.

Add-ons for Your Telephoto Lens

Once you've purchased your wide-angle lenses, you'll be set to accessorize them with a few handy add-ons. Most of these are the same sort of things you might have considered for your telephoto lenses, plus some new options. Here are a few to consider.

Up Front

Some accessories attach to the front of your lens. Your wide-angle lens, whether prime or zoom, will almost certainly be furnished with a lens hood. Use it. It will cut down on flare, and also serves as protection for that big front surface. Wide

angles tend to have their front glass exposed, so a hood is an essential bit of armor to stave off glancing blows—or worse.

As with telephoto lenses, you'll want to have the *right* lens hood, one that cuts off the light just outside the limits of your prime or zoom's field of view, without vignetting. The kind of lens hood that bayonets onto the outside of the lens barrel, rather than attaching to the filter screw is best. Attach a filter or two to your lens, then screw a lens hood onto the filter stack, and you're just asking for vignetting. (More on this shortly.)

One thing to remember is that even properly designed lens hoods may be insufficient to shield the front of your lens from the glare of the sun. A wide angle's broad perspective is just too encompassing to avoid flare entirely. So, you might consider shooting from shady positions, or, at least, shielding your lens with a cupped hand when glare is especially bad.

Filters are a valuable accessory for wide-angle lenses, too, and they must be selected to avoid vignetting problems no matter how your lens hood attaches. Thick single filters, such as polarizers, may cause vignetting, and you'll almost certainly get shadows in the corners of your photos if you stack several filters together or use stepping rings to mount filters of a larger size on a lens that has a smaller filter thread, as shown in Figure 3.14. Extra thin filters, including polarizers, are available to minimize this problem. Before you pile on filters, think about your shot—is this filter really necessary? You might not need both a neutral density filter (to gain access to a longer shutter speed as a special effect) *and* a polarizer, because the polarizing filter cuts down light levels all by itself. You might not need a graduated filter or other special effects filter at all if you think you can add the effect in your image editor later on.

Figure 3.14 Step-up and step-down rings can let you use the same filter on lenses with different filter threads, but they can lead to vignetting when used with wide-angle lenses.

FILTERS BEHIND

Some of the wide-angle lenses I own use filters located *behind* the main optics of the lens, in a kind of wheel arrangement, so you can dial in the filter you want to apply. Such lenses were designed with these filters to avoid the problems of vignetting and the high cost of super-large attachments on the front. Unfortunately, these built-in filters don't include all the kinds you'll need, such as polarizers or graduated neutral density filters. Most commonly, they offer filtration of various colors.

Polarizer Problems with Wide Angles

Don't be chagrined if you've never heard of this problem: Polarizers can produce uneven results across the field of view when using lenses wider than about 28mm (equivalent, depending on your camera's crop factor, if any). It's caused by simple rules of physics. Any polarizer works best when the camera is pointed 90 degrees away from the light source (the light is to your immediate right or left), and provides the least effect when the camera is directed 180 degrees from the light source (that is, the light source is behind you).

Most wide angles and all normal and telephoto lenses have a field of view that is narrow enough that the difference in angle between the light source and your subject is roughly the same across the image field. The problem begins with very wide-angle lenses. Think about it: An 18mm lens (equivalent, again) has a field of view of about 90 degrees, so it's possible for subjects at one side of the frame to be oriented exactly perpendicular to the light source, while subject matter at the opposite side of the frame will actually face the light source (at a 0-degree angle). Everything in between will have an intermediate angle. In this extreme case, you'll get maximum polarization at one side of your image, and a greatly reduced polarization effect at the opposite edge.

Fortunately, this uneven polarization phenomenon isn't seen much. Polarizers are problematic with very wide-angle lenses. Most users avoid them with such lenses because of the vignetting they cause, and also because super-wide lenses usually call for super-large filters, which can be expensive. Many people don't know how to use a polarizer correctly, anyway, and end up pointing the camera in a direction that's greater than 90 degrees from the light source, which tends to minimize the polarization effect and, at the same time, the unevenness.

The only cures for uneven polarization are to not use a polarizer with ultra-wide lenses, make sure the camera is aimed at an angle greater than 90 degrees from the light source (but, then, what's the point of using a polarizer?), or attempt to fix the uneven lighting in an image editor such as Photoshop.

Behind the Scenes

Other accessories can be added to the rear of your lens. Most often, these are extension tubes or bellows that let you use your wide angle as a close-up lens. Wide-angle prime lenses, in particular, can make spectacular close-up optics for macro work. I'll show you how to take macro photography to the next level in Chapter 5.

Working with Wide Angles

This next section will provide some practical advice for getting the most from your wide-angle lenses. I'll offer some tips for overcoming some of the technical challenges of working with wide lenses, and show you how to apply the special characteristics of these lenses creatively.

Minimizing Barrel Distortion

As you saw earlier in this chapter, barrel distortion is an effect that's sometimes barely noticeable, but rarely an asset to a photograph when it does crop up (unless you're looking for a fish-eye look), and seems to be an almost inevitable result when using extreme wide-angle lenses. So, if you don't particularly want to have this kind of warping in your photos, what can you do?

Here are a couple tricks that might come in handy. The first one is easy: Just hide the distortion in plain sight. Figure 3.15 shows a shot of a building, taken with a 12mm (18mm equivalent) wide-angle lens. It would have been plagued by barrel distortion, except that the photo was deliberately composed and cropped to minimize the slight warping that occurred. You can use any or all of the following techniques to achieve similar results:

◆ At the bottom of the frame is some leafy groundcover, which contains no straight lines, so any barrel distortion at this edge of the frame is effectively disguised. The plantings weren't quite as extensive as pictured because their coverage was exaggerated by the very wide angle of the lens. A few feet of plants now looks like a lush decorative bed.

◆ At the top of the frame I left lots of room for the sky and some trees that, again, have no straight lines to reveal any barrel distortion. When shooting wide-angle photos, you can rarely go wrong by avoiding straight lines at the edges of the photo.

◆ Left and right of the photo, I used trees, both as a frame for the building, and to further disguise any barrel distortion. If those columns in the edifice display any curvature, it's covered up by the trees.

◆ I cropped the photo to further trim the left and right sides of the composition. This wasn't originally shot as a vertically oriented picture. My digital SLR had enough resolution to allow shooting horizontally, then trimming off the edges that might have had some barrel distortion. The focus of the picture was to be on the building, not the foliage, and the somewhat vertical framing looked good.

The second way to counter barrel distortion is to remove it in your photo editor. I'm going to use Photoshop as an example, for reasons only known to the gazillion users who have made Photoshop the most popular image editor among advanced photo nuts like us. However, your own image editor probably has tools that can achieve much the same effect.

Figure 3.15 Barrel distortion? You can't object to it if it's cleverly hidden, as in this photo.

Figure 3.16 has the kind of barrel distortion you're likely to encounter in every-day shooting. There are also some perspective distortion problems, but I'll show you how to deal with them in the next section. For now, we've got a pretty good shot, except for the curving in the columns at left and right.

There was no way to "hide" the straight lines at the edges of the frame. In fact, when I took this picture, my shooting position was just about the only one that allowed taking in the whole courtyard using the wide-angle lens I had available. Stepping forward even a few feet would have made a much less interesting composition, and stepping backward would have positioned the columns obtrusively in the frame (see the Pro Secret, "Small Move, Big Change" that follows). What I saw was what I wanted to get, so I shot away.

Figure 3.16 There was no easy way to avoid barrel distortion in this shot, but it can be fixed easily.

Back at my digital darkroom, I used Photoshop CS 2.0's Lens Correction filter to modify the image. You'll find the tool in the Filter > Distort > Lens Correction menu. The window shown in Figure 3.17 pops up, with a variety of fixes for various lens ills, including chromatic aberration, vignetting, perspective difficulties, and, for this photo, barrel/pincushion distortion correction.

A handy grid appears overlaid on your image. All I did was adjust the Remove Distortion slider until the columns at left and right lined up with the grid and became straight lines again. Moving to the right adjusts for barrel distortion; sliding to the left corrects for pincushioning. When the image looked right, I clicked OK, and then cropped to exclude the area bent out of the image by the correction tool, and produced a rectangular image once more, as shown in Figure 3.18.

Figure 3.17 The Lens Correction plug-in has tools for correcting many kinds of lens defects, including barrel distortion.

Figure 3.18 The corrected photo still has some tilting lines (see the nearest column base) but, overall, looks much better.

Small Move, Big Change

An important thing to remember when using wide-angle lenses is that a small change in position can make a large modification in your composition. The subject matter in the foreground, in particular, is likely to change its appearance and change its relationship with the background, too. Moving even one foot higher, or stooping down to waist level can also drastically change your composition. That's not necessarily a bad thing—you can often get a much more interesting look by altering your perspective a bit—but it's something you need to be constantly aware of when you shoot with wide lenses.

Figures 3.19, 3.20, and 3.21 show how significant these changes can be. All were taken with a 12mm wide-angle lens (18mm equivalent) at the same f/stop and shutter speed. (I checked each file's EXIF data to be sure, because the images looked so very different, even to me.) Ignoring their artistic merits for the moment (although 3.19 is particularly wretched), you can see how the structure was originally framed by the trees, and how this framing changed as I took no more than a few steps forward. I ended up with three very different photos while moving just half a dozen feet.

Figure 3.19 Too much emphasis on an unsightly foreground (and sideground) in this original version.

Figure 3.20 A few steps forward created this view, with trees still framing the composition.

Figure 3.21 Another few steps, and now the grassy lawn becomes a more significant part of the composition.

Using Size Distortion

One characteristic of wide-angle lenses is the way they seemingly distort the relative size of objects. Subjects closer to the camera seem much larger than objects that are actually only a little farther away. Size distortion can be annoying when it's unintentional—say, when you use a wide lens to shoot a human face—but can create some interesting effects in other circumstances. If you have trouble picturing exactly what this effect will do to your photos, Figure 3.22 provides an effective illustration.

Figure 3.22 The top photo was taken with a 35mm (equivalent) lens, while the bottom version was shot with the equivalent of an 18mm lens.

Figure 3.23 An extreme wide-angle lens distorts the shape of this classic car in a creative way.

Both shots were taken from approximately the same angle, but the top photo was shot from several feet away with a 35mm (equivalent) lens, and the bottom version was exposed using an 18mm lens positioned a few inches from the closest ceramic miniature. If you compare the two, it's easy to see that the extra-wide-angle version exaggerates the size of the tiny pot that's nearest to the camera. You can use this effect to cause nearby objects to loom and dominate an image, while those farther away appear smaller and less important.

Sometimes the size distortion can be used just for fun, to create a wacky look, as in Figure 3.23. For this photo, I wanted an unconventional look for an unconventional classic automobile. The auto was parked among a group of other cars and the surroundings weren't particularly attractive. So I got as close as possible to the front fender and shot from this angle, using the distortion as a way of emphasizing the curving lines of this automobile.

One way *not* to use the distortion in relative sizes that wide-angle lenses provide is in portraits of humans. If you get too close with a lens that is too wide, your subject's nose will appear too large in relation to the rest of the face, and the ears will seem to be much too small, as you can see in Figure 3.24.

Figure 3.24 Wide-angle lenses don't lend themselves to head-and-shoulders photos of humans (or animals) unless you're looking for a comical effect.

Emphasizing the Foreground

A wide-angle phenomenon that goes hand-in-hand with distorting the size of objects in the foreground is the tendency to *emphasize* those objects even if their relative size doesn't seem bizarre. Any time you use a wide-angle lens, the background will seem farther away and less important, while the foreground will take up more area, in comparison.

An example is shown in Figure 3.25, taken with a 28mm lens (equivalent) of a stately *faux* castle, built in the United States from an original design in 1904. The grounds of this former mansion are particularly beautiful, and I wanted to emphasize the brickwork and stairs that, in this photo, seem to lead up to the front door. In truth, the castle lies 50 yards farther up the hill, but the angle I used, combined with the wide-angle perspective, helps to unify the foreground and background.

Figure 3.25 A wide-angle view emphasizes the foreground in this photo.

You can see how use of the wide-angle lens provides extra depth and a three-dimensional feel. You can emphasize this by getting down low, as I did for the castle photo (because the grounds sloped away from the façade of the building), and for the next example, shown in Figure 3.26. It shows a flower bed of chrysanthemums which was actually about 20 feet deep, but because of the low angle, and 24mm (equivalent) lens, looks much wider.

Figure 3.26 This bed of mums looks much larger than it really was because the wide-angle lens exaggerates the foreground.

Working with Perspective Distortion

Perspective distortion is the convergence caused when the camera is tilted so that the plane of the sensor is not parallel to the plane of the subject. It's most commonly seen in architectural photos and with other types of subjects that have straight lines that make this convergence obvious. Often, the camera is tilted back to take in the top of a tall building or structure, which then appears to be falling backwards, as you can see in the unfortunate photo shown in Figure 3.27. In this case, I had my back up against another building, was already using my widest 18mm (equivalent) lens, and had no recourse but to tilt the camera. The church was an historic landmark, and I wanted to capture the façade because of its architectural interest, so I fired away, knowing there was no easy fix for this photo.

Figure 3.27 There wasn't a lot that could be done to avoid converging lines in this photo if the entire façade was to be included in the shot.

I had greater hopes for the image shown in Figure 3.28, the former home of a prosperous dairy farming family of the Western Reserve, built in 1845. It was fixable using the tools built into Photoshop. This photo provided more to work with, because there was plenty of room around the house itself within the shot to allow perspective correction. I was able to stretch and tilt parts of the image to bring the straight lines (mostly) back into the desired parallel orientation.

Figure 3.28 The two-way perspective distortion in this shot can be fixed easily in an image editor.

However, this photo was not as easy to correct as you might think, because it was not taken head-on, facing the house, but, rather from one side, nearer to the right front corner than to the left front corner. So, I had to make several transformations within Photoshop. Within the Lens Correction plug-in, I used the Vertical Perspective slider within the Transform area to adjust for the apparent backwards tilt of the image. This step made the vertical lines of the walls and windows perpendicular. Then, I needed a touch of the Horizontal Perspective slider to line up the roof and footer. The Angle control within the Transform area was set to 355 degrees to rotate the image slightly to align it with the bottom of the frame.

But I wasn't done yet. Applying all these changes, I found that the right wall was slightly "shorter" than the left wall, so I used Photoshop's Edit > Transform > Distort feature to fix that by dragging the handles on the right side of the selection (only) up and down. At this point, I noticed that there was a little barrel distortion in the roof and footer, so I went back to the Lens Correction plug-in and moved the Remove Distortion slider to the right to finish off the photo, as shown in Figure 3.29. It was a bit of work, but the results were much more satisfactory.

Figure 3.29 The edited version is a great improvement with all the straight lines lined up as they should be.

Using Depth-of-Field

Another characteristic of wide-angle lenses you can put to good use is the generous depth-of-field provided at any particular f/stop. Figure 3.30 shows the cloisters of a European cathedral, photographed with a moderately wide 28mm lens (equivalent) with an f/3.5 and 1/30th second exposure at ISO 400. The actual cloisters were fairly dimly lit, solely by light that spilled in from the courtyard at left on this overcast day. They appeared much darker in real life than you see in this photo, which is a tribute to the long dynamic range of the sensor in my digital SLR and, perhaps, careful exposure on my part.

I didn't want to increase the ISO past 400, because my camera produces more noise at higher ISOs than I would find acceptable for the subtle textures in this subject. The 1/30th second exposure was about as long as I dared to use, even with the camera mounted atop a monopod. I follow my own advice and use a camera support for exposures as long as 1/30th second, and I knew from experience that even with the monopod I might get a little camera shake at 1/15th or 1/8th second. But, lucky me, my 28mm lens is sharp at f/3.5, and, thanks to the miracle of wide-angle depth-of-field, the zone of sharpness was extensive enough at that f/stop to bring virtually everything in the photo into sharp (enough) focus.

Take advantage of your wide-angle lens' bountiful depth-of-field characteristics when you photograph subjects that can benefit from an extended zone of sharpness. Sometimes you'll want to use selective focus to isolate subjects, but other times you'll want to render a large area of your image sharply, and that's where wide angles are particularly useful.

Figure 3.30 A wide-angle lens, a monopod, and a 1/30th second exposure yielded a sharp photo at f/3.5.

Wide Angles and Flash

Wide-angle lenses can be problematic when working with flash, because electronic flash often doesn't provide coverage that's wide enough to illuminate the entire field of view of a wide lens. The result is dark edges or corners. The problem can be even worse when using a dSLR's built-in speedlight, because many wide-angle prime lenses and zooms are large enough that they cast a shadow into your frame. Even if the lens itself doesn't produce one of these shadows, the huge lens hoods provided with many wide-angle lenses might do so, as you can see in Figure 3.31.

Flash manufacturers don't produce units that by default cover a full wide-angle perspective for several reasons. The most important factor is that widening the flash's angle of coverage spreads the unit's limited amount of illumination over a larger area, reducing the power and "reach" of the flash when it's used with longer focal lengths. A flash that might provide enough light to evenly illuminate a frame

Figure 3.31 A double whammy! With this dSLR's built-in flash, the lens hood of an 18mm–70mm zoom produces a semicircular shadow at the bottom of the frame at 18mm, and the sides of the image don't get enough illumination, either.

at 18 feet with a focal length of 50mm (equivalent) might be effective only to 7 or 8 feet if that same light is spread enough to cover a 24mm to 28mm (equivalent) focal length.

The solution, of course, is to design electronic flashes so that their coverage "zooms" in and out to match the coverage of the lens. By shifting the flash tube forward and back inside the flash head, the spread of the light can be varied to better suit the perspective of the lens being used. Sophisticated dSLR dedicated flash units communicate with the camera, which "tells" the flash the actual focal length of the lens, so this zooming can be performed automatically. Less automated flash units may have settings or, perhaps, a flip-down lens that let you adjust the flash coverage in fixed increments.

Another reason why flash units aren't designed to automatically cover wider fields of view is that it's difficult to define what perspective is needed. Some might rarely use any lens wider than 24mm (equivalent), while others would be dissatisfied with any flash that doesn't cover at least the field of view of an 18mm lens (or wider). Because it's so difficult to spread a flash unit's coverage over such a wide area, you'll usually find that even flash with a zoom feature probably can be used effectively with lenses that are no wider than 28mm.

Despite all the complications, electronic flash can be used effectively with wide-angle lenses. Here are some tips that will help you get better results.

◆ **Do-it-yourself spread.** You can easily broaden the reach of your electronic flash by bouncing the light from a larger surface, such as an umbrella, or even a bounce card on the flash itself, like the one shown in Figure 3.32. The illumination will automatically be spread and diffused, offering wider coverage that is also softer and less harsh. Flash can also be bounced off a ceiling, wall, or other handy surface. This technique sometimes works for moderately wide lenses. The thing to watch out for is light fall-off: portions of your subject closest to the reflecting surface (such as a ceiling) will be significantly brighter than those only a little farther away. Keep the inverse square law in mind. A person's head that's three feet from the ceiling (where the light appears to originate) will receive four times as much light as their waist three feet lower. That's two full f/stops!

◆ **Use a supplementary or off-camera flash.** To avoid shadows cast by your lens or lens hood, eschew your built-in flash in favor of an external unit that's located a few inches higher (if mounted on your camera's hot shoe), or which can be removed and used entirely off camera. The dedicated flash unit for the camera used in Figure 3.31 automatically zooms out to illuminate the full frame at 18mm, and its higher position would not have cast a shadow of the lens hood.

◆ **Lose that hood.** You might find that removing your lens hood is enough to avoid shadows from a built-in flash. Or, you might zoom in a little, sacrificing a little wide-angle coverage for more flash coverage.

◆ **Use several flash units.** Whether you're working with umbrellas, bouncing your flash off the ceiling, or working with direct flash, you can get more coverage by using several different speedlights. Each additional flash should have some sort of slave triggering device, either built-in or attached so that all of them will fire at the same time. You can find more information on using multiple flash in Chapter 6.

◆ **Use a diffuser.** If your flash unit wasn't furnished with a diffuser dome, which spreads the light much like an umbrella, you can purchase one from third parties, such as Sto-Fen (**www.stofen.com**). A diffuser is shown in Figure 3.33.

Figure 3.32 Bounce cards or wide-angle diffusers on an electronic flash can spread the light for broader coverage.

Figure 3.33 Diffusers that fit over your flash head can improve the coverage area of your unit.

Wide-Angle Tips

You've learned a lot about wide angle lenses in this chapter. Here are some idea-sparkers to get you started using these lenses creatively. Some of them are techniques you might not have thought of, while others illustrate that rules are often made to be broken.

Go Abstract

Because of the unique perspective that a wide-angle lens deployed from an unusual angle can provide, you'll find that many familiar objects might take on an abstract aspect that's more interesting than the subject's ordinary, more realistic appearance. Get close, and size distortion or perspective distortion change an object's appearance. Flatten yourself on the ground and shoot upwards, or climb up high and shoot down, and you'll often get a dramatic view, as shown in Figure 3.34. Abstract images are interesting even when you're not sure exactly what the original subject matter was.

Figure 3.34 Wide angles can turn an ordinary structure into an abstract image.

Go Vertical

Some photographers take the term *wide angle* too literally, and use these lenses only in a horizontal or landscape orientation. Part of the reason is that, often, many subjects suffer from perspective distortion when the camera is rotated 90 degrees. Don't let a fear of odd or distorted perspectives scare you away from the interesting compositions you can get with vertical framing. Figure 3.35 shows an architectural image in which the converging lines produced when the camera was tilted back were incorporated into the composition. The angles lead your eye from the base of the image up to the top.

Figure 3.35 Wide-angle lenses don't have to provide a wide view—they can show tall, too!

Don't Point the Camera at the Sun

Wide-angle photos outdoors often include lots of sky as an important compositional element. If you want a deep blue sky with lots of fluffy white clouds, accompanied by a detailed foreground/background, don't point the camera at the sun. You'll find it almost impossible to expose for the extra-bright sky and still retain detail in the foreground under ordinary conditions (a graduated neutral density filter with the top half darker than the bottom half can help). Instead, have the sun off to one side, or even behind you, so that both the sky and your landscape are illuminated to a similar degree.

Point the Camera at the Sun

Rules are made to be broken. You'll find that including the sun in some of your images, or, off to one side just out of the frame, can provide an interesting effect. The wide-angle lens will make the sun seem farther away, while smaller f/stops can produce dramatic star-like points. Or, you can wait until the sun is setting and no longer is overpoweringly bright, as you can see in Figure 3.36, in which the sun is completely obscured by clouds.

Figure 3.36 Including the sun, even if obscured by clouds, can add interest to a wide-angle shot.

Use Wide Angles for People Pictures

Longer lenses are traditionally used for portraits and pictures of people, because they provide a more flattering rendition. That doesn't mean that wide angles can't be used, too. You'll find that full-length portraits of people can be taken with wide lenses in a pleasing way, and actually can include more of the subject's personality by showing more of the person's environment. Even fish-eye lenses can be effective if you want to show someone at work, surrounded by the tools of their trade, as shown in Figure 3.37. Avoid the extreme close-ups and comically enlarged noses, and you'll find that wide-angle lenses offer another, useful take on human subjects.

Figure 3.37 Wide-angle lenses can provide an interesting view of human subjects.

Wide Angles Are Good Underwater

If you have or can get an underwater housing for your digital SLR, you'll find that wide-angle lenses are often your best choice for subsurface shooting. Even the "cleanest" water has particulate matter that diffuses light and masks detail, and some underwater venues are downright murky. A wide-angle lens lets you get closer, with less water between your camera and the subject you're shooting. Your images will have better contrast and be sharper, to boot. So, if you're exploring underwater photography include wide-angle lenses in your plans.

Next Up

The next several chapters explore some specialized kinds of shooting that are especially well-suited for digital SLRs. Chapter 4 looks at infrared photography in some detail. You've probably read a little bit about this kind of imaging, but you're about to find that there's a lot more to infrared shooting than white foliage!

4

Advanced Infrared Photography

You won't find much written about digital infrared photography, which is a shame, because it's one of those photo arenas, like macro photography, that can be a powerful creative outlet, with whole new ways of seeing and picturing both familiar and unfamiliar subject matter. I'm going to resolve the dearth of information available about digital infrared photography with dSLRs by devoting a whole chapter to the subject.

After reading this mini-treatise, you may grow to love IR photography and pursue it with a passion. Or, you may decide that this weird branch of photoillustration is not for you. However, I think you'll be glad you learned about the topic, nevertheless. When you want a certain other-worldly look in your pictures, IR imaging can produce photographs that can be obtained in no other way, as you can see in Figure 4.1. You're not limited to daytime landscapes, either: IR photography can be applied to people pictures, indoor shots, night photography, and other situations.

I covered IR photography in a limited way in two of my other books, *Mastering Digital Photography* and *Mastering Digital SLR Photography*. Even if you've read either of those books you can prepare to learn something new. If IR photography in general is new to you, prepare to be amazed.

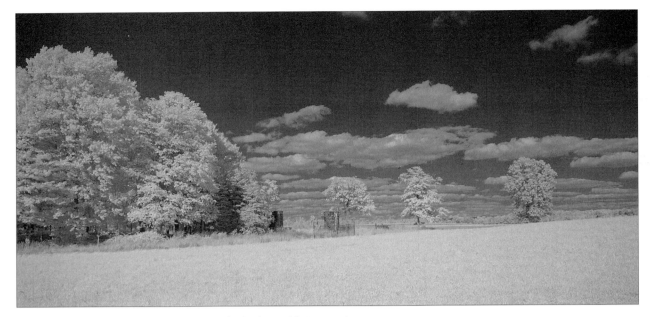

Figure 4.1 Infrared photos have a unique look obtainable in no other way.

What's Infrared Photography?

Before we get started, I want to clear up one common misconception. All infrared photography of the digital kind captures images in what is called the *near infrared* (NIR) range; that is, the infrared light that's just beyond the range of human vision. Such photography does *not* capture far infrared or heat radiation. So if you have a hankering to mimic the commandos in the movies and photograph the heat signatures of, say, gullible friends wandering through the woods at dark in search of the elusive snipe, you're out of luck. Nor can you track jet airplanes like a heat-seeking missile. Almost all digital SLR IR photos rely on subjects that reflect healthy amounts of infrared light, not those that emit it (unless you happen to be photographing your TV's IR remote control).

To really understand how infrared photography works with a digital SLR, it can be helpful to recall a little from high school science class lessons on how our eyes work, and compare that with how digital sensors operate. Digital image capture devices like the sensor in your dSLR don't perceive light the way our eyes do. It's not even close. Because of that, I'll explain each kind of "seeing" separately.

The Eyes Have It

What you see as an image is actually a composite of two images, created by two different kinds of biological cells in the retinas of your eyes. When you're looking straight ahead in brightly lit environments, you're really, in a sense, experiencing a kind of tunnel vision. Your brain concentrates on the information received by the full-color, less-sensitive receptors called cones in a surprisingly narrow field of view directly in front of you, and more or less ignores the information being received from the periphery by your eye's more sensitive, colorblind rods—that is, unless a fast-moving object approaches you from the side and catches your attention. You're not even aware of the difference between your straight-ahead and side fields of view, because your brain processes all the information for you, automatically, and combines the two into one "picture."

Your brain also subtly colors the appearance of what you're viewing, too. It connects the dots to form straight lines and patterns (which is how the surface of Mars got "canals" and giant faces). Our minds actually modify the colors we see to match our expectations, too. I once attended a Kodak class in which a narrator told about a trip across country, showing various photos of a train as it progressed from the East Coast to the West Coast. As the views progressed from one to another, the presenter talked about other aspects of the "trip," and didn't call our attention to a subtle change that was unfolding before our eyes. Indeed, nothing at all appeared to be unusual about the train photos that we'd been staring at intensely for five minutes. Then, the narrator showed the first and last photos side by side. One had a strong blue cast, while the other was equally biased towards the red-orange. Each of the intervening photos were slightly more tinted towards the final, reddish image. The eyes of the audience automatically adjusted their perceptions of the photos so that all of them looked "normal."

Something similar happens to you every day. That white shirt or blouse you're wearing looks perfectly white outdoors in bright sunlight. Go indoors where the incandescent illumination is very warm and reddish, and the garment will still look white. Skin tones may look a little pallid under some kinds of fluorescent lights, but our clever brains filter out most of the greenish tint. Our eyes have a form of the automatic white balance feature found in digital cameras. Our eyes process the things we see so that what we see is what we *think* we should get, as you can see in Figure 4.2.

Finally, our eyes are limited in both the extent and number of colors we can see. The retinas are sensitive to certain colors of light, while others in what we call the deep-blue range that turns into ultraviolet and the deep red range that becomes infrared, are invisible to us. The absolute number of different tones and hues we can differentiate is limited, too, in some cases to as few as 64 different shades. The human eye is a complex mechanism that combines the properties and quirks of a "sensor" (the retina) and a "processor" (our brains).

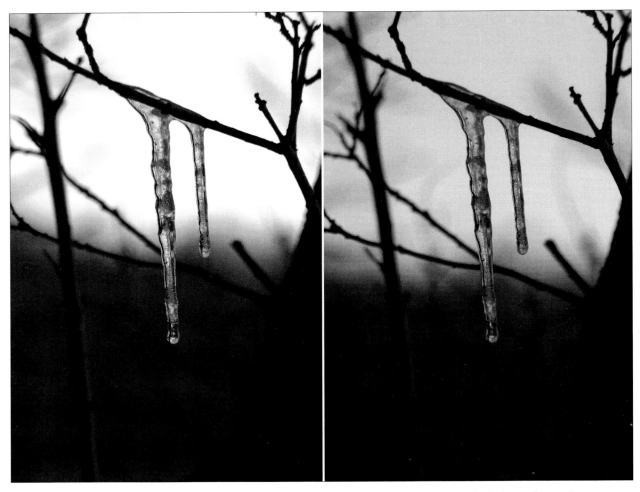

Figure 4.2 Thanks to our flexible brains, either of these shots might appear to have correct color balance if viewed independently.

How Sensors Perceive Color

Digital imaging involves the same combination of sensor/processor, but in a very different configuration. For the sake of our infrared discussion, ignore for a second that the light your sensor captures is colored, quite literally, by the red, green, and blue filters placed atop the individual photosites. Let's talk about the sensor's overall sensitivity to colors. Unlike your eye, the sensor sees an entire scene from a single "retina" or matrix of photosites. With the exception of some long dynamic range sensors from Fuji, a digital camera sensor has no extra-sensitive rods and color-oriented cones. Each photosite is assigned to a specific pixel position and does double duty to capture both brightness information and (thanks to the over-laid color filter) color data. Nor is there any automatic white balance, beyond

what's provided in the software that processes the sensor's data. The information that a sensor grabs is based entirely on simple rules of the physics of light.

Well, maybe the rules aren't quite *that* simple, because light itself is a fairly amazing phenomenon, the subject of multiple books, and the center of many puzzling mysteries. Light is usually described as a form of energy, similar to heat, x-rays, radio waves, or television signals. Yet, light has characteristics of matter, too. As energy, it moves in *waves*, like the ripples produced in a pond when you drop in a pebble. As matter, it contains tiny particles called *photons*.

Long ago, scientists thought that light must consist of waves *or* as particles. Sir Isaac Newton, one of the founders of optical science, theorized that light consisted of particles he called *corpuscles*. However, the wave theory seemed to offer a better explanation of the behavior of light until Albert Einstein shook things up at the beginning of the 20th century. Einstein's work showed that light had dual natures as both wave *and* particle. Although that seems weird, there is no real conflict, because Einstein also demonstrated that energy and matter are really the same thing in a different form, whether used to produce electricity in nuclear power plants or to build houses.

So, as matter, light's photons are free to whack into things, such as the corneas of our eyes or the light-sensitive particles on film, allowing us to see images and capture them in photo-sensitive emulsions. As energy, in wave form, light can oscillate in different frequencies, both tight bundles of waves with little space between the peaks and troughs, and longer, lazier undulations with longer intervals between them. We call the distance between these peaks or troughs the *wavelength* of the electromagnetic signal.

The varying frequencies of light let us see different colors. For the rather narrow range of frequencies that can be detected by human eyes and digital sensors, we see shorter wavelengths as violet; longer wavelengths are seen as red. Figure 4.3 is a simplified representation of the entire electromagnetic spectrum (not drawn to

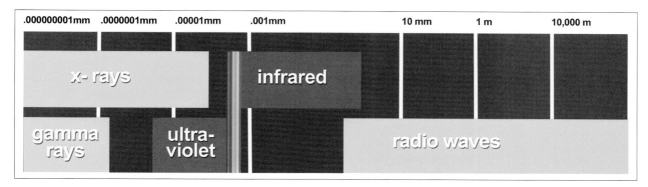

Figure 4.3 That tiny sliver that looks like a rainbow represents the entire range of visible light compared to the entire electromagnetic spectrum—and the illustration isn't even drawn to scale!

scale), with the visible wavelengths of light shown as that little sliver of rainbow in the middle.

The light we can see ranges in wavelength from about 400 nanometers (violet) to 700 nanometers (deep red). A nanometer is not a gauge found in an iPod but, rather, one billionth of a meter, a tiny increment used to measure the distance between the peaks and troughs of electromagnetic waves, as shown in Figure 4.4. At the high-energy end of the spectrum (at left), the distance between waves is relatively short, while at the low-energy end (at right), the wavelengths are longer. (I've exaggerated the difference in the illustration.)

Both natures of light are used in the creation of digital images. In a digital camera, light passes through the lens, which focuses the light, with the amount of bending depending on the wavelength of the light (as you learned in the section on chromatic aberration in Chapter 2). Then, as the waves of light converge on the photosites in the sensor, the particle nature of light takes over and the photon particles are collected.

Figure 4.4 We see shorter wavelengths as violet (left) and longer wavelengths as red (right).

While some colors are filtered out, so that each photosite "sees" only red, green, or blue light, the actual light passing through the filters extends beyond the visible spectrum we can see. In fact, the incoming light also contains a significant amount of invisible, *near-infrared* (NIR) illumination, which is considered to be light in the 700–1200 nanometer range. It would also contain light from the other end of the spectrum, the ultraviolet, but the glass used in camera lenses does a pretty good job of filtering out most UV light, and the popular UV filters that photographers like to use to protect their lenses can remove much of the rest.

Of course digital camera sensors aren't necessarily especially sensitive to UV, but they do see infrared much better than our eyes do. CCD and CMOS sensors are particularly sensitive to IR. Indeed, you'll find that most digital cameras include a special filter, called a *hot mirror*, to remove most of the infrared from the light reaching the sensor. Inexpensive digital point-and-shoot cameras might not have such a filter, but as the price tag increases on a camera, the greater the likelihood that it includes an effective IR filter.

WHENCE THERMAL

Thermal infrared, which digital cameras can't detect, resides in the 3000 nanometer and longer range of wavelengths. Those waves are significantly longer, but are still rather short: 3000 nanometers is only 3 millionths of a meter in length. Other non-visible electromagnetic waves at this end of the spectrum are much, much longer, with TV, FM radio, and AM radio wavelengths measured in meters and hundreds of meters between peaks.

That's because uncontrolled IR illumination robs images of detail and color accuracy. Many kinds of subjects, particularly foliage, reflect a lot more infrared light in proportion to visible light, compared to other objects that nominally have the same visible reflectance. It's entirely possible for two subjects to appear to be the same color to our eyes, but reflect infrared so differently that they appear quite different when photographed by cameras with poor IR filtering. That's not an acceptable outcome with more expensive digital cameras, so IR-blocking filters are standard issue.

Fortunately, for those of us with a curious or IR-oriented creative bent, these filters are far from perfect when it comes to removing infrared from the illumination that reaches your sensor. Enough IR remains that you can usually place a filter of your own on your lens to remove everything *except* the residual infrared and take photos using that small amount of IR that manages to run the cutoff filter gauntlet. Of course, this little dribble of IR illumination is only enough for very long exposures (measured in seconds), but, for the intrepid, that can be sufficient.

Characteristics of Infrared Photography

Infrared imaging's unique look is caused by several different attributes of that breed of photography. Any one of them might be reason enough to prompt an investigation into infrared photography, but as a group of interesting properties, they are very compelling. Here are the main attributes of infrared shooting.

- **Atmosphere piercing depth.** You might like the hazy quality that masks a distant mountain range, either for its romantic look or because a hazy view caused by light scattering as it bounces off particles in the atmosphere is what we have to put up with in real life. Or, you might *hate* the effect and seek to counter it with a so-called haze filter on your lens. Infrared photography is the ultimate haze filter. Infrared light cuts right through haze, which is why aerial photographers, reconnaissance teams, and anyone using satellite imagery is so interested in shooting in the infrared portion of the spectrum.

◆ **Back to monochrome.** There's always been something special about black-and-white photography, and infrared imaging almost forces you to look at your subjects in a monochromatic way. Even though "color" infrared photography is possible (I'll show you how later in this chapter), most of the images will still be black, white, and shades of gray, magenta tones, or a color scheme described as "brick and cyan." Some of the best infrared photos don't even look as if they've been taken by infrared light. They are merely interesting grayscale photos, like the one shown in Figure 4.5.

Figure 4.5 This image isn't obviously an infrared shot on first glance, but the IR look does give it an old-timey, European flavor.

◆ **False color.** When shooting infrared, you still need to use your camera's color photography mode. Experts in digital infrared photography recommend setting your camera's white balance manually, using grass as your sample. That white balance will provide the best overall grayscale images in your final picture.

◆ **Unexpected relationships.** Infrared photography produces tonal values and relationships that are unexpected and interesting. Subjects such as foliage reflect more infrared light than other objects, and skies may be darker than they seem when viewed by visible light. These unusual relationships are fodder for unusual and compelling photographs.

◆ **Light loss.** The IR filter blocks the visible illumination, leaving you with an unknown amount of infrared light to expose by. Typically, you'll lose 5 to 7

f/stops, and will have to boost your exposure by that much to compensate. A tripod and long exposures, even outdoors, may be in your future.

◆ **Long exposure quirks.** Because infrared exposures can be several seconds long, or more, your photos will usually be taken with the camera mounted on a tripod, and moving objects will be rendered as blurs or ghosts. The effects of longer exposures can be very interesting, indeed.

◆ **Shooting blind.** The visible light cutoff filter you'll be using means that your dSLR viewfinder will appear to be completely black. The LCD review may be a little weird, too. You can't focus, you can't frame your image, and can't measure exposure accurately. From a creative standpoint, this means you must either shoot blind and take what you get or carefully compose your image before mounting the IR filter. Both approaches lead to fascinating results, either resulting from pure chance, or from the need to work out your composition thoughtfully ahead of time.

◆ **Focus problems.** Infrared light doesn't focus at the same point as visible light, so your autofocus system might or might not work properly. Lenses used to have an infrared marking on them that could be used in conjunction with the focus scale on the lens to correct the point of focus after you'd manually adjusted the image. Of course, we don't use manual focusing much these days, so you may have to experiment to determine how best to focus your camera for infrared photos. If you're shooting landscapes, setting the lens to the infinity setting probably will work (even though *infrared infinity* is at a different point than visible light infinity).

◆ **Grainy look.** You'll find that infrared photographs often take on a grainy look. Part of that aspect comes from the different way in which your sensor captures and handles infrared illumination. But the look is also accentuated by the tendency to boost ISO settings to shorten those long exposures, and you must add the focus factor discussed above, that IR light doesn't focus at the same point as visible light. If you focus through your viewfinder, you may find that your image is still not sharply focused. I'll explain more about this effect later.

◆ **Metering problems.** Exposure systems are set up to work with visible illumination. The amount of IR reflected by various subjects differs wildly, so two scenes that look similar visually can call for quite different exposures under IR.

◆ **Lens coatings.** Some lenses include an anti-IR coating that produces central bright spots in IR images. A few Canon lenses fall into this category. Test your lens for this problem before blaming the artifacts on your filter or sensor.

Technical Requirements for Infrared Photography

This section will tell you everything you need to know about selecting a camera and lens for infrared photography, choosing a filter and other accessories, and actually setting up to take a picture.

What Can You Photograph?

Anything that reflects a lot of infrared makes a good subject, because it appears strangely light in tone compared to the way in which that object is ordinarily seen. Subjects that reflect very little infrared provide excellent contrast, because they look darker than we expect. Flower petals are bright under IR, but other parts of the plant, such as the seeds, may appear dark. Skies photograph fairly dark under IR conditions, but fluffy clouds, like those in Figure 4.1 earlier, may stand out in stark white contrast, because the water vapor they contain scatters the infrared wavelengths.

Human skin is free from many defects under infrared illumination, offering some interesting, if weird, portrait possibilities. Indeed, the washed-out look that skin takes on, the lighter tone to lips and other features, coupled with the extra contrast and graininess you can get with IR imaging produces a unique look, as you can see in Figure 4.6.

What Kind of Light Do You Need?

You need illumination that's rich in infrared wavelengths. Daylight is a good source, but incandescent lights are also rich in infrared. Hot coals, gas flames, fireplaces, and other burning light sources glow red in the visible spectrum, but also emit lots of infrared light. Even if you can't see a visible glow, most objects heated to 480 degrees F or higher will emit light strongly in the IR range. You might not be able to make photographs from the *heat* emitted by a fireplace, but the IR illumination the hearth produces is great.

Figure 4.6 Try this at home! But make sure your subject is prepared for the strange appearance that infrared portraits can create.

Is Your Camera IR Capable?

Of course, you shoot your photos with the camera you have, so before you set out to explore infrared photography, you'll want to see just how capable your camera is in this arena. While I haven't been able to test every digital SLR to see how well

it renders IR, I have found significant differences, even within a particular vendor's product line.

For example, the Nikon D70s filters out much of the infrared illumination, but still lets enough through to allow wonderful IR images. I've found that the Nikon D2X, on the other hand, is at least three stops *less* sensitive to infrared than the D70s. Used side-by-side in identical situations and at the same ISO setting with the same IR filter, the D70s can expose IR photos properly under bright daylight at 1/15 second and f/4, while the D2X requires as long as a full second. You might think that with the camera mounted on a tripod in both cases, the difference isn't important. However, when you're photographing subject matter that moves even slightly (with landscape photographs this movement can come from the leaves and branches on trees), the slower shutter speed mandated by a less-sensitive camera can lead to unwanted blur. (If you *want* blur, the limitation becomes an advantage.)

Moreover, you might be able to take IR photos with the more sensitive camera using a monopod at 1/15th second, whereas that full second exposure would call for a solid tripod. Indeed, I've found the D70 to be a better choice for IR photography much of the time, because of this sensitivity advantage, compounded by the lower levels of noise it produces at ISO 1600.

Testing for IR Sensitivity

You can easily test to see if your camera is sensitive to IR illumination. All you need to do is photograph a source of infrared light. If you own a television, VCR, DVD player, or sound system, you undoubtedly have an IR source handy—your remote control. Media Center PCs and other computers, MP3 players, microwave ovens, camcorders, or digital SLRs, and dozens of other gadgets can also be operated with an infrared remote control.

The old trick of pointing the remote at your camera and pressing the button works, but isn't ideal. I've developed a slightly more sophisticated technique that makes it even easier to tell whether your camera is adept at capturing IR. Just follow these steps:

1. Mount your camera on a tripod at night or in a room that can be darkened.
2. Using the Manual exposure mode, select an exposure of about 15 seconds with your lens wide open.
3. Darken the room.
4. Start the exposure (use your self-timer if you want).
5. Stand in front of the camera, point the remote control at the lens, and press down and hold a button.

6. Wave the remote control as you point it at the lens.

7. When the exposure is finished, choose a smaller f/stop and repeat Steps 4 to 6. Continue until you've run through five or six ever-smaller stops.

When you evaluate the photos you've taken, if your camera is sensitive to IR illumination you'll see that, because you waved the remote control, the IR source will be shown as a dotted line, as you can see in Figure 4.7. That's because IR remotes don't issue a continuous beam of infrared light but, rather, spurt out data packets in a code that tells the receiving device what command is being delivered. This method works better than simply pointing the remote at the camera and taking a picture because the dotted lines are more distinct than the "glow" that might be spotted on a non-moving remote. That glow is probably overexposed, too, so you really can't tell how sensitive your camera is to IR. Compare the dotted lines from several different exposures and you'll get a good idea whether your sensor easily images IR information, or whether it's relatively insensitive.

Figure 4.7 If your camera is sensitive to infrared, the remote's IR will be visible in your photos.

Desperate Measures

If your digital SLR turns out to be not so good for IR photography, you might be tempted to turn to some desperate measures, which are used with mixed success by a few dedicated IR shooters.

One of these steps is to purchase a camera especially for digital infrared photography. One mondo-expensive (think $12,000 plus), 22-megapixel medium format digital SLR features a removable IR filter (the separate filter can be taken out and cleaned, too, reducing the problem of sensor dust). You'd have to be doing a lot of IR photography to experiment with a camera like this (or else need it for super-high-resolution photography work, also). There was a lot of excitement when Canon introduced the Canon EOS 20Da, which has extended deep-red sensitivity, plus the ability to lock up the mirror, open the shutter, and see a "live" black-and-white preview. Alas, it turns out that this camera, intended for astrophotography, is optimized for hydrogen-alpha light and its IR sensitivity isn't significantly better for terrestrial photography. Unless you're photographing a lot of nebulae, you'll want to pass on this camera, too.

Another reckless measure is to operate on the camera, removing the built-in IR blocking filter entirely. The ease of this surgery varies from camera to camera and,

of course, renders the camera less suitable for ordinary photography. If you do a bit of Googling on the Web, you'll find step-by-step instructions for various camera models. If you own an older dSLR, have the necessary skills, and don't want to use it for non-IR imaging any more, building your own IR-capable camera is a serious option.

The final desperate option is to eschew digital SLR shooting altogether, and resort to a non-dSLR camera that happens to have a high sensitivity to IR. Some older Nikon CoolPix 900-series models and a few Canon point-and-shoots are prized for their ability to capture infrared. As a bonus, you won't be shooting blind, as you use the optical viewfinder window of these cameras to compose your photo, or even see a dim preview on the rear-panel LCD.

Obtaining an IR Filter

This is one case where photographic terminology can be confusing. You'll see references to the IR filter or hot mirror in your camera, which *blocks* IR illumination, as well as to the IR filter placed on your lens, which *passes* infrared, but blocks everything else. It's easy to get the two types of "IR filter" confused. This section deals with the kind of IR filter that lets infrared light pass through to the sensor.

HOT MIRROR, COLD MIRROR, WHO'S COUNTING?

As you read up about infrared, you'll find the terms *hot mirror* and *cold mirror* both used. In practice, they have the opposite effects. A hot mirror reflects infrared, but allows the rest of the visible spectrum to pass through. A cold mirror passes infrared, but reflects visible light. The origin of the two terms becomes clearer when you trace them back to their original applications. Hot mirrors have been used to protect systems by reflecting heat away at an angle. They're used for specialized applications such as microscopy. Cold mirrors operate within a wide range of temperatures in systems such as lasers, to reflect visible light while transmitting infrared illumination.

The filter you want should block as much as possible of the light below 700 nanometers, while transmitting light in the 700–1200 nanometer range, where infrared illumination resides. Of course, filters that we can afford to purchase don't block *all* the visible light. In practice, a filter is considered to be effective if it removes at least 50 percent of the illumination at a particular wavelength. Table 4.1 shows a table of common filters (using the Wratten numbering system developed by Eastman Kodak Company), showing the wavelength at which a minimum of 50 percent of the light is removed.

Table 4.1 Light Blocked by Red/Infrared Filters

Filter Number	50% blockage
Wratten #25	600nm
Wratten #29	620nm
Wratten #70	680nm
Wratten #89B	720nm
Wratten #88A	750nm
Wratten #87	800nm
Wratten #87C	850nm
Wratten #87B	940nm
Wratten #87A	1050nm

The filters below 700 nanometers (the #25, #29, and #70) are really just deep red filters, not particularly useful for digital infrared photography, even though they had some uses with a few types of infrared film imaging. The true IR filters start with the very popular #89B (also commonly known by the R72 designation applied to it by Hoya). As the cutoff point moves higher in the spectrum, these filters typically become more expensive, which is why the Hoya R72 is such a popular filter. At the high end you'll find filters like the #87A, which, at 1050 nanometers, actually cuts off some of the true infrared illumination.

In practice, you'll find that many newer cameras with more rigorous built-in IR cutoff filters, simply won't handle any of the #87-series filters. These are closer to true infrared filters and may not pass enough light for many newer sensors to form an image, even with very long exposures. Unless you know your sensor is highly sensitive to IR (say, it's an older camera like a Canon EOS D30), you're better off sticking to the #89B (Hoya R32) or #88A filters. The #87-series filters are much more expensive, anyway.

Your choices for the physical form of the filter are varied, with several options to consider. Here are your main alternatives:

Standard Filter Size

You can purchase many IR filters in sizes with threads to fit your particular lens. If you need, say, a 67mm IR filter, you simply order one in that size and mount it on the front of your lens when you're ready to shoot. There are some advantages and disadvantages to this approach.

- **Simplicity.** Buying and using a single IR filter is a no-brainer. The size of the filter thread is probably printed or etched on the front of your lens barrel.

- **Cost.** Standard filter sizes are not excessively expensive in moderate diameters. While infrared filters are not cheap, you can frequently get away for a lot less than $100. However, if you need a 77mm filter to fit your fast wide-angle lens, expect to pay $150 or more for one of these huge pieces of glass.

- **Non-interchangeability.** A given filter fits only lenses with the same size thread, so your IR filter may not fit all the lenses you'd like to use it with. My favorite optics are a 105mm macro lens, a 28mm–200mm zoom, and an 18–70mm all-purpose zoom that take 52mm, 62mm, and 67mm filters, respectively. So, I purchase 67mm-threaded filters and mount them on all three lenses using 52mm–67mm and 62mm–67mm adapter rings.

Gelatin Filters and Custom Filter Holders

You can purchase many filters, including infrared filters, as 2 × 2-inch gelatin squares, sometimes mounted between pieces of glass. Just buy the filter you want to use and drop it into a filter holder designed for that purpose on the front of your lens. The factors to consider with this approach are:

- **Simplicity.** Filters of this sort are even easier to use than the screw-in kind. Drop them in, and you're ready to go. You can even slide the filter out to restore your view through the finder when you want to compose a new image.

- **Cost.** If you already own a filter holder, such as those provided for the Cokin system, a drop-in infrared filter can be very inexpensive. Of course, if you need to purchase the mounting system, you'll have an initial outlay of $30 or so for the holder. Real tightwads can tape filters to the front of their lenses, too.

- **Interchangeability.** You can buy adapters for filter mounting systems for many different thread sizes, so you might be able to use the same IR filter on several different lenses in your collection.

- **Extra stuff hanging on your lens.** One reason I prefer the standard-filter-size option over filter holders is that the latter are a little klutzy and require fastening a bunch of extra stuff to the front of your lens. Of course, infrared photography is often slow-moving contemplative work involving non-mobile subjects such as landscapes, so all this paraphernalia may not be a concern for you.

Make Your Own Filter

It's entirely possible to make your own IR filter using the technique I'll describe next. Rolling your own will cost you a little time, but can be more satisfying for those who like to work with their hands, and far less expensive than either of the two filter purchase options outlined above.

Make Your Own IR Filter

You can build your own infrared filter. All you need is filter material, which can be purchased at low cost or even obtained for free, and some sort of a convenient holder. This section will show you how to put together your own IR filter inexpensively.

Here's what you need to get started:

Filter material. Believe it or not, *unexposed,* processed Kodak Ektachrome E-6 transparency film makes a fine infrared filter. If you're a veteran of the days when film was used for photography, you might have used Ektachrome film in your 35mm SLR. What we're looking for are the 4 × 5-inch sheets of this film used by professional photographers. If you have a pro friend, you might be able to wangle a couple of unexposed sheets that have been processed. Studies by photo tech wizard Andrew Davidhazy, the famed professor of imaging and photographic technology at the Rochester Institute of Technology, report that one thickness of E6 film is roughly equivalent to a #87 filter, while two thicknesses become visually opaque and provide approximately the equivalent of a #88 filter in terms of light transmission.

Your E6 film "filter" can be cut down and placed in front of your lens, but a more useful application for this kind of visible light blocker is as a filter placed over your electronic flash unit and used for photography in locations where the existing light is already very dim. You can also use multiple flash units to provide higher levels of artificial IR illumination. Plus, as Professor Davidhazy points out, E6 filters on flash don't melt or buckle as easily as gelatin filters in the same application.

If you don't want to work with E6 film filters, you can purchase Wratten gelatin filters in sizes such as 3 × 3 or 4 × 4 inches from your retailer. It's unlikely that a local store will have these specialized items in stock, so you may have to special order them, or purchase from a mail order firm. They're not as cheap as you might expect for a little square of filter material; a #89A filter costs about $55 in the 3 × 3-inch size, and $85 as a 4 × 4-inch square. On the other hand, the equivalent filter in a standard screw-in 77mm size can cost as much as $175. A 4 × 4-inch gelatin filter is 100mm on a side, so you might be able to create more than one filter from one of them.

Filter mount. The most convenient way to attach a filter to a lens is with a screw-on mount. In building your own IR filter, you can call on photographic history as an aid. A kind of filter holder dating back from before filters in standard screw-in sizes were available can come in very handy.

You see, in ancient times, lenses didn't have common systems for mounting filters up front. Some lenses had threads, others used bayonet mounts. Some required push-on mounts to hold accessories. The solution was the Series system, which used standard filter *sizes* and holders tailored to each type of lens. You can still buy Series adapters and filters today, and they're easily found in the used/junk bins of most camera stores because they have been largely supplanted by standard filter sizes.

The Series system works like this: The filter mount comes in two pieces, shown in Figure 4.8. One piece attaches to your lens, using either a screw-in thread that matches your lens' filter thread size or by a bayonet or push-on mount suitable for your particular lens. Several different size ranges are available, called

Figure 4.8 A Series adapter consists of two parts, and the filter fits between them.

Series VI, VII, VIII, or IX (or, today, 6, 7, 8, or 9), with each Series size suitable for a range of lens diameters. There can be a little overlap; for example, a Series VII ring might fit lenses in the 46mm—67mm range, with Series VIII fitting lenses with 62mm to 77mm diameters. A standard size (for that Series) retaining ring screws into the inner ring, with enough space between the two for a Series-sized filter.

The Series system is remarkably flexible. You'd buy an inner ring, say a Series VII size, for each of your lens sizes, a set of Series VII filters, and one outer Series VII retaining ring and use the combination with multiple lenses. Other accessories, such as lens adapters, can also be screwed into Series adapters.

What you want to find is a set of Series rings that fit one or more of your lenses (your camera store may have them for a couple dollars in their "junk" box) and an old, scratched Series filter of the same size.

Once you've got all the pieces together, it's time to make your IR filter. Just follow these steps:

1. The junk filter will have a rim made of aluminum or some other metal surrounding the glass filter. Take a jeweler's saw, Dremel tool, or other utensil and score the rim in two places on opposite sides so you can carefully split the rim into two pieces.

2. Remove the original glass from the filter and set the rim pieces aside.

3. Use the original glass as a template to cut a circular piece of your gelatin IR filter of the exact same size.

4. Carefully reassemble the two rim pieces with your round gelatin filter in the slot that formerly held the glass filter.

5. Use cyanoacrylic ("super") glue to bond the two rim pieces together. Hold tightly until the bond forms. You might want to wait 24 hours before handling the new filter, depending on the instructions provided with your glue.

6. Fasten the inner ring of your Series adapter to your lens.

7. Drop in the IR filter you just made.

8. Attach the retaining ring. That's all there is to it.

Taking Your First Infrared Photo

Taking infrared photos is easy now that you have the hard part out of the way. This next section will take you step by step through the process. Follow these steps and you are on your way. Locate a subject you'd like to photograph using IR illumination, and get started.

Set White Balance

If you want to get some cool color infrared effects in post-processing, you'll need to set your white balance accordingly. Automatic white balance and all the default settings (daylight, cloudy, tungsten, etc.) aren't necessarily suitable. You'll need a custom setting. Most digital SLRs have some provision for measuring the white balance of an object under particular illumination, and using that as a preset value. Usually, you'll point the camera at a neutral object, such as a gray card, tell the camera to measure that, and store the value as a custom white balance setting.

That's not exactly what we want here. The goal is to set the white balance based on the IR reflectance of an object, and the best way to do that is to measure white balance from a subject that reflects a lot of infrared. Most experienced shooters use the grass or leafy trees as their "neutral" WB target. The procedure varies, depending on your dSLR. Usually, you'll have to choose White Balance from the Menu system, select Custom, and then a choice named Measure or Set that allows you to point the camera at a subject and measure its white balance by pressing a button, such as the shutter release.

The value is then stored as a preset. If you're lucky, your camera will have several preset slots so you can re-use that WB setting the next time you shoot under similar conditions. If you're *very* lucky, your dSLR is like mine, and allows you to type in a name for the setting, so you can remember what that preset value is used for. Presets aren't a panacea, however; any time you shoot under different lighting conditions, you'll want to set your IR white balance again.

Mount the Camera on a Tripod, Compose, and Focus

It's unlikely that you'll be able to take your infrared photos hand-held, so your next step is to mount your camera on a tripod. Frame your picture carefully and then twist all the proper knobs and levers to lock the tripod's position solidly. Once you mount the IR filter on the lens, you'll no longer be able to view your composition, so you'll want your camera to remain in position without shifting.

So, before you mount the IR filter, focus your image. Strictly speaking, infrared light doesn't focus at the same point as visible light (which accounts for some of the softness of IR images, caused by chromatic aberration), so any visual focus

point you set will not be 100 percent accurate. Back in the olden days, lenses were marked with IR focus indicators. You could focus visually, then set the distance shown by the normal focus mark opposite the IR marker to achieve sharp IR focus. Today, your best bet is to use a small enough f/stop that the depth-of-field provided will cover the discrepancy. Working in your favor are the facts that the most popular IR subjects are landscapes, with proper focus at infinity (and IR infinity isn't far away), and that wide-angle lenses, with their bounteous depth-of-field, are most frequently used for IR photography.

If you're shooting closer subjects, at wider f/stops, with longer lenses, you might have a challenge on your hands. You can either "bracket" focus by adjusting focus manually or change the focus to a point a little *closer* than the point of visual focus. When my 85mm f/1.8 lens is focused at 10 feet for visible light, the correct infrared focus point is closer to 9 feet. If I am shooting an object 5 feet away, IR focus is approximately 4 feet, 12 inches. The difference will be greater with longer lenses, and less with wider optics, and at infinity with any lens the difference isn't very much at all. Of course, sometimes sharp focus isn't always essential if you're looking for a blurry, photojournalistic look as in Figure 4.9.

Figure 4.9 Sharp focus isn't essential for images that are intended to have an "accidental" quality to them.

Set Exposure, Mount the IR Filter, and Shoot

With your composition and focus locked in, it's time to go ahead and set exposure. You'll want to use manual exposure, although you can make a reading by visible light as a starting point. Any reading your camera makes with the filter in place won't be much more useful, in any case. You might want to activate your camera's noise reduction feature, which can help eliminate the noise you're going to get from the long exposures that ensue. Shoot in RAW format, so you'll have the ability to adjust your image as you import it into your image editing software.

Mount the IR filter, and then manually set exposure so it's ten or 11 f/stops more generous than your initial reading/guess. It's probably a good idea to close the eyepiece shutter at your viewfinder, or cover the opening with your hand, as light can flow into the camera and affect your reading. The basic exposure is only a starting point, because IR exposures can vary so much depending on the camera, filter, and other factors that you can't expect to be very close on the first try. After you've gained a little experience, you'll know whether to start out at f/11 and 1/4 second, or f/11 and 15 seconds under a particular set of conditions.

Now you're ready for your first exposure. You might want to use a cable release or remote control to trigger your camera—better to avoid camera shake during the beginning of the exposure. If my subject is not moving, I usually use my camera's self-timer. Setting the timer to a two-second delay allows enough time for the camera and tripod to stop vibrating, but doesn't leave you standing around like an idiot waiting for the exposure to begin. You'll have plenty of time to stand by looking dumb during the long exposure. I've actually taken 30-second exposures which were followed by 30-second dark frame/noise reduction "exposures," so I had enough time to get caught up on my reading between shots.

Once the exposure is over, review the image on your LCD. You might need to shield the LCD with your hand so you can get a good look at the dim, red-tinted image. You may not be able to tell if the exposure is good, but you can certainly see if the photo is unspeakably dark, or completely washed out. Adjust your shutter speed appropriately and take another photo. It may take two or three pictures, but eventually you'll arrive at the right exposure for your infrared photos.

When you've finished taking your IR pictures, it's time to go back to your computer and process them.

WATCH FOR HOT SPOTS

Light bouncing around inside the camera, and various properties of your sensor can cause hot spots in your infrared image that aren't detectable in photos made by visible light. One of my dSLRs faithfully produces a hot spot at the entire right edge of the frame. I haven't been able to track down the cause, but have learned to crop my photos in the camera to exclude this area. There's not much you can do about permanent hot spots, other than learn to live with them.

Infrared Post Processing

For the most part, your IR photos won't be usable as-is. They'll be bright red, probably either too dark or too light, and will cry out for some post-processing fixes. This next section will show you exactly what you need to do to optimize your images. I'm going to use Photoshop for my examples, but other image editors have similar tools you can work with.

We're going to start out with a scene that looks like Figure 4.10, when shot in full color with no infrared hanky-panky applied. Once photographed through an IR filter, though, the image appears as shown in Figure 4.11. Yours will look like that, too, because the IR filter you used still passes some visible light, and most of that will be red. So, your basic image will be captured solely by the red-filtered photosites in your sensor. For the most basic kind of infrared photo, all you need to do is convert the image to black and white.

Figure 4.10 The original scene looks like this.

Figure 4.11 Photographed through an IR filter, the same scene has a distinct reddish cast.

One way to do that is to use your image editor's convert-to-black-and-white command, such as Photoshop's Image > Adjustments > Desaturate command. Usually, though, that won't provide you with an effective tonal rendition. Your image will usually look flat and unattractive, as shown in Figure 4.12.

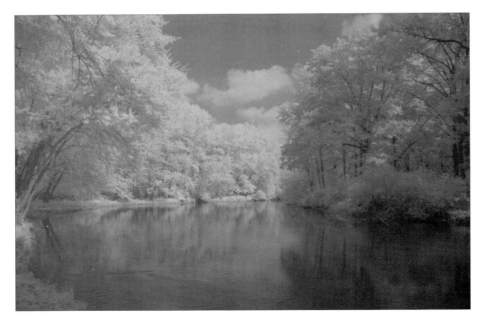

Figure 4.12 A great infrared shot can be ruined by a clumsy attempt to turn it into a black-and-white image, as shown here.

Instead, you'll get better results by viewing the image using Photoshop's Channels palette, looking at the red, green, and blue channels individually. Usually, the red channel will look best. The other two are darker and murkier because the visible and infrared light that sneaks through the IR filter isn't captured as well by the green and blue pixels in your sensor.

With only the red channel visible in the Channels palette, choose Ctrl + A (Command + A on the Mac) to select the entire channel, press Ctrl/Command + C to copy the channel information, then choose File > New and paste the channel down into a new document. Flatten the document and you have a new, monochrome infrared photo like the one shown in Figure 4.13.

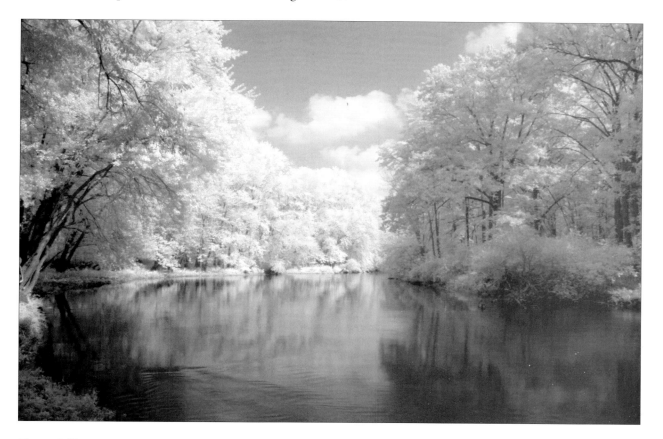

Figure 4.13 Using the red channel only to create a black-and-white image gives the IR shot a brighter, livelier look.

If you want to preserve some of the full color information that seeps through and creates a false-color infrared photo, you'll need to do what is popularly called "channel swapping" to convert the infrared image into a bogus but fascinating color representation. Just follow these steps in Photoshop:

1. Choose Image > Adjustments > Auto Levels. You'll end up with an image that looks like Figure 4.14. You might actually find this look interesting and stop right here. But, to learn about channel swapping, you'd better press on.

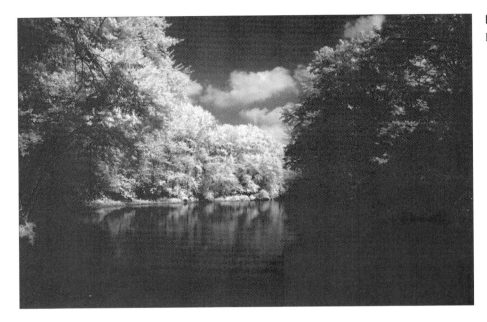

Figure 4.14 Auto Levels produces this look.

2. Next, choose Image > Adjustments > Channel Mixer.

3. The Red Channel should be active in the Output Channel drop-down list at the top of the Channel Mixer dialog box.

4. In the Source Channel area, type 0 into the % box to the right and above the Red slider.

5. Next, type 100 into the % box to the right and above the Blue channel slider. This converts all the Red information to Blue, as shown in Figure 4.15.

6. Choose Blue from the Output Channel drop-down list.

7. In the Source Channel area, type 100 into the % box next to the Red slider.

8. Type 0 in the % box next to the Blue slider, as you can see in Figure 4.16.

9. Click OK. You've effectively swapped the red and blue channels. Your final image should look like Figure 4.17.

Figure 4.15 Change Red to Blue in the Channel Mixer.

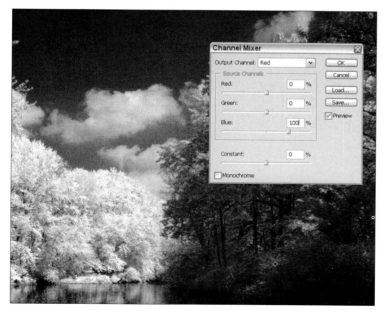

Figure 4.16 Then change Blue to Red.

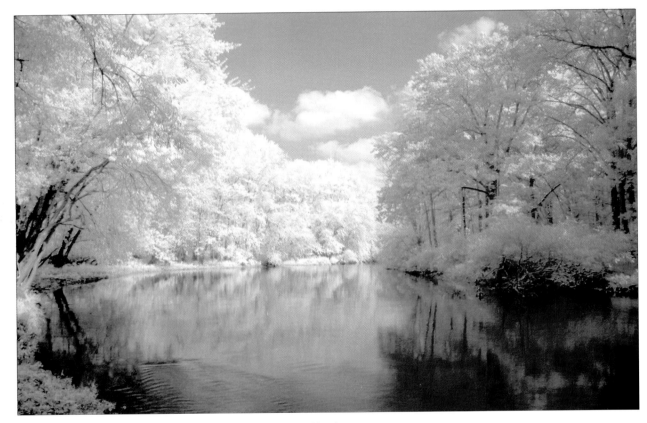

Figure 4.17 The final image with swapped channels looks like this.

Next Up

There's a lot more you can do with infrared imaging. It's become very popular in the fashion world, and can lend a new look to sports photography, too. In this chapter I've given you all the information you need to go out and explore this interesting photographic frontier. In the next chapter, we're going to get small as I show you how to take the related pursuits of close-up, macro, and product photography to the next level with an in-depth look at some advanced equipment and techniques.

5

Close-Up, Macro, and Product Photography

One thing that digital SLRs do especially well is capture images of subjects from relatively close distances. A dSLR might be your tool of choice, whether you're shooting a close-up detail of some component of a classic automobile, a macro shot of a flower, or attempting to portray your company's bread-box-sized product in an attractive way (even though it happens to be about as photogenic as a bread box).

Digital SLRs are eminently suited for this kind of photography because they address the three most challenging technical barriers facing anyone who wants to shoot up-close and personal. Other kinds of cameras might not be quite up to overcoming these potential roadblocks. Indeed, digital SLRs even have some advantages over film SLRs in this arena: In the film days it was common to shoot Polaroid images of product setups to preview lighting and other image attributes. With a digital SLR, you can see the results of your efforts in seconds, make any changes necessary, and then shoot again.

The other key challenges of shooting these types of pictures include framing, focusing, and using the right lens for the job.

For example, framing close-up images accurately can be problematic if your camera uses an optical viewfinder window that doesn't have the exact same field of view as your sensor. Or, perhaps, your non-SLR digital camera uses an LCD viewfinder that shows only 80 to 85 percent of the frame, and is difficult to view under bright or very dim light. Digital SLRs provide the same field of view as the sensor, usually showing 95 to 100 percent of the frame, with a bright, clear view.

Focusing a close-up image can be tricky with non-dSLR cameras, particularly if their non-optional autofocus mechanisms make it difficult for you to choose the exact focus zone used. Even the best LCD viewfinders give you only a rough approximation of the depth-of-field you'll get in the finished photo. Virtually all dSLRs, on the other hand, allow you to choose the focus zone yourself or, if you like, disable autofocus completely so you can focus manually through visual feedback. (Your dSLR may still provide an indicator when correct focus is achieved, even when you're focusing manually.) It's easy to judge depth-of-field with a dSLR, and the DOF preview button found on many cameras closes down the lens to the actual taking aperture so you can view a dimmer but more accurate rendition of the sharpness zone you can expect.

Finally, non-dSLR cameras are probably equipped with lenses that aren't optimized for close-up photography. They may not focus as closely as you would like at the focal lengths you want to use. If you're using a dSLR and the lens mounted on

your camera won't give you the close-up properties you need, you can detach the lens and put on optics that do the job. And your choices of specialized macro lenses are broad, too. You might choose among 60mm, 105mm, or 200mm macro lenses, or select a macro zoom lens, because each of these lenses have advantages for certain kinds of close-up photography (as I'll show you in this chapter).

Of course, you don't need to buy expensive special lenses to shoot macro images or make good product photographs. The lenses you already own might be up to the task if fitted with an inexpensive close-up attachment. Or, that $99, 50mm f/1.8 lens can be adapted easily for this kind of photography.

Macro and close-up photography are a lot of fun because you can find things to shoot anywhere. You don't have to jump into a car or airplane to search for an exotic subject, when you might have something suitable in your refrigerator or spice cabinet. You might even find an exquisite subject right in your own garden, as shown in Figure 5.1. This brand of photography works well with many hobbies, such as coin and stamp collections, gardening, flower arranging, or nature studies. Wouldn't you like to document all that hard work you put into your model airplanes? Are you getting ready to pass on a prized family porcelain figurine to your children, but still interested in retaining a photo

Figure 5.1 You might find a perfect subject for close-up photography in your own garden.

as a cherished reminder? Close-up photography is great for documentation as well as for more creative explorations of the angles, textures, and strange perspectives of objects photographed from inches away.

This chapter explains exactly what you need and how to use it to get great close-up, macro, and product photos.

Elements of Close-Up and Macro Photography

Whether you're photographing your hobby collections, flowers or insects in nature, or your company's high-tech widgets, close-up and macro photography mean just one thing: larger-than-normal images. Beyond that, the exact terminology applied is open to a little debate. Close-up photography is sometimes considered to be images taken from not very far away—usually no more than 12 to 24 inches— while macro photography is often thought of as imagery that's captured much, much closer.

However, as I'll explain, the distance between the camera and the subject is largely irrelevant. Only the relative size of the subject in the frame really counts. After all, a photo taken of a flower from four inches away with a 55mm macro lens will appear to be roughly the same size as one taken from seven or eight inches away with a 105mm macro. So, for the rest of this chapter I'll use the terms close-up and macro more or less interchangeably. However, you should realize that macro photography, regardless of nomenclature, is *not* microphotography (which are tiny little photos, such as microfilm images), nor is it photomicrography (pictures taken through a microscope).

The main elements of macro photography are magnification, perspective, and depth-of-field. I'll explain each of them in the next sections.

Magnification

As I've already revealed, magnification of the subject is more important than focusing distance when you're taking macro photographs. Beginners want to know how close they can get to their subject, without bothering to wonder whether proximity has any real bearing on what they want to do: get a close-up image. Exactly what is it that you want to get close to your subject—the front of the lens or the sensor? A point-and-shoot digital camera with a lens that doesn't extend far out from the camera body might be able to focus within two inches of the front of the camera. A different camera with the same focal length lens, but a different lens design that protrudes more might be able to poke its snoot within an inch of the same subject and achieve sharp focus—and yet produce exactly the same size image. In practice, it's the distance from the sensor's focal plane to the subject that matters (when it matters).

And most of the time, it's the focal length of the lens and the magnification you achieve that's more important than the raw distance between your lens hood and the subject you're shooting. For example, if you're photographing your stamp collection, you might be able to fill the frame with a particular stamp using a 55mm macro lens from four inches away, or achieve the *exact same size* frame-filling image with a 200mm macro lens positioned 15 inches distant. Both lenses provide roughly the same magnification, even though one can focus much more closely than the other. It's the magnification that counts. Figure 5.2 shows an example of

Figure 5.2 Taking a photo from a few inches away with a wide-angle lens (top) produces the same size image as one captured at double the distance with a lens of twice the focal length.

this phenomenon, using a three-dimensional object. The top image was pho-
tographed from a few inches away with a wide-angle lens. The bottom version was
captured with a lens having roughly twice the focal length, but from twice as far
away. The images are roughly the same size, but the perspective is subtly different.

With a flat subject like a postage stamp, there really isn't much of an advantage
with using one lens over the other. That's not true of other types of subjects, as
you'll see in the next section on perspective. Because final image size depends on
both the lens focal length and distance to the subject, magnification is the most
useful way of expressing how an image is captured with macro photography. If
your magnification is 1X, the object will appear the same size on the sensor (or
film) as it does in real life, completely filling the frame. At 2X magnification, it
will be twice as big, and you'll only be able to fit half of it in the frame. At .5X,
the subject will be half life-size and will occupy only half the width or height of
the frame. These magnifications are most commonly referred to as ratios: 1X is
1:1, 2X is 2:1, .5X is 1:2, and so forth. As you work with close-up photography,
you'll find using magnifications more useful than focusing distances.

In fact, macro lenses are often spec'ed based on the magnifications they provide.
One macro lens will be advertised as providing 1:2 magnification, while another
is listed as offering 1:1 (or 1X) magnification. You'll even see some "macro" zoom
lenses listed with, say, 1:4 magnification, even though such paltry capabilities
barely qualify as macro specifications at all. Even so, magnification figures allow
you to compare lenses and accessories based on their real-world close-up per-
formance.

Perspective

Once you begin photographing subjects that are not flat like postage stamps or
coins, the concept of perspective comes into play. Lenses that provide the exact
same degree of magnification don't offer the same perspective, for the same rea-
sons that wide-angle lenses and telephotos provide different views of a subject.
Parts of a subject that are much closer to the lens, relatively speaking, than other
parts are rendered much larger, in proportion.

Just as noses grow in apparent size and ears shrink when shooting portraits with
a wide-angle lens, if you're taking a macro photograph of, say, a small figurine, the
portions of the figurine closest to the lens will look oversized when using a macro
lens with a shorter focal length, and more normal when shot with a macro lens
having a longer focal length. That's true even if the magnification provided in
either case were exactly the same.

You can see how this works by studying Figures 5.3 and 5.4 carefully. The former
was taken with a wide-angle lens, while the latter was shot from the same angle
twice as far away, with a lens having twice the focal length. As in Figure 5.2, the

Figure 5.3 The perspective in this close-up taken with a wide-angle lens from a few inches away...

Figure 5.4 ...is very different from this version taken from twice the distance with a longer lens.

two versions are about the same size. However, you can see the perspective differences more clearly. See how, in Figure 5.3, the flower in the clown's hat is partially hidden behind his tuft of hair, because the lens was so close to the figurine that the hairline actually obscured part of the flower. Yet, from a greater distance, the flower is completely visible, even though the angle from the camera to the figurine was kept the same. See how the clown's nose is larger in Figure 5.3—because it's closer to the camera—even though, overall, the face seems to be narrower than in Figure 5.4. Similarly, the ears are smaller in the first version than in the second. You need to take these perspective differences into account when shooting three-dimensional subjects.

There are four main reasons why macro lenses are offered in various focal lengths:

- **Perspective.** Longer lenses may provide more acceptable perspective for three-dimensional objects. Such lenses are bulkier, and gain even more length as they are focused, proportionately, compared to macro lenses of shorter focal lengths. However, when you need the perspective a longer lens provides, you'll

accept those drawbacks to get it. Many photographers (myself included) own several macro lenses. I use my compact, convenient 55mm macro lens when appropriate, and turn to my 105mm macro lens when I need its perspective (or other characteristics described next).

- **Distance.** I've already mentioned twice that a macro lens with a longer focal length must be used at a greater distance to achieve the same magnification. When you're photographing living creatures that are difficult to approach closely, that distance can be important. Beasties with even a modicum of intelligence, such as tree frogs, will become apprehensive when a photographer pokes a macro lens at them from a couple inches away. Others, like hummingbirds and other flighty creatures, may flee entirely. In such cases, you'll find that a 200mm or similar focal length macro lens can provide the perfect combination of magnification and subject distance.

- **Ease of lighting.** When you're shooting three-dimensional objects, one thing you'll have to contend with is the need to illuminate your subject. A longer focal length gives you more room to place lights or even simply to allow the existing lighting to make its way to your subject.

- **Extra magnification.** When using conventional macro lenses, getting closer and closer to your subject to increase magnification requires increasing the distance between the elements of the lens and the sensor. For example, a 55mm lens might require 55mm of extension to produce a 1:1 magnification, and 110mm of extension to create a 2:1 magnification factor. To get the same magnification with a 200mm macro lens, you'd need 200mm (four inches) of extension for 1:1 and a whopping 400mm (eight inches!) for 2:1. Obviously, it's easier to get higher magnifications with shorter lenses. There are other techniques that I'll show you later in this chapter.

When you're shooting tabletop setups, especially product shots or things like architectural models, perspective and lighting become especially important. Use the right macro lens and distance, and your perspective and lighting will be realistic and flattering. Use the wrong macro lens (say, one with too short a focal length) and your model may more closely resemble a badly lit mockup.

Depth-of-Field

The third technical consideration for close-up photography is the depth-of-field – or lack of it – that you might have to work with it. Depth-of-field is most important when working with three-dimensional objects. You probably don't need much when you're photographing stamps and coins, but will require a great deal more for your product photography or those shots of your pewter soldier collection.

While the available DOF is related to the focal length of the macro lens you use, it's usually not an overriding factor in choosing the focal length of your lens. All macro lenses (or any other type of lens) have limited depth-of-field when used to photograph subjects up close, so you'll have to deal with it whether you're using a short macro, telephoto macro, or tele-zoom macro lens. Choose your focal length based on perspective and distance first, and the magnification you hope to achieve.

Of course, the depth-of-field provided by a given lens is also related to the f/stop used, with larger f/stops providing less DOF, and smaller f/stops offering more. You can review Chapters 2 and 3 if you need a refresher on depth-of-field, its causes, and effects. However, as a general rule of thumb, figure that you'll want to use a small enough f/stop to provide ample DOF in most cases, unless you're using selective focus as a creative tool.

At typical close-up distances, even a few f/stops either way can make a dramatic difference, as you can see in Figures 5.5, 5.6, and 5.7, taken at f/5.6, f/11, and f/22, respectively.

Figure 5.5 This version was taken with the lens opened to f/5.6.

Figure 5.6 There's more depth-of-field when the lens is stopped down to f/11.

Figure 5.7 Without changing the focus point, it's possible to get this much depth-of-field at f/22.

Equipment Required

The good news is that you probably have most of what you need to get decent close-up photos. Just about any dSLR with, perhaps, a close-up lens attachment or an extension tube or two (both available for $60 or less), can do the job. The bad news is that, as you do more macro work, you'll find that more specialized equipment and accessories will let you do your job faster, provide sharper results, or enable you to achieve greater magnifications. Close-up gadgetry isn't overly expensive (most accessories cost $100 to $300 unless you decide to purchase a fancy macro lens or specialized lighting equipment) compared to, say, sports photography (where fast, long lenses can cost thousands of dollars). You can become as equipment-obsessed as you want, or not, if you choose. This section will outline the equipment options so you can decide for yourself what you must have, and what you must do without.

Your Macro dSLR

Most dSLRs already have all the features you need to get started, but not all digital single lens reflexes are created equal when it comes to macro photography. Here are some of the small—but potentially important—differences.

Viewfinder

Any dSLR viewfinder provides a good view of your macro subject, but some are better. The key differences lie in coverage area, viewfinder magnification, and brightness.

- **Coverage area.** Not all dSLRs show the entire area imaged on the sensor in the viewfinder. Some provide a slightly cropped view. That means you have to compose your images more carefully to avoid including extraneous image information in your picture. Ordinarily, it's no big deal to crop out the extra subject matter, but if the view is very inaccurate and you must crop out a lot, then you're wasting pixels that could otherwise have been applied to your image. Vendors provide the coverage area offered by their cameras in the list of specifications. Anything from 95 to 100 percent is very good. A viewfinder with a 95-percent coverage area crops out only the thin band around the edge shown in green in Figure 5.8.

- **Viewfinder magnification.** This factor is more critical. Because of various technical challenges, the viewfinders in some lower-cost dSLRs offer lower magnification than others, particularly if you're used to viewing the big bright image of a film SLR. Magnification is relative to the focal length of your lens, of course, but the convention is to express viewfinder magnification in terms of the view you'd see with roughly a 50mm (equivalent) lens. If the size of the image through the viewfinder seems to be the same as the image seen with

Figure 5.8 If your viewfinder shows 95 percent of the actual image area, you lose only the portion around the edges shown in green.

the unaided eye, the viewfinder magnification is said to be 100 percent. Some dSLRs provide a relatively tiny view of 72 percent or less. Others offer 86-percent magnification or more. The more magnification you get, the easier it is to view, compose, and focus your subject. Figure 5.9 shows the difference in apparent size between an 86-percent viewfinder and one with only 75-percent magnification.

■ **Brightness.** Those viewfinders with small magnification factors look small *and* dim, but other factors can produce a view that's not bright. Some cameras use expensive solid glass prism systems to bounce the light from the mirror to your eye. Others use mirrors that are much less bright. The focusing screen the image is focused on can also affect brightness. Unfortunately, the relative brightness of a viewfinder image isn't part of its specifications. You'll have to look through the camera and compare it to views through other dSLRs to know if the view is as bright as it can be, or check the discussions in photography user forums for guidance.

BOOSTING MAGNIFICATION

Some dSLRs can be fitted with magnifying eyepieces that enlarge the viewfinder image. They cost around $50, and can be well worth the expenditure.

Figure 5.9 A viewfinder with 86-percent magnification is much easier to use than one with the 75-percent magnification found in some budget dSLRs.

Depth-of-Field Preview

Most dSLRs have a button that can be depressed to stop the lens down from the viewing aperture (wide open) to the f/stop that will be used for the actual exposure. This DOF preview can provide a more accurate look at how deep the zone of focus will be, although stopping down the lens also makes the view dimmer and harder to see. Other cameras have no DOF button at all.

Mirror Pre-Release

I've already discussed the advantages of having a mirror pre-release capability in earlier chapters. A mirror lock-up lets you swing the mirror out of the way just before exposure, minimizing movement of a tripod-mounted camera, and potentially providing sharper images during exposures of about 1/15th second to 1 second. (Mirror vibration has less effect on exposures that are longer or shorter than that.)

Interchangeable Focus Screens

High-end, professional dSLRs, and a few less pricey cameras offer interchangeable focus screens. Some screens are better for close-up photography than others, offering extra brightness and/or grids that make it easier to line up subject matter in the viewfinder.

In-Camera Image Stabilization

At this writing, Konica Minolta is the only dSLR vendor offering cameras with image stabilization built in. Anti-shake mechanisms mean you can hand-hold your camera at longer shutter speeds. If you're shooting macro photos without a tripod, this steadying can be an enormous advantage. Of course, that's assuming you can maintain the same distance from your subject so that it isn't subjected to changing focus, too.

Image Stabilization: In the Camera or In the Lens?

Although most photographers think of image stabilization in terms of what it can do for them when using long lenses (say, for wildlife photography) or for low light photography (when you have to shoot at 1/8th second wide open), it is also an exciting option for macro photography. When shooting close-up pictures, you might not be using a long lens, and might need to use a relatively slow shutter speed, not because the light is lacking, but because you want to expose at f/22 to maximize depth-of-field.

If you're not using a tripod, IS can help steady your camera and allow you to use a reasonably slow shutter speed without the need to boost ISO to noise-filled levels. When IS is activated, the camera or lens

makes adjustments to counter camera shake by moving lens elements or the sensor itself. Which method is used depends on which digital camera you have. Canon, Nikon, and others use optical image stabilization, while Minolta builds the technology right into the camera. The advantage of in-camera IS is that you don't need to purchase a special lens to put it to work. If you're using a Konica Minolta dSLR, you can use your existing macro lens and still benefit from anti-shake technology.

The chief pitfall of using IS for macro work is the need to keep the camera at a fixed distance from your subject. Depth-of-field may be so shallow that camera movement along the axis of the lens may throw the image out of focus. Image stabilization counters up and down and side to side motion, and does nothing for camera movement that's back and forth. So, you'll still need to keep a steady hand when shooting up close, even if you have IS operating.

Lenses for Macro and Product Photography

Product photography of bread-box-sized objects (which is what we'll be covering later in this chapter) isn't as demanding as all-out macro shooting in terms of lens requirements. For product photos, you may even be able to get away with the basic lens furnished with your camera.

It's a different story for true macro work. For the best results, you'll want a lens designed specifically for close-up photography or, if one is not available, a lens that is known to perform well in this application. I'll explain the various types next.

Using Your Existing Lenses

Your current lenses, even zoom lenses, can be used for macro photography if they focus closely enough. Although these lenses aren't designed to produce optimum results at close range, they'll frequently provide pleasing results. If they don't focus closely enough, I'll show you how to enable them to focus closer using close-up attachments, extension tubes, and other accessories, later in this chapter.

Although zooms can be pressed into service for macro work, you'll find that fixed focal length, prime lenses will usually do a much better job. Indeed, a lowly 50mm f1.8 "normal" lens (in full-frame terms) may cost less than $100 (if you don't already own one) and will probably be, dollar-for-dollar, the sharpest lens you own. These 50mm lenses frequently make very fine, bargain basement macro lenses. Wide-angle prime lenses in the 24mm to 35mm range can be your second choice for double duty. Even longer lenses, such as 85mm to 105mm optics, can make good macro lenses when coupled with some of the accessories described later on.

Using Special Macro Lenses

These are lenses designed especially for close-up photography, in focal lengths from about 50mm to about 200mm. I've already outlined earlier why it's useful to have macro lenses in a variety of focal lengths to increase distance and optimize perspective. Specialized macro lenses include features like smaller minimum f/stops (f/32 or f/45 apertures are not that unusual), longer focusing barrels to allow increasing magnification without the need for attachments, conveniently placed controls to allow switching into macro focusing mode, and "limit" switches that confine the lens' autofocus mechanism to either the close-up or the normal focusing range so your camera won't "hunt" needlessly back and forth. Of course, most importantly, such lenses have optics that are optimized for sharp close-up images.

Macro lenses can cost a few hundred dollars or more than $1,000, depending on the lens and its capabilities. If the expenditure gives you pause, remember that a macro lens can also be used for non-macro work. That 105mm f/2.8 macro lens is a fairly fast medium telephoto lens, too.

Close Focus Gadgetry

There are a lot of gadgets and accessories that make your close-focus work a lot easier and more productive. This section will cover the key add-ons you'll want to consider to save yourself time and produce better results.

Close-up Lenses

Don't confuse badly named *close-up lenses*, with actual macro lenses. The former are actually filter-like attachments that screw onto the front of a true lens and enable it to focus closer. Technically, close-up lenses *are* simple lenses; they just lack the mounts and focusing mechanisms that would allow you to use them all by themselves. Instead, they must always be used attached to another lens.

Close-up lenses, like the one shown in Figure 5.10, are generally labeled with their relative "strength" or magnification, using a measure of optical power called "diopter." The diopter value of a lens measures its refractive power, expressed as the reciprocal of the lens' focal length in meters. A diopter with a value of 1 would, all by itself, focus parallel rays of light at one meter; a 2 diopter would focus the light at 1/2 meter, and a 3 diopter would focus the light at 1/3 meter.

Figure 5.10 Diopter lens attachments can add close-focusing capabilities to non-macro lenses.

Of course, these lenses aren't used all by themselves when serving as close-up attachments for camera optics. In that case, you need to factor their magnification in with the actual focusing abilities of the lens. In this configuration, close-up lenses are available in magnifications from +1 diopter (mild) to +10 diopters (strong). The actual formula used to calculate the effect of a diopter lens is:

Camera Focal Length/(1000/diopter strength)=Magnification at Infinity

So, a +4 diopter mounted on a 125mm lens would work out to 125/(1000/4)=0.5, or half life-size *when focused at infinity.* Magnification is larger when a lens equipped with a diopter attachment is focused even closer. For example, if a 50mm lens normally focuses as close as one meter (39.37 inches; a little more than three feet), a +1 diopter will let you focus down to one-half meter (about 20 inches); a +2 diopter to one-third meter (around 13 inches); a +3 diopter to one-quarter meter (about 9.8 inches); and so forth. If your lens normally focuses closer than one meter, you'll be able to narrow the gap between you and your subject even more.

Diopter attachments can be stacked to provide greater magnification. You can purchase several close-up lenses (they cost roughly $20 each and can often be bought in a set) so you'll have the right one for any particular photographic chore. You can combine several, using, say, a +2 lens with a +3 lens to end up with +5, but avoid using more than two close-up lenses together. The toll on your sharpness will be too great with all those layers of glass. Plus, three lenses can easily be thick enough to vignette the corners of your image.

The key factors to consider when using diopter attachments are these:

- **Quality varies.** As with filters, the quality of construction and the glass itself can vary from vendor to vendor. While most filters are simply flat pieces of glass with an antireflection coating, and then mounted in a frame, diopter attachments are true lenses. So, the quality of the lens can impact the quality of your final image, particularly if you do choose to stack a pair of them together. More expensive diopter lenses may consist of more than one element, such as the two-element diopters known as *achromats.*

- **No effect on exposure.** Close-up lenses have virtually no effect on exposure, which is not true with other macro options that increase magnification by lengthening the distance between the lens and the sensor.

- **Works with multiple lenses.** A diopter attachment can be used with any lens having a compatible filter thread size or appropriate step-up or step-down ring.

- **May cause vignetting.** As with filters, a close-up lens or stack of lenses can cause vignetting.

- **No infinity focus.** With a close-up lens attached, your lens will no longer focus to infinity; it can only be used for macro focusing.

Extension Tubes

Extension tubes are a solution for those who already own a macro lens and want to increase their magnification by getting in tighter with a subject, as well as those who own a non-macro lens that could be pressed into service for close-ups if only it could focus a little closer. They operate by increasing the distance between the lens and the sensor. You attach the tube to your camera body (it has a fitting that's just like the attachment end of a lens), and fasten the lens to the tube's mount, which is a twin of the lens mount on your camera body. The tubes come in various depths, from about 10–12mm to 50mm, as you can see in Figure 5.11.

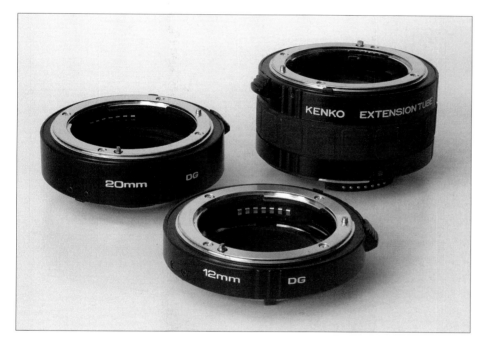

Figure 5.11 Extension tubes come in several different sizes, each producing a fixed amount of extension.

The combination provides a closer focusing range for your lens, with the range depending on the depth of the tube and the original focusing range of your lens. The simplest way to visualize what an extension tube does is to imagine the lens focused at infinity. In that mode, attaching a 50mm extension tube to a 50mm lens would produce a combination capable of producing a life-size (1:1) image *when the original lens is focused at infinity.* A 25mm extension tube would give you a 1:2 (half life-size) image, while a 12.5mm tube would produce a 1:4 magnification. In practice, the focusing mechanism of the lens being extended continues to operate, so you can focus even closer than those minimum figures.

You're probably already way ahead of me on this, but those tube extensions used in the previous example provide different magnification factors when used with lenses of shorter or longer focal lengths. For example, when a 50mm tube is used

with a 25mm lens, you get a 2:1 (twice life-size) image; the 25mm tube gives you 1:1 magnification, and the 12.5mm tube offers 1:2 magnification.

Similarly, when used with a 100mm lens, the 50mm tube produces 1:2 magnification (half life-size), the 25mm tube 1:4 magnification, and so forth.

Things to consider when using extension tubes:

- **Reduced exposure.** Moving the aperture farther from the sensor reduces its apparent size, causing a decrease in exposure. The penalty is two f/stops for an extension equal to the focal length of the lens; that is, moving a 50mm lens out an additional 50mm using an extension tube changes the lens' maximum aperture from, say, f/2 to f/5.6. Or, a working f/stop of f/11 would actually be the equivalent of f/22. Your camera's autoexposure system should compensate for this reduced exposure automatically, but if you're calculating exposure manually for some reason, you should be aware of the difference.

- **No quality hit.** Unlike diopter lenses, extension tubes don't affect the quality of your image. There are no glass elements in an extension tube.

- **Mechanical/electrical coupling.** When your lens is separated from the camera body, provisions must be made to restore communications between the lens and camera for functions such as automatic aperture open/close commands, aperture setting, and automatic focus. The least expensive extension tubes may have none of these, turning your lens into a manual focus, preset exposure lens (which can be a major problem if you have a lens without an aperture ring—the aperture is set from a dial on the camera body). Or, an extension tube might have auto aperture open/closing (so you can view the image with the f/stop wide open, but the lens closes down to the taking aperture automatically when the shutter is released). The best tubes retain all automatic functions, using couplings like those shown in Figure 5.12.

Figure 5.12 The best extension tubes have couplings for all the automatic features of your lens.

■ **Autofocus limitations.** The loss of light using extension tubes may reduce the amount of illumination on the focusing screen (which is used by the camera to measure contrast of the image and set focus) sufficiently that, with slower lenses, autofocus no longer works. The tipping point is often around f/5.6. If you have an f/4 lens and lose two stops from the extra extension, the lens becomes, effectively, an f/8 lens and autofocus functions may fail. You might be forced to focus manually even though you have "fully automatic" extension tubes.

■ **No infinity focus.** As with close-up lenses, you can no longer focus to infinity when a lens is mounted on an extension tube.

Bellows

A bellows is an accordion-like, variable length extension that is much more flexible (ahem) than an extension tube, because it can provide a full range of magnifications, not simply the relatively fixed set offered by extension tubes. One end of the bellows has a lens-like mount that attaches to your camera, while the other end has a camera body-like mount used to attach the lens, as you can see in Figure 5.13. Supporting the bellows is a rail that can move the lens-end of the bellows closer to and farther from the camera body, decreasing and increasing the amount of extension.

The whole thing is attached to a focusing rail mounted on a tripod. The focusing rail can be moved to and fro in relation to your subject. In that way, you can set

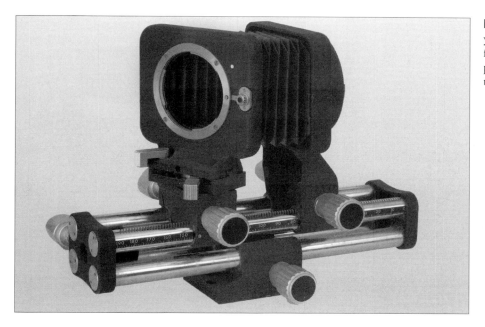

Figure 5.13 A bellows lets you extend your lens much farther from the sensor than is possible with a set of extension tubes.

the amount of extension with the upper rail, and then move the entire assembly closer or farther from your subject. Both sets of rails are often etched with millimeter markings, so you can easily see how much extension is being used, and how far you are moving the bellows toward or away from your subject.

You'll find that a bellows costs quite a bit more than extension tubes, usually several hundred dollars or more, and may be more difficult to find in your local camera shop. They're worth a special order if you do a great deal of close-up work and want to extend your lenses as far as possible. Keep in mind that bellows don't couple with the autofocus, autoexposure, or autodiaphragm features of your lens, so you'll have to handle these tasks manually. Some bellows are equipped with a "double" cable release that can stop down your lens at the same time it trips the shutter, but these gadgets were designed for film cameras. Modern digital SLR cameras generally don't have the older-style screw-in cable release sockets, and rely on electrical or infrared remote triggers instead.

Bellows often have sophisticated features to further increase your close-up versatility. These include:

- **Rotating camera mount.** This allows you to rotate the camera from the horizontal to the vertical position while the bellows itself is still attached to a tripod. You can then shoot horizontal or vertical compositions without adjusting the tripod's orientation.

- **Lens standard shift/tilt.** This feature lets you move the lens up or down vertically, or tilt the lens up and down or rotate it side to side, providing fine-tuning perspective adjustments much like a perspective control lens or view camera.

- **Rotating standard.** This feature lets you reverse the lens mounting standard so that the lens can be oriented with the front elements pointing toward the sensor, and the rear elements toward your subject. This orientation provides a bit more magnification and can improve sharpness. I'll tell you more about this technique later in this chapter.

- **Slide copy attachment.** These fasten to the bellows and allow copying 35mm slides with a digital camera. Such an attachment, like the one shown in Figure 5.14, can be useful for those who don't have a scanner capable of capturing transparencies.

Figure 5.14 Slide copier attachments let you make digital duplicates of your 35mm slide collection—or copy negatives, too.

Other Useful Gadgets

There are a few other useful gadgets and accessories that can make your close-up and product photography easier. Here are some of them.

Focusing Rail

Even if you're not using a bellows attachment, you can find separate focusing rails that can be used to help you precisely position your camera. Although there are variations in how they are constructed, the basic concept is the same. The focusing rail consists of three components:

- **Focusing Block.** This is a block with a standard socket that attaches to a tripod. It has a slot that accepts the rail itself, and has a screw to lock the rail into one position, and a knob that can be turned to move the rail back and forth.

- **Focusing Rail.** This is a machined metal shaft that mates with the focusing block and slides within its track.

- **Focusing Stage.** This is a camera platform that fastens to the top of the focusing rail, and includes a tripod screw that can fix the camera to the stage. It may also have a knob to advance the stage back and forth along the rail, plus a screw to fix the stage tightly in one position.

To picture what a focusing rail looks like, examine Figure 5.13 shown earlier, and visualize a camera mounting platform replacing the bellows on the top rail. With the camera, tripod, and focusing rail all fastened together, you can independently move the camera closer or farther from your subject, or move just the rail, in very fine increments. You'd use this system to make small changes in the distance between your camera and subject (without the need to move the subject matter, which might be carefully positioned). Perhaps you've set the lens to its closest focus position, and simply want to move the camera until a certain portion of your subject is in sharpest focus. If you do a lot of close-up work at very short distances, a focusing rail can be an especially valuable accessory.

Reversing Rings

Reversing rings let you reverse engineer your lenses, in a sense. Even if use of bellows or extension tubes lets you focus your lens closer than you could normally, you might not be getting the best optical performance from that lens, particularly if it is not a macro lens to begin with. That's because lenses are designed to be their sharpest when the distance between the subject and the optical center of the lens is *greater* than the distance from the optical center to the film or sensor. If you tip that relationship on its head, your lens may not perform at its best.

The solution is to mount the lens backwards, so the lens mount is facing your subject, and the "front" of the lens is pointed towards the sensor. This orientation usually produces sharper results, and may even increase the magnification factor.

A reversing ring is a dual-sided metal ring with a male thread matching your lens' filter thread on one side, and a duplicate of the lens mount on the other. Simply screw the threaded side into your filter thread, turn the lens around and mount it on the camera, facing the "wrong" way, as you can see in Figure 5.15. You can also mount the reversed lens on an extension tube or two, or on a bellows to get the maximum amount of magnification.

Figure 5.15 With a reversing ring you can mount a lens on your camera with the "front" facing the sensor.

You can also purchase the inverse of a reversing ring, which has a female filter thread on one side and a camera mount on the other. This ring fastens to the other end of the reversed lens, adding a filter thread that can be used to attach a filter if you like, but which is most often coupled with a slide copying attachment or other accessory that normally screws onto the front of an unreversed lens.

When a lens is reversed in this manner, its automatic diaphragm is disabled for both automatic stop-down and autoexposure features (you'll have to change the aperture manually, assuming your lens has an aperture ring), and autofocus is also uncoupled. So, you'll need to focus manually, too. Reversing rings are an excellent accessory for turning non-macro lenses into close-up optics, and work particularly well with prime lenses in the normal to wide-angle focal lengths, and can take you *really* close for shots like the one shown in Figure 5.16.

Figure 5.16 A reversed lens can get you really, really close with a high degree of magnification.

Bellows Lenses

These are a specialized kind of lens, designed especially for macro use on a bellows. Unlike a conventional lens, these are mounted in short barrels, such that even with the extra extension provided with a bellows you can focus to infinity. That capability means you can use a bellows lens over a wider range of distances, from the inch or less your bellows offers at maximum magnification, to distances of several feet all the way out to infinity.

You might be able to adapt many oddball lenses not specifically built for use with a bellows if you can find a way to mount them on your bellows, and the lens is capable of covering the image circle of your sensor when extended. For example, I've used several of my old enlarger lenses successfully on a bellows.

Backgrounds

Although backgrounds aren't really gadgets, they make useful accessories for your close-up shooting. Plain backgrounds can provide a neutral setting for your close-up or tabletop shots, while not-so-plain backgrounds can add some interest. You'll want to collect various backgrounds.

Seamless rolls of paper make good backgrounds for product shots, especially in white, because you may need to "knock out" the background so the product image can be overlaid within an ad, brochure, or slide in a presentation. For smaller items, a piece of posterboard can be bent into a curve to give you a clean, unobtrusive background like that shown in Figure 5.17.

Figure 5.17 A piece of posterboard can make a smooth seamless background.

You'll also want to collect lots of swatches of colored cloth, like those in Figure 5.18, as well as lengths of fabric. Black velour or velvet is particularly useful, as it absorbs virtually all the light that strikes it, giving you the ability to create pitch-black backgrounds when you need them.

Figure 5.18 Cloth swatches and rolls of fabric make excellent backgrounds.

Lighting Equipment

Close-up, macro, and product photography is so heavily steeped in careful planning and deliberate composition that you'll want to put forth your best efforts in lighting your subjects, too. Your lighting options include existing light (modified with reflectors if necessary), electronic flash units, and incandescent lamps, which can range from high-intensity desk lamps to photoflood lights. In rare cases, you might use light emitted by your subject matter if you're shooting a romantic dinner's place settings, illuminated by candlelight.

Whether using continuous lighting or electronic flash, you'll want to use the same lighting techniques you'd apply to portraiture (you'll find more information on portrait and other kinds of lighting in Chapter 6). Such lighting can be contrasty, providing just enough illumination for the highlights of your subject, but with not enough light to open up the shadows. Or, your illumination of choice might be more even or diffuse. Just keep in mind that contrasty lighting tends to emphasize details and "look" sharper, while more diffuse lighting masks defects and "looks" softer.

Learn to use reflectors to provide main lighting and to fill in shadows (again, more on this in Chapter 6). Pieces of cardboard, foamboard, aluminum foil, Mylar sheets (such as space blankets), and umbrellas can be used successfully with macro photography. A particularly useful tool is a tent, which "wraps around" your subject and provides soft, even illumination from all sides. Tents are great for product photography of shiny things, such as jewelry or silverware. I'll show you how to make your own tent from common household materials in Chapter 7.

Don't forget to have some black "reflectors" as light blockers to reduce the glare from bright sources of illumination. A sheet of black posterboard works, although even black reflects some light. For extra light absorption, consider a small piece of black velour. If you're trying to take photos of seashells in their natural habitat, a black cloth will help.

Flash Light

I'll cover electronic flash in more detail in Chapter 6, but want to point out that the flash built into your digital camera may work fine for quick-and-dirty pictures, but usually it will provide illumination that is too bright, too harsh, and might not cover your subject completely. This is because built-in flash are typically "aimed" to light subjects that are at least a few feet away from the camera. It's more difficult to visualize how electronic flash illumination will look in the finished picture. While available light provides an automatic "preview," with electronic flash, what you get may be a total surprise. On the plus side, the short duration of electronic flash will freeze any moving subject this side of a hummingbird.

Electronic flash is most applicable to macro work indoors, especially if you plan to work with several lights and set them up on stands. Outdoors, you might be limited to one or two battery-operated flash units. Here are your choices for electronic flash used for close-up photography:

- **Built-in flash.** This is the flash unit built into your digital camera. You'll find that in extreme close-ups, the light it produces will look unnatural and may not illuminate your subject evenly. You probably can't aim the built-in flash in any meaningful way, and may find that the lens casts a shadow on your close-up subject.

- **External flash units.** Many digital cameras have a connector for attaching an external flash unit. These can be inexpensive flash units designed for conventional film cameras, or more elaborate (and more costly) devices with modeling lights, which are extra incandescent lamps that mimic the light that will be emitted by the flash.

- **Slave flash.** These are electronic flash units with light-detecting circuitry that automatically trigger them when another flash goes off. You can also purchase add-on slave detectors that set off any flash. Slaves are useful when you want to use two or more electronic flash. Keep in mind that you may need to disable your main flash's preflash feature to avoid tripping the slave too early.

- **Ringlights.** These are specialized electronic flash units made especially for close-up photography. They have circular tubes that fit around the outside of a camera lens, providing very even lighting for close-ups. Ringlights are generally a professional tool used by those who take many close-ups, particularly with interchangeable lens cameras. If you can afford an SLR digital camera, and do enough close-up work to justify a ringlight, they make a great accessory.

Flashlights

No, I'm not really going to suggest that you use flashlights (or "torches" in jolly old England) to illuminate your macro and product shots. But, other forms of incandescent lights are excellent tools for lighting indoor close-ups of things that don't move readily. While not as intense as electronic flash, that's not usually a problem with your camera locked down on a tripod and with longer exposures. Many of the close-up illustrations in this chapter were taken with incandescent lighting. Their main advantage is that you see exactly what your lighting effect will be (indeed, studio flash units usually have an incandescent light, too, not for illumination but as a "modeling light").

Incandescent lights are cheap, too, so you can use several to achieve the exact lighting effect you want. The most important thing to remember when using them is to set your white balance manually, or make sure your camera's automatic white-balance control is turned on. These lights are much more reddish than daylight or electronic flash.

Any gooseneck high-intensity lamp or table lamp that you can twist and turn to adjust its angle will work great as illumination for close-up pictures. Other types of lamps can also be used, but will be less flexible, so to speak, when it comes to positioning. High-intensity bulbs may have too much contrast, especially for shiny objects. You can use reflectors to soften their light, or investigate adjustable neck lamps that can use conventional "soft-white" light bulbs. Watch out for the heat generated by your incandescent lamps! They are a poor choice for photographing ice sculptures or chocolate candies, but a good choice for illuminating burgers and fries you want to be toasty warm after the shoot is over.

Practical Close-Up and Product Photography

Now that you've been grounded in the equipment and basics of shooting up close, I'm going to devote the rest of this chapter to a discussion of various types of macro and product photos you may encounter, and show you some of the things that can be done, using specific examples. Consider these as mini-projects, if you like, and try to apply the techniques I'll be showing you to duplicate or improve on my results.

The Chessboard

Frequently, you'll want to take a mundane object and imbue it with an air of mystery or glamour. For this exercise, I selected a cheap glass chessboard purchased at a close-out store for $3.99, complete with chessmen and a set of rounded glass checkers.

My first attempt was to raise the glass chessboard up on a quartet of risers (actually four 16-ounce spring water bottles) so light could come from underneath if I wanted. Then I set up three of the chess pieces on the board, and a pair of high-intensity desk lamps on either side. A piece of white cardboard made up the background. My initial shot looks like Figure 5.19.

In this case, I focused on the center piece, the queen. With the aperture set to f/16, there was enough depth-of-field provided by my 55mm macro lens to allow all three pieces to be in focus, yet the chessboard itself fades off into blurriness in the background. (Remember that two-thirds of the available depth-of-field is allocated

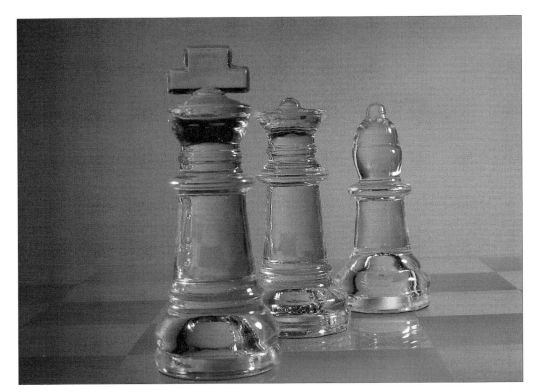

Figure 5.19 Two high-intensity lamps illuminated this scene.

to the area behind the plane of sharp focus, and one-third in front of it.) If you wanted the background to be more out of focus, you might want to focus on the front piece, instead, allowing the available DOF to keep the other two pieces sharp. I fiddled with the lights to get the gradation shown.

To get a moodier shot, I swapped the light colored background for black velour, opened the lens to f/8, and focused on the piece I placed in front in a new arrangement. The wider f/stop threw the other pieces and the background out of focus, and I feathered the lighting simply by moving the desk lamps so the edges of the beam they cast no longer shined on the back of the chessboard or the background. I ended up with the image you see in Figure 5.20.

Sometimes, a dramatic change in viewpoint of your basic subject can prompt ideas for new images. So, I tried getting down low, *under* the chessboard, and shooting up at the pieces for the image you see in Figure 5.21. Then, I removed the chess pieces entirely and started over with the glass checkers, discovering a whole new look, shown in Figure 5.22. The lesson here is not to be satisfied with your first few attempts with a particular subject. Keep changing the lighting, the focus, the angles, the backgrounds, or other parameters until you get something you like.

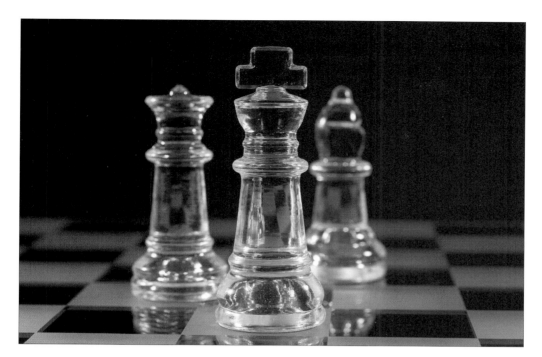

Figure 5.20
Changing the background and the lighting leads to this moodier shot.

Figure 5.21
Shooting up from under the chessboard provides a whole new perspective.

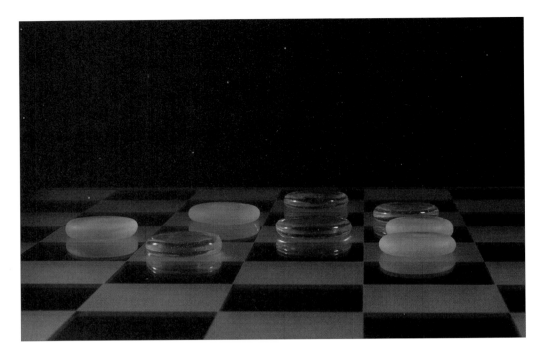

Figure 5.22
Starting over with the squat checkers instead of the tall chess pieces offered additional creative ideas.

Ode to a Glass

As you saw in the previous exercise, transparent objects are a challenge to photograph because they can be formless, colorless, and nearly invisible unless you apply lighting and reflections creatively. Probably the ultimate in transparent challenges is a simple glass of water or other liquid. I picked up such a glass and decided to see what I could do with it in close-up. The basic glass is shown in Figure 5.23, a totally monochromatic image (even though it was shot in color) in which the glass, water, and contrast between the lights form an abstract pattern.

For this shot, I moved the camera above the rim of the glass and used a pair of studio flash units off to either side, but above the glass. I used no umbrella, so the direct flash was sharp and harsh and accentuated the lines of the glass and the reflections in the water.

For Figure 5.24, I dumped out the water, dried the glass, and placed a blue swatch of cloth behind it. Photographed with a large enough lens opening to throw the blue cloth out of focus, this picture shows how transparent objects can be made to assume the colors of their surroundings; the glass itself becomes blue.

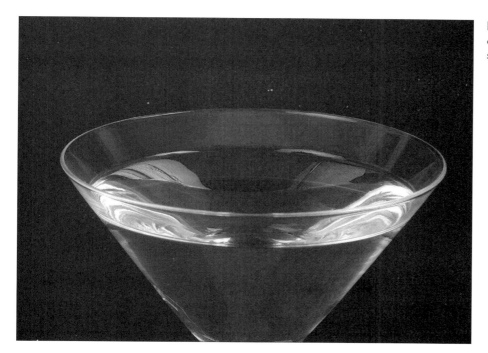

Figure 5.23 Transparency is one of the most difficult subjects to photograph.

Figure 5.24 The glass takes on a blue hue from its surroundings in this simple shot.

Figure 5.25 shows the same glass with a twist of lemon—actually a whole lemon dropped in the glass, and illuminated by a single flash bounced off an umbrella placed to the left. Fill-in illumination came from a reflector off to the right that bounced some of the main flash's light into the shadow areas.

Figure 5.25 Is this a photo of the glass, or of the lemon? Or is it both?

For my final shot, I went back to the original concept of glass illuminated by two flash units, but placed several drops of blue food coloring in the water. I watched the colors snake around until they formed an interesting pattern, then took the image you see in Figure 5.26. Note that for all these shots, and with the chess board photographed earlier, I focused manually, both because I wanted to choose for myself which object should be the focus of the setup, and also because auto-focus systems of digital SLRs sometimes have problems locking in on smooth images of this sort.

Figure 5.26 If your subject isn't quite interesting enough, feel free to add a dash of color on your own.

Knock Yourself Out

As I mentioned earlier in this chapter, one of the tasks you'll commonly encounter when doing product photography is the need to photograph your subject on an absolutely blank background, so it can be lifted out and either put on a new background or presented against a white background so the product blends into the rest of the page, in, say, an ad or catalog. A typical example is shown in Figure 5.27, although, in this case, there's a little bit of shadow under the tomatoes.

I'm going to show you a quick way to knock out a product image from its background, a method inspired by an old film camera technique called *in camera masking*, in which an image of a subject exposed in the camera is used as a mask for itself, to allow that subject to be photographed against a different background in a second exposure. My knockout technique is not the same, because it's not done in the camera.

For my real-life example, I needed a knocked-out shot of a particular camera for a book project. I needed it in a hurry. Although shooting against a white seamless background with lots of light on the background gets you part of the way there, the background that results isn't truly all of one tone. That has to be accomplished later, in an image editor like Photoshop, following the steps I describe next.

1. I mounted the camera I was photographing on a small tabletop tripod, which allowed me to position the camera at any angle I liked. I didn't fret because the tripod was going to appear in the picture; it could be knocked out manually. My initial shot looked like Figure 5.28.

Figure 5.27 Food photos are often photographed against plain, white backgrounds.

Figure 5.28 The original shot looked like this.

2. In Photoshop, I duplicated the base layer containing the camera image, and then used the brightness/contrast controls to crank up the contrast while reducing the brightness, until I had an almost-silhouette of the camera. The goal was to keep the edges distinct, while reducing the background to pure white, as you can see in Figure 5.29.

3. Then, I used the Magic Wand to select the now-white background. I pressed Shift + Ctrl + I (Shift + Command + I on the Mac) to reverse the selection so only the camera (and tripod) were selected.

4. Returning to the original layer containing the camera image, I pressed Ctrl + J (Command + J on the Mac) to copy the selection into a new layer of its own.

5. The knocked-out camera was fairly clean. I had only to erase the tripod image along the bottom edge (which was a fairly easy, straight-line erasure), composite in a fake LCD image, add a little noise to mimic the LCD's texture, and I had my product shot in about 10 minutes from start to finish.

Figure 5.29 A high-contrast version provides a mask that can be used to copy only the camera.

Figure 5.30 After the tripod is removed, the knocked-out version looks like this.

Outdoors, with Glass

The projects in this last section have been heavily oriented towards indoor macro and product photography, but that's not to imply that you can't shoot close-ups

outdoors when the weather is good. The next few sections will emphasize outdoor work, where the challenges can be greater because you don't have as much control over your lighting or environment.

When internationally celebrated Seattle glass artist Dale Chihuly was commissioned to produce a work for a university near me, I was determined to go take pictures of the fabulous hunk of blown glass, even though I would be shooting outdoors where I had less control over the light, and needed to use a longer lens to get true close-ups that showed the texture and shape of the work.

My only control over the lighting was the ability to pick my time, so that's what I did. I waited until two hours before dusk when the sun was low in the sky and captured the photo shown in Figure 5.31, in which a portion of the glass sculpture is illuminated from behind, which really showed off the inner features of the translucent artwork. Then, I moved to the other side and photographed the detail in Figure 5.32, as illuminated by the late-afternoon sun from the front, concentrating on the surface features.

Figure 5.31 This close-up photo of a small portion of a Dale Chihuly glass sculpture (which was actually quite tall) was illuminated from the rear.

Figure 5.32 Shown illuminated from the front, the sculpture has a completely different look and feel.

It's a Jungle out There

The challenge involved in photographing living things outdoors sometimes lies in getting them to hold still! You often have to accept the lighting as it is, perhaps adding a reflector here or there to fill in shadows. But then you have to contend with your subject wandering off or waving in the wind.

For example, the spider shown in Figure 5.33 definitely didn't appreciate my interrupting her web building. Miss Charlotte frequently scuttled up under a leaf and refused to come out until I had remained totally still for a few minutes, even though I was shooting with a 105mm macro lens and keeping a safe distance. I managed this shot during one of her calm periods.

Figure 5.33 The itsy-bitsy spider lacked a handy water spout to flee to, and so ended up in this arachnidan portrait.

For Figure 5.34, I had the wind to contend with. Each time I tried to focus on the thistle, it would waver slightly in the breeze, completely throwing the focus out of whack. Attempting to grab the stem and hold the plant immobile was hopelessly futile, because each touch set the stem vibrating even more wildly than the wind had done. The solution was to wait patiently until the wind died down, focus manually, and, with the lens almost wide open at f/4, capture this shot.

A reversed 35mm wide-angle lens yielded this high-magnification shot of a dandelion, but I had to press the blossom up against an index card to hold it still enough for an exposure. The camera was mounted on a tripod, but focus was still critical for the image you see in Figure 5.35.

Figure 5.34 Photographing this thistle proved to be a thorny problem.

Figure 5.35 A reversed wide-angle lens provides extra magnification for this ultra-close look at a dandelion.

Making Your Own Subject Matter

One of the nice things about macro photography is that if you don't have something interesting to photograph, you can probably scrounge up an interesting subject in your desk drawer. The old, worn micrometer and mystery key were no farther away than my left elbow as I wrote this chapter. I grabbed them from the drawer, set up my camera on a tabletop tripod I keep on my desk, and took this close-up with a 55mm macro lens (see Figure 5.36) using the desk lamp for illumination.

A needle and thread photographed against a black background with desk lamps on either side resulted in this interesting ultra-close-up shot, seen in Figure 5.37. The entire project took only a few minutes to set up and complete, demonstrating that simple subjects can sometimes be the best.

Figure 5.36 "Found" art occurs in the photographic world, too, as you can see in this junk drawer subject matter.

Figure 5.37 A needle and thread are all you need for an interesting composition and study in contrasts.

Instead of reversing a short focal length lens to achieve this degree of magnification, I used my 55mm macro lens on a bellows cranked about halfway out to provide the extension needed for this shot. Because the camera and bellows were locked down on a tripod, I wouldn't have minded a long exposure, but I was afraid the thread would begin vibrating. So, I bumped the sensitivity up a little to ISO 400, focused carefully, and captured this image at about 1/60th second at f/5.6.

Part of the Whole

It's not necessary to show the entire object when shooting a close-up image or product illustration. Sometimes a portion of the subject is all you need to see. When I decided to sell one of my classic cameras on eBay, I knew that condition would be important, and that a serious collector was more interested in details than an overall shot of the camera. So, my eBay auction included photographs like the one shown in Figure 5.38, which revealed the pristine condition of the camera in loving detail.

Figure 5.38 Picturing only part of an object lets you maximize your close-up's content, while emphasizing the most important components.

Of course, I didn't want to exaggerate the smallest defects, and retouching the image to remove them would have been dishonest, so I used soft umbrella light with just enough contrast to show the texture and surface of the camera, without casting shadows that would make small scratches look worse than they were. The lighting provided an accurate rendition of the camera, which sold quickly at a decent price.

Next Up

If you enjoyed working with macro photography, you'll want to check out Chapter 7, in which I show you how to build some gadgets, such as a do-it-yourself reversing ring and a simple lighting tent, that will help you even more. But, before construction begins, you'll want to learn more about pro lighting and studio techniques in the chapter that follows.

6

Pro Lighting and Studio Techniques

For many digital SLR photographers, one elusive goal is to step up from amateur snapshooting to true professional-quality photography. One milestone on that journey is the move into what so many think of when they picture a professional shooter: studio photography. No matter how good a dSLR photographer is, no matter how closely his work matches or exceeds that of working professionals, shooting in a studio seems to be the hallmark of a serious photographer. There's a lot of truth in that, because the ability to work well in a studio environment is one of the skills you'll find in virtually every pro.

Full-time action photographers for leading magazines may spend most of their time in sports venues with long lenses and radio-controlled cameras or lights, but any of them can capture a compelling cover portrait of an athlete back at the publication's in-house studio. Wedding photographers who produce their best work in churches, synagogues, and gardens probably are applying studio techniques to their "candid" shots, and are equally comfortable shooting formal engagement portraits. Commercial photographers find studio skills a must, and pros in the photojournalism field also have opportunities to set up lights and work in a studio.

You're ready to take this step, too, if you haven't already. Many of the techniques in the last chapter apply to all kinds of studio work. Indeed, the kind of product photography I introduced you to in Chapter 5 is just studio photography on a smaller scale. One of the main skills needed in studio photography is the ability to use lighting, and you're well on the way to mastering that, too. Above all, the tips I provided in Chapter 1 on raising the bar on quality will help you become a competent studio photographer. If nothing else, studio photography is about excellence.

Of course, no single chapter can teach you everything you need to know about studio photography. Anything involving studio lighting is fair game in this chapter—including the product-type photography introduced in Chapter 5. What I hope to do in this chapter is show you some of the studio techniques needed to take good individual portraits, and then offer advice on how those techniques can be more broadly applied to group portraits, product photography, and other work in the studio.

Vive Les Différences!

One of the joys of non-studio photography (call it candid photography) is that there isn't a fixed set of skills needed to begin shooting satisfying images. If you knew nothing when you purchased your first dSLR, you could probably set it for autofocus, choose programmed exposure, remove the lens cap, and begin taking pictures. Even fairly specialized photographic realms like sports photography, close-ups, or landscape photography can be indulged in by beginners. Results might not be good, on average, and there might be a large percentage of clunkers mixed in with a smaller number of good shots, but, as they say, practice makes perfect.

Perhaps the reason that studio photography is seen as the purview of the advanced or professional photographer is that there is a basic skill set that needs to be mastered to achieve decent results. It's highly unlikely that you'll accidentally encounter the perfect lighting setup already in place, with no need for tweaking and adjustment. Unless you're working with a professional model or someone with that aptitude, you won't achieve effective posing right off the bat, nor are you likely to set up your product photos in the best possible way. Unless you've learned what to do, your choice of lens and focal length might be less than optimum, and you'll probably position the camera in the worst possible place a few times.

Portraits, in particular, need to follow some established conventions in posing and lighting if they are going to "look" like portraits. That's the main reason why a professional photographer can shoot a portrait that looks professional whether it was taken in the studio, your living room, or back yard. Figure 6.1 was not taken in a studio, but the same techniques that would have been used in a studio were applied to that image, especially

Figure 6.1 Once you've learned studio techniques, you can apply them anywhere.

for the lighting. In this particular case, I used available light and reflectors to mimic the lighting effects I'd be looking for in a studio.

So, the best way to sum up the difference between studio photography and non-studio photography is to assume that the former is a bit more exacting, that more of the parameters of the shot are under the photographer's control, and studio work requires more skills, knowledge, and experience. Fortunately, if you have the patience to do the job properly, the skills and knowledge can be easily obtained, and will soon add up to a wealth of experience. Indeed, a novice photographer can achieve dramatic improvements simply through better composition and lighting alone.

The good news is that you don't need to have a real studio to shoot studio images. In fact, most of the readers of this book will never have a dedicated studio. At best, you may have a location in your home that serves double-duty as a studio. I've taken some of my favorite portraits in an attic "studio" that was little more than a large space hung with multiple rolls of seamless backdrop paper, a few painted backgrounds, and lots of room to arrange lights. When I moved to a newer home without an attic, my studio moved, too, to a 16 × 20-foot basement area with 10-foot ceilings directly under my home office. The background paper was easy to hang from the ceiling joists.

I've pinned up lengths of fabric to cover our drapery in front of our patio door, arranged lights carefully so they didn't bump up against the exercise bike or piano, and used a bar stool as a posing stool. You can do the same. Even if you don't have room to set aside for a permanent studio, you probably have an area that can be temporarily reconfigured to serve as a photographic environment. Back the car out of the garage, hang a backdrop, and you have a studio. Move the dining room table off to one side and pin up some fabric, and you can have a decent shooting location. If your rec room is a wreck, you still might be able to use it to shoot portraits in a pinch.

Your Studio Camera

Your digital SLR is probably ideal for any studio work you want to do, when compared to your average point-and-shoot digital camera or even those high-end electronic viewfinder models. Here are some of the things to keep in mind.

- **Resolution.** Studio work is sophisticated and exacting, so you'll want to use a camera with at least 6 to 8 megapixels of resolution. Studio shots are often blown up to large size for display, so extra resolution will help you. I think you'll find it hard to resist making 8 × 10 and larger prints of your best efforts, too, so you'll be glad you sprung for a few million more pixels when you bought your camera.

- **Normal to short telephoto lens.** While there is a place for the wide-angle lens in studio photography, most of the time you'll be using a normal to short telephoto zoom lens, in the 40mm to 105mm range. Anything longer than that will require stepping back too far within the tight confines of the typical studio setup. A modest zoom range will give you the focal lengths you need for product photography, as well as a lens that offers flattering renditions of human faces for portraiture.

- **Flash capabilities.** All digital SLRs can connect to an external flash through the hot shoe on top of the prism, but you'll also want the ability to plug in studio flash, which connects to what is called a standard PC or X connector, like the one shown at upper center in Figure 6.2. The PC is said to stand for Prontor-Compur, two early shutter manufacturers, not "personal computer," while X stands for a kind of flash synchronization—in this case, electronic flash. (In ancient times, flash could also mean flash *bulbs* which used M synchronization or FP [focal plane] sync. Today, only X sync remains.) If your dSLR lacks a PC/X connector, a slide-in hot shoe adapter with the appropriate external flash connector can be found. Some more advanced digital cameras, particularly digital SLRs, might be able to work with flash triggered wirelessly. You can also purchase a little gadget that slides into the hot shoe and will trigger your slave-equipped flash units wirelessly.

Figure 6.2 If you want to shoot in a studio, your dSLR must have the ability to connect external flash units.

Digital cameras offer you many advantages in studio photography. Most important of all is the chance to review the images before the session is over. Don't discount the importance of this. Many studio setups for product photography take a significant amount of time to arrange. You may spend quite awhile positioning the lights. If you're shooting a portrait sitting, your victims spent some time getting spiffed up for the photos. There was a lot of time invested even before you began snapping pictures.

With a digital camera and a handy computer or monitor nearby, you can review your images on a big screen, as in Figure 6.3, before you tear down your setup, or your subjects change clothes and become slovenly again. If there are any problems, you can stage a reshoot immediately. Here are some things to look for in both product and people photos:

Figure 6.3 Connect your dSLR to a monitor to review your shots before you tear down your setup.

- **Focus.** Look for images that are poorly focused. It's difficult to tell for sure on your camera's LCD screen, so you might want to copy the images to a computer and check focus on the larger display monitor. Or, your digital camera's video out capabilities might connect directly to a television or monitor in your studio area.

- **Position.** Look for mispositioned objects, gaps between people in a group shot, wrinkled clothing, or unsightly expressions.

- **Lighting.** Check for bad shadows, excessive contrast, hot spots on glasses, and poor separation between your subject and the background.

- **Sharpness.** If you're not using flash, look for blur caused by subject or camera motion.

Studio Set Up

Setting up a studio in your home on a temporary basis has an unexpected side benefit. If the gear you need can be quickly disassembled and packed away, there's no reason why it can't go on the road, too. That informal, portable studio setup that fits in your family room during use, and a closet when it's not being used can probably be toted outside the home and set up in other locations, too.

That's something you should take into consideration when "designing" your home studio: You might want to choose the gear so it can be used in somebody else's home, too, whenever you want to take your show on the road. The equipment you need to assemble breaks down into three categories: lighting gear, backgrounds, and a place for your products and/or victims to reside during the photographic process.

Deep Background

I've already discussed backgrounds in Chapter 5. Now it's time to get serious about your backgrounds. You don't necessarily need an expensive, formal environment. Portraits, for example, can show people in their natural habitat, even when you're shooting formal portraits. You'll find that professional posing and lighting, and perhaps a little judicious use of selective focus will make your image "look" like a portrait, even if the background is the fireplace in the living room, or a wall of books.

Seamless Paper

A long roll of paper can make an inexpensive and versatile backdrop, although they can be expensive to ship (buy yours locally, if you can!), and, in the broader widths, tricky to transport home in your car (take the SUV, pickup truck, or borrow one). All you need to do is hang the roll on some sort of support (more on that later) and unroll as much as you need for your session, bringing enough down

to cover a couple of feet of floor so your subject(s) can stand on it. As a section of the backdrop paper becomes dirty or wrinkled, you just roll down some more, cut off the damaged part, and just throw it away. You can keep a selection of three to five different rolls and switch them as needed.

Seamless paper comes in a variety of colors, widths, and lengths. Although vendors like Savage manufacture rolls that are 140 inches wide, the most popular standard size among pros is 107 inches by 50 yards. If you don't want to spend $170 or more for a single roll of paper, you'll find 107 inch by 12 yard rolls available for as little as $40, and half-roll sizes that measure 53 inches by 12 yards for about 20 bucks. The smallest rolls, 26 inches by 12 yards are even less, but are best suited for close-up and tabletop work.

There are several advantages to using seamless paper rolls for backgrounds:

- **Low cost.** It's hard to beat 36 running feet of background material for $20. You'll wrinkle or soil the part that lays flat on the ground in strips of about three or four feet, so your 12 yards are probably good for a minimum of 10–12 shooting sessions, even if you shred the initial few feet each time. (Tip: a hard surface is easier on the paper than carpet, reducing the tendency for punctures.)

- **Compactness.** You can take down the seamless paper and store the roll upright in a corner when not being used. Or, if your studio is in a garage or a family room with beamed ceilings, you can fasten the roll to hangers on the ceiling and leave it there between sittings.

- **Versatility.** You don't need to buy rolls in dozens of colors. You can change the appearance of a roll of seamless paper simply by adjusting the lighting. A medium gray background can photograph as off-white when brightly and evenly illuminated, or appear to be dark gray and almost black when you reduce the amount of light spilling over from your subject. Colored background lights can change the hue of your seamless paper, and clever use of lights and various go-between (gobo) objects can create textures in shadow that add interest. Or, feather the light to create a gradient from background to foreground.

- **Smooth transition.** Thanks to the "seamless" attribute, there need be no dramatic transition between background and foreground, increasing your flexibility when shooting full-length subjects.

You can just hang your paper rolls from the ceiling, as I did for Figure 6.4. If you're doing a *lot* of studio work, you might want to move up to expensive rigs that have multiple rollers with different backdrops suspended on it. The portrait photographer creates one set of portraits with one background, and then another set with a second or even third background.

Figure 6.4 If your studio is in a basement or garage, you may be able to hang your backdrops from the ceiling.

Textured Backdrops

Interesting backgrounds can be made from textured surfaces, too. Lengths of cloth purchased from a fabric store, a large piece of burlap, a 4 × 8-foot piece of plywood with fake brick glued to it, as in Figure 6.5, can all be used as interesting backdrops. Like seamless paper, these can be relatively cheap, and can be transformed in appearance through the use of lighting and selective focus. While rigid sheets of wood aren't particularly portable or easy to store, you can stack them together against a wall in an area that you've allocated for frequent studio use.

Painted Backdrops

You can buy painted backdrops with everything from abstract patterns to woodland scenes daubed on them, but you can also make your own. Get some large sheets or rolls of canvas, tack the material to a wall, and create your own patterns. Use a sponge and a selection of paints in the same basic colors (blues or browns, say) and dab at random to build up a pleasant background pattern. You might want to start with slightly lighter tones in the center and work your way out to darker shades at

Figure 6.5 Make your own backdrops out of fabric, paneling, or fake brick.

the edges, mimicking the effect of a background light. Or, you might choose to keep the same tonal relationships throughout and use your lighting to provide any needed separation between the subject and the background.

Background Support

If you can't mount a couple hooks in the ceiling to hold your backgrounds, use light stands with a cross bar between them to hold rolls of paper, drapes, or other backgrounds upright.

Lighting Equipment

Effective lighting is the one element that differentiates studio photography from candid or snapshot shooting. Working in the studio gives you the opportunity to illuminate your subject in a flattering, attractive, and creative way. Lighting can make a mundane product look a little more glamorous. I once had a client that manufactured truck clutches and wanted "glamour" product shots, which, as it turned out, was in the client's mind nothing more than the clutch on a white seamless background, lit by a soft spot. When you're shooting people, good lighting can make wide faces look narrower, and thin faces broader. Lighting can diminish the effects of big ears and bald heads—or draw attention to them if your subject feels that distinctive features can be a trademark.

To achieve all these effects, you need lighting equipment that gives you the type of control you need, so the illumination is soft when it needs to be soft, bright and sparkly when you want it so, or strong and dramatic when appropriate. As you might guess, having control over your lighting means that you probably can't use the lights that are already in the room. You'll need separate, discrete lighting fixtures that can be moved, aimed, brightened, and dimmed on command.

Selecting your lighting gear will depend on the type of photography you do, and the budget you have to support it. It's entirely possible for a beginning photographer who does studio work infrequently to create a basic, inexpensive lighting system capable of delivering high-quality results, just as you can spend megabucks for a sophisticated lighting system.

Incandescent Lights

Incandescent lighting is basically the same lighting used in our homes, but in studio work, involves a greater degree of control. You can buy inexpensive specialized fixtures that can be populated by extra-bright tungsten or halogen lamps, using the same kinds of reflectors and other accessories used with electronic flash. Or, you can purchase clamp-on lamps for a few dollars and make the add-ons you need yourself. Here are some of the pros and cons of using incandescent light in your studio, with the pros first:

- **Low cost.** Incandescent lights, even though designed specially for studio use, are relatively inexpensive.

- **What You See Is What You Get.** As long as you've turned off the other lights in the room, the illumination of your subject will be exactly what you see

through the viewfinder. If the shadows are too dark, you'll see that. If there's an unfortunate shadow cast by a nose, you'll see that, too. Incandescent light makes a great set of training wheels for a new studio photographer, because it's impossible to position the lights incorrectly without getting instant visual feedback that reveals your goof.

- **Easy exposure.** The lights illuminating your subject are the same lights used to calculate exposure. You can let your camera's autoexposure system figure it out or meter the exposure yourself using the camera or a hand-held light meter.

Note that even more experienced photographers can benefit from all three of these pros. Everyone likes to save money and dispense with problems visualizing lighting effects or calculating exposure. When I photographed a tripod head for an illustration earlier in this book, I knew I was going to have problems, because the tripod was basically black. I wanted some specular highlights to help edges and corners and other details show up. So I used an incandescent floodlight bounced off an umbrella and manipulated the position of the lamp and umbrella until I got what I wanted, shown in Figure 6.6.

Here are the cons of using incandescent light:

- **Less illumination.** Incandescent lights typically provide much less illumination than electronic flash units at a given distance, so you'll need longer exposures and larger f/stops. Several other drawbacks below are related to this reduced illumination.

- **No action stopping.** Electronic flash freezes any movement, which can be useful when you're photographing people. Incandescent lights with their longer exposures, on the other hand, can promote blurriness if your subject moves during exposure, and from camera shake if you're hand-holding the camera.

Figure 6.6 ■ Tricky subjects can be lit most effectively with incandescent lighting that shows you exactly what you will get.

- **Tied to a tripod.** You'll often need to use a tripod for studio work with incandescent lights. That may not be much of a problem if you're photographing products and using fixed setups. But for people pictures, the freedom to move around with a hand-held camera not mounted to a tripod can be valuable.

- **Color problems.** Your digital SLR's incandescent white balance setting may not match the color of the light your source puts out, forcing you to make fixes in an image editor or fine-tuning your camera's internal white balance. Plus, the color temperature of a lamp can change as it ages.

In general, incandescent lights work best for inanimate objects, still lifes, table-tops, and similar subjects. Electronic flash might make a better choice for people, pets, and things requiring the extra depth-of-field that higher intensity electronic flash affords.

Electronic Flash

Flash has become the studio light source of choice for serious photographers, because of all the advantages you can deduce from the "cons" listed previously for incandescent light: It's more intense, freezes action, frees you from using a tripod (unless you want to use one to lock down a composition), with a snappy light quality that matches daylight, and offers a relatively consistent color balance. (Color balance changes as the flash duration shortens, but some flash units can "report" to the camera the exact white balance they need for any given exposure.)

Similarly, if you read the previous section carefully, the drawbacks of electronic flash should be apparent as well. Strobe lighting is more expensive, doesn't show you exactly what the lighting effect will be (unless you use a second source called a *modeling light* for a preview), and the exposure of electronic flash units is more difficult to calculate.

Fortunately, all these drawbacks can be easily overcome. Electronic flash units designed for studio use can cost $200 or less. You'll need at least two, three would be better, and four would be ideal if you want both a background and hair light. There are flash lighting kits available that include all the lights and accessories you need for a very reasonable price. These all have built-in modeling lamps so you can judge the effects of the light before exposure.

The typical studio flash has something that incandescent lights usually lack: the ability to dial in reduced light levels without the need to change the position of the flash. So, correct exposure isn't all that difficult to calculate, even if you are using your flash at reduced power, because the output is always proportional. If you want one-stop less illumination, cut the power in half, or to one quarter for a two-stop difference. As you'll see shortly, this can be very important when you're balancing light to lighten or darken shadows.

Types of Electronic Flash

Electronic flash units, also called, variously, *strobes* or *speedlights*, come in several different varieties that can be useful in a studio environment, ignoring, for the moment, the flash unit that may be built into your camera. One type is the simple external flash unit that fits in the hot shoe of your digital SLR. The other two are designed specifically for studio applications. The next few sections provide a comparison.

Basic Flash

Although most flash units of this type fit in a camera's hot shoe (or optionally, a flash bracket or frame), they can also be mounted on light stands or other supports and used as studio illumination. Basic flash also are still available as "handle mount" or "potato masher" flashes, which are more powerful and used in professional photojournalism applications, often with separate battery packs.

There are three drawbacks to a basic flash unit. One is that they are designed to operate on battery power and work best in that mode, even if you use a plug-in pack to extend the useful life of the battery juice. An AC adapter might be available for a basic flash, but it might not.

The second drawback to a basic flash unit is the general lack of a modeling light. Some shoe-mount flashes have an ersatz modeling light feature, which flashes the unit many times at low power to provide a sort of continuous illumination you can use to judge the lighting effect. If all other room lights are dim, you might be able to use this effect, especially for very simple lighting setups like the two-umbrella illumination used to create the shot shown in Figure 6.7. However, these

Figure 6.7 Very simple lighting setups, like this two-light product (or produce) shot with even, diffused illumination, can be pulled off even by basic electronic flash units.

multiflashes are too weak to overcome significant available light. Instead, you might be able to rig a small incandescent light next to your flash to serve as a modeling light substitute.

The final problem with using a basic flash unit in the studio is the relatively long recycling time between flashes. When using such a flash on battery power, recycle times may be five to eight seconds or more, which can put a real crimp in your portrait photography. I can guarantee that in every session you'll shoot one picture and your subject will immediately break into a smile a half-second later that you'll want to capture for posterity. A five second delay will seem like half an hour in those cases.

Many flash units of this type can be attached to a beefier battery pack, made by Quantum or other vendors, which not only extends shooting time, but reduces recycling time as well.

Studio Flash

The traditional studio flash is a multi-part unit, consisting of a flash head that mounts on your light stand, and is tethered to an AC (or sometimes battery) power supply. A single power supply can feed two or more flash heads at a time, with separate control over the output of each head.

When they are operating off AC power, studio flash don't have to be frugal with the juice, and are often powerful enough to illuminate very large subjects, or to supply lots and lots of light to smaller subjects. The output of such units is measured in watt seconds (ws), so you could purchase a 200ws, 400ws, or 800ws unit, and a power pack to match.

Their advantages include greater power output, much faster recycling, built-in modeling lamps, multiple power levels, and ruggedness that can stand up to transport, because many photographers pack up these kits and tote them around as location lighting rigs. Studio lighting kits can range in price from a few hundred dollars for a set of lights, stands, and reflectors, to thousands for a high-end lighting system complete with all the necessary accessories.

Monolights

These are "all-in-one" studio lights that have the flash tube, modeling light, and power supply built into a single unit that can be mounted on a light stand. Monolights are available in AC-only and battery-pack versions, although an external battery eliminates some of the advantages of having a flash with everything in one unit.

Monolights can be a little more economical, with 200, 400, and 800 watt-second units available for about $200 to $400. They are certainly more portable, because all you need is a case for the monolight itself, plus the stands and other accessories

you want to carry along. Because these units are so popular with photographers who are not full-time professionals, the lower-cost monolights are often designed more for lighter duty than professional studio flash. That doesn't mean they aren't rugged; you'll just need to handle them with a little more care, and, perhaps, not expect them to be used eight hours a day for weeks on end.

In most other respects, however, monolights are the equal of traditional studio flash units in terms of fast recycling, built-in modeling lamps, adjustable power, and so forth.

Flash Accessories

Flash units don't work in a vacuum. Well, perhaps the *flash tubes* operate within a vacuum, but the units themselves work best when you have the right accessories for controlling and modifying your flash illumination. Here are the key tools and gadgets you need:

Reflectors and Umbrellas

Direct flash is rarely useful, because it's too harsh, too direct, and too difficult to control. Reflectors and umbrellas are essential tools to let you shape the light so it has the qualities you need, while directing it into areas of the scene that need it. Photo umbrellas are just that: large fold-out reflectors just like those you use to shield you from the rain or sun, but with some specialized qualities that make them especially suitable for photography.

Other kinds of reflectors can be pieces of foamboard, Mylar, or a reflective disk held in place by a clamp and stand. Although some expensive umbrellas and reflectors are available, spending a lot isn't necessary. A simple piece of white foamboard does the job beautifully. Use your main light source to light a three-quarter section of your subject, and then position the reflector to bounce light onto the remaining quarter. This will lighten up the shadows and give a greater sense of dimension to your photo. If you want a little less softness in the shadows, use a metallic reflector.

Umbrellas have the advantage of being compact and foldable, while providing a soft, even kind of light. They're relatively cheap, too, with a good 40-inch umbrella available for as little as $20. The key attributes to be aware of when purchasing an umbrella are:

- **Size.** The larger the umbrella, the larger the area the light from your flash is spread over. That means softer light, but also the potential for reduced illumination—particularly if your umbrella is of the translucent variety. You can find umbrellas as small as 30 inches, but the 40-inch variety, like the one shown in Figure 6.8, is among the most popular. If you want a very broad, diffuse light source, look for 50- and 60-inch umbrellas.

Figure 6.8 Umbrellas are inexpensive and provide an even, soft illumination, like this white version, or more contrasty light when silver-lined umbrellas are used.

■ **Translucency.** A significant amount of light can go right through a white umbrella, rather than reflect back at your subject. In addition, the light that keeps on going will eventually bounce off something and back towards your subject. You might not want that uncontrolled ambient light. There are white umbrellas with black outside surfaces that absorb the light that doesn't reflect back. The black outer cover may be removable so you can take it off when you do want the light to bounce around behind the umbrella, or when you want to turn the umbrella around and make an exposure using the even softer light that goes *through* the fabric onto your subject.

■ **Contrast.** You can vary the quality of the light reaching your subject by choosing your umbrella's fabric carefully. A soft white umbrella provides the most diffuse illumination. A silver inside surface will produce more contrast and sharper highlights in your images. Various silver surfaces are available, ranging from diffuse silver to very shiny.

■ **Color.** Umbrellas are available in various colors, too. Gold umbrellas are prized for the warm skin tones they produce. Shiny blue-toned umbrellas are also available for a colder look. Once you become deeply involved with studio work, you'll probably want at least a few umbrellas in different sizes, textures, and colors.

Soft Boxes

Soft boxes are large, square, or rectangular devices that may resemble a square umbrella with a front cover, and produce a similar lighting effect. They can extend from a few feet square to massive boxes that stand five or six feet tall—virtually a wall of light. With a flash unit or two inside a soft box, you have a very large, semi-directional light source that's very diffuse and very flattering for portraiture and other people photography.

Soft boxes are also handy for photographing shiny objects. They not only provide a soft light, but if the box itself happens to reflect in the subject (say you're pho-tographing a chromium toaster), the box will provide an interesting highlight that's indistinct and not distracting.

You can buy soft boxes, or make your own. Some lengths of friction-fit plastic pipe and a lot of muslin cut and sewed just so may be all that you need.

Slave Units

When you're using more than one electronic flash, you'll need some way to trig-ger the flash units that aren't connected to your camera by a cord. Slaves are elec-tronic devices that sense the main flash going off (usually by light or radio waves) and trigger the attached flash an instant later.

You can purchase slave units as separate devices that plug into an existing flash. Many studio flash have a slave sensor built in, and there are a few flash units that *are* slaves. That is, they can only function as a subsidiary flash unit used in con-junction with one or more other flash devices. There are some that resemble light bulbs that screw into lamp sockets, and you can actually use them in that mode when photographing interiors. They fit in a room's lamps just like the original bulbs, but fire when the main flash does, providing lamp-like illumination that has the properties of electronic flash instead.

Light Stands

Although incandescent lights need light stands, too, I've put the discussion of this accessory in this section. Lightweight minitripods that can be set on tabletops or other elevated surfaces and positioned as needed can work, while those on a strict budget using basic electronic flash units can use any of a wide variety of clamps with standard 3/8-inch tripod threads that can also hold a flash and be used to position it high enough to work effectively. Some tripods also come with feet or stands they can be mounted on so that they can be set erect on a flat surface.

Light stands should be strong enough to support an external lighting unit, up to and including a relatively heavy flash with soft box or umbrella reflectors. You want the supports to be capable of raising the lights high enough to be effective.

Look for light stands capable of extending 6 to 7 feet high. The 9-foot units usually have larger, steadier bases, and extend high enough that you can use them as background supports. You'll be using these stands for a lifetime, so invest in good ones. I bought the light stand shown in Figure 6.9 when I was in college, and have been using it for decades.

Snoots and Barn Doors

These fit over the flash unit and direct the light at your subject. Snoots are excellent for converting a flash unit into a hair light, while barn doors give you enough control over the illumination by opening and closing their flaps that you can use another flash as a background light, with the capability of feathering the light exactly where you want it on the background. Both are shown in Figure 6.10.

Figure 6.9 Light stands can hold lights, umbrellas, backdrops, and other equipment.

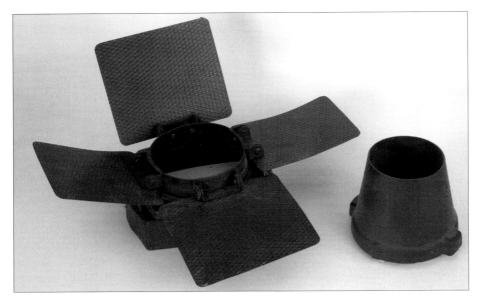

Figure 6.10 Snoots and barn doors allow you to modulate the light from a flash or lamp, and are especially useful for hair lights and background lights.

Studio Lighting Basics

There are three main things to remember about lighting when you branch out into studio work. First, lighting is the palette you'll be using to paint your photographic portraits. Second, the direction the light comes from molds the appearance of your subject much as a sculptor molds clay. And, finally, the character of the light is the "color" you use, whether soft, harsh, or some gradation in between.

This next section will explain the basics of studio lighting. I'll include some individual portrait examples and provide diagrams you can use to get good results your first time. You'll also learn the nomenclature used for various types of lights, and how those lights should be placed.

AGE OF DIFFUSION

The stage of the imaging process where diffusion is applied can make a significant difference in the look of the image. When you soften the light itself, everything illuminated by that light is given a softer look. Apply the diffusion to the light entering the camera, and the softness tends to spread from lighter areas into darker areas, which fills in the shadows and reduces the detail most in the highlights. Within an image editor, diffusion can be applied two different ways, by spreading highlight detail into the shadows, or by "smearing" the shadow detail out into the highlights. This is much the same idea as when diffusion is applied to a photographic negative as opposed to the same amount of diffusion applied to a positive, transparency image. Today, thanks to image editors, we can have it both ways.

The Qualities of Light

If you want to shoot like a pro in the studio, first master the qualities of light. A spotlight or a lamp in a reflector, or an electronic flash pointed directly at a subject is highly directional and produces a hard effect. That hard light is harsh and unflattering when used in portrait situations, because all the light comes from a relatively small source. This kind of light can be good if you want to emphasize the texture of a subject in, say, a product photograph, and are looking for as much detail and sharpness as possible.

In fact, many kinds of photographic projection and optical gear take advantage of point-source lighting to maximize sharpness. A specialized type of photographic enlarger, for example, may be equipped with such a source to get the sharpest possible image from a piece of film. Of course, the point-source light emphasizes any scratches or dust on the film, so the technique works best with originals that are virtually perfect from a physical standpoint.

If you're picturing a fabric and want the details of the weaving to show up, a direct light might be best. However, most portrait subjects benefit from a softer light, with images of men needing only a little diffusion, while women and teenagers can look best with a lot of softness. You can diffuse this light in many ways, using umbrellas, diffusers, and other techniques. It's even possible to add a little softness in Photoshop, although the effect is not exactly the same. Figure 6.11 shows how lighting and focus can emphasize or de-emphasize texture.

As I've said, direct light is not as good a choice for portraiture. People rarely look their best under a direct light, because even a baby's skin is subject to imperfections that we don't see under home illumination (which is deliberately designed to be non-harsh). Only in direct sunlight are we likely to look our worst.

So, the typical portrait is made using softer illumination, such as that produced by bouncing light off the umbrellas discussed earlier. As light strikes the reflector, the light scatters. It bounces back towards the subject and appears to come from a much larger source, rather than the bulb or flash unit that produced it. The dis-

Figure 6.11 High contrast lighting and sharp focus emphasizes texture; soft lighting and soft focus disguise it.

tance of the light source from the subject also has a bearing on the quality of light. When the light source is relatively far from the subject, the light seems to come from a relatively small area.

When the reflected light source is moved closer to the subject, the light now appears to be much broader, relatively, and correspondingly softer. You'll need to keep this characteristic in mind as you set up your lights for portraiture. If you need to move a light back farther from the subject, you'll also need to take into account the changing nature of the light. A larger umbrella may help keep the lighting soft and gentle. Or, you simply might want to have slightly "edgier" lighting for your subject. As long as you are aware of the effect, you can control it.

Balance of Light

Another characteristic that must be controlled is the relative balance between multiple light sources. The main source of light doesn't illuminate the entire subject. There will be shadow areas that must be given partial illumination so they will have detail and not remain inky black. Shadows are lightened using a secondary light source called a fill light. The proportion of main light to fill light produces a lighting ratio, with high ratios (4:1 or more) providing harsh lighting, while lower ratios (such as 2:1) result in more even illumination and a softer effect.

Lighting ratios are determined by the relative strength of the multiple light sources, compared to each other. Assume a low contrast lighting situation in which the main light is twice as bright as the fill light. There are several reasons why this relationship may be so. The main light may be a more powerful lighting unit. At the same distance, the more powerful unit will beam down more light on the subject.

However, it's also possible that the light sources are the same strength, but the main light appears to be brighter because it is closer to the subject. Thanks to something called the *inverse square* law, moving a light source twice as far away reduces the light by 4X (not 2X). In photographic terms, that translates into a two f/stops difference, not the single f/stop you might expect. For example, a light source placed 8 feet from your subject will provide *one-quarter* as much illumination as the same source located just 4 feet from the subject. After moving the light twice as far away, you'd have to open up two f/stops to keep the same exposure, as shown in Figure 6.12.

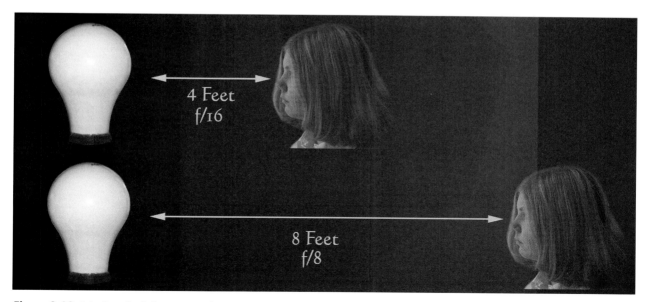

Figure 6.12 Moving the light twice as far away calls for four times as much exposure, or two full f/stops.

You can make the inverse square law work for you. If you find a source is too strong, either by itself or relative to other light sources you're using, simply moving it twice as far away will reduce its strength to one-quarter its previous value. Or, should you need more light, you can gain two f/stops by moving a light source twice as close. (Keep in mind that the softness of the light is affected by the movement, too.)

There are times when you won't want to adjust the light intensity entirely by moving the light because, as you've learned, the farther a light source is from the subject, the "harder" it becomes. In those cases, you'll want to change the actual intensity of the light. This can be done by using a lower power setting on your flash, switching from, say, a highly reflective aluminum umbrella to a soft white umbrella, or by other means.

Working with Ratios

When lighting a subject, the most common way to balance light is to use ratios, which are easy to calculate by measuring the exposure of each light source alone (either with your camera's exposure meter or using an external flash meter). Once you have the light calculated for each source alone, you can figure the lighting ratio.

For example, suppose that the main light for a portrait provides enough illumination that you would use an f/stop of f/11. The supplementary light you'll be using is less intense, is bounced into a more diffuse reflector, or is farther away (or any combination of these) and produces an exposure, all by itself, of f/5.6. That translates into two f/stops' difference or, putting it another way, one light source is 4 times as intense as the other. You can express this absolute relationship as the ratio 4:1. Because the main light is used to illuminate the highlight portion of your image, while the secondary light is used to fill in the dark, shadow areas left by the main light, this ratio tells us a lot about the lighting contrast for the scene.

In practice, a 4:1 lighting ratio (or higher) is quite dramatic, and can leave you with fairly dark shadows to contrast with your highlights. For portraiture, you probably will want to use 3:1 or 2:1 lighting ratios for a softer look that lets the shadows define the shape of your subject without cloaking parts in inky blackness. Figure 6.13 shows 4:1, 3:1, and 2:1 lighting ratios. I placed the main light so it illuminated the far side of the face so you could see the amount of detail in the shadows more easily at each ratio.

If you use incandescent lighting or electronic flash equipped with modeling lights, you will rarely calculate lighting ratios while you shoot. Instead, you'll base your lighting setups on how the subject looks, making your shadows lighter or darker depending on the effect you want. If you use electronic flash without a modeling light, or flash with modeling lights that aren't proportional to the light emitted by

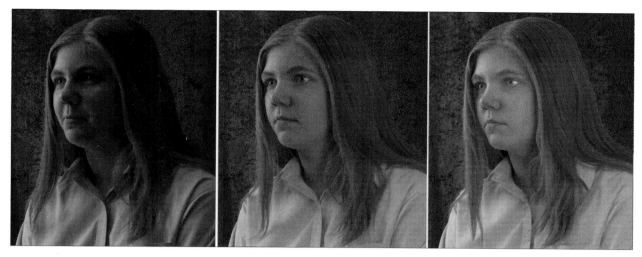

Figure 6.13 Left to right: 4:1, 3:1, and 2:1 lighting ratios.

the flash, you can calculate lighting ratios. If you do need to know the lighting ratio, it's easy to figure by measuring the exposure separately for each light and multiplying the number of f/stops difference by two. A two-stop difference means a 4:1 lighting ratio; two-and-a-half stops difference adds up to a 5:1 lighting ratio; three stops is 6:1 and so forth.

Working with Multiple Light Sources

Because studio lighting often involves working with multiple light sources, it's best to learn the terminology for each particular type of light source before we get into placing them for effect. The terms I'm going to use apply to both incandescent lights and electronic flash, and don't necessarily have to be "formal" light sources. A window light can function as a main light, and a cardboard reflector can be a fill light. It's how a light is used that counts. Figure 6.14 shows the four basic lights used in a studio setting.

Main Light

The main light, which is also called a *key* light, provides most of the illumination for your subject. It can actually be the *only* light you use, especially if the main light is large and soft (such as a soft box) and positioned so there are no obtrusive shadows. Often, though, a main light is used with a fill light, and the position of the two lights work to create the particular lighting effect.

The main light is most often placed in front of the subject and on one side of the camera or the other, as you'll see in the examples later in this chapter. Some kinds of lighting call for the main light to be placed relatively high, above the subject's

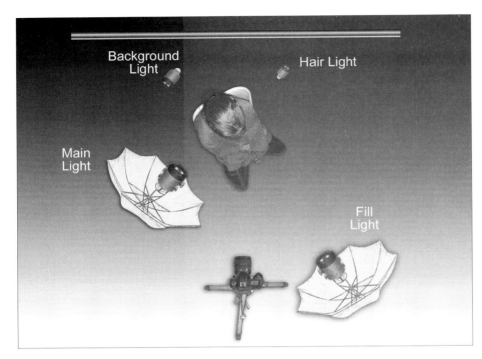

Figure 6.14 The four basic lights used in the studio.

eye-level, or lower at eye-level. You usually won't put a main light lower than that, unless you're looking for a monster effect.

Located to the side of your subject, a main light becomes a sidelight that illuminates one side of the subject (as in the much copied *Meet the Beatles* album cover) or it can light up the profile of a subject who is facing the light itself. Moved behind the subject, the main light can produce a silhouette effect if no other lights are used, or a backlit effect if additional lighting is used to illuminate the subject from the front.

You'll usually position the main light at roughly a 45-degree angle from the axis of the camera and subject. The main light should be placed a little higher than the subject's head. The exact elevation is determined by the type of lighting setup you're using. One thing to watch out for is the presence or absence of catch lights in the subject's eyes. You want one catch light in each eye, which gives the eye a slight sparkle. If you imagine the pupils of the eyes to be a clock face, you want the catch lights placed at either the 11 o'clock or 1 o'clock position. You might have to raise or lower the main light to get the catch light exactly right, or to keep light from reflecting off glasses if your subject wears spectacles.

You most definitely do not want *two* catch lights (because you're using both main and fill lights) or no catch light at all. If you have two catch lights, the eyes will

look extra sparkly, but strange. With no catch light, the eyes will have a dead look to them. Sometimes you can retouch out an extra catch light, or add one, with Photoshop, but the best practice is to place them correctly in the first place.

Fill Light

The fill light is the light that's used to brighten and soften the shadow areas created by the main light. For the most versatile setup, use the same model flash for your fill light as you do for your main light. This gives you the option of setting the same power settings or to reduce the fill light's setting to create a different ratio without moving the flash. Or, you can reverse the ratio so the fill becomes the main light, and vice versa.

Just because you can use both flash units at their highest power settings and create an even light doesn't mean you have to. You can always dial down the power setting on your second flash head and create a more interesting lighting effect for your subject. Experiment with 2:1 and 3:1 power ratios and see which you prefer. If the main and fill are almost equal, the photo will be relatively low in contrast. With the fill dialed down and the main light much more powerful, the shadows will be darker and the image will have a higher contrast.

If you have a fill light that doesn't let you reduce or increase the power, try moving the flash back a bit, or placing a diffuser such as a handkerchief over the flash. Thanks to your digital camera's review feature, you can quickly see if you've reduced the amount of light enough. Your fill light should be roughly the same height as your main light, although slightly lower is fine, too.

Hair Light

The hair light is a small, carefully controlled light used to put a bright spot separating the subject's hair from the background, which can be particularly helpful if your subject has dark hair. This type of lighting can also be referred to as rim lighting. Most often, the hair light is controlled via either a snoot or through a barn doors attachment on a flash head.

The light itself doesn't need to be particularly powerful, because it's responsible for lighting only a small area. Most often, the hair light is positioned closely to the subject (just out of the camera's view) via a boom (raised arm attached to a lighting stand) that allows it to reach into the portrait area from up high. To use a hair light, position it so that the light is directed almost straight back into the camera, raking across the top of the subject's head. Move it forward until the light spills over slightly onto the subject's face. At that point, tilt the light back again until it is no longer illuminating the subject's face.

Background Light

The background light is used to both illuminate the background and create some separation between the subject and background by making the background a little brighter than the main subject. This light is generally mounted on a short lighting stand and is pointed upward at the background. Be careful to position it so that the lighting stand stays hidden behind your subject. Set the background light about 2 feet from the backdrop and about 2 to 3 feet off the ground. Angle it upward about 45 degrees so that the light spreads upward and outward from below your subjects. To spread the light, mount a diffuser of some sort, such as a handkerchief on the light head to soften it as it spreads up the backdrop. Using the screen helps prevent the light from creating a hot spot. This light can also provide interesting lighting effects on the background when used with colored gels or cookies. You can even turn the background light towards the back of the subject, producing a halo or backlight.

Figure 6.15 shows both a hair light and background light used for an informal portrait.

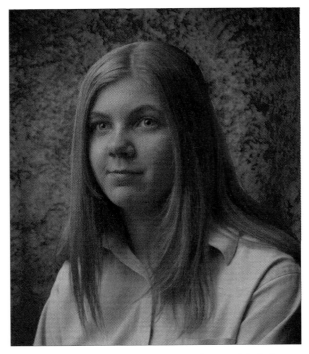

Figure 6.15 Both a hair light and background light have been applied.

Common Lighting Techniques

Although I'll describe each of the most common lighting techniques, you'll want to set up some lights and see for yourself exactly how they work. When looking at any of these lighting diagrams, keep in mind that the arrangement of the lights can be reversed to produce a mirror image portrait with your subject looking in the opposite direction.

Short Lighting

Short lighting and broad lighting (discussed next) are two different sides of the same coin. Together, they are sometimes referred to as "three-quarter lighting," because in both cases the face is turned to one side so that three quarters of the face is turned toward the camera, and one quarter of the face is turned away from the camera.

Short lighting, also called narrow lighting, is produced when the main light illuminates the side of the face turned away from the camera. Because three-quarters

of the face is in some degree of shadow and only the "short" portion is illuminated, this type of lighting tends to emphasize facial contours. It's an excellent technique for highlighting those with "interesting" faces. It also tends to make faces look narrower, because the "fat" side of the face is shadowed, so those with plump or round faces will look better with short lighting. Use a weak fill light for men to create a masculine look. This is a very common lighting technique that can be used with men and women, as well as children.

To set up a short lighting arrangement, turn your subject's face so that it is angled somewhat to the right or left of the camera, but not enough to produce a profile. When the subject is turned in this way, the side of the face you can see more of is called the broad side of the face, while the side you see less of is known as the short or narrow side of the face.

In short lighting, set up your main light to illuminate the short side of the subject's face and then add a fill light or reflector to fill in some light on the broad side of the face. Add a fill light to separate your subject from the background for a good three-light setup and a hair light for a four-light configuration.

Short lighting is a particularly nice form of lighting for the female face because it accentuates the eyes, cheeks, nose, and mouth in an attractive way. This style of lighting can also be used to make a broad male face look thinner.

In Figure 6.16, our subject is looking over the photographer's left shoulder. The main light is at the left side of the setup, and the fill light is at the photographer's right. Because the fill light is about twice as far from the subject as the main light, if both lights are of the same power, the fill light will automatically be only one-quarter as intense as the main light (thanks to the inverse-square law). If the shadows are too dark, move the fill light closer, or move the main light back slightly. The portrait that results from this arrangement is shown in Figure 6.17.

Broad Lighting

In many ways, broad lighting, the other three-quarter lighting technique, is the opposite of short lighting. The main light illuminates the side of the face turned toward the camera. Because most of the face is flooded with soft light (assuming you're using an umbrella or other diffuse light source, as you should), it de-emphasizes facial textures (teenagers may love this effect) and widens narrow or thin faces. Figure 6.18 is the lighting diagram used to produce the image shown in Figure 6.19, which pictures the same subject as above, but with broad lighting instead. Broad lighting may not be the best setup for this teenager, because she has a broad face, but styling her hair so it covers both sides of her face reduces the effect. That let me use broad lighting and its feature-flattering soft light.

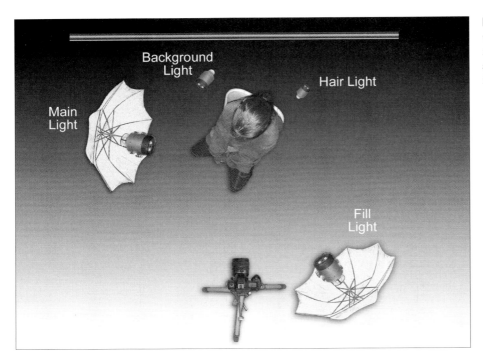

Figure 6.16 For a portrait using short lighting arrange the main light so it illuminates the side of the face that's farthest from the camera.

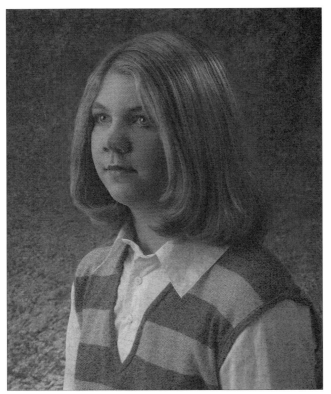

Figure 6.17 A portrait using short lighting.

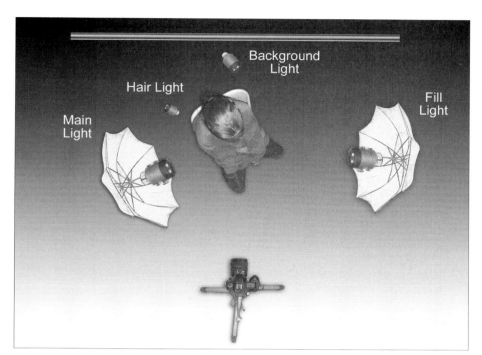

Figure 6.18 For a portrait using broad lighting, arrange the main light so it illuminates the side of the face that's closest to the camera.

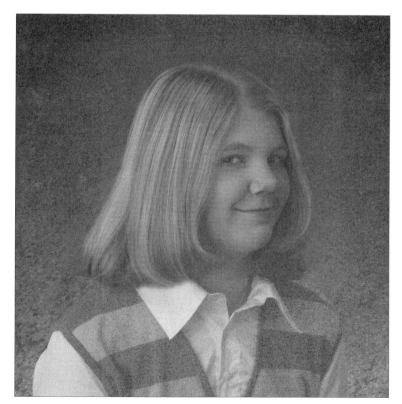

Figure 6.19 A portrait using broad lighting.

To set up a broad lighting arrangement, turn your model's face so that the main light illuminates the broader side of the face. Then, use your reflector to bounce some light into the shadow areas of your subject's face. Be careful with this lighting technique because it can make a normal face seem very full. While broad lighting is a useful lighting technique for thin faces, it should be used carefully with women.

Butterfly Lighting

Butterfly lighting was one of the original "glamour" lighting effects. The main light is placed directly in front of the face above eye-level and casts a shadow underneath the nose. This is a great lighting technique to use for women, because it accentuates the eyes and eyelashes, and emphasizes any hollowness in the cheeks, sometimes giving your model attractive cheekbones where none exist.

Butterfly lighting de-emphasizes lines around the eyes, any wrinkles in the forehead, and unflattering shadows around the mouth. Women love this technique, for obvious reasons. Butterfly lighting also tends to emphasize the ears, making it a bad choice for men and women whose hairstyle features pulling the hair back and behind the ears.

Butterfly lighting is easy to achieve. Just place the main light at the camera position, and raise it high enough above eye-level to produce a shadow under the nose of the subject. Don't raise the light so high the shadow extends down to his or her mouth. The exact position will vary from person to person. This type of lighting creates a subtle butterfly of light with the bridge of the nose the axis for the "wings" of light that spread over the eyes and cheeks.

If a subject has a short nose, raise the light to lengthen the shadow and increase the apparent length of the nose. If your victim has a long nose, or is smiling broadly (which reduces the distance between the bottom of the nose and the upper lip), lower the light to shorten the shadow.

You can use a fill light if you want, also placed close to the camera, but lower than the main light, and set at a much lower intensity, to reduce the inkiness of the shadows. Figure 6.20 is the diagram for applying butterfly lighting (without a fill light), while Figure 6.21 shows the final result. Notice that the ears aren't a problem with this portrait, because they are hidden behind the model's hair. Because this young woman has blonde hair, I've toned back on the use of hair light in all the photos.

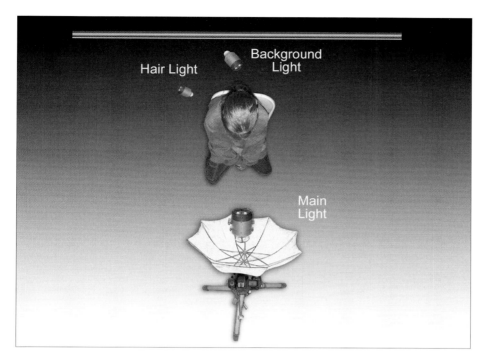

Figure 6.20 With butterfly lighting, the main light is located high and above the camera.

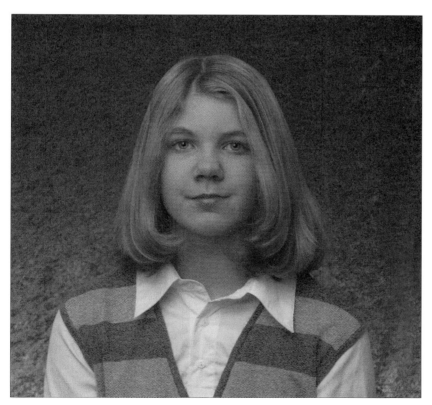

Figure 6.21 Butterfly lighting is a basic glamour lighting scheme that's flattering to women.

To set up butterfly lighting, position your main light straight on to your subject, high above his or her eyes with the light pointed directly on the nose. This is what enables the light to spread out in the butterfly pattern. Use a background light to separate your subject from the backdrop.

Butterfly lighting should always be considered for a female subject, although that doesn't mean you always need to choose this style. If you use it with a girl or woman who has short hair, the same problem with the ears can occur. This style of lighting does not work as well for men because it tends to throw too much light on the ears.

Rembrandt Lighting

Rembrandt lighting is another flattering lighting technique that is better for men. It's a combination of short lighting (which you'll recall is good for men) and butterfly lighting (which you'll recall is glamorous, and therefore good for ugly men). The main light is placed high and favoring the side of the face turned away from the camera, as shown in Figure 6.22. The side of the face turned towards the camera will be partially in shadow, typically with a roughly triangular illuminated patch under the eye on the side of the face that is closest to the camera. For Rembrandt lighting, place the light facing the side of the face turned away from the camera, just as you did with short lighting, but move the light up above eye-level. If you do this, the side of the face closest to the camera will be in shadow. Move the light a little more towards the camera to reduce the amount of shadow, and produce a more blended, subtle triangle effect, as shown in Figure 6.23. Eliminate or reduce the strength of the fill light for a dramatic effect, or soften the shadows further with fill light. When used with men, this patch can be especially dramatic to show off the planes of the male's face.

Side Lighting

Side lighting is illumination that comes primarily directly from one side, and is good for profile photos. You can use it for profiles or for "half-face" effects like the Fab Four on the much copied/parodied cover of *Meet the Beatles/With the Beatles*. The amount of fill light determines how dramatic this effect is. You can place the main light slightly behind the subject to minimize the amount of light that spills over onto the side of the face that's toward the camera. Note that subjects with long hair that covers the cheeks may have most of their face obscured when side lit in this way. Either comb the hair back or go for the mysterious look that my model requested in this case.

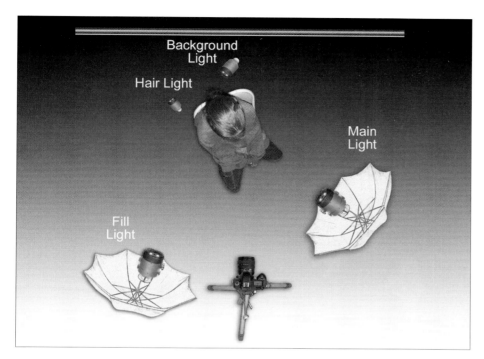

Figure 6.22 Place the main light high when creating a Rembrandt lighting effect.

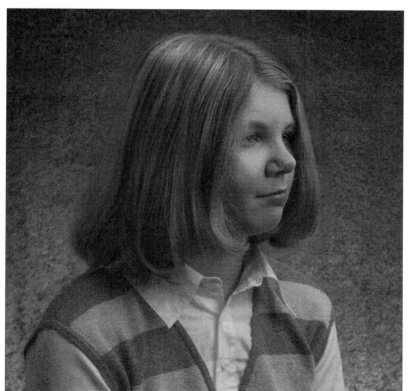

Figure 6.23 This is a "glamour" lighting effect that works for women and men.

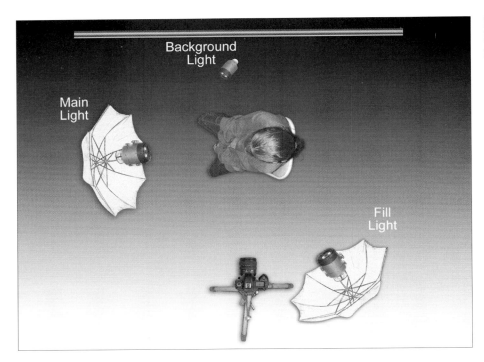

Figure 6.24 Move the main light to the side for a side-lit portrait.

Figure 6.25 Side lighting can be very dramatic.

Backlighting

Backlighting, also known as rim lighting, can create an almost magical glow or halo-like effect for your subject. With a backlit photo, most of the illumination comes from behind the subject and doesn't really light the subject as much as it defines its edges. Use additional fill light to provide for detail in the subject's front. You can use the background light for backlighting, and put your main and fill lights to work in a subordinate roll by reducing their intensity. Or, you can use the main light as the backlight (place it below or above the camera's field of view), and fill in the shadows with your fill light.

This lighting style calls for your main light to be placed behind the subject while a fill light prevents the face from falling into shadow. The result is a rim of light highlighting your subject's form.

There are several different ways of using backlighting:

- **Full backlighting.** The main light is positioned directly behind the subject about even with her head. Check your composition carefully to make sure the light is hidden from the camera's view.

- **Side rim-lighting.** Use just a hint of backlighting to add some glow to one side of the head. This is similar to hair lighting. In this case though, use a small light rather than your main light. Set up a small light with a snoot on a boom pointed at the side of the head, away from the camera. If you don't have a boom arm, try using a light stand as close to your model as possible while keeping it out of the shot.

Next Up

I'm going to finish off the book with some super-secret Pro Secrets, in the form of a host of techniques, tools, and gadgets you can make yourself, including an amazing clean-your-own sensor kit that won't cost you an arm and a leg.

7

More Build-It-Yourself Gadgets and Tricks

As a hobby, photography ranks second only to amateur magic in terms of the gadgetry, ad hoc devices, and tricky techniques concocted to provide an amazing and impressive visual effect. As a profession, photography doesn't rank very far behind heart surgery in the number of labor-saving and life-saving devices invented by the practitioners themselves.

The origins of photo tinkering go back as far as the beginnings of photography itself. Photography was invented by experimenters who wondered if asphalt-like tar could capture an image (it could, eventually) or, later, whether motion picture film could be adapted for use in smaller, more portable cameras (thus changing the world of photography forever). The first practical color film, Kodachrome, was the brainchild of a pair of precocious professional musicians, who were lucky enough to gain the support of Kodak to further their amateur research.

Early photographers were often artists who built their own cameras, coated their own film plates, and erected portable darkrooms they built themselves to process their work. In the years since, dedicated photographers, both amateur and professional, have been fond of cobbling together gadgets that let them take pictures that otherwise would require expensive equipment, or to create images that would be impossible to produce with existing gear at any price.

This chapter consists entirely of Pro Secrets similar to the projects and tips scattered throughout this book (so I'll skip the icons). These are all ideas you can use to add a new dimension to your photography, while saving yourself a bit of money on bought'n thingamajigs, doohickeys, and gadgets.

No Camera Left Behind

On my recent photo safari to Spain, I protected my camera equipment from loss or theft by a simple expedient: My gear never left my side. Even when I wasn't shooting pictures, I was able to keep my key items with me, because I was traveling light, with just two digital camera bodies and three lenses. I might have looked a little odd in casual restaurants with my camera bag tucked between my feet, but I always knew where my stuff was at all times. I'd updated my camera insurance policy before the trip, but I still didn't want the inconvenience of losing some essential piece of gear, nor of explaining to my insurance agent how I managed to lose $8,000 worth of equipment.

Of course, 300,000 laptops, equally as valuable to their owners, are reported stolen annually. There has to be a better way to keep track of camera equipment—and there is. It need cost you no more than $25 for additional peace of mind.

The answer is in one of those child proximity alarms. They come in two pieces: a transmitter that you can affix to your child (or hide in your camera bag), and a receiver, which goes in Mom's purse or Dad's pocket. If your treasure is moved more than 15 feet from the transmitter, a loud alert sounds. Neither component will weigh you down—together they have no more heft than four quarters (or Euros). The receiver measures $2.5 \times 1.75 \times 0.2$ inches, while the transmitter is an even more Lilliputian $1.75 \times 1.5 \times 0.2$ inches. They operate on long-life button cells.

This gadget pair, which lists for about $24.95, can help you in several ways. Say you set your camera bag down and begin taking pictures, absent-mindedly wandering away from your gear. The alarm will let you go no more than 15 feet or so from your bag before it sounds its reminder. You'll probably want to avoid triggering the alarm, so merely having the system activated can help train you, in Pavlovian fashion, to remain close at hand.

You won't forget to take your bag when you exit your hotel room, either, nor leave it under the table in the restaurant after you pay your check. Set the volume low enough to be heard, but not enough to be bone-chilling. A proximity alarm will even help you in the worst-case scenario, when a nefarious camera thief grabs your bag and runs off. A 15-foot head start isn't great, but, because it's *your* equipment, you just might be more highly motivated to be fleet of foot than the snatcher, who just wants to make a living, not attract undue attention.

Of course, in very crowded settings the alarm won't help you much, nor will it deter sophisticated gangs that are set up to swap your bag among them and head in different directions to avoid pursuit. You should take extra care in such situations and not rely on gadgetry.

Reversing Ring on the Cheap

In Chapter 5 I told you about lens reversing rings, which let you turn a prime lens around backwards and mount it with the front element facing the sensor. These rings can easily cost $20 or more, but you should be able to make your own for less than $5. Here's how:

Hie off to your camera store, and search through their junk box until you locate an old Series adapter ring with a thread that fits the front filter thread of your lens. Then, locate a T-mount adapter that fits your camera. T-Mounts were used to allow a single non auto-diaphragm, non-autofocus (in other words fully manual) lens to be fitted to several different camera bodies. Both items together, used, should cost less than $5.

Then, get yourself some *good* cyanacrylate (super) glue or Epoxy, and weld the two together, with the front, retaining ring of the Series adapter mated to the screw thread of the T-mount. You'll end up with a ring like the one shown in Figure 7.1. Because the filter-thread half of the Series adapter can be removed and replaced with a different one, you'll find this reverse adapter combination can be used with multiple lenses. Just find an adapter with the same Series size, but with a thread for your alternate lenses.

In use, just attach the Series adapter into the front filter thread of your lens, and connect the T bayonet to the lens mount of your camera. For obvious reasons, your glue job should be *very* solid and secure, but I'll re-state the obvious because it's so important: If your two adapters separate, it's likely that your lens will fall off the camera and go crashing to the ground. Not a happy outcome.

Figure 7.1 Glue a series adapter ring to a T-mount to create your own reversing ring.

Pinhole Camera

Are you tired of paying money for expensive glass, just to get a new perspective in your pictures? How would you like an inexpensive lens that has no glass at all, and costs you anywhere from $5 to nothing? This is your chance to own the world's most inexpensive pinhole camera, and use it to explore a type of photography that's equally compelling for both beginners and experienced shooters. Practice up now,

and you might be ready to participate in the next Worldwide Pinhole Photography Day, held annually on a selected day in April. (For more information, check out **www.pinholeday.org.**) With minimal work, you can take pictures like the one shown in Figure 7.2.

Figure 7.2 Mount a pinhole on your $1,000 dSLR and you can get photos like this one, blurry and vignetted and extra primitive in appearance.

If you aren't familiar with pinhole photography, you should be aware that it differs in a few ways from traditional photography, especially from the respect that there is no lens involved, not even *in abstentia*. A lens focuses light arriving from many different directions to a common focus on the sensor, as you should know (if not, go back and review Chapters 2 and 3, or else No Soup For You!). The lens has a fixed focal length, so it's important that it's positioned a precise distance from the sensor; otherwise, the image is out of focus.

Pinhole imaging doesn't involve "focus" at all. Instead, light emerging from the pinhole is *projected* onto the sensor and, because the pinhole is so small, only a small number of rays of light from each point on the subject is allowed to pass and reach the sensor. In effect, because the number of rays for each point are projected, the image is formed and "looks" as if it is more or less in focus. But, because multiple rays do reach the sensor, this "focus" isn't perfect, and the image is less than perfectly sharp.

There are some interesting effects caused by using this projection phenomenon rather than focusing the light, as is done with a lens.

- **Smaller is better.** That's why a *pinhole* is required: the smaller the hole, the fewer the rays of light that are allowed to pass per point on the subject, and the sharper the image appears. If the pinhole could be made so small that only a single ray of light per point could pass, you'd have a very sharp image indeed—if it were not for other factors involved, including diffraction that results when some of the rays are bent slightly by collisions with the edges of the hole.

- **Magnification changes.** When you move the pinhole closer to or farther from the sensor, something interesting happens. The "focal length" changes. That's not really true, because a pinhole image isn't really focused, nor does the pinhole have a focal length (which is hard to define for an optical component that doesn't focus the light). As I said, the image is *projected* onto the sensor, so when you move the pinhole, its representation is enlarged or reduced, depending on the distance. To get a "telephoto" pinhole, just move the hole a greater distance away from your sensor.

- **Almost unlimited depth-of-field.** If an image is never really in focus or out of focus, it's hard to define depth-of-field, too, isn't it? As it turns out, with pinhole images the "sharpness" of the subject (which is never really that great in the first place) is fairly uniform within the image field, from front to back. Your tiny pinhole mimics the effect of a small aperture in conventional photography, broadly applied "depth-of-field." Only objects that are closer to the pinhole than the pinhole is to the sensor will be significantly less sharp, because the rays of light will actually *diverge* rather than converge.

- **Really long exposures.** Projecting an image onto the sensor doesn't really allow much light to reach the sensor, and the pinhole is actually smaller than the smallest commonly used f/stops (usually f/256 or smaller). So, you'll end up needing very long exposures, and, obviously will want to mount your camera on a tripod. Noise build-up from using higher ISOs and extended exposures won't help your image sharpness, either, but that's part of the charm of pinhole photography.

You can make your own precision pinhole to use for experimental photography. You need a body cap of the kind that is used to protect the lens opening of your dSLR when no lens is mounted. You want the kind that has a plastic flange that fits snugly into the bayonet lens mount of your digital SLR. You don't want one of those translucent plastic caps that fit over the outside of the lens mount as if it were a tin of Pringles. If your camera was furnished with that sort, hop over to your camera store and buy a proper body cap.

You'll also need a very thin piece of metal. Extra heavy aluminum foil can work in a pinch, but if you're serious about pinhole photography you'll want to create a more rugged, precise pinhole. Obtain a piece of brass shim stock from .003 to .005 inches thick. You can find this material in hobby shops, as it is used by hobbyists to build whatever it is they construct. You'll also find shim stock at hardware stores and auto parts stores. You'll also need some other readily available tools and materials that are mentioned in the steps that follow. The body cap and brass shim are the parts that are most critical.

When you're ready to create your pinhole, follow these steps:

1. Find the exact center of the body cap, using your favorite high school geometry method. If that was too long ago for easy recall, check out the diagram at **www.dbusch.com/prosecrets/bisect.jpg.** Or, you can just eyeball it.

2. Cut a hole in the center of the body cap. Don't worry that the hole is too large. You're going to cover it with a pinhole.

3. Place a piece of brass shim material a little larger than the body cap on a piece of corrugated cardboard. The cardboard will keep the shim material flat and prevent it from bending or crimping.

4. Take a ballpoint pen and place the point on the center of the material, then tap with a rubber mallet or similar tool to create a dimple in the shim.

5. Use a sewing needle to make a pinhole in the center of the dimple.

6. With a fine nail file, emery board, or extra-fine sandpaper, smooth the burrs that result when you piece the shim with the needle.

7. Cut the shim using heavy metal shears to a size that will fit over the hole in your body cap.

8. Paint the shim flat black with spray paint. Use the needle to reopen the pinhole carefully after the paint has dried.

9. Glue or tape the shim over the hole in the body cap, centering the pinhole, if necessary using the method described in the URL above. That's all there is to it.

To use your pinhole camera, fasten the body cap to your camera, place the camera on a tripod, and take a few time exposures, starting with a second or two at a low ISO setting. Review your images on your LCD and adjust the exposure if necessary. If you want to take some telephoto pictures, mount an extension tube on your camera body first before installing the body cap. Even a 12mm extension tube will increase your "focal length" (actually just the apparent magnification) dramatically. Your pinhole device might look like the one shown in Figure 7.3.

Figure 7.3 Add an extension tube to create a "telephoto" pinhole camera.

The Amazing Multi-Color Shutter

One amazing effect that hasn't seen as much use in the digital realm as it did in the film world is the Harris Shutter, a device that lets you make a series of consecutive "exposures" in one frame using red, green, and blue filters separately. The result is that anything that's stationary receives roughly the same red, green, and blue exposures that would be provided with a traditional shot, but moving subjects are separately rendered by the individual colors at various stages of movement. The traditional subject of these multi-colored photos is moving water, as in Figure 7.4, but there's a lot more that you can do with this technique. Actually, there are several completely different techniques you can use to achieve the effect. One of them doesn't involve a Harris Shutter, which I'll show you how to make shortly, and the second one doesn't even require using filters during the exposure!

What I'll call the Harris Effect, after Kodak wizard Bob Harris, who developed the famed Shutter, is based on simple optical science. All images captured by film or a digital sensor are actually three different images, one each for red, green, and blue light. With film, each of these colors of light is captured by a film layer sensitive specifically to that color of light. In virtually all digital cameras, filters over

Figure 7.4 The Harris Shutter gives you images that look like this, with moving objects colored in red, green, and blue streaks.

the individual photosites limit a particular site to sensitivity to red, green, or blue illumination.

In a normal exposure, all three sets of photosensitive grains/pixels are exposed simultaneously in a proportion that represents the balance of those colors in the original image. To activate the Harris effect, you need to provide each of those exposures separately. If there is a time lag between the various colors, and the camera remains absolutely fixed in place, then, as I noted, non-moving objects in the scene will be rendered more or less normally if each of the three separate exposures are equal in length. But if something happens to be moving—say running water, an automobile, or some other object—the position of that subject will be slightly different, producing red, green, or blue streaks, as well as cyan, magenta, and yellow streaks where the primary blurs overlap. With an imaginative choice of subjects, the effect can be beautiful and intriguing.

There are three easy ways of producing this effect. I'll show you each of them in the sections that follow.

Three Discrete Exposures

This one is easy, and requires no more equipment than a tripod and a set of color filters you might already own. If not, you can buy inexpensive versions of each of these filters for $10 each, or less. This method, unlike the Harris shutter technique, simplifies applying the color effect to time exposures, but it's clumsy enough that you'll see why the Harris Shutter was developed. Just follow these steps.

1. Mount your camera on a tripod facing the subject you'd like to capture.

2. Calculate an exposure for the scene, then add one f/stop's worth. Because of the way the Harris effect exposes an image, more exposure is required. Use a small f/stop and a low ISO setting so your total exposure will be a long one, preferably several seconds in length.

3. Have red, green, and blue filters at the ready. Ideally, these should be equivalent to Kodak Wratten #25, #61, and #38A.

4. Mount the red filter in front of the lens. You can simply hold the filter in front of the lens (which is best from the standpoint of not moving the camera between "exposures") or drop the filter into a holder such as a Cokin filter holder.

5. Open the camera shutter using your camera's Time exposure setting, which will allow the shutter to remain open until the shutter release is pressed a second time.

6. When one-third of your exposure time has elapsed, quickly move a black card in front of the lens, ahead of the filter, to block any further exposure.

7. Swap the first filter for the second, usually by slipping the first filter out of the holder and dropping in the second. Be careful not to nudge the camera.

8. Repeat steps 6 and 7 with the second and third filters. You can estimate one-third of the exposure time by counting off, or viewing a stop watch set within sight range (unless you have three hands). In all cases, work quickly to minimize the amount of time the shutter is open to reduce the chances of noise.

9. At the end of the final exposure, move the black card into place over the lens, and close the shutter.

Although this method works okay, you can see that the whole procedure is clumsy and likely to be inaccurate. Some colors are likely to receive too much exposure. For that reason, the actual Harris shutter works much better. I'll describe its use next.

Making and Using the Harris Shutter

The Harris Shutter solves the problem of swapping three colored filters during a single exposure by using a sliding panel with a trio of filters as the "shutter" itself. Here's how to make one:

1. Construct a thin "box" that will fit in front of the lens and extend above and below it, similar to the one shown in Figure 7.5. You can use thin cardboard if you're just planning on doing a few experiments, or go full out and use thin metal, wood, or other rugged material. The best design will have a lower end that's closed and long enough to catch the sliding panel after all the filters have passed in front of the lens.

2. Cut a round hole in the front and rear of the box.

3. Use a Series adapter ring on the panel closest to the camera to allow fastening the assembly to your lens.

4. Create a sliding panel that can be dropped through the box in front of the adapter ring. Make the lower end long enough that when placed in the box, it passes in front of the ring, to avoid snags.

5. To use the device, position the slide in the chute so it covers the lens, and choose a slow shutter speed from 1/2 second to 1/30th second. Press the shutter release while letting go of the slide. Some slides drop more quickly than others, so you might have to adjust your exposure time so that the full exposure is made during the slide's descent.

You can forget about all this folderol and skip the whole shutter paradigm if you follow the instructions for achieving an almost identical effect digitally.

Figure 7.5 Your Harris Shutter should look like this.

Digital Harris Shutter

I came up with this novel way of mimicking a Harris Shutter with a digital camera more than three years ago, but it's been independently discovered by a few other tinkerers since then, so I decided it's time to reveal my own special method. The inspiration for this method comes from the technique mentioned first. Although most digital SLRs don't have double exposure capabilities, I reasoned

that it should be possible to take three completely separate images within a short period of time, each of them through a different color filter, and then merge the individual pictures in Photoshop to create a Harris-like effect.

Then, I realized that the three separate filters aren't needed at all: Your digital camera also takes three individual shots through its own color filters. The only thing you really need to do is take three images and then combine the red channel of one, the blue channel of a second exposure, and the green channel of a third to get almost exactly the same look.

Of course, the result isn't precisely like the Harris Shutter effect. With a Shutter-derived photo, the transition from red to green to blue is gradual, so there is a bit of blending between the three versions in the moving part of your subject. If you shoot three separate shots instead and merge the channels, each of the three colors is much more distinct.

Here's how to produce the effect shown in Figure 7.6. The technique has two parts, one in-camera, and the second within an image editor such as Photoshop. I'll explain them separately. First, with your camera, follow these steps:

1. Mount your camera firmly on a tripod. You'll need to hold the camera steady between shots, so a tripod is your best bet. However, I have had good luck just bracing my camera on a railing or other support.

2. For best results, focus manually and set the exposure manually. Use your camera's autofocus and autoexposure features if you like, but then lock both settings in manually. You don't want exposure or focus to change between your consecutive shots.

3. Set your camera for consecutive shooting/sequence shooting. This will allow you to take exposures one after another within a short span.

Figure 7.6 Three separate photos, merged in Photoshop, produce this multi-color effect.

4. When you're ready to go, gently depress the shutter release and take at least five consecutive shots. You actually need only three, but you'll find that the bounceback from pressing the shutter release for the first shot will cause the camera to move slightly. The first shot or two won't be exactly registered with each other, while the three in the middle will be almost precisely the same. This phenomenon makes it practical to shoot these photos without a tripod if you hold the camera steady, braced against something, expecting to discard the first couple and last couple pictures in the series.

5. Repeat the series a few times, as you'll discover that the effect of the moving objects in your image, as rendered in the red, green, and blue colors, will be different each time.

When you've taken your series, import the shots into Photoshop, or another image editor, and follow these steps.

1. Select each of the consecutive shots in turn, using Ctrl + A (Command + A on the Mac), and paste the image down into a new, empty document. When you've got three or more images pasted that seem to be in good register, you can stop.

2. Look at each layer in turn by turning the eyeball icon next to it on or off. This will allow you to see if any of the layers are seriously out of register. Examine non-moving objects, such as buildings or tree trunks and see if they are aligned in all the layers. Ignore things that moved (such as running water) or things that could have moved (particularly foliage) in making your evaluation.

3. Choose one layer and click the Channels palette. Highlight the Red channel and press Ctrl + C (Command + C on the Mac) to copy the black-and-white information to the Clipboard.

4. In a new, blank RGB document, click the Channels palette again, and press Ctrl + V (Command + V on the Mac) to paste the red channel into the red channel of the new document.

5. Go back to the original images, choose a different layer, go to the Channels palette again, and this time copy the green channel. Paste it down in the green channel of the new document.

6. Repeat Step 5, but use the blue channel instead. Your new document will have red, green, and blue channels, but each will have been copied from a different original shot, taken a fraction of a second earlier/later than the other channels, as you can see in Figure 7.6.

There are lots of variations on this theme that you can play with. For example, paste the red channel into the green channel of the new document; the green channel into the blue channel; and the blue channel into the red channel. That will give the non-moving parts of your image an interesting false-color look.

Or, select Image > Mode > CMYK to convert your RGB image to cyan, magenta, yellow, and black; then use the step outlined previously with a new, blank CMYK document to copy *four* colors to four new channels in the second version.

Soft Lights Are Your Friends

As you learned in the last chapter, soft lighting can be used to create flattering portraits, reduce reflections on shiny objects, or disguise the texture of subjects that are too rough looking in their native state. There are lots of ways you can make your own soft lights, as I'll show you in this section.

Milk Bottle Soft Light

The light emitted by an external flash may be too harsh. That's why flash diffusers mentioned in Chapter 6, like those offered from Sto-Fen and others, are available to clip onto your unit. Although they are priced reasonably, if you drink milk in your household, you can have an effective diffuser for free.

Such diffusers are closely related to "soft boxes." Any soft box is, as you might guess, a box-like affair holding a light source, such as and having a large diffusing surface to soften the light. They're widely used to provide flattering lighting for portraits and for product photography where glare might be a problem. You can build your own soft box, and one built out of a milk bottle is one of the easiest to construct.

Figure 7.7 You can press any empty translucent container into service as a flash diffuser.

An empty translucent gallon milk bottle is at the large end of the scale. You can also use half-gallon sizes, or any other translucent bottle you find that will fit over your flash head. Creating one is ridiculously easy. Empty the bottle, wash it out, remove the labels, cut a whole in the spout large enough to fit your flash, and you're in business, as you can see in Figure 7.7.

Milk Bottle Tent

A milk bottle also can be used as a lighting tent for close-up and macro photography. Building your own lighting tent can be the best move you ever made if you regularly photograph shiny things that pose seemingly insurmountable reflection problems when captured using conventional lighting techniques. This section will help you get started.

An easy way to create a small tent is to use a translucent, diffusing object that can fit around the subject you're photographing. An ordinary one-gallon plastic milk container, like the one shown in Figure 7.8, can do a good job. You'll want the kind that is white and translucent. Clean the jug carefully and cut off the bottom so you can place it over your subject. Enlarge the opening in the top so your camera lens will fit through. You can light the jug from all sides to provide a soft, even lighting, while photographing the subject through the top.

This makeshift kind of tent works only with small objects that can fit inside, and your camera-to-subject distance may be constrained by the size of the jug. A better choice is to build a full-fledged tent framework out of lumber, using 2 × 2 or 2 × 4 studs to create an open cube. Then staple or fasten sheets of muslin, white plastic trash bags, or other translucent white material to each face of the cube. Attach the diffusing material only at the top of the frame.

Figure 7.8 A translucent plastic milk bottle can be pressed into service as a makeshift tent.

Flip up the material on any side to insert your macro subject matter on an appropriate stand or backdrop. You can cut flaps in the material on all four sides, plus the top, so you can insert the camera lens as required, or close the flap and move to another side for a different angle. I like to set the tent apparatus on a tall barstool so I can get close from any angle and move around for the best perspective.

A cubical tent of this sort offers all kinds of flexibility in terms of use and how you light it. For example, you can place stronger lights on one side and slightly weaker lights on the other to provide a soft modeling effect. Or hit all the sides with bright lights for flat, low-contrast illumination. Figure 7.8 shows a photograph of a coin made inside a tent. There was enough directional quality to the light so that the raised features of the coin can still be seen easily. Yet, nearly all the glare that a direct light source would produce has been eliminated. It may not be the best coin photograph in the world, but you can see how the soft lighting has no glare to interfere with viewing the coin's features, but there is still enough contrast to see the texture of the coin.

Figure 7.9 Tent lighting can be directional, yet soft and without glare.

Clean Your Sensor

In my book *Mastering Digital SLR Photography*, I warned readers about the importance of removing dust from digital sensors. I'll recap some of that information here, but plan on going a step further. I'm going to show you exactly how to do it, and most importantly, how to make your own equipment for effectively cleaning your sensor. Because commercial sensor kits can cost $100 or more, you can save a lot of money with the information in this section.

Dust is everywhere. There's no getting around it. No matter how careful you are, some of it is going to settle on your camera. Dust on the outside of the camera is unsightly, but potentially dangerous to an image only when it manages to get inside your lenses in sufficient quantities to provide unwanted diffusion. It's annoying when it invades your focusing screen, and potentially invites scratches on the delicate surface of your dSLR's mirror when it's cleaned off clumsily. Some dust may settle in the mirror chamber and find its way onto the anti-aliasing filter atop your sensor, at which position it holds the possibility of showing up on every single picture you take at a small enough aperture to bring it into sharp focus. No matter how careful you are and how cleanly you work, eventually you will get some dust on your camera's sensor. This section explains the problem and provides some tips on minimizing dust and eliminating it when it begins to affect your shots.

Identifying and Dealing with Dust

We're all surrounded by dust and dirt, and each time you remove a lens to mount another, a bit of dust will waft inside your camera, often clinging to the sides and bottom of the mirror box. A bit will land on the mirror itself, where it will be invisible through the viewfinder (unless it is a truly humongous blotch), or stick to the underside of the focus screen, where you will be able to see it. Dust in none of these places will affect your pictures, although it's likely you'll find them annoying.

I recommend removing dust in these locations with a blower, especially dust on the mirror, which is easily scratched. Serious cleaning efforts, including those with wet swabs, is not only unnecessary but unwise. If you scratch your mirror or focus screen, you'll know what annoyance is.

It's better to concentrate on the dust particles that cling to the shutter curtain and rear portions of the mirror box. They're likely to be stirred up by the motion of the curtain and make their way inside to the sensor. Taking a photo with the camera pointed upwards will put the law of gravity to work against you. The dust settles on the outer surface of the sensor, rather than the sensor itself. Some vendors help keep this dust from sticking. Olympus uses an ultrasonic device that should shake any dust particles loose, where it falls to the bottom of the camera and becomes embedded in a sticky-tape-style patch. Although I have never seen a treatise on the subject, I assume that this sticky patch remains sticky for a very long time and doesn't tend to "fill up" with dust particles.

Some digital SLRs and some users tend to be more susceptible to dust on the sensors than others. If you frequent the newsgroups, you'll see reports from owners who have never had a dust problem with their cameras, as well as from those who need to clean their sensors once every week or two. It's possible that the "clean" photographers don't know how to recognize sensor dust, and the "dirty" are really picky, or that each group takes fewer or more pictures of the type in which sensor dust is obvious.

In my own case, my first digital SLR, a low-end model, showed the effects of dust within two weeks of purchase, and I had removed the lens perhaps no more than three or four times. Later, I bought a $5,000 pro dSLR and went several months before needing to clean it. Go figure.

Sensor dust is less of a problem than it might be because it shows up only under certain circumstances. Indeed, you might have dust on your sensor right now and not be aware if it. The dust doesn't actually settle on the sensor itself, but, rather, on a protective filter a very tiny distance above the sensor, subjecting it to the phenomenon of *depth-of-focus*. Depth-of-focus is the distance the focal plane can be moved and still render an object in sharp focus. At f/2.8 to f/5.6 or even smaller, sensor dust, particularly if small, is likely to be outside the range of depth-of-focus and blur into an unnoticeable dot.

However, if you're shooting at f/16 to f/22 or smaller, those dust motes suddenly pop into focus. You won't even see them if you look at your sensor with the shutter open and the lens removed, but they'll be there. The period at the end of this sentence, about .33mm in diameter, could block a group of pixels measuring 40 × 40 pixels (1600 pixels in all!) on a typical high-resolution sensor.

Dust spots that are even smaller than that can easily show up in your images if you're shooting large, empty areas that are light colored. Dust mites are most likely to show up in the sky, or in white backgrounds of your seamless product shots, and less likely to be a problem in images that contain lots of dark areas and detail, as shown in Figure 7.10.

Figure 7.10 Only the dust spots in the sky are apparent in this shot.

To see if you have dust on your sensor, take a few test shots of a plain, blank surface (such as a piece of paper or a cloudless sky) at small f/stops, such as f/22, and a few wide open. Open Photoshop, copy several shots into a single document in separate layers, then flip back and forth between layers to see if any spots you see are present in all layers. You may have to boost contrast and sharpness to make the dust easier to spot.

Remember that dust particles are *not* dead pixels, which can be another, albeit more rare problem. Pixels in your sensor can fail and thenceforth always produce a light pixel in that location (it's always "on") or a dark pixel (it won't register light at all). It's usually easy to differentiate dust from dead pixels. Both appear in the same place in every picture, but dust shows up as irregular blotches. Dead pixels are just that, dark or light pixels surrounded by other sharply defined imperfect pixels produced by your camera's demosaicing algorithm using the faulty information from one pixel to "correct" the pixels that surround it. Your camera can be taught to ignore dead pixels through a technique called *pixel mapping*, which locks the defective pixels out. Some dSLRs have pixel mapping built into their setup menu, while others require sending the camera back to the manufacturer. The "fix" (after all, your pixel is *not* restored to life) will be low in cost or free if the camera is under warranty.

Avoiding Dust

Of course, the easiest way to protect your sensor from dust is to prevent it from settling on the sensor in the first place. Here are my stock tips for eliminating the problem before it begins.

- **Clean environment.** Avoid working in dusty areas if you can do so. Hah! Serious photographers will take this one with a grain of salt, because it usually makes sense to go where the pictures are. Only a few of us are so paranoid about sensor dust (considering that it is so easily removed) that we'll avoid moderately grimy locations just to protect something that is, when you get down to it, just a tool. If you find a great picture opportunity at a raging fire, during a sandstorm, or while surrounded by dust clouds, you might hesitate to take the picture, but, with a little caution (don't remove your lens in these situations, and clean the camera afterwards!), you can still shoot. However, it still makes sense to store your camera in a clean environment. One place cameras and lenses pick up a lot of dust is inside a camera bag. Clean your bag from time to time, and you can avoid problems.

- **Clean lenses.** There are a few paranoid types that avoid swapping lenses in order to minimize the chance of dust getting inside their cameras. It makes more sense just to use a blower or brush to dust off the rear lens mount of the replacement lens first, so you won't be introducing dust into your camera sim-

ply by attaching a new, dusty lens. Do this before you remove the lens from your camera, and then avoid stirring up dust before making the exchange.

■ **Work fast.** Minimize the time your camera is lens-less and exposed to dust. That means having your replacement lens ready and dusted off, and a place to set down the old lens as soon as it is removed, so you can quickly attach the new lens.

■ **Let gravity help you.** Face the camera downward when the lens is detached so any dust in the mirror box will tend to fall away from the sensor. Turn your back to any breezes or sources of dust to minimize infiltration.

■ **Protect the lens you just removed.** Once you've attached the new lens, quickly put the end cap on the one you just removed to reduce the dust that might fall on it.

■ **Clean out the vestibule.** From time to time, remove the lens while in a relatively dust-free environment and use a blower bulb (*not* compressed air or a vacuum hose) to clean out the mirror box area. A blower brush is generally safer than a can of compressed air, or a strong positive/negative airflow, which can tend to drive dust further into nooks and crannies.

■ **Be prepared.** If you're embarking on an important shooting session, it's a good idea to clean your sensor *now*, rather than come home with hundreds or thousands of images with dust spots caused by flecks that were sitting on your sensor before you even started. Before I left on my recent trip to Spain, I put both cameras I was taking through a rigid cleaning regimen, figuring they could remain dust-free for a measly 10 days. I even left my bulky blower brush at home. It was a big mistake (see Worst-Case Scenario, below), but my intentions were good.

WORST-CASE SCENARIO

Careful planning sometimes goes awry. I was traveling extra light and certainly didn't want to take my sensor cleaning kit, particularly the bulky AC adapter required by one of my cameras to lock up the mirror for cleaning. So, 4,000 miles from my bulb blower, I found myself shooting sunset photos on the last day of my trip and picture review showed a huge spot of dust smack in the middle of the sky. It was visible even on the 2.5-inch LCD on the back of my camera. On an impulse, I decided to do the worst possible thing, partly as an experiment, and partly because I wasn't thinking clearly. I decided to clean the sensor in the field, without tools. I knew the consequences, and this was the tail end of my trip, plus I had a second camera body to use if I goofed up this one. So I decided to go ahead. I happened to be very lucky: *don't* try this at home.

I removed the lens, set the camera on Bulb, and opened the shutter for a long exposure. (There's no separate mirror lock-up function for this camera when no AC adapter is connected.) Then, because my mouth was very, very dry (actually, I was dying of thirst), I puckered up and puffed an extremely vigorous blast of air from my own personal lungs onto the sensor, with the camera held at an angle that would encourage the dust to fall off the sensor. Later on, I slapped my forehead thinking about what would happen if a bit of moisture, or worse, was carried onto the sensor. However, the ending was happy; the huge dust mite fell off and I continued the trip with a clean sensor. However, I could have easily been writing this telling you how I messed up my camera. The lesson I learned was that I will never again travel without my blower bulb.

Removing Unsightly Dust

Perhaps you weren't very lucky. You've taken some shots and notice a dark spot in the same place in every image. What's the best method for removing dust from photos after it's already settled in? Try these after-the-fact fixes.

- **Clone them out.** Clone the spots out with your image editor. Photoshop and other editors have a clone tool or healing brush you can use to copy pixels from surrounding areas over the dust spot or dead pixel. This process can be tedious, especially if you have lots of dust spots and/or lots of images to be corrected. The advantage is that this sort of manual fix-it probably will do the least damage to the rest of your photo. Only the cloned pixels will be affected.

- **Filter them out.** Use your image editor's "dust and scratches" filter. A semi-intelligent filter like the one in Photoshop can remove dust and other artifacts by selectively blurring areas that the plug-in decides represent dust spots. This method can work well if you have many dust spots, because you won't need to patch them manually. However, any automated method like this has the possibility of blurring areas of your image that you didn't intend to soften.

- **Let your camera's software try to remove them.** Try your camera's "dust reference" feature. Some dSLRs have a dust reference removal tool that compares a blank white reference photo containing dust spots with your images, and uses that information to delete the corresponding spots in your pictures. However, such features generally work only with files you've shot in RAW format, which won't help you fix your JPEG photos. Dust reference subtraction can be a useful after-the-fact remedy if you don't have an overwhelming number of dust spots in your images.

Sensor Cleaning

Sooner or later you'll have to make a decision. Should you clean your sensor yourself, or pack up your camera and send it to the manufacturer and let their crack technical staff do the job for you? Or should you let the friendly folks at your local camera store do it?

The important thing to remember is that if you choose to let someone else do it, they will be using methods that are more or less identical to the techniques you would use yourself. None of these techniques are difficult, and the only difference between their cleaning and your cleaning is that they might have done it dozens or hundreds of times. If you're careful, you can do just as good a job.

Of course vendors won't tell you this, but it's not because they don't trust you. It's not that difficult for a real goofball to mess up his camera by hurrying or taking a shortcut. Perhaps the person uses the "Bulb" method of holding the shutter open and a finger slips, allowing the shutter curtain to close on top of a sensor cleaning brush. Or, someone tries to clean the sensor using masking tape, and ends up with goo all over its surface. If your vendor recommended *any* method that's mildly risky, someone would do it wrong, and then the manufacturer would face lawsuits from those who'd contend they did it exactly in the way the vendor suggested, so the ruined camera is not their fault.

As a result, vendors tend to be conservative in their recommendations, and, in doing so, make it seem as if sensor cleaning is more daunting and dangerous than it really is. Some vendors recommend only dust-off cleaning, through the use of reasonably gentle blasts of air, while condemning more serious scrubbing with swabs and cleaning fluids. These same manufacturers sometimes offer the cleaning kits for the exact types of cleaning they recommended against, for sale in Japan only, where, apparently, your average photographer is more dexterous than those of us in the rest of the world. These kits are similar to those used by the vendor's own repair staff to clean your sensor if you decide to send your camera in for a dust-up.

In practice, removing dust from a sensor is similar in some ways to cleaning the optical glass of a fine lens. It's usually a good idea to imagine that the exposed surfaces of a lens are made of a relatively soft kind of glass that's easily scratched, which is not far from the truth (although various multi-coatings tends to toughen them up quite a bit). At the same time, imagine that dust particles are tiny, rough-edged boulders that can scratch the glass if dragged carelessly across the dry surface. Liquid lens cleaners can reduce this scratching by lubricating the glass as a lens cloth or paper is used to wipe off the dust, but can leave behind a film of residue that can accumulate and affect the lens' coating in another fashion. Picture the lens wipes as potential havens for dust particles that can apply their own scratches to your lenses.

Sensors have similar characteristics, with a few differences. Sensors can be affected by dust particles that are much smaller than you might be able to spot visually on the surface of your lens. The filters that cover sensors tend to be fairly hard compared to optical glass. Cleaning even a 24mm × 36mm full-frame sensor within the tight confines of the mirror box can call for a steady hand and careful touch. Worse, if your sensor's filter becomes scratched through inept cleaning, you can't simply remove it yourself and replace it with a new one.

There are four basic kinds of cleaning processes that can be used to remove dusty and sticky stuff that settles on your dSLR's sensor. All of these must be performed with the shutter locked open:

- **Air cleaning.** This process involves squirting blasts of air inside your camera with the shutter locked open. This works well for dust that's not clinging stubbornly to your sensor.

- **Brushing.** A soft, very fine brush is passed across the surface of the sensor's filter, dislodging mildly persistent dust particles and sweeping them off the imager.

- **Liquid cleaning.** A soft swab dipped in a cleaning solution such as ethanol is used to wipe the sensor filter, removing more obstinate particles.

- **Tape cleaning.** There are some who get good results by applying a special form of tape to the surface of their sensor. When the tape is peeled off, all the dust goes with it. Supposedly. I'd be remiss if I didn't point out right now that this form of cleaning is somewhat controversial; the other three methods are much more widely accepted.

I'll describe each of these methods with enough detail for you to do it yourself, assuming you have the right tools. Then, later on in this chapter I'll show you how to get or make the tools at absolute minimum cost. When you consider that one popular sensor brush sells for almost $100, and that little swabs for wet-wiping your sensors can cost $10 each, I think you'll appreciate the advice I'm going to offer.

First Things First

The first thing to do is to learn how to lock up your camera's mirror so you can gain access to the sensor. You'll probably have to use a menu item in your dSLR's setup page to flip up the mirror and lock it in place. Some vendors recommend locking up the mirror for cleaning only if a camera is powered by an AC adapter, rather than by a battery, and some cameras don't allow the mirror to be locked up at all without an AC adapter connected. The idea is that if the battery fails while you're cleaning the sensor, a damaged mirror, shutter, or sensor can result. Some folks have noted that they experience power brownouts and blackouts much more

often than their battery runs out, and that they'd rather take their chances with battery power. Unless you're shooting in a studio, taking time-lapse photos, or doing other power-intensive kinds of photography, you probably won't need an expensive AC adapter for anything other than sensor cleaning.

An alternative to mirror lockup is a Bulb or Time exposure. While I've used Bulb to open the shutter in a pinch, it's not a recommended method for common use. When using Bulb, the sensor is active, and some say that a live sensor builds up a static charge that actually attracts dust. Others don't like leaving a live sensor exposed to light for long periods of time, noting that the filter overlays are made of dyes that can fade from long exposure. I don't have solid evidence to refute any of these cautions, but I tend to avoid using Bulb to clean the sensor for another reason: It's too easy to accidentally close the shutter before all the tools are out of the way.

Once you've removed the lens and managed to get the mirror flipped up, you should proceed with the cleaning process, and work as quickly as you can to minimize the chance of more dust settling inside. Have a strong light available, or one of those headband illuminators to brighten up the inside of your camera so you'll know what you're doing.

Air Cleaning

Your first attempts at cleaning your sensor should always involve gentle blasts of air. Many times, you'll be able to dislodge dust spots, which will fall off the sensor and, with luck, out of the mirror box. Attempt one of the other methods only when you've already tried air cleaning and it didn't remove all the dust.

Here are some tips for doing air cleaning:

■ **Use a clean, powerful air bulb.** Your best bet is bulb cleaners designed for the job, like the Giotto Rocket shown in Figure 7.11. Smaller bulbs, like those air bulbs with a brush attached sometimes sold for lens cleaning or weak nasal aspirators may not provide sufficient air or a strong enough blast to do much good. There have also been reports of those bulbs having a fine powder inside that can be deposited on your sensor.

■ **Hold the camera upside down.** Then look up into the mirror box as you squirt your air blasts, increasing the odds that gravity will help pull the expelled dust downward, away from the sensor. You may have to use some imagination in positioning yourself.

Figure 7.11 Use a robust air bulb like the Giotto Rocket for cleaning your sensor.

- **Never use air canisters.** The propellant inside these cans can permanently coat your sensor if you tilt the can while spraying. It's not worth taking a chance.

- **Avoid air compressors.** Super-strong blasts of air are as likely to force dust into places you don't want it to be, including under the sensor filter, than they are to remove it.

Brush Cleaning

If your dust is a little more stubborn and can't be dislodged by air alone, you may want to try a brush, charged with static electricity, which can pick off dust spots by electrical attraction. One good, but expensive, option is the Sensor Brush sold at **www.visibledust.com**. Ordinary artist's brushes are much too coarse and stiff and have fibers that are tangled or can come loose and settle on your sensor. The Sensor Brush's fibers are resilient and described as "thinner than a human hair." Moreover, the brush has a wooden handle that reduces the risk of static sparks. Later in this chapter, I'll show you a cheaper alternative you can prepare yourself.

Brush cleaning is done with a dry brush by gently swiping the surface of the sensor filter with the tip. The dust particles are attracted to the brush particles and cling to them. You should clean the brush with compressed air before and after each use, and store it in an appropriate air-tight container between applications to keep it clean and dust free. Although these special brushes are expensive, one should last you a long time. They are offered in various sizes to fit different dSLR sensor widths. You can also use a brush to dust off the surfaces inside the mirror box.

Liquid Cleaning

Unfortunately, you'll often encounter really stubborn dust spots that can't be removed with a blast of air, or flick of a brush. These spots may be combined with some grease or a liquid that causes them to stick to the sensor filter's surface. In such cases, liquid cleaning with a swab may be necessary. During my first clumsy attempts to clean my own sensor, I accidentally got my blower bulb tip too close to the sensor, and some sort of deposit from the tip of the bulb ended up on the sensor. I panicked until I discovered that liquid cleaning did a good job of removing whatever it was that took up residence on my sensor.

You can make your own swabs out of pieces of plastic (some use fast food restaurant knives, with the tip cut at an angle to the proper size) covered with a soft cloth or PEC*PAD (I'll show you how to do this later). However, if you've got the bucks to spend, you can't go wrong with good-quality commercial sensor cleaning swabs, such as those sold by Photographic Solutions, Inc. (**www. photosol.com/swabproduct.htm**). (Note that Photographic Solutions also sells

special very expensive swabs, and so doesn't recommend PEC*PADs for sensor cleaning. But thousands of photographers have been happily using them for years.) Vendors selling these swabs will recommend the right size for your particular dSLR.

You want a sturdy swab that won't bend or break, so you can apply gentle pressure to the swab as you wipe the sensor surface. Use the swab with methanol (as pure as you can get it, particularly medical grade; other ingredients can leave a residue), or the Eclipse solution also sold by Photographic Solutions. Eclipse is actually quite a bit purer than even medical grade methanol. A couple drops of solution should be enough, unless you have a spot that's extremely difficult to remove. In that case, you may need to use extra solution on the swab to help "soak" the dirt off.

Once you overcome your nervousness at touching your camera's sensor, the process is easy. You'll wipe continuously with the swab in one direction, then flip it over and wipe in the other direction. You need to completely wipe the entire surface; otherwise you may end up depositing the dust you collect at the far end of your stroke. Wipe; don't rub.

Tape Cleaning

There are people who absolutely swear by the tape method of sensor cleaning. The concept seems totally wacky, and I have never tried it personally, so I can't say with certainty that it either does or does not work. In the interest of completeness, I'm including it here. I can't give you a recommendation, so if you have problems, please don't blame me.

Tape cleaning works by applying a layer of Scotch Brand Magic Tape to the sensor. This is a minimally sticky tape that some of the tape cleaning proponents claim contains no adhesive. I did check this out with 3M, and can say that Magic Tape certainly *does* contain an adhesive. The question is whether the adhesive comes off when you peel back the tape, taking any dust spots on your sensor with it. The folks who love this method claim there is no residue. There have been reports from those who don't like the method that residue is left behind. This is all anecdotal evidence, so you're pretty much on your own in making the decision whether to try out the tape cleaning method or not.

Making Your Own Tools

You can buy special kits with the tools to clean your sensor, or you can purchase the tools individually or make them yourself. This next section will show you how to save a bit of money on your sensor cleaning implements.

Rocket Blower

Saving a little money on a blower by purchasing a nasal aspirator isn't worth it, in my opinion. The Giotto Rocket Blower, shown earlier in Figure 7.11, is available in three sizes, 5.3, 6.75, and 7.5 inches tall, priced from about $9 to $11. The smallest is perfect for your camera bag, and the largest makes a powerful tool to use at home. The prices are so reasonable that it makes little sense to get anything else. These blowers feature a detachable, directible air stream tube, and an air inlet valve that prevents backflow from the air tube. The "rocket ship" base lets you stand the blower on its end so the tip doesn't need to rest on any surface where it can pick up dust. Highly recommended.

Sensor Brush

A brush can be used to flick dust off your sensor. It's an extremely safe method, as it's unlikely that a soft brush will scratch a hard glass sensor filter, even if a piece of grit were caught in the bristles.

However, not just any brush will do. You need a soft, extremely clean brush made of nylon, with slippery, thin bristles of a uniform thickness. Nylon picks up a dust-attracting charge of static electricity when air is blown through it. Moreover, the brush should be about 14–24mm wide, to fit the surface of dSLR sensors, and have a wooden or acrylic handle that is non-conductive, so it won't pick up static electricity from your body. Finally, an effective sensor cleaning brush should not contain sizing (used to stiffen the brush), glue (which can leak down into the bristles from the handle), or grease and other contaminants.

Your best source of such brushes are brushes used to apply cosmetics, those with nylon bristles, as shown in Figure 7.12. If you find a brush that meets all the criteria listed, you'll still need to clean it *very* thoroughly before its first use. It probably has sizing, perhaps some glue, and almost certainly oil from the fingers of anyone who has handled the brush before. The cleaning process involves several steps:

1. First, do a rough cleaning to get out most of the contaminants. Work some dishwasher fluid into the bristles and rub gently with your fingers.

2. Hold the brush in the stream of water under the tap, pointed upwards so the water runs down the tip to the handle.

Figure 7.12 A nylon-bristled cosmetics brush can be used to clean a sensor.

3. Repeat until the bristles feel slippery, clean, and without deposits of oil or other contaminants. Pretend you're washing your hair; when the bristles feel clean, they are clean—mostly.

4. When the brush is thoroughly rinsed out, rinse it out again in distilled water. This will remove any remaining sizing or oils, plus calcium that might hide in your tap water if it's hard.

5. Let the brush dry before you test it for any remaining gunk.

6. Once the brush is dried, take a filter that has been carefully cleaned, and swipe across the surface of the filter many, many times. Several hundred swipes is not too many.

7. Examine the filter carefully. If there is any residue in the brush it will show up as fine lines on the filter surface. If you discover these lines, clean off the filter, re-clean the brush, and test again.

To use your brush, just blow air through it to activate the electrical charge. Then sweep it across your sensor from one side to the other. Remove the brush from the mirror box, recharge it again with air, and sweep it across the sensor in the other direction. That should remove all the dust. Close the shutter, recharge the brush a third time, and clean the underside of the mirror and the sides and bottom of the mirror box, where dust tends to accumulate.

Take a test shot, and if you still have dust, repeat the sensor brushing, or continue on to the sensor swabbing method, using a swab you make yourself.

Sensor Swab

Swabs for your sensor are easy to make. You need just three components for wet cleaning, a base for your swab, the swab material itself, and a cleaning liquid. I'll address each of these separately.

Swab Base

You need a firm tool you can use to swipe inside your camera, across the sensor surface. You can use a narrow rubber spatula, a wooden tongue depressor, or a tool like a plastic knife, shown in Figure 7.13, that you can pick up at any fast food restaurant. Many folks prefer one over the other. The rubber spatula is softest, with the most amount of "give," with wooden tongue depressors coming in second. A plastic knife is the firmest of all. None of these surfaces will actually be touching the sensor, so it's up to your preference which type to use. They are cheap enough you can make a swab with all three and choose the one you like best.

Cut off the tip of the swab's handle, then use a file to remove any burrs or sharp spots on the tip, like the rough edges you can see in Figure 7.14. This is very important, as the tip will be covered by a relatively thin layer of wiping material and a burr could easily press through to scratch your sensor.

Figure 7.13 A free plastic knife can be truncated and used as the base for a sensor swab.

Figure 7.14 Don't leave the tip of the handle rough like this; file it smooth to a bevel edge.

Swab Material

There is little need to use anything other than PEC*PADs, available from Photographic Solutions (URL above). These pads are clean, lint free, and soft, exceeding common lens tissue in all these respects. They cost only a few cents each, so it's false economy to use anything else. To form the swab, follow these steps:

1. Fold the PEC*PAD in half.

2. Slip the swap base inside the folded pad, avoiding touching the tip of the swab, which will be touching the sensor. You don't want to transfer any oils from your finger.

3. Fold the top edge down over the swab, as shown in Figure 7.15.

4. Fold the other half over to create a tightly wrapped swab, as shown in Figure 7.16.

5. Wrap some tape around the finished swab to hold the pad in place.

Figure 7.15 Fold the PEC*PAD in half and insert the handle.

Figure 7.16 Fold and tape the pad to fit the handle snugly.

Cleaning Liquid

Get yourself some Eclipse solution, which is the purest methanol you can buy. A small bottle like the one shown in Figure 7.17 will last a long time, because you use only a few drops for each cleaning. Keep in mind that Eclipse is flammable and so can't be taken on an airplane. If you travel by air, you'll have to leave your wet cleaning kit behind.

To use your sensor cleaning kit, apply one drop of Eclipse solution to each side of the tip. Lock your mirror up so you can see the sensor, as shown in Figure 7.18. Then, swab across your sensor the full width from one side to the other, flip the swab over, and swab in the other direction, as in Figure 7.19. That should be all it takes.

Figure 7.17 Eclipse solution is the purest methanol you can buy.

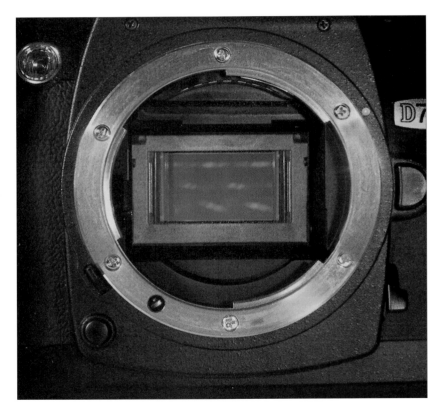

Figure 7.18 Lock up the mirror and open the shutter to reveal the sensor.

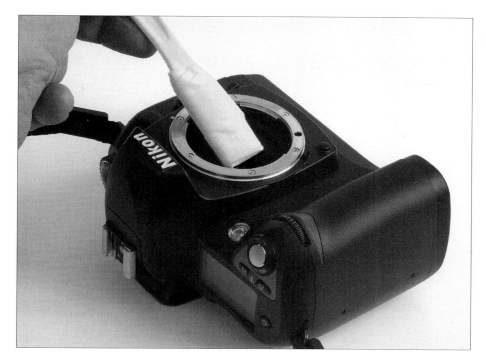

Figure 7.19 Use the swab to clean the sensor surface.

Next Up

That's all, folks. I hope you've enjoyed this in-depth look at ways to get the most out of your digital SLR, and use the information I've provided as only a jumping-off point for further experimentation, study, and shooting. Photography isn't really something you learn once. Your skills, knowledge, and results will improve the more photos you take.

Glossary

If you've turned to this portion of the book, there's probably a technical term you don't fully understand, or, perhaps, you'd like to see how related photographic concepts or techniques fit together. So, I've stuffed it with all the most common words you're likely to encounter when working with your digital camera and the photographs you create. This glossary includes most of the jargon included in this book, and some that is not within these pages, but which you'll frequently come across as you work. Most of the terms relate to digital cameras or photography, but I've sprinkled in a little information about image editing and photo reproduction.

16-bit images So-called "48-bit" image files that contain 16 bits of information (65,535 different tones) per channel, rather than the 8 bits per channel found in ordinary, 24-bit 16.8 million color images. Photoshop CS 2 can work with 16-bit channels using a limited number of its tools to provide more accurate colors in the final image, while other image editors may require conversion to 8-bit format before they can manipulate them.

acutance A way of describing sharpness by measuring the transitions between edge details in an image.

additive primary colors The red, green, and blue hues which are used alone or in combinations to create all other colors you capture with a digital camera, view on a computer monitor, or work with in an image-editing program like Photoshop. See also *CMYK*.

AE/AF lock A control that lets you lock the current autoexposure and/or autofocus settings prior to taking a picture, freeing you from having to hold the shutter release partially depressed.

airbrush Originally developed as an artist's tool that sprays a fine mist of paint, the computer version of an airbrush is used both for illustration and retouching in most image-editing programs.

Figure A.1 The additive primary colors, red, green, and blue combine to make other colors, plus white.

ambient lighting Diffuse nondirectional lighting that doesn't appear to come from a specific source but, rather, bounces off walls, ceilings, and other objects in the scene when a picture is taken.

analog/digital converter In digital imaging, the electronics built into a camera or scanner that convert the analog information captured by the sensor into digital bits that can be stored as an image bitmap. See also *bitmap*.

angle of view The area of a scene that a lens can capture, determined by the focal length of the lens. Lenses with a shorter focal length have a wider angle of view than lenses with a longer focal length.

anti-alias A process in image editing that smoothes the rough edges in images (called jaggies or staircasing) by creating partially transparent pixels along the boundaries that are merged into a smoother line by our eyes.

Figure A.2 Anti-aliasing reduces the jagginess visible in diagonal lines.

aperture-preferred A camera setting that allows you to specify the lens opening or f/stop that you want to use, with the camera selecting the required shutter speed automatically based on its light-meter reading. See also *shutter-preferred*.

aperture ring A control on the barrel of many SLR lenses that allows setting the f/stop manually. Some lenses have the aperture set by the camera only, and lack this ring.

artifact A type of noise in an image, or an unintentional image component produced in error by a digital camera or scanner during processing.

aspect ratio The proportions of an image as printed, displayed on a monitor, or captured by a digital camera. An 8 × 10-inch or 16 × 20-inch photo each have a 4:5 aspect ratio. Your monitor set to 800 × 600, 1024 × 768, or 1600 × 1200 pixels has a 4:3 aspect ratio. When you change the aspect ratio of an image, you must crop out part of the image area, or create some blank space at top or sides.

aspherical element A component of a lens that is not a cross-section of a sphere, but rather formed from a non-spherical surface to provide better correction characteristics.

autofocus A camera setting that allows the camera to choose the correct focus distance for you, usually based on the contrast of an image (the image will be at

maximum contrast when in sharp focus) or a mechanism such as an infrared sensor that measures the actual distance to the subject. Cameras can be set for *single autofocus* (the lens is not focused until the shutter release is partially depressed) or *continuous autofocus* (the lens refocuses constantly as you frame and reframe the image).

autofocus assist lamp A light source built into a digital camera that provides extra illumination that the autofocus system can use to focus dimly lit subjects.

averaging meter A light-measuring device that calculates exposure based on the overall brightness of the entire image area. Averaging tends to produce the best exposure when a scene is evenly lit or contains equal amounts of bright and dark areas that contain detail. Most digital cameras use much more sophisticated exposure measuring systems based in center-weighting, spot-reading, or calculating exposure from a matrix of many different picture areas. See also *spot meter*.

B (bulb) A camera setting for making long exposures. Press down the shutter button and the shutter remains open until the shutter button is released. Bulb exposures can also be made using a camera's electronic remote control, or a cable release cord that fits to the camera. See also *T (Time)*.

back focus The tendency of an autofocus system to apply focus *behind* the point of true focus.

background In photography, the background is the area behind your main subject of interest.

back lighting A lighting effect produced when the main light source is located behind the subject. Back lighting can be used to create a silhouette effect, or to illuminate translucent objects. See also *front lighting, fill lighting,* and *ambient lighting.* Back lighting is also a technology for illuminating an LCD display from the rear, making it easier to view under high ambient lighting conditions.

balance An image that has equal elements on all sides.

Figure A.3 Back lighting produces a slight silhouette effect, and also serves to illuminate the translucent petals of this flower.

ball head A type of tripod camera mount with a ball-and-socket mechanism that allows greater freedom of movement than simple pan and tilt heads.

barrel distortion A defect found in some wide-angle prime and zoom lenses that causes straight lines at the top or side edges of an image to bow outward into a barrel shape. See also *pincushion distortion.*

beam splitter A partially silvered mirror or prism that divides incoming light into two portions, usually to send most of the illumination to the viewfinder and part of it to an exposure meter or focusing mechanism.

bilevel image An image that stores only black-and-white information, with no gray tones.

bit A binary digit, either a 1 or a 0, used to measure the color depth (number of different colors) in an image. For example, a grayscale 8-bit scan may contain up to 256 different tones (2^8), while a 24-bit scan can contain 16.8 million different colors (2^{24}).

bitmap A way of representing an image as rows and columns of values, with each picture element stored as one or more numbers that represent its brightness and color. In Photoshop parlance, a bitmap is a bi-level black/white-only image.

black The color formed by the absence of reflected or transmitted light.

black point The tonal level of an image where blacks begin to provide important image information, usually measured by using a histogram. When correcting an image with a digital camera that has an on-screen histogram, or within an image editor, you'll usually want to set the histogram's black point at the place where these tones exist.

blend To create a more realistic transition between image areas, as when retouching or compositing in image editing.

blooming An image distortion caused when a photosite in an image sensor has absorbed all the photons it can handle, so that additional photons reaching that pixel overflow to affect surrounding pixels producing unwanted brightness and overexposure around the edges of objects.

blowup An enlargement, usually a print, made from a negative, transparency, or digital file.

blur In photography, to soften an image or part of an image by throwing it out of focus, or by allowing it to become soft due to subject or camera motion. In image editing, blurring is the softening of an area by reducing the contrast between pixels that form the edges.

bokeh A buzzword used to describe the aesthetic qualities of the out-of-focus parts of an image, with some lenses producing "good" bokeh and others offering "bad" bokeh. *Boke* is a Japanese word for "blur," and the h was added to keep English speakers from rhyming it with *broke*.

Out-of-focus points of light become discs, called the *circle of confusion*. Some lenses produce a uniformly illuminated disc. Others, most notably *mirror* or *catadioptic* lenses, produce a disc that has a bright edge and a dark center, producing a "doughnut" effect, which is the worst from a bokeh standpoint. Lenses that generate a bright center that fades to a darker edge are favored, because their bokeh allows the circle of confusion to blend more smoothly with the surroundings. The bokeh characteristics of a lens are most important when you are using selective focus (say, when shooting a portrait) to deemphasize the background, or when shallow depth-of-field is a given because you're working with a macro lens, long telephoto, or with a wide open aperture. See also *mirror lens, circle of confusion*.

Figure A.4 The out-of-focus discs in the background are slightly lighter at the edges than in the center, producing "bad" bokeh.

bounce lighting Light bounced off a reflector, including ceiling and walls, to provide a soft, natural-looking light.

bracketing Taking a series of photographs of the same subject at different settings to help ensure that one setting will be the correct one. Many digital cameras will automatically snap off a series of bracketed exposures for you. Other settings, such as color and white balance, can also be "bracketed" with some models. Digital SLRs may even allow you to choose the order in which bracketed settings are applied.

brightness The amount of light and dark shades in an image, usually represented as a percentage from 0 percent (black) to 100 percent (white).

broad lighting A portrait lighting arrangement in which the main light source illuminates the side of the face closest to the camera.

buffer A digital camera's internal memory which stores an image immediately after it is taken until the image can be written to the camera's non-volatile (semi-permanent) memory or a memory card.

burn A darkroom technique, mimicked in image editing, which involves exposing part of a print for a longer period, making it darker than it would be with a straight exposure.

burst mode The digital camera's equivalent of the film camera's "motor drive," used to take multiple shots within a short period of time.

calibration A process used to correct for the differences in the output of a printer or monitor when compared to the original image. Once you've calibrated your scanner, monitor, and/or your image editor, the images you see on the screen more closely represent what you'll get from your printer, even though calibration is never perfect.

Camera RAW A plug-in included with Photoshop CS 2 that can manipulate the unprocessed images captured by digital cameras.

camera shake Movement of the camera, aggravated by slower shutter speeds, which produces a blurred image. Some of the latest digital cameras have *image stabilization* features that correct for camera shake, while a few high-end interchangeable lenses have a similar vibration correction or reduction feature. See also *image stabilization*.

candid pictures Unposed photographs, often taken at a wedding or other event at which (often) formal, posed images are also taken.

cast An undesirable tinge of color in an image.

CCD Charge-Coupled Device. A type of solid-state sensor that captures the image, used in scanners and digital cameras. See also *CMOS*.

center-weighted meter A light-measuring device that emphasizes the area in the middle of the frame when calculating the correct exposure for an image. See also *averaging meter* and *spot meter*.

chroma Color or hue.

chromatic aberration An image defect, often seen as green or purple fringing around the edges of an object, caused by a lens failing to focus all colors of a light source at the same point. See also *fringing*.

chromatic color A color with at least one hue and a visible level of color saturation.

chrome An informal photographic term used as a generic for any kind of color transparency, including Kodachrome, Ektachrome, or Fujichrome.

CIE (Commission Internationale de l'Eclairage) An international organization of scientists who work with matters relating to color and lighting. The organization is also called the International Commission on Illumination.

circle of confusion A term applied to the fuzzy discs produced when a point of light is out of focus. The circle of confusion is not a fixed size. The viewing distance and amount of enlargement of the image determine whether we see a particular spot on the image as a point or as a disc.

close-up lens A lens add-on that allows you to take pictures at a distance that is less than the closest-focusing distance of the lens alone.

CMOS Complementary Metal-Oxide Semiconductor. A method for manufacturing a type of solid-state sensor that captures the image, used in scanners and digital cameras. See also *CCD*.

CMY(K) color model A way of defining all possible colors in percentages of cyan, magenta, yellow, and frequently, black. Black is added to improve rendition of shadow detail. CMYK is commonly used for printing (both on press and with your inkjet or laser color printer). Photoshop can work with images using the CMYK model, but converts any images in that mode back to RGB for display on your computer monitor.

color correction Changing the relative amounts of color in an image to produce a desired effect, typically a more accurate representation of those colors. Color correction can fix faulty color balance in the original image, or compensate for the deficiencies of the inks used to reproduce the image.

Color Replacement A new tool in Photoshop and Photoshop Elements that simplifies changing all of a selected color to another hue.

comp A preview that combines type, graphics, and photographic material in a layout.

Figure A.5 The subtractive colors yellow, magenta, and cyan combine to produce all the other colors, including black.

composite In photography, an image composed of two or more parts of an image, taken either from a single photo or multiple photos. Usually composites are created so that the elements blend smoothly together.

Compact Flash A type of memory card used in most digital single lens reflexes.

composition The arrangement of the main subject, other objects in a scene, and/or the foreground and background.

compression Reducing the size of a file by encoding using fewer bits of information to represent the original. Some compression schemes, such as JPEG, operate by discarding some image information, while others, such as TIF, preserve all the detail in the original, discarding only redundant data. See also *GIF*, *JPEG*, and *TIF*.

continuous autofocus An automatic focusing setting in which the camera constantly refocuses the image as you frame the picture. This setting is often the best choice for moving subjects. See also *single autofocus*.

continuous tone Images that contain tones from the darkest to the lightest, with a theoretically infinite range of variations in between.

contrast The range between the lightest and darkest tones in an image. A high-contrast image is one in which the shades fall at the extremes of the range between white and black. In a low-contrast image, the tones are closer together.

contrasty Having higher than optimal contrast.

crop To trim an image or page by adjusting its boundaries.

dedicated flash An electronic flash unit designed to work with the automatic exposure features of a specific camera.

densitometer An electronic device used to measure the amount of light reflected by or transmitted through a piece of artwork, used to determine accurate exposure when making copies or color separations.

density The ability of an object to stop or absorb light. The less light reflected or transmitted by an object, the higher its density.

depth-of-field A distance range in a photograph in which all included portions of an image are at least acceptably sharp. With many dSLRs, you can see the available depth-of-field at the taking aperture by pressing the depth-of-field preview button, or estimate the range by viewing the depth-of-field scale found on many lenses.

depth-of-field preview A control on many cameras that closes the lens down to the taking aperture so the amount of depth-of-field can be seen before taking the picture.

depth-of-field scale A set of markings on a lens that show the approximate depth-of-field at a given f/stop.

Figure A.6 Depth-of-field determines how much of an image, such as the batter in this photo, is in sharp focus, and what parts, such as the background, are out of focus.

depth of focus The range that the image-capturing surface (such as a sensor or film) could be moved while maintaining acceptable focus.

desaturate To reduce the purity or vividness of a color, making a color appear to be washed out or diluted.

diaphragm An adjustable component, similar to the iris in the human eye, which can open and close to provide specific sized lens openings, or f/stops. See also *f/stop* and *iris*.

diffraction The loss of sharpness due to light scattering as an image passes through smaller and smaller f/stop openings. Diffraction is dependent only on the actual f/stop used, and the wavelength of the light.

diffuse lighting Soft, low-contrast lighting.

diffusion Softening of detail in an image by randomly distributing gray tones in an area of an image to produce a fuzzy effect. Diffusion can be added when the picture is taken, often through the use of diffusion filters, or in post-processing with an image editor. Diffusion can be beneficial to disguise defects in an image and is particularly useful for portraits of women.

digital processing chip A solid-state device found in digital cameras that's in charge of applying the image algorithms to the raw picture data prior to storage on the memory card.

digital zoom A way of simulating actual or optical zoom by magnifying the pixels captured by the sensor. This technique generally produces inferior results to optical zoom.

Figure A.7 Diffusion can hide defects and produce a soft, romantic glow in a female subject.

diopter A value used to represent the magnification power of a lens, calculated as the reciprocal of a lens' focal length (in meters). Diopters are most often used to represent the optical correction used in a viewfinder to adjust for limitations of the photographer's eyesight, and to describe the magnification of a close-up lens attachment.

dither A method of distributing pixels to extend the number of colors or tones that can be represented. For example, two pixels of different colors can be arranged in such a way that the eye visually merges them into a third color.

dock A device furnished with some point-and-shoot digital cameras that links up to your computer or printer, and allows interfacing the camera with the other devices simply by dropping it in the dock's cradle.

dodging A darkroom term for blocking part of an image as it is exposed, lightening its tones. Image editors can mimic this effect by lightening portions of an image using a brush-like tool. See also *burn*.

dot A unit used to represent a portion of an image, often groups of pixels collected to produce larger printer dots of varying sizes to represent gray or a specific color.

dot gain The tendency of a printing dot to grow from the original size to its final printed size on paper. This effect is most pronounced on offset presses using poor-

quality papers, which allow ink to absorb and spread, reducing the quality of the printed output, particularly in the case of photos that use halftone dots.

dots per inch (dpi) The resolution of a printed image, expressed in the number of printer dots in an inch. You'll often see dpi used to refer to monitor screen resolution, or the resolution of scanners. However, neither of these uses dots; the correct term for a monitor is pixels per inch (ppi), whereas a scanner captures a particular number of samples per inch (spi).

dummy A rough approximation of a publication, used to evaluate the layout.

dye sublimation A printing technique in which solid inks are heated and transferred to a polyester substrate to form an image. Because the amount of color applied can be varied by the degree of heat (and up to 256 different hues for each color), dye sublimation devices can print as many as 16.8 million different colors.

electronic viewfinder (EVF) An LCD located inside a digital camera and used to provide a view of the subject based on the image generated by the camera's sensor.

emulsion The light-sensitive coating on a piece of film, paper, or printing plate. When making prints or copies, it's important to know which side is the emulsion side so the image can be exposed in the correct orientation (not reversed). Image editors such as Photoshop include "emulsion side up" and "emulsion side down" options in their print preview feature.

equivalent focal length A digital camera's focal length translated into the corresponding values for a 35mm film camera. For example, a 5.8mm to 17.4mm lens on a digital camera might provide the same view as a 38mm to 114mm zoom with a film camera. Equivalents are needed because sensor size and lens focal lengths are not standardized for digital cameras, and translating the values provides a basis for comparison.

Exif Exchangeable Image File Format. Developed to standardize the exchange of image data between hardware devices and software. A variation on JPEG, Exif is used by most digital cameras, and includes information such as the date and time a photo was taken, the camera settings, resolution, amount of compression, and other data.

existing light In photography, the illumination that is already present in a scene. Existing light can include daylight or the artificial lighting currently being used, but is not considered to be electronic flash or additional lamps set up by the photographer.

export To transfer text or images from a document to another format.

exposure The amount of light allowed to reach the film or sensor, determined by the intensity of the light, the amount admitted by the iris of the lens, and the length of time determined by the shutter speed.

exposure program An automatic setting in a digital camera that provides the optimum combination of shutter speed and f/stop at a given level of illumination. For example a "sports" exposure program would use a faster, action-stopping shutter speed and larger lens opening instead of the smaller, depth-of-field-enhancing lens opening and slower shutter speed that might be favored by a "close-up" program at exactly the same light level.

exposure values (EV) EV settings are a way of adding or decreasing exposure without the need to reference f/stops or shutter speeds. For example, if you tell your camera to add +1EV, it will provide twice as much exposure, either by using a larger f/stop, slower shutter speed, or both.

eyedropper An image-editing tool used to sample color from one part of an image so it can be used to paint, draw, or fill elsewhere in the image. Within some features, the eyedropper can be used to define the actual black points and white points in an image.

feather To fade out the borders of an image element, so it will blend in more smoothly with another layer.

fill lighting In photography, lighting used to illuminate shadows. Reflectors or additional incandescent lighting or electronic flash can be used to brighten shadows. One common technique outdoors is to use the camera's flash as a fill.

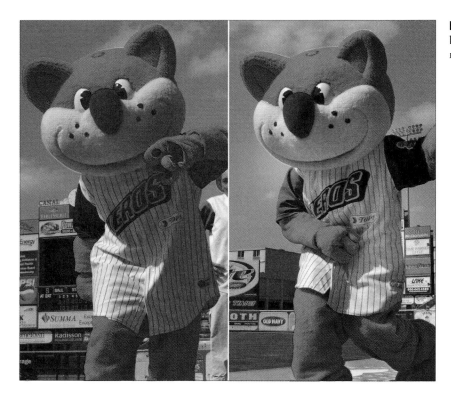

Figure A.8 Fill flash has brightened the shadows on this mascot's jersey.

filter In photography, a device that fits over the lens, changing the light in some way. In image editing, a feature that changes the pixels in an image to produce blurring, sharpening, and other special effects. Photoshop CS includes several new filter effects, including Lens Blur and Photo Filters.

FireWire (IEEE-1394) A fast serial interface used by scanners, digital cameras, printers, and other devices.

flash sync The timing mechanism that insures that an internal or external electronic flash fires at the correct time during the exposure cycle. A dSLR's flash sync speed is the highest shutter speed that can be used with flash. See also *front curtain sync* and *rear curtain sync*.

flat An image with low contrast.

flatbed scanner A type of scanner that reads one line of an image at a time, recording it as a series of samples, or pixels.

focal length The distance between the film and the optical center of the lens when the lens is focused on infinity, usually measured in millimeters.

focal plane An imaginary line, perpendicular to the optical access, which passes through the focal point forming a plane of sharp focus when the lens is set at infinity.

focus To adjust the lens to produce a sharp image.

focus lock A camera feature that lets you freeze the automatic focus of the lens at a certain point, when the subject you want to capture is in sharp focus.

focus range The minimum and maximum distances within which a camera is able to produce a sharp image, such as two inches to infinity.

focus servo A dSLR's mechanism that adjusts the focus distance automatically. The focus servo can be set to single autofocus, which focuses the lens only when the shutter release is partially depressed, and continuous autofocus, which adjusts focus constantly as the camera is used.

focus tracking The ability of the automatic focus feature of a camera to change focus as the distance between the subject and the camera changes. One type of focus tracking is *predictive*, in which the mechanism anticipates the motion of the object being focused on, and adjusts the focus to suit.

four-color printing Another term for process color, in which cyan, magenta, yellow, and black inks are used to reproduce all the colors in the original image.

framing In photography, composing your image in the viewfinder. In composition, using elements of an image to form a sort of picture frame around an important subject.

frequency The number of lines per inch in a halftone screen.

fringing A chromatic aberration that produces fringes of color around the edges of subjects, caused by a lens' inability to focus the various wavelengths of light onto the same spot. *Purple fringing* is especially troublesome with backlit images.

front-curtain sync The default kind of electronic flash synchronization technique, originally associated with focal plane shutters, which consist of a traveling set of curtains, including a front curtain (which opens to reveal the film or sensor) and a rear curtain (which follows at a distance determined by shutter speed to conceal the film or sensor at the conclusion of the exposure).

For a flash picture to be taken, the entire sensor must be exposed at one time to the brief flash exposure, so the image is exposed after the front curtain has reached the other side of the focal plane, but before the rear curtain begins to move.

Figure A.9 Extreme magnification reveals fringing at the player's shoulders, a chromatic aberration caused by the lens' inability to focus all the colors of light on the same spot.

Front-curtain sync causes the flash to fire at the *beginning* of this period when the shutter is completely open, in the instant that the first curtain of the focal plane shutter finishes its movement across the film or sensor plane. With slow shutter speeds, this feature can create a blur effect from the ambient light, showing as patterns that follow a moving subject with subject shown sharply frozen at the beginning of the blur trail (think of an image of The Flash running backwards). See also *rear-curtain sync*.

front focus The tendency of an autofocus system to apply focus in front of the point of true focus.

front lighting Illumination that comes from the direction of the camera. See also *back lighting* and *side lighting*.

f/stop The relative size of the lens aperture, which helps determine both exposure and depth-of-field. The larger the f/stop number, the smaller the f/stop itself. It helps to think of f/stops as denominators of fractions, so that f/2 is larger than

f/4, which is larger than f/8, just as 1/2, 1/4, and 1/8 represent ever smaller fractions. In photography, a given f/stop number is multiplied by 1.4 to arrive at the next number that admits exactly half as much light. So, f/1.4 is twice as large as f/2.0 (1.4 × 1.4), which is twice as large as f/2.8 (2 × 1.4), which is twice as large as f/4 (2.8 × 1.4). The f/stops which follow are f/5.6, f/8, f/11, f/16, f/22, f/32, and so on. See also *diaphragm*.

full-color image An image that uses 24-bit color, 16.8 million possible hues. Images are sometimes captured in a scanner with more colors, but the colors are reduced to the best 16.8 million shades for manipulation in image editing.

gamma A numerical way of representing the contrast of an image. Devices such as monitors typically don't reproduce the tones in an image in straight-line fashion (all colors represented in exactly the same way as they appear in the original). Instead, some tones may be favored over others, and gamma provides a method of tonal correction that takes the human eye's perception of neighboring values into account. Gamma values range from 1.0 to about 2.5. The Macintosh has traditionally used a gamma of 1.8, which is relatively flat compared to television. Windows PCs use a 2.2 gamma value, which has more contrast and is more saturated.

gamma correction A method for changing the brightness, contrast, or color balance of an image by assigning new values to the gray or color tones of an image to more closely represent the original shades. Gamma correction can be either linear or nonlinear. Linear correction applies the same amount of change to all the tones. Nonlinear correction varies the changes tone-by-tone, or in highlight, midtone, and shadow areas separately to produce a more accurate or improved appearance.

gamut The range of viewable and printable colors for a particular color model, such as RGB (used for monitors) or CMYK (used for printing).

Gaussian blur A method of diffusing an image using a bell-shaped curve to calculate the pixels which will be blurred, rather than blurring all pixels, producing a more random, less "processed" look.

GIF (Graphics Interchange Format) An image file format limited to 256 different colors that compresses the information by combining similar colors and discarding the rest. Condensing a 16.8-million-color photographic image to only 256 different hues often produces a poor-quality image, but GIF is useful for images that don't have a great many colors, such as charts or graphs. The GIF format also includes transparency options, and can include multiple images to produce animations that may be viewed on a Web page or other application. See also *JPEG* and *TIF*.

graduated filter A lens attachment with variable density or color from one edge to another. A graduated neutral density filter, for example, can be oriented so the neutral density portion is concentrated at the top of the lens' view with the less dense or clear portion at the bottom, thus reducing the amount of light from a very bright sky while not interfering with the exposure of the landscape in the foreground. Graduated filters can also be split into several color sections to provide a color gradient between portions of the image.

grain The metallic silver in film which forms the photographic image. The term is often applied to the seemingly random noise in an image (both conventional and digital) that provides an overall texture.

gray card A piece of cardboard or other material with a standardized 18-percent reflectance. Gray cards can be used as a reference for determining correct exposure.

grayscale image An image represented using 256 shades of gray. Scanners often capture grayscale images with 1024 or more tones, but reduce them to 256 grays for manipulation by Photoshop.

halftone A method used to reproduce continuous-tone images, representing the image as a series of dots.

high contrast A wide range of density in a print, negative, or other image.

highlights The brightest parts of an image containing detail.

histogram A kind of chart showing the relationship of tones in an image using a series of 256 vertical "bars," one for each brightness level. A histogram chart typically looks like a curve with one or more slopes and peaks, depending on how many highlight, midtone, and shadow tones are present in the image.

Figure A.10 A histogram shows the number of tones at each of 256 brightness levels.

Histogram palette A palette in Photoshop that allows making changes in tonal values using controls that adjust the white, middle gray, and black points of an image. Unlike the histogram included with Photoshop's Levels command, this palette is available for use even when you're using other tools.

hot shoe A mount on top of a camera used to hold an electronic flash, while providing an electrical connection between the flash and the camera.

hue The color of light that is reflected from an opaque object or transmitted through a transparent one.

hyperfocal distance A point of focus where everything from half that distance to infinity appears to be acceptably sharp. For example, if your lens has a hyperfocal distance of 4 feet, everything from 2 feet to infinity would be sharp. The hyperfocal distance varies by the lens and the aperture in use. If you know you'll be making a "grab" shot without warning, sometimes it is useful to turn off your camera's automatic focus and set the lens to infinity, or, better yet, the hyperfocal distance. Then, you can snap off a quick picture without having to wait for the lag that occurs with most digital cameras as their autofocus locks in.

image rotation A feature found in some digital cameras, which senses whether a picture was taken in horizontal or vertical orientation. That information is embedded in the picture file so that the camera and compatible software applications can automatically display the image in the correct orientation.

image stabilization A technology, also called vibration reduction and anti-shake, that compensates for camera shake, usually by adjusting the position of the camera sensor or lens elements in response to movements of the camera.

incident light Light falling on a surface.

indexed color image An image with 256 different colors, as opposed to a grayscale image, which has 256 different shades of the tones between black and white.

infinity A distance so great that any object at that distance will be reproduced sharply if the lens is focused at the infinity position.

infrared illumination The non-visible part of the electromagnetic spectrum with wavelengths above 700 nanometers. See also *near infrared.*

interchangeable lens Lens designed to be readily attached to and detached from a camera; a feature found in more sophisticated digital cameras.

Figure A.11 A shutter speed of 1/8th second is too slow to prevent blur from camera shake (top), but works just fine when the camera's image stabilization feature is turned on.

International Standards Organization (ISO) A governing body that provides standards used to represent film speed, or the equivalent sensitivity of a digital camera's sensor. Digital camera sensitivity is expressed in ISO settings.

interpolation A technique digital cameras, scanners, and image editors use to create new pixels required whenever you resize or change the resolution of an image based on the values of surrounding pixels. Devices such as scanners and digital cameras can also use interpolation to create pixels in addition to those actually captured, thereby increasing the apparent resolution or color information in an image.

invert In image editing, to change an image into its negative; black becomes white, white becomes black, dark gray becomes light gray, and so forth. Colors are also changed to the complementary color; green becomes magenta, blue turns to yellow, and red is changed to cyan.

IR filter A filter that removes visible light and allows only infrared light to pass to the sensor.

iris A set of thin overlapping metal leaves in a camera lens, also called a diaphragm, that pivot outwards to form a circular opening of variable size to control the amount of light that can pass through a lens.

jaggies Staircasing effect of lines that are not perfectly horizontal or vertical, caused by pixels that are too large to represent the line accurately. See also *anti-alias.*

JPEG (Joint Photographic Experts Group) A file format that supports 24-bit color and reduces file sizes by selectively discarding image data. Digital cameras generally use JPEG compression to pack more images onto memory cards. You can select how much compression is used (and therefore how much information is thrown away) by selecting from among the Standard, Fine, Super Fine, or other quality settings offered by your camera. See also *GIF* and *TIF.*

Figure A.12 Jaggies result when the pixels in an image are too large to represent a non-horizontal/vertical line smoothly.

Kelvin (K) A unit of measurement based on the absolute temperature scale in which absolute zero is zero; used to describe the color of continuous spectrum light sources, such as tungsten illumination (3200 to 3400K) and daylight (5500 to 6000K).

lag time The interval between when the shutter is pressed and when the picture is actually taken. During that span, the camera may be automatically focusing and calculating exposure. With digital SLRs, lag time is generally very short; with non-dSLRs, the elapsed time easily can be one second or more.

landscape The orientation of a page in which the longest dimension is horizontal, also called wide orientation.

latitude The range of camera exposures that produces acceptable images with a particular digital sensor or film.

layer A way of managing elements of an image in stackable overlays that can be manipulated separately, moved to a different stacking order, or made partially or fully transparent. Photoshop allows collecting layers into layer sets.

lens One or more elements of optical glass or similar material designed to collect and focus rays of light to form a sharp image on the film, paper, sensor, or a screen.

lens aperture The lens opening, or iris, that admits light to the film or sensor. The size of the lens aperture is usually measured in f/stops. See also *f/stop* and *iris*.

lens flare A feature of conventional photography that is both a bane and creative outlet. It is an effect produced by the reflection of light internally among elements of an optical lens. Bright light sources within or just outside the field of view cause lens flare. Flare can be reduced by the use of coatings on the lens elements or with the use of lens hoods. Photographers sometimes use the effect as a creative technique, and Photoshop includes a filter that lets you add lens flare at your whim.

lens hood A device that shades the lens, protecting it from extraneous light outside the actual picture area which can reduce the contrast of the image, or allow lens flare.

lens speed The largest lens opening (smallest f/number) at which a lens can be set. A fast lens transmits more light and has a larger opening than a slow lens. Determined by the maximum aperture of the lens in relation to its focal length; the "speed" of a lens is relative: A 400 mm lens with a maximum aperture of f/3.5 is considered extremely fast, while a 28mm f/3.5 lens is thought to be relatively slow.

lighten A Photoshop function that is the equivalent to the photographic darkroom technique of dodging. Tones in a given area of an image are gradually changed to lighter values.

lighting ratio The proportional relationship between the amount of light falling on the subject from the main light and other lights, expressed in a ratio, such as 3:1.

Figure A.13 Even when the sun or another bright object is not actually within the picture area it can cause reduced contrast and bright areas in an image. A lens hood helps prevent this flare.

line art Usually, images that consist only of white pixels and one color, represented in Photoshop as a bitmap.

line screen The resolution or frequency of a halftone screen, expressed in lines per inch.

lithography Another name for offset printing.

lossless compression An image-compression scheme, such as TIFF, that preserves all image detail. When the image is decompressed, it is identical to the original version.

lossy compression An image-compression scheme, such as JPEG, that creates smaller files by discarding image information, which can affect image quality.

luminance The brightness or intensity of an image, determined by the amount of gray in a hue.

LZW compression A method of compacting TIFF files using the Lempel-Ziv Welch compression algorithm, an optional compression scheme offered by some digital cameras.

Figure A.14 When carried to the extreme, lossy compression methods can have a serious impact on image quality.

macro lens A lens that provides continuous focusing from infinity to extreme close-ups, often to a reproduction ratio of 1:2 (half life-size) or 1:1 (life-size).

macro photography The process of taking photographs of small objects at magnifications of 1X or more.

magnification ratio A relationship that represents the amount of enlargement provided by the macro setting of the zoom lens, macro lens, or with other close-up devices.

Match Color A new feature of Photoshop that allows synchronizing color palettes between images to provide consistent hues.

matrix metering A system of exposure calculation that looks at many different segments of an image to determine the brightest and darkest portions.

maximum aperture The largest lens opening or f/stop available with a particular lens, or with a zoom lens at a particular magnification.

mechanical Camera-ready copy with text and art already in position for photographing.

microdrive A tiny hard disk drive in the Compact Flash form factor, which can be used in most digital cameras that take Compact Flash memory.

midtones Parts of an image with tones of an intermediate value, usually in the 25 to 75 percent range. Many image-editing features allow you to manipulate midtones independently from the highlights and shadows.

mirror lens A type of lens, more accurately called a *catadioptric lens*, which contains both lens elements and mirrors to "fold" the optical path to produce a shorter, lighter telephoto lens. Because of their compact size and relatively low price, these lenses are popular, even though they have several drawbacks, including reduced contrast, fixed apertures, and they produce doughnut-shaped out-of-focus points of light (because one of the mirrors is mounted on the front of the lens).

mirror lock-up The ability to retract the SLR's mirror to reduce vibration prior to taking the photo, or to allow access to the sensor for cleaning.

moiré An objectionable pattern caused by the interference of halftone screens, frequently generated by rescanning an image that has already been halftoned. An image editor can frequently minimize these effects by blurring the patterns.

monochrome Having a single color, plus white. Grayscale images are monochrome (shades of gray and white only).

negative A representation of an image in which the tones and colors are reversed: blacks as white, and vice versa.

neutral color In image-editing's RGB mode, a color in which red, green, and blue are present in equal amounts, producing a gray.

neutral density filter A gray camera filter reduces the amount of light entering the camera without affecting the colors.

noise In an image, pixels with randomly distributed color values. Noise in digital photographs tends to be the product of low-light conditions and long exposures, particularly when you have set your camera to a higher ISO rating than normal.

noise reduction A technology used to cut down on the amount of random information in a digital picture, usually caused by long exposures at increased sensitivity ratings. Noise reduction involves the camera automatically taking a second blank/dark exposure at the same settings that contain only noise, and then using the blank photo's information to cancel out the noise in the original picture. With most cameras, the process is very quick, but does double the amount of time required to take the photo. Noise reduction can also be performed within image editors and stand-alone noise reduction applications.

Figure A.15 Higher ISO settings lead to the random grain patterns known as noise.

normal lens A lens that makes the image in a photograph appear in a perspective that is like that of the original scene, typically with a field of view of roughly 45 degrees. A quick way to calculate the focal length of a normal lens is to measure the diagonal of the sensor or film frame used to capture the image, usually ranging from around 7mm to 45mm.

open flash A technique used for "painting with light" or other procedures, where the tripod-mounted camera's shutter is opened, the flash is triggered manually (sometimes several times), and then the shutter is closed.

optical zoom Magnification produced by the elements of a digital camera's lens, as opposed to *digital zoom* which merely magnifies the captured pixels to simulate additional magnification. Optical zoom is always to be preferred over the digital variety.

overexposure A condition in which too much light reaches the film or sensor, producing a dense negative or a very bright/light print, slide, or digital image.

pan-and-tilt head A tripod head allowing camera to be tilted up or down or rotated 360 degrees.

panning Moving the camera so that the image of a moving object remains in the same relative position in the viewfinder as you take a picture. The eventual effect creates a strong sense of movement.

panorama A broad view, usually scenic. Photoshop's new Photomerge feature helps you create panoramas from several photos. Many digital cameras have a panorama assist mode that makes it easier to shoot several photos that can be stitched together later.

parallax compensation An adjustment made by the camera or photographer to account for the difference in views between the taking lens and the external viewfinder.

PC terminal A connector for attaching standard electronic flash cords, named after the Prontor-Compur shutter companies which developed this connection.

perspective The rendition of apparent space in a photograph, such as how far the foreground and background appear to be separated from each other. Perspective is determined by the distance of the camera to the subject. Objects that are close appear large, while distant objects appear to be far away.

perspective control lens A special lens, most often used for architectural photography, that allows correcting distortion resulting from a high or low camera angle.

Photo CD A special type of CD-ROM developed by Eastman Kodak Company that can store high-quality photographic images in a special space-saving format, along with music and other data.

pincushion distortion A type of distortion, most often seen in telephoto prime lenses and zooms, in which lines at the top and side edges of an image are bent inward, producing an effect that looks like a pincushion.

Figure A.16 This exaggerated example shows pincushion distortion (top) and barrel distortion (bottom).

pixel The smallest element of a screen display that can be assigned a color. The term is a contraction of "picture element."

pixels per inch (ppi) The number of pixels that can be displayed per inch, usually used to refer to pixel resolution from a scanned image or on a monitor.

plug-in A module such as a filter that can be accessed from within an image editor to provide special functions.

point Approximately 1/72 of an inch outside the Macintosh world, exactly 1/72 of an inch within it.

polarizing filter A filter that forces light, which normally vibrates in all directions, to vibrate only in a single plane, reducing or removing the specular reflections from the surface of objects and emphasizing the blue of skies in color images.

portrait The orientation of a page in which the longest dimension is vertical, also called tall orientation. In photography, a formal picture of an individual or, sometimes, a group.

positive The opposite of a negative, an image with the same tonal relationships as those in the original scenes—for example, a finished print or a slide.

prepress The stages of the reproduction process that precede printing, when halftones, color separations, and printing plates are created.

prime A camera lens with a single fixed focal length, as opposed to a zoom lens.

process color The four color pigments used in color printing: cyan, magenta, yellow, and black (CMYK).

RAW An image file format offered by many digital cameras that includes all the unprocessed information captured by the camera. RAW files are very large, and must be processed by a special program supplied by camera makers, image editors, or third parties, after being downloaded from the camera.

rear-curtain sync An optional kind of electronic flash synchronization technique, originally associated with focal plane shutters, which consist of a traveling set of curtains, including a front curtain (which opens to reveal the film or sensor) and a rear curtain (which follows at a distance determined by shutter speed to conceal the film or sensor at the conclusion of the exposure).

For a flash picture to be taken, the entire sensor must be exposed at one time to the brief flash exposure, so the image is exposed after the front curtain has reached the other side of the focal plane, but before the rear curtain begins to move.

Rear-curtain sync causes the flash to fire at the *end* of the exposure, an instant before the second or rear curtain of the focal plane shutter begins to move. With slow shutter speeds, this feature can create a blur effect from the ambient light,

Figure A.17 Photoshop's Adobe Camera RAW allows you to tweak RAW images as they are imported.

showing as patterns that follow a moving subject with subject shown sharply frozen at the end of the blur trail. If you were shooting a photo of The Flash, the superhero would appear sharp, with a ghostly trail behind him.

red eye An effect from flash photography that appears to make a person's eyes glow red, or an animal's yellow or green. It's caused by light bouncing from the retina of the eye, and is most pronounced in dim illumination (when the irises are wide open) and when the electronic flash is close to the lens and therefore prone to reflect directly back. Image editors can fix red eye through cloning other pixels over the offending red or orange ones.

red-eye reduction A way of reducing or eliminating the red-eye phenomenon. Some cameras offer a red-eye reduction mode that uses a preflash that causes the irises of the subjects' eyes to close down just prior to a second, stronger flash used to take the picture.

reflection copy Original artwork that is viewed by light reflected from its surface, rather than transmitted through it.

reflector Any device used to reflect light onto a subject to improve balance of exposure (contrast). Another way is to use fill-in flash.

Figure A.18 Digital cameras usually have several features for avoiding the demon red-eye look, but you'll still get the effect when you least want it.

register To align images.

registration mark A mark that appears on a printed image, generally for color separations, to help in aligning the printing plates. Photoshop can add registration marks to your images when they are printed.

reproduction ratio Used in macrophotography to indicate the magnification of a subject.

resample To change the size or resolution of an image. Resampling down discards pixel information in an image; resampling up adds pixel information through interpolation.

resolution In image editing, the number of pixels per inch used to determine the size of the image when printed. That is, an 8 × 10-inch image that is saved with 300 pixels per inch resolution will print in an 8 × 10-inch size on a 300 dpi printer, or 4 × 5-inches on a 600 dpi printer. In digital photography, resolution is the number of pixels a camera or scanner can capture.

retouch To edit an image, most often to remove flaws or to create a new effect.

RGB color mode A color mode that represents the three colors—red, green, and blue—used by devices such as scanners or monitors to reproduce color. Photoshop works in RGB mode by default, and even displays CMYK images by converting them to RGB.

saturation The purity of color; the amount by which a pure color is diluted with white or gray.

Figure A.19 Fully saturated (left) and desaturated (right).

scale To change the size of all or part of an image.

scanner A device that captures an image of a piece of artwork and converts it to a digitized image or bitmap that the computer can handle.

Secure Digital memory card Another flash memory card format that is gaining acceptance for use in digital cameras and other applications.

selection In image editing, an area of an image chosen for manipulation, usually surrounded by a moving series of dots called a selection border.

selective focus Choosing a lens opening that produces a shallow depth-of-field. Usually this is used to isolate a subject by causing most other elements in the scene to be blurred.

self-timer Mechanism delaying the opening of the shutter for some seconds after the release has been operated. Also known as delayed action.

sensitivity A measure of the degree of response of a film or sensor to light.

sensor array The grid-like arrangement of the red, green, and blue-sensitive elements of a digital camera's solid-state capture device. Sony offers a sensor array that captures a fourth color, termed *emerald*.

shadow The darkest part of an image, represented on a digital image by pixels with low numeric values or on a halftone by the smallest or absence of dots.

Shadow/Highlight Adjustment A new Photoshop feature used to correct over-exposed or underexposed digital camera images.

sharpening Increasing the apparent sharpness of an image by boosting the contrast between adjacent pixels that form an edge.

shutter In a conventional film camera, the shutter is a mechanism consisting of blades, a curtain, plate, or some other movable cover that controls the time during which light reaches the film. Digital cameras can use actual shutters, or simulate the action of a shutter electronically. Quite a few use a combination, employing a mechanical shutter for slow speeds and an electronic version for higher speeds.

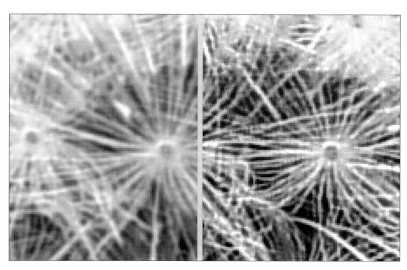

Figure A.20 Increasing the contrast between pixels (right) makes an image appear to be sharper than the unprocessed version (left).

shutter lag The tendency of a camera to hesitate after the shutter release is depressed prior to making the actual exposure. Point-and-shoot digital cameras often have shutter lag times of up to 2 seconds, primarily because of slow autofocus systems. Digital SLRs typically have much less shutter lag, typically 0.2 seconds or less.

shutter-preferred An exposure mode in which you set the shutter speed and the camera determines the appropriate f/stop. See also *aperture-preferred*.

side lighting Light striking the subject from the side relative to the position of the camera; produces shadows and highlights to create modeling on the subject.

single lens reflex (SLR) camera A type of camera that allows you to see through the camera's lens as you look in the camera's viewfinder. Other camera functions, such as light metering and flash control, also operate through the camera's lens.

slave unit An accessory flash unit that supplements the main flash, usually triggered electronically when the slave senses the light output by the main unit, or through radio waves.

slide A photographic transparency mounted for projection.

slow sync An electronic flash synchronizing method that uses a slow shutter speed so that ambient light is recorded by the camera in addition to the electronic flash illumination, so that the background receives more exposure for a more realistic effect.

SLR (single lens reflex) A camera in which the viewfinder sees the same image as the film or sensor.

SmartMedia An obsolete type of memory card storage, generally outmoded today because its capacity is limited to 128MB, for digital cameras and other computer devices.

smoothing To blur the boundaries between edges of an image, often to reduce a rough or jagged appearance.

soft focus An effect produced by use of a special lens or filter that creates soft outlines.

soft lighting Lighting that is low or moderate in contrast, such as on an overcast day.

solarization In photography, an effect produced by exposing film to light partially through the developing process. Some of the tones are reversed, generating an interesting effect. In image editing, the same effect is produced by combining some positive areas of the image with some negative areas. Also called the Sabattier effect, to distinguish it from a different phenomenon called overexposure solar-

ization, which is produced by exposing film to many, many times more light than is required to produce the image. With overexposure solarization, some of the very brightest tones, such as the sun, are reversed.

specular highlight Bright spots in an image caused by reflection of light sources.

spot color Ink used in a print job in addition to black or process colors.

spot meter An exposure system that concentrates on a small area in the image. See also *averaging meter*.

subtractive primary colors Cyan, magenta, and yellow, which are the printing inks that theoretically absorb all color and produce black. In practice, however, they generate a muddy brown, so black is added to preserve detail (especially in shadows). The combination of the three colors and black is referred to as CMYK. (K represents black, to differentiate it from blue in the RGB model.)

T (time) A shutter setting in which the shutter opens when the shutter button is pressed, and remains open until the button is pressed a second time. See also *B (bulb)*.

telephoto A lens or lens setting that magnifies an image.

thermal wax transfer A printing technology in which dots of wax from a ribbon are applied to paper when heated by thousands of tiny elements in a printhead.

threshold A predefined level used by a device to determine whether a pixel will be represented as black or white.

thumbnail A miniature copy of a page or image that provides a preview of the original. Photoshop uses thumbnails in its Layer and Channels palettes, for example.

TIFF (Tagged Image File Format) A standard graphics file format that can be used to store grayscale and color images plus selection masks. See also *GIF* and *JPEG*.

time exposure A picture taken by leaving the shutter open for a long period, usually more than one second. The camera is generally locked down with a tripod to prevent blur during the long exposure. See also *bulb*.

time lapse A process by which a tripod-mounted camera takes sequential pictures at intervals, allowing the viewing of events that take place over a long period of time, such as a sunrise or flower opening. Many digital cameras have time-lapse capability built in. Others require you to attach the camera to your computer through a USB cable, and let software in the computer trigger the individual photos.

tint A color with white added to it. In graphic arts, often refers to the percentage of one color added to another.

tolerance The range of color or tonal values that will be selected with a tool like the Photoshop's Magic Wand, or filled with paint when using a tool like the Paint Bucket.

transparency A positive photographic image on film, viewed or projected by light shining through film.

transparency scanner A type of scanner that captures color slides or negatives.

tripod A three-legged supporting stand used to hold the camera steady. Especially useful when using slow shutter speeds and/or telephoto lenses.

TTL Through the lens. A system of providing viewing through the actual lens taking the picture (as with a camera with an electronic viewfinder, LCD display, or single lens reflex viewing), or calculation of exposure, flash exposure, or focus based on the view through the lens.

tungsten light Usually warm light from ordinary room lamps and ceiling fixtures, as opposed to fluorescent illumination.

underexposure A condition in which too little light reaches the film or sensor, producing a thin negative, dark slide, muddy-looking print, or dark digital image.

unipod A one-legged support, or monopod, used to steady the camera. See also *tripod.*

unsharp masking The process for increasing the contrast between adjacent pixels in an image, increasing sharpness, especially around edges.

USB A high-speed serial communication method commonly used to connect digital cameras and other devices to a computer.

viewfinder The device in a camera used to frame the image. With an SLR camera, the viewfinder is also used to focus the image if focusing manually. You can also focus an image with the LCD display of a digital camera, which is a type of viewfinder.

vignetting Dark corners of an image, often produced by using a lens hood that is too small for the field of view, or generated artificially using image-editing techniques.

white The color formed by combining all the colors of light (in the additive color model) or by removing all colors (in the subtractive model).

white balance The adjustment of a digital camera to the color temperature of the light source. Interior illumination is relatively red; outdoors light is relatively blue. Digital cameras often set correct white balance automatically, or let you do it through menus. Image editors can often do some color correction of images that were exposed using the wrong white-balance setting.

white point In image editing, the lightest pixel in the highlight area of an image.

wide-angle lens A lens that has a shorter focal length and a wider field of view than a normal lens for a particular film or digital image format.

xD card A very small type of memory card, used chiefly in Olympus and Fuji digital cameras.

zoom In image editing, to enlarge or reduce the size of an image on your monitor. In photography, to enlarge or reduce the size of an image using the magnification settings of a lens.

zoom ring A control on the barrel of a lens that allows changing the magnification, or zoom, of the lens by rotating it.

Index